Darwin's Mi

DR. HANS J. ZILLMER

DARWIN'S MISTAKE

Antediluvian discoveries prove:
dinosaurs and humans co-existed

Original title:
"Darwins Irrtum"

*Translated from German
by Tracey J. Evans
and Richard Demarest*

Original German edition:
© 1998 by Langen Müller in F.A. Herbig Publishing House, Munich (Munich),
Mrs. Frauke Hoppen (e-mail: f.hoppen@hergig.net)
Thomas-Wimmer-Ring 11, D-80539 Munich/Germany
Telephone (+49) 089-290880, Fax (+49) 089-29088144
http://www.herbig.net and www.zillmer.com

English edition:
© Langen Müller 2002
Frontier Publishing
PO Box 48
1600 AA Enkhuizen
the Netherlands
Tel. +31-(0)228-324076
Fax +31-(0)228-312081
info@fsf.nl
http://www.fsf.nl

Produced by Philip Coppens and Herman Hegge

Contents

The Author

Dr. Hans J. Zillmer, born 1950, holds two degrees in engineering (for further details see the entry in "Who´s Who in the World ", "Who´s Who in Science and Engineering" and "Who´s Who in Germany"), advising engineer of the engineer chamber NRW (Germany). He works as a civil engineer in an advisory capacity and has been a building contractor for many years. For more than 30 years, he has been concentrating on contentious findings and inconsistencies in our perception of the world. Numerous educational trips and the active participation in excavations, most recently in 1999, deepened his knowledge. He has several publications, lectures, radio and television interviews to his credit.

"Darwins Irrtum" (Darwin's Mistake) was published 1998 by the publishing house Langen Müller in Munich (Germany) and translated in nine languages, including Spanish, Italian, Czech, Slovakian and Bulgarian. "Darwins Irrtum" had its fourth edition in Germany in 2001.

Internet: www.zillmer.com (author) and www.herbig.net

Prologue

Once upon a time, there was a 200-year-old worldview elaborately proven by every available field of science. Only very little was left to be discovered and knowledge was virtually unlimited...

A modern fairy-tale that resulted from the theories of planetary mechanics by Isaac Newton and the "Theory of Evolution" by Charles Darwin: an all-embracing harmony was supposed to have constantly prevailed. According to these principles, the universe, and therefore our Earth, developed gradually and uniformly.

By mere coincidence, a protozoon grew out of an amino acid. It then did not go on to grow into a *two-celled life form* but, as Evolution Theory has it, immediately developed into a complex life form. If that is true, a question that until now has not been asked, arises: Where did that second cell come from, after the first one had merely developed by some incredible coincidence? Was there a set of incredible coincidences at work or had there originally been only two? In this case, at one time, at least, a life form with two cells must have existed. Why does this organism, or even one with three or four cells, not exist in nature now?

How did the *genetic code become a part of the cell?* And where did it come from? These questions still belong to the great mysteries of life. Be that as it may, life is supposedly proven to have originated in the water and subsequently developed further ashore. All this is believed to have happened very slowly and systematically.

Charles Lyell's geological theory on the exclusive effectiveness of miniscule contemporary forces on changes on the Earth's surface laid the foundations for our present view of the world. This means that the appearance of the Earth has merely changed slightly and insignificantly in the course of the Earth's history. Darwin's Evolution Theory again is *implicitly* built on this dogma, for continuous gradual development is possible only if there were no drastic global catastrophes. Darwinism is based on the assumption that the fittest species survives by means of the selection principle. Mutation, natural selection and isolation are the decisive factors of evolution.

Today, these theories are attributed the quality of *unassailable cardinal laws.* This book points out the contradictions of these theories by using fossils, petrified findings and by taking ancient records into consideration: chaos prevailed, not uniformity. The Old Testament, in particular, will be consulted to answer open questions.

Until two hundred years ago, virtually all of mankind believed in God's Creation. The Darwinian Theory of Evolution long went unrecognized because it strictly denied biblical genesis and the special role mankind derived from it for itself, relegating it to the sphere of legend. By bringing forth rock solid evidence, this book will expose the Theory of Evolution as a misconception. The latest research has unmasked as simple fraud what until now seemed *the* unshakable pillar of Darwinism: Ernst Haeckel's Biogenetic Basic Law.

All these theories were put forth during the last century and require radical reconsideration. Only outsiders and their interdisciplinary considerations are capable of starting off this re-evaluation, even if it provokes vehement protest, as was the case when Immanuel Velikovsky published his books.

The above-mentioned theories of uniformity reject any global catastrophe as a matter of principle because it would prove that a uniform development of the species is unfounded. All observations made today are still projected into the Earth's past. This is a comfortable system with fixed, unchanging key features, allowing calculation and interpretation of any phenomenon. If, however, there was at least one "end of the world", then all theories of uniformity would be false and, thus, inevitably furnish inaccurate results.

If one can prove that species that are assumed to have lived in succession, actually *existed simultaneously*, one denies that there could have been such a thing as evolution. In this case, Darwinism *by its own definition* is a castle in the air, without any foundation in reality.

1 Artifact or Fake?

During my summer vacation in 1988, I read an interesting book by Johannes von Buttlar about extraordinary discoveries and findings[1]. One chapter briefly reported that in recent decades, marks of human feet and shoes were repeatedly found next to petrified dinosaur tracks. The discovery site was located in the area of Paluxy River, near Glen Rose, in the United States. It also described an old weather-beaten hammer with a broken wooden handle. A family by the name of Hahn had found the hammer in 1934 near London, a small Texas town. This site and the one at the Paluxy River belong to the same part of the Llano Uplift mountain range. Nothing but the broken end of the handle of the fossilized hammer had stuck out of the mountain rock. Originally, solid sandstone had entirely encased the hammerhead and its wooden handle. Not until a massive piece of rock had been forced open was it possible to examine and analyze the discovery.

Naturally, such discoveries contradict the Theory of Evolution by Charles Darwin. Dinosaurs are thought to have become extinct an estimated 64 million years ago. Based on the findings of anthropology, *homo erectus*, the first human to walk erect, developed two or three million years ago. All conventional schools of thought, and the theory of Evolution in particular, teach that dinosaurs and humans missed each other by more than 60 million years.

The idea that humans, as well as dinosaurs, could have left their footprints in the same geological stratum is incompatible with scientific principles. Moreover, finding a man-made hammer that, according to geological dating methods, was embedded in 140-million-year-old rock, does not at all fit into the concept of the theory of Evolution; a theory that has long since become dogma.

This brings up the question of the actual age of the surrounding rock. It must have been of soft consistence when dinosaurs and humans left their now petrified marks, a consistence *comparable* to that of a fast-setting plaster cast. Much the same applies to the limestone that enclosed the hammer. Limestone today is an ingredient in modern fast-setting cement. Presuming that the discoveries and prints described here are no forgeries but reliable evidence, some interesting conclusions can be drawn: *dinosaurs and humans lived at the same time and the limestone dates back to that time.* In other words: sedimentary rock (sediments) contains evidence of a time when creatures co-existed that, by our understanding of the world, could not possibly have lived contemporaneously.

The question of when these events took place remains unanswered. It seems obvious that humans and dinosaurs co-existed in this world at least 64 million years ago. For, at that point in time, all of these animals presumably suddenly became extinct. According to the laws of geology, rock too is allegedly very old.

Let us assume that these scientific theories are correct. The sensational conclusion we then have to draw is that mankind is not a relatively young species, but actually goes back to an – until now – unknown long-forgotten past.

However, is that necessarily true? Could it be the other way around: dinosaurs survived and became extinct only several thousand years ago? In that case, mankind would have to be a rather young species. This, on the other hand, leads to the conclusion that the imprint bearing rocks of Paluxy River too derive from a more recent past. This possibility will surely be seen as sensational and virtually invites hyper-criticism, for under these circumstances, the crust of the Earth also dates back to very recent times.

There is unanimous agreement among geologists and paleontologists that the rock strata in question are approximately 140 million years old and go back to the beginning of the Cretaceous period. Consequently, mankind as well as dinosaurs should be just as old. However, are these scientific datings correct? If I question geological dating methods as a matter of principle, then we arrive at interesting alternative possibilities. Either:

· Limestone, dinosaurs, and mankind are all at least 64 million years old;

· Dinosaurs, mankind and the respective geological strata are relatively young, possibly only a few thousand years old;

· The mutual age to be determined lies somewhere between these extremes.

The conclusions drawn from the discoveries are practically unbelievable. Assuming authenticity of these finds can be verified, our seemingly proven prehistoric worldview suddenly turns out to be a misconception. A number of accounts in various books and magazines about finds that seemed to contradict conventional ideas of the Earth's history had attracted my attention. I therefore decided to delve further into the matter and investigate the soundness of these accounts first-hand.

2 A Fossil Hammer

Thorough examinations of the fossil hammer have confirmed its authenticity. We therefore have to conclude that there was no such thing as a gradual development, no evolution. The discovery of the hammer demands a fundamentally different worldview.

A Visit in Glen Rose

On the occasion of a round-trip in the MidWest of the USA in 1993, I took the opportunity to visit Glen Rose, the county seat of Somervell County, Texas. The local sights to see are the "Somervell County Museum" and the "Dinosaur Valley State Park". While the museum holds relics of the prehistoric past, the national park displays well-preserved dinosaur tracks found near the Paluxy River.

Somervell County Museum is located in the historical center of the town. On a brief tour, I noticed that the fossils on exhibit lacked any apparent order. Petrified wood of different sorts and shapes, fossilized bits of coral, old shark teeth, and fossilized dinosaur tracks hewn out of bare rock were displayed immediately next to fossilized trilobites, skull fragments of large mammals, bones of various primitive life forms, and other findings dating from primeval times discovered near Glen Rose over the past decades.

A closer examination of the exhibits gave food for thought. All of these fossils were found in the same geological stratum. This would indicate the co-existence of various primeval animals from supposedly very different periods of time. It would also strip Darwin's Theory of Evolution, the foundation of our currently accepted conception of the world, of its realistic basis: if dinosaurs and mammals lived in co-existence, there could not have been any development, an evolution of the species.

I visited the museum to look for the hammer encased in rock. To make identification easier, I had brought a photocopy of the published picture. An elderly woman, Mrs. Jeannie Mack, was the museum's director. She confirmed that the hammer had been on display in the museum some time ago and remarked that it mostly had gone unnoticed. She could clearly identify the unique specimen in the picture; obviously the hammer was more than a mere fairy-tale. Although she did not know where the hammer was currently kept, she directed me to a museum, of which I had not yet heard, said to be located some six or seven miles away from "Dinosaur Valley State Park".

A short ride brought me to the "Creation Evidence Museum" near "Dinosaur Valley State Park". It consisted of something that looked like two large adjoining office containers and exhibited various finds and pictures, mostly documenting fossilized human and dinosaur footprints. The size of some human footprints was above average. The director of the museum, Carl Baugh, was also participating in nearby excavations.

After a first brief conversation, my family and I went to see "Dinosaur Valley State Park". We found scores of fossilized dinosaur prints on the rocky banks and in the bed of Paluxy River. It was amazing to find these tracks in such high geological strata. It would seem logical that water flowing over the footprints would have quickly eroded these remnants beyond recognition. On the other hand, these traces, according to Darwin to be at least 64 million years old, looked as if they had just been made. I also found two prints showing the roughly oval form of a human foot. There were, however, no recognizable details such as the mark of the big toe.

Description of the Hammer

When we returned to the "Creation Evidence Museum", Dr. Baugh provided me access to the results of the research done on the fossil hammer.

This ancient tool has a simple form, similar to the type of hammer that is still common in Germany today. The handle was a very hard petrified crystal with an intact structure. It was possible to ascertain that the interior of the handle had partly turned into porous coal. There is no way to scientifically explain this combination of carbonization and petrification. I have not heard of a similar piece found anywhere in the world. Two very different processes must have occurred simultaneously or in short succession.

The outer layers of the hammer's handle reminded me of the petrified stumps and piles of wood I had seen earlier at the "Petrified Forest National Park" in Arizona, on a visit in 1988. The exhibits there, pieces of the cut-up piles of wood, had completely petrified and displayed a homogenous crystal structure. I do not know of one piece discovered in that park that contained a coal interior comparable to that of the fossil hammer. The age of the trees there is officially estimated at between 100 and 200 million years. Wood petrifies when it is buried in silt deposited by flooding rivers or seas and silicates, such as are found in volcanic ash, where it dissolves and impregnates the material. These substances replace the hydrogen and oxygen portions in the wood and begin the petrification process by silicification. This may produce very solid

opal or quartz minerals. The final product is approximately 5 times heavier than common pinewood.

This short description of the hammer handle should make it obvious that the fossil hammer must be authentic and very old. In spite of all our modern technical abilities, it has never been possible to produce petrified wood with porous coal inside. It therefore is out of the question that such a hammer could be a hoax. I must clearly emphasize this point, as most artifacts which contradict the accepted view of the world we are accustomed to are normally accused of being forgeries. Our traditional schools of thought, however, are at a loss when it comes to explaining this hammer. Petrified wood, and therefore this ancient tool, is supposed to be at least 140 million years old. Official scientific authorities, however, say that humans capable of manufacturing high quality tools have only existed for a few millennia. Something concerning these datings and the enormous time intervals of the geological era must be erroneous. Is humanity really many millions of years old or are we a young species? Did the processes of rock formation take place more recently than is believed?

Examination of the Hammer

Before I look into these questions, I would like to give a more detailed description of the hammerhead's characteristics in order to make the full extent of the mystery clear. Two different institutes carried out detailed research,[1] independently of one another. John Mackay, Director of Australia's "Creation Science Foundation", analyzed the hammer thoroughly during his visit to the United States. A number of Australian metallurgists, as well as those working at the respected metallurgic Institute "Batelle Memorial Laboratory" in Columbus, Ohio (USA), took part in these analyses. Sophisticated electron microscopes served to examine structure and composition of the steel the hammerhead was made of.

The results of the examinations were as mysterious as they were bewildering. The hammerhead, chemically speaking, consisted of 96.6 % iron, 2.6 % chlorine, and 0.74 sulphur. Incredibly, this material is almost entirely solid iron! Other additives or impurities were not detected.[2]

Non-destructive testing methods of steel quality comprise of x-ray examination, magnetic testing, as well as ultrasonic detection. X-rays showed *no evidence of inclusions or irregularities* in the steel hammerhead. This meant it was tempered and hardened in some way. In general, chemically genuine and

unworked steel is rather soft. The even structure, however, suggests that this hard steel was manufactured using a sophisticated technology.

The results of the examination are as sensational as they are unbelievable. Anyone with the slightest knowledge of steel manufacturing knows that every modern steel-making process inevitably leads to carbon or silicon impurities! I emphasize the word *inevitably*. Steel production without these impurities is simply unthinkable! No other known ingredients used for refinement such as copper, titanium, manganese, cobalt, or molybdenum, vanadium, wolfram or nickel could be traced. We employ these and other elements in steel manufacturing to achieve different properties needed for different fields of application.

The high quantity of chlorine in the fossil hammerhead is remarkable as well. Chlorine plays no part in modern steel manufacturing and is not used at all today, so it is impossible to produce the high steel quality of the type found here by today's manufacturing methods. This leads us to the next question: Who manufactured this hammer and when?

Based on the standpoint of accepted research and science, it is impossible

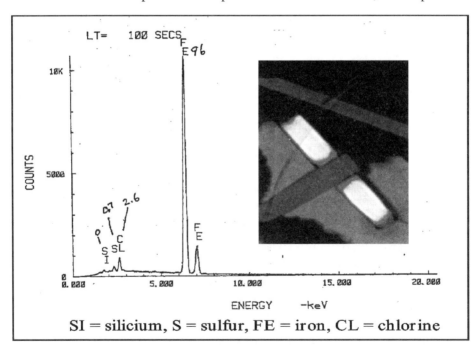

SI = silicium, S = sulfur, FE = iron, CL = chlorine

*Fig. 1: **Diagram of Examination.** The results of the examinations using highly sophisticated electron microscopes by the metallurgic institute "Batelle Memorial Laboratory" are presented in the diagram. They found nearly pure iron. The radiogram of the hammerhead shows a homogenous steel structure with no signs of inclusions or impurities.*

for this hammer to exist, much less to have ever been manufactured. For the reasons given, it is thus out of the question that we are dealing with a "hoax" hammerhead. Much the same has been shown concerning the hammer handle. Two forgery-proof materials, for which we have no scientific explanation, are combined in one tool. This is extraordinary evidence of a very different history of Earth and mankind!

If our school teachers are correct, there is no other conclusion than that an alien visiting Earth must have lost the hammer. Still, I have one other, more logical explanation to offer and I will present it later in this book. My explanation, however, is not in accordance with traditional scientific theory.

The fossil hammer shows more peculiar features still. In breaking open the hammer's original stone enclosure in 1934, the upper edge of the metal head was damaged, leaving a small notch. The inside of the notch revealed a shiny silvery surface. Until today, more than 60 years later, the color of the notch has not changed. No traces of rust are perceptible. The relatively high concentration of chlorine coinciding with a total absence of carbon, which would cause corrosion by reacting with oxygen, may be responsible for this phenomenon. The remaining surface area of the hammerhead is of dark blackened color as if exposed to fire, of which the carbonized inside of the hammer's handle testifies. An analysis of the coating yielded the following results: 82.9 % iron, 8.9 % silicon, 3.6 % sulphur, 2.5 % calcium, 1.3 % chlorine and 0.78 % potassium. The composition of this crust could, on one hand, correspond to the chemical reaction between the elements of the metal and the material of the rock that encased the hammer. On the other hand, it may also reflect dissolved mineral substances in the ground water the material was exposed to.

Some of the rock in which the hammer was embedded looks as if it was glued to the hammerhead or had melted into the metal. John Mackay, as well as other American experts, has speculated that this phenomenon on the metal surface could have been caused by the exposure to no less than two atmospheric pressures under simultaneous shielding from ultraviolet radiation. This basically presupposes very different atmospheric pressure conditions than we have ever experienced or suspected. But any other plausible explanation has yet been found. Summing up, we have the following facts:

· The hammer is man-made.
· The handle consists of petrified wood. Its interior is carbonized.
· The hammerhead consists of a genuine metal, which we are not able to

produce, and it does not corrode (rust).

· The hammer was completely encased in rock.

· Fire, as well as running water, has virtually simultaneously affected the hammer.

· When the metal of the hammer was produced, probably at least two atmospheric pressures prevailed on Earth.

Natural Origin of Steel?

If none of our modern technologies is capable of producing such a metal, then the question remains: could the metal of the hammerhead simply be of natural origin? Different explanations are conceivable. One obvious possibility is that the steel was formed in the core of a metallic meteorite. If the steel was thus naturally smelted and later found, it merely would have had to be cut and worked on.

Seen from a technical point of view, such a method, without any further refinement of the steel and its inevitable impurities, would, as we know from experience, never produce a good solid hammer. Apart from that, the material of most ferrous meteorites contains nickel and small impurities in the form of cobalt, aluminum, sulphur, phosphore, chrome and carbon. The meteorite theory therefore has to be ruled out.

It is also conceivable though that the base material was discovered in a deposit somewhere on Earth. However, no such discovery has been documented yet. Iron ore is only found in combination with other elements, mostly carbon.

With all of these possibilities ruled out, the only conclusion left is that the hammer was made under fundamentally different atmospheric conditions, using a technical method unknown to us.

When was it made?

The hammer evidently was once complete and today it is still partly encapsulated in massive sandstone. Part of the metal has chemically combined with the surrounding rock. It inevitably follows that the fossil hammer dates from an earlier time than the material surrounding it.

Geologists estimate the rock to be at least 140 to 400 million years old. If this estimate is correct, the hammer is at least as old. It has to be concluded

that mankind has not just existed for some 4 million years, but for more than 140 million years from a geological point of view, or maybe even 400 million years. If one doubts this dating and proves it wrong by detecting a mistake in the theories underlying the dating methods, then the hammer, and along with it the rock and the estimated time the dinosaurs are said to have become extinct, may only date back to 10,000 years.

This is exactly my task in this book. I want to point out and prove the inconsistencies and basic weaknesses of the methods used to determine such dates. Significant consequences for the theoretical course of the development of Earth's history will be the result, if I prove my case.

As forgery and hoax have to be ruled out due to the technical, optical, chemical and physical characteristics of the hammer, the traditional school of scientific thought has involuntarily pushed the origins of mankind far back into the past. Actually too far. Why? Because that would reduce the current Theory of Evolution to a mere fantasy. In such a case, man existed even before there were apes.

According to prevailing scientific school of thought, the latter could not have developed before the sudden extinction of the dinosaurs, which allegedly was 64 million years ago. The gradual evolution of larger mammals supposedly did not begin before then. This reveals a fundamental contradiction in the standard scientific school of thought, automatically bringing up a rhetorical but, nevertheless in the spirit of the Theory of Evolution, logical question. Did apes then descend from man?[3] Seen from this perspective, evolution and incidental gradual development of mankind through a series of coincidences and mutations over long periods of time look like fairy-tales.

Followers of the Theory of Evolution have only two options in dealing with evidence of the co-existence of dinosaurs and humans: ignore it or proclaim it a hoax. This is exactly the manner in which it has been dealt with, even if it meant slandering the individuals concerned. Ideas that jeopardize official opinions are ignored and, if possible, polemically exposed to public ridicule. Because, if only one single finding is authenticated, almost all schoolbooks as well as virtually all syllabi of corresponding fields of study would have to be altered. Suddenly, everything would be different. Who, however, would voluntarily undertake such an effort? Who wants to admit to fundamental errors, even if such errors were to be attributed to the working models of last century's scientific authorities?

One feels taken straight back to the Middle Ages, when science and the church taught that the Earth was flat. People like the Dominican friar Giordano Bruno (1548–1600) had to pay with their lives for new ideas, even though the

historian Plutarch (46–120 AD) proclaimed an infinite universe with numerous inhabited worlds. He also correctly stated that the Earth was neither the center of the universe, nor that of our solar system.

A different theory

In this book, I will seek to prove that a huge worldwide flood blanketed enormous areas of the Earth as much as mountain high no longer than 10,000 years ago. In its course, the fossil hammer, as well as other objects to be described later, may have been deposited and embedded.

There is a great deal of evidence for this assumption, such as the petrified hammer handle and the crust melted into the steel of the hammerhead, something that could only be the result of great pressure and heat. In this case, however, one has to accept that the hammer and its surrounding *rock are young!* This would call into question the scientifically fixed age of mountains. At the same time, a minimum of 140 million years, or perhaps as many as 400 million years, would have *to be deleted from history*. As far as the development of mankind and animals is concerned, these are the crucial periods of development. According to Darwin's Theory of Evolution, without these eras, there should be no such thing as mankind or mammals. They, apart from some smaller mammals about the size of rats, are believed only to have developed until after the extinction of dinosaurs. Taking this as a given, the hard-core issue remains: how old, or rather how young, is the Earth, indeed? Could it be that it is 400 million years younger than previously presumed? Or is the Earth actually relatively young?

3 Dinosaur and Men Walked Together

The prerequisite for an evolution allegedly to have taken place in accordance with the law of Darwin is the slow development of species and the survival of those to have best adapted to their environment by selection and concurrent edging out of the less well adapted. If it is possible to document co-existence of all life forms – including mankind – at a certain point in time, the Theory of Evolution must be wrong, as its – by its own definition – basic conditions are not fulfilled. Findings of fossils and fossilized tracks prove exactly this.

A Type of Rock Similar to Concrete

In the area of Paluxy River, hardly any compact rocks with a thickness of several meters exist. A multitude of different overlapping layers was identified. These rock layers vary in thickness and differ widely in durability. The consecutive layers of extremely hard rock and more or less solidified debris on the whole resemble the skins of an onion. The layers are sharply separated and therefore could not have developed at the same time or gradually, one after another. The more solidified layers show stress fractures that usually are the result when materials of soft consistence – such as concrete – cool or solidify. The comparison with concrete suggests itself, as limestone is a sedimentary stone that solidifies through the admixture of calcium carbonate, carbonic lime. The solidity of the resulting sediment depends partially on the quantity of lime present, whereas the origin of this hardening agent in such masses has not yet been scientifically explained.

Within the scope of this book, I will put forward a theory for discussion: I developed it in an attempt to explain this phenomenon and the related rapid development of sediments. Being a civil engineer, it set me thinking that mortar as well as concrete are produced by mixing gravel and other additives such as water and cement, the latter in the end being obtained by exposing lime to heat. Solid limestone consists of the same basic materials. It therefore stands to reason that mountains that mainly include limestone rose fast and not over long periods of time.

The different rock layers are the result of consecutive floods that occurred in short intervals after another. This offers a conclusive scenario: an animal or a human walks across the soft sludge or any other muddy ground material,

leaving deep tracks behind. Hours later another flood brings new, soft material in the form of deposits, covering the ocean floor deposited earlier along with the footprints left behind. This new, fine-grained layer is of a certain thickness and conserves the tracks contained in the older layer underneath. This rock produced by hydraulic setting (lime, gypsum, cement) is easy to remove after hardening, and so the tracks resting in the layers below are uncovered in a similar process as if one were to take a plaster cast for the purpose of illustration or as evidence.

It turned out that tracks of dinosaurs, mammals and human beings were discovered in identical layers – impressively illustrated by the exhibits of the two museums in Glen Rose. Of the rock layers examined by now eight or more scientists include such tracks, every layer including relics of different species that according to Darwin's theory could not have lived in the same period of time, nor even in periods close to each other. This serves to prove that the Theory of Evolution in respect to macroevolution (the succession of one species by another) is wrong.

Discoveries of the Past 100 Years

In 1908, a spring tide tore open the limestone layers at the Paluxy River, uncovering prints of dinosaur feet. Differing, gigantic prints of various dinosaur species were discovered. On top of that, one found an entire sequence of human foot prints about 14 inches – 35.5 centimeters – long, clearly showing all the characteristics of a human foot. The size of the print though suggests a human body more than 6 feet 7 inches – 2 meters – high.

In the decades to follow, hundreds of dinosaur prints were found within the radius of a few miles. Over and over again, tracks of humans or larger mammals were identified next to them or even in them.

We are not at all talking about an isolated human foot print here or there, but of continuous right-left-sequences, virtual trails, displaying alternating prints of left and right feet in the appropriate distances during a forward motion, comparable to those of a human of today walking or running.

Isolated prints were hewn out of the solid rock by farmers and residents and kept as souvenirs. One very nice and distinct sample has become known as the "Burdick-Print". It was discovered in the area of Glen Rose around 1940 and was for a long time displayed in the shop window of a store in Arizona that sold minerals. The geologist Don Patton, in co-operation with the archeologist Carl E. Baugh, undertook detailed examinations, proving

not only that this print from the area of the Paluxy River consisted of a very *unusual kind of limestone,* but also that it bore all the characteristics of a human foot in a somewhat side-ward motion.

This isolated piece of rock containing the footprint was cut into four separate segments in the zone of the toes and the heel. The sectional view clearly shows a bent run of the layers between and below the toes, as would be the result of punctual pressure on soft ground material. The plastic material pressed together under the foot displays a curve, indicating locally produced pressure on the stressed material. In addition to that, the areas between the toes nicely show that the rock – when it was still soft mud – was pressed together in certain places: The more dense structure is characterized by darker shades, whereas unstressed rock material is of lighter colors. This is especially obvious in the sectional cut containing the heel.

The originally soft mud – solid limestone today – rose up between the toes. The curve structure of the now hard rock is easily distinguished, and the two sectional views of the toes show the qualitative picture we would expect to find here. Before those sectional cuts were made, scientific circles considered this human footprint an *obvious forgery,* arguing the print showed too clearly the characteristics of a human foot.

The results of the study, however, revealed that certain typical stresses in this limestone could not have been faked. No stonemason could have achieved such results for the reasons discussed. *Forgery therefore is out of the question.*

In later years, about 1970, Dr. Cecil Dougherty did more thorough research in the vicinity of Glen Rose using scientific methods. He published his results in a book titled "Valley of the Giants".[5]

On July 11, 1971, Paluxy River dried out completely – a circumstance substantially helpful when doing research. The amazing thing about the findings of Dr. Dougherty was that they were discovered in top strata, as well as directly on the surface. Discovery sites of fossilized dinosaur prints as such do not seem so unusual. We, however, have to bear in mind that these animals are supposed to have been extinct for 64 million years. According to scientific opinion, rocks develop gradually over an extensively long period of time. Therefore tracks of any kind, assumed to be that old, should rest much deeper in rock formations.

It should not be possible to make these findings in the upper geological strata. This contradicts geology's worldview and its underlying theory – Lyell's dogma of the sole activity of minute current forces forming Earth's surface.

Darwin's Theory of Evolution is *unconditionally* based upon this dogma.

Doesn't it set one thinking that the remnants of the so called Stone Age or the Roman Empire – at most a couple of thousand of years old – are found lying deeper beneath the surface of the Earth than these traces of dinosaurs, supposedly more than 64 and up to 250 million years old? Don't we read of entire skeletons of various kinds of dinosaurs found on the surface of the Earth in all corners of the world, such as the Gobi Desert in Mongolia, almost every other day? Seen in this context with the simultaneous discovery of human relicts, such evidence seems virtually uncanny.

Apart from the footprints of dinosaurs and humans, Dr. Dougherty discovered the fossilized print of a dinosaur's tail and that of a completely ordinary dog paw, located only about three feet 3 inches – one meter – away from a three-toed dinosaur footprint, all located on the property of the "Jeannie Mack Farm", in 1980. Dogs and other larger mammals of the kind are not assumed to have existed contemporaneously with dinosaurs.

Dr. Dougherty studied the area of and around Glen Rose for ten years. During this time, he documented more than one hundred footprints of dinosaurs and fifty of humans with and without shoes, as well as some other strange finds.

The human footprints that are often found are very large and must have been made by giant people. Dr. Dougherty found a footprint with a length of 21.5 inches – 54.61 centimeters – and a maximum width of 4.06 inches – 10.32 centimeters – in the front part of the foot. *The same layer* contained prints of three-toed dinosaurs.

If we consider these footprints forgeries, we have to ask ourselves: Why would anyone imitate such large and thereby unusual tracks that would virtually seem to suggest that they are fakes? Would one not copy something more normal and familiar?

Tall humans, however, are not that unusual. The skeleton of a man almost 9 feet – three meters – tall was found in Italy.[6] The tallest human of the century with a documented height of 8 feet 11 inches – 2.72 meters –[7] is

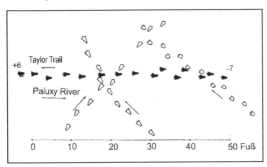

Fig. 2: Taylor Trail. The sketch shows all the prints of the Taylor Trail discovered to this day. Black tracks represent the three-toed dinosaur prints containing human footprints.

supposed to have been an American, Robert Pershing Wadlow, who died in 1940.

On the other hand, the Bible as well as the Sumerian-Babylonian epic "Gilgamesh", probably the oldest scripture in the world, include extensive and detailed reports of giants, said to have survived the Flood. In a later chapter, I will address the issue of gigantism in greater detail.

Research in the Past

Since 1982, Carl Baugh, in co-operation with Don Patton, the Australian archeologist Clifford Wilson and other scientists, has intensively studied these findings. It is remarkable that new and not yet documented evidence and fossils are found even today. Unfortunately, some forgeries were revealed in the area of the Paluxy River. But who made these copies and why? Nothing is known about these. Be that as it may, studies and finds in all parts of the world had to fight with forged material. Critics often point at these forgeries – especially in the media – to find a pretext not to have to deal with authentic finds. The scientific magazine "Nature" reported on the human footprints in the Glen Rose area as early as 1986, assessing them to be forgeries.[8] In the following issue, however, geologist Dr. John Morris of "Institute for Creation Research" in El Cajun, California, confirmed the authenticity of the prints.[9] The controversy persists.

For these reasons, Carl attached great importance to the accuracy of his studies. Excavations in the area of the "Creation Evidence Museum" only take place once or twice a year. At these occasions, experts of different scientific fields are invited, while excavations are documented by photographs and video.

Under such circumstances, there is only one way to convince the public of the authenticity and natural-ness of these tracks: to carve open an untouched layer in the presence of scientists and journalists, in front of running television cameras excludes the potential of a hoax.

If one is lucky, original untouched prints will be discovered. Such prints, according to the scientific school of thought, should be between 140 and 400 million years old. This is the step Dr. Baugh took. The risk this included was that this specific excavation might not discover any tracks at all. The people invited surely would not come all that way for a second try.

In one of his books[10], Baugh describes an excavation in January 1987. Apart from several professors and scientists, the press (Fort Worth Star Telegram) was present. A reporter, Mark Schumacher of the Television Station

"Dallas Channel 5 KXAS-TV", flew in by helicopter from Dallas. At this event, footprints were discovered that clearly showed all five toes of a human being.

By choosing such a procedure, forged fossilized prints can be ruled out. At the same time, the conventional worldview of evolution is exposed as an illusion. According to this theory and the prevailing biogenetic laws, dinosaurs and humans cannot possibly have lived during the same period of time. The studies even revealed footprints of humans under layers that included traces of dinosaurs. According to Darwin, this suggests that humans are older than certain species of dinosaurs. The deeper the rock layers lie, the more primitive and older in respect to their development the fossils contained in the layer must be, Darwin stated.

An entire trail of individual dinosaur prints was found in the top layer. If dinosaurs really became extinct 64 million years ago, no such prints could possibly be found on the Earth's surface. Erosion would have simply erased them. Did dinosaurs and humans live together in a distant past? Are the tracks found so well preserved because they are young and not very old?

In the riverbed of Paluxy River, usually no single, isolated prints are found. Instead, we find continuous print sequences of alternating left and right feet. These trails are usually named after the people who discovered them. "Clark Trail" and "Taylor Trail" are located outside of "Dinosaur Valley State Park". Both trails only lie a couple of hundred meters apart, showing similar tracks. The "Taylor Trail", named after his discoverer Stan Taylor, lies in the present riverbed and thereby in a much deeper stratum than the "Clark Trail" that is to be found under the top limestone layer on the mountain ridge. Geologically speaking, millions of years separate the footprints of dinosaurs and humans they contain.

The "Taylor Trail" became known in the late sixties. At the time, only nine prints were discovered. Limestone and river gravel of the Paluxy River covering them had to be cleared away. Today, these tracks lie directly in the riverbed, flooded by the high waters of the river and covered by river gravel. The older tracks too, though still clearly visible, have become slightly blurred by progressing erosion. Luckily, the limestone in this area is of a very hard structure, in contrast to the rock material of the "Clark Trail". It therefore is suitable for a more thorough examination.

Recent Research

After repeated clearances of the old prints of the known "Taylor Trail", Carl and Don Patton uncovered a new series of prints, in addition and continuation of the tracks discovered until then. Research, carried out since, revealed that the "Taylor Trail" consists of at least four different crossing dinosaur trails. The most interesting and longest trail is made up of 15 continuous prints, running almost parallel to the present course of the riverbank. The individual prints were numbered from –7 to +6. Thorough examinations showed and documented tracks of humans in and around the fossilized dinosaur prints.

In some cases, several, or in less cases, all five toes are clearly perceptible, while other prints solely show the big toe. This is perfectly normal, bearing in mind that walking conditions over muddy grounds vary in terms of walking speed and direction with every step.

In any case, the prints give us the impression of a human, walking in the footprints of the dinosaur. Imagining a muddy surface, it is much easier to follow an existing track, for here there is no or at least less mud. Naturally, the large tracks of a dinosaur are particularly fit for such a way to move.

Moving over soft grounds was the subject of different field tests. The results resemble the fossilized tracks found, showing similar characteristics.

Considering these circumstances and the softness of the ground, both dinosaur and human must have crossed the terrain's surface within a very short period of time from one another. Shortly after they left, a soft mass must have covered their tracks, preserving them. It could not have taken days, months or even years till, as scientific theory suggests, fossilization was completed. Other influences, such as the weather, would have eroded them. There is no doubt about that.

Another Visit to Glen Rose

In 1994, the "Taylor Trail" was flooded again. Plans were made for another clearance in August 1996, to allow the continuation of studies.

I took this opportunity to pay Glen Rose another visit, as well as Dr. Baugh and his "Creation Evidence Museum". I simply had to see the proof of the co-existence of mankind and dinosaurs with my own eyes. On August 6, 1996, my family and I arrived in Ft. Worth and immediately moved on to the town of Glen Rose.

First I went to the realtor Grover Gibbs, who has his office located right in the town's historical center. He had work as a guide in the early seventies, leading visitors from Dallas to see the excavations of Dr. Cecil N. Dougherty. This made him an eyewitness of exceptional quality. I had brought photos of prints that had since eroded. He confirmed their authenticity.

Afterwards, we drove to the "Creation Evidence Museum" outside of the town. Unfortunately, we missed Carl Baugh. He was on his third expedition to the jungle of New Guinea, aiming to discover live dinosaurs and document their existence. His research was based on native accounts about living dragons, whom the natives were terrified of. These dragons were said to plunder the graves of tribe members and even hunt down humans.

Still, geologist Don Patton was there. He led the excavation and the fresh clearance of the "Taylor Trail". He had become the expert on this trail, having done extensive research on it in recent years.

In tropical temperatures, we, my daughter and myself, joined helpers from different parts of the United States in their work in the riverbed. Working conditions were unpleasant, not only because of the repulsive leeches, poisonous plants and snakes. More than one foot (30 centimeters) of gravel had to be removed from the riverbed and tracks and lifted up over the riverbank. The next step included the filling of sandbags that were to be placed around the area of the trail, before pumping out the water.

After one week of work, on the last day of the excavation, a Japanese television crew showed up and started to shoot our clearing of the "Taylor Trail". Unfortunately, this also was the day I had to leave and return to Germany.

My daughter was so enthusiastic about the insights and evidence found that she did not want to return to Germany with me. Instead, she wanted to spend the last week of her school holidays there. It was clear to me that intellectual conflicts would be inevitable when she returned to the scientific subjects in high school, where the Theory of Evolution – and along with it Darwin's laws – would probably be presented as unquestionable dogma.

During my stay in Glen Rose, I had the chance to take a closer look at a formation of layers in the riverbank of the Paluxy. Overall, it was a little more than one meter long. There, my daughter and I found fossils that can not be brought in line with a slow deposition of dead life forms. Under normal circumstances, snails, mussels, and other animals die in the water and sink to the ground. If this happens often and long enough, they are assumed to form a layer of fossils, similar to the one we were studying.

When mussels die and sink to the ground, their muscles slacken and the shells open. Generally, only *live* mussels stay *closed*. This layer, however, revealed

prints of closed mussels of various kinds and sizes. This implied that they did not die of a natural cause. Death came all of a sudden and took these animals by surprise, leaving them no chance for their muscles to slacken and open their shells. Closed mussels require a sudden cause of death. Their mass occurrence in fossils all over the world actually has to be interpreted as evidence of a cataclysm that occurred rapidly.

Fossils found in Germany, too, are considered to have developed over long periods of time. This, however, does not explain the fossilization of animals that resulted in a kind of snapshot. A famous fossilization shows a larger fish with a smaller fish in its mouth, fossilized while having its meal. Was the fish suffocated by the size of its meal – this being the scientific interpretation – or was it taken by surprise, by some sudden event that not only surprised but also killed, and preserved, it?

Rapidly hardening stone allows not only skeletons to fossilize, but soft parts of the body as well. In 1998, a small, 9.45 inches – 24 centimeters – long saurian was found in the South of Italy. His "perfectly fossilized intestine" is still rather well discernible. The Italian scientists Dal Sasso and Signore point out muscle tissue was preserved, as well as reddish deposits, thought to be traces of the liver.[11] This animal was rapidly preserved and fossilized, otherwise the soft tissues would have decayed and rotted or served to feed other animals.

In the area of Holzmaden, Germany, a fossilized birth scene was discovered: an ichthyosaurus, 21.65 inches long – 55 centimeters – whose head was still lying between the dam's pelvic bones. This fossilized birth is no singular tragedy – as masses of fish-saurian skeletons prove that virtually all were fossilized one over the other in large quantities like salted herrings in a barrel. The enormous accumulation of carcasses cramped together on such a small space and their rapid preservation immediately suggests a cataclysm.

In other fossilized animals, it is still possible to discern traces of body tissue, preserved in the stone as shades of different colors. An entire – from head to toe – fossilized animal must have been enclosed by soft material in an extremely short period of time. Had this process taken longer, by the time of the fossilization no body tissue, and very probably no remains of bones either, would have survived. Could it be a mere coincidence that such finds are the rule rather than the exception?

Without the least effort, we also were able to find fossils of worms. They appeared in a cross-section view on the limestone surface and were easy to discern. Seeing a worm on the edge of the rock in cross-section means he was enclosed by the surrounding limestone. As there were fossilized worms to be found under and on the surface of the rocks, a sudden event must have

taken those animals by surprise. Apart from that, this means, the worms are older than the limestone surrounding them, as it still must have been in a soft state when it covered them, for they could not have penetrated the hardened limestone. It is the same scenario over and over again. Something must have led to a sudden and rapid hardening of large quantities of originally soft mud.

In the riverbed, we found petrified wood of various sizes showing its fine, crystalline surface structure. In general, it is considered to be several million years old. If science is correct, this kind of wood could only be found in a river with surface water in a few, exceptional cases, as it would usually lie in substantially deeper strata.

These circumstances taken into account, something must be wrong about the scientific theory. The insights and personal experiences presented here can hardly be called wrong, therefore science must be greatly and profoundly in error.

There is a simple explanation for our finds: the traces and remains of different animals in muddy ground as well as the fossils must have been preserved rapidly, for in any other case, they either would have decayed, been washed away, or blurred. The remarkable appearance of the sudden death of these snails, mussels, and worms points to an equally sudden event.

One possible explanation may be the worldwide Flood, as described in the Old Testament of the Bible. After a literal reading of the Bible in earlier centuries, in recent times, the conviction most encountered is to interpret the Flood as a phenomenon that was locally restricted to Mesopotamia. In the meantime, however, there is evidence and several publications that go back to the old interpretation of a world-envelopping Flood. In the course of this book, I will attempt to confirm this interpretation. I will show that the entire Earth was exposed to a cataclysmic flood no more than 10,000 years ago, in the course of which almost all life was destroyed. Did Noach and his ark exist after all? Be that as it may, humans and dinosaurs lived in co-existence.

4 The Mystery of Time

Findings of fossilized human traces are only one piece of the puzzle of a new, to be written worldview. Should dinosaurs have, at least temporally, co-existed with humans, then it must be possible to make other discoveries in the respective geological layers which, according to Darwin, could not possibly be found in one and same layer. This would also contradict the premise of geology, stating that the layers of the Earth, from a global point of view, formed continuously and over great periods of time, millimeter by millimeter.

Dinosaurs on the Surface of the Earth

Dr. Baugh reported he had found two skeletons of dinosaurs with about 100 bones each apart from single-pieced finds in layers (too) *close to the surface.*[12] An observation that applies to almost all such discoveries all over the world.

In the Kimberly area around Winton, Australia, a dinosaur-trail was discovered that was more than 50 miles long (80 kilometers), consisting of several thousand fossilized footprints of various kinds of dinosaurs. Clearly, such discoveries of fossilized footprints are no coincidence or a unique event. On closer examination, it appears to be the rule. In large parts of our Earth, basically similar climatic and geological conditions must have prevailed, enabling the preservation of prints. Why, however, are there no ongoing fossilization processes to be found today, neither globally nor locally?

After 64 million years, any kind of remains, be they skeletons or footprints, from the dinosaur-epoch should be hidden deep in the ground. The usual explanations for these discoveries, lying there for all to see, as landslides, side effects of Earthquakes, faults of Earth strata, or regrouping of the Earth's crust, can only satisfy the uninterested observer or apply only sufficiently to isolated cases.

In April 1998, the magazine "Illustrierte Wissenschaft" (Science Illustrated) reported on an exceptional discovery. The British amateur geologist Alan Dawn discovered an almost *complete* skeleton of a swimming, carnivorous saurian, approximately 10 feet (three meters) long. The skeleton of the animal, allegedly to have become extinct 150 million years ago, was not buried several meters deep in the ground – as would be expected from a biological or geological point of view. Instead, its *bones were sticking out of the ground.*[13]

Archeologists discovered a large saurian skeleton in Central Mongolia –

the largest discovery ever found in Asia. The dinosaur 70 feet (21 meters) long and 20 feet (six meters) high must have weighed an estimated 100 tons. It was found in the Western Xilin Gol Steppe. This region is often referred to as the "Dino Cemetery" because of the large number of skeletons and eggs of dinosaurs that were found here.[14] A more than 70 million year old skeleton that can be found in a steppe? Even if we take major storms and equivalent drifts into account, discoveries such as this one must be seen as exceptional strokes of luck. Other press reports, however, mention comparable finds all over the world.

A lady in Brazil took her dog for a walk and stumbled over an entire dinosaur skeleton. Off the shore of Sumatra, fishermen found a skeleton in their nets and were afraid of – what they thought – were the remains of a dragon. The scientists flew in and identified the find as the remains of a swimming saurian. So you just go out, after 64 million years, and catch a skeleton with an ordinary fishing net? Should these bones not long since have decayed, been covered by corals, or in some other way pulverized by the millstone of time?

Fossilized dinosaur eggs, even untouched entire nests of eggs, are discovered all over the world. I tacitly assume, even though this has in no way been secured that these nests of large eggs are dinosaur nests, although I usually thinks of birds right away when it comes to this context. Actually, it has not at all been proven that all of these eggs stem from dinosaurs. Be that as it may, an egg from such a find made in the Chinese province of Henan was examined at the Methodist Hospital in Arcadia, California, using a special laser and x-rays. This way, it was possible to make the embryo in the egg visible. These transient finds, with their originally delicate contents *which, however, did not decay or rot during the process of fossilization, testify to a very fast preservation.*

Dinosaurs were not buried as humans are. The remains of our human ancestors are mostly to be found in graves. This way, they were protected from rapid decay. But even these bones rot relatively fast. Then why, after aeons of time, do we find so many remains of dinosaurs that were not buried and thus not protected? Bones of these primeval animals were found in North and South America, Africa, Europe, Australia, Mongolia and the Antarctic. In all cases, skeletons and fossilized traces were found close to the surface or directly in the top layer.

This fact should make us think.

If an animal had died in primeval times, its carcass should have rotted. Skeletons of a couple of meters in length, and particularly of such height, do not simply survive – especially not in loose sand! Not entirely and not at all as

1 *"Somervell County Museum" in Glen Rose.*

2 *Exhibits at "Somervell County Museum". The dinosaur bone and the skull of a primeval bull.*

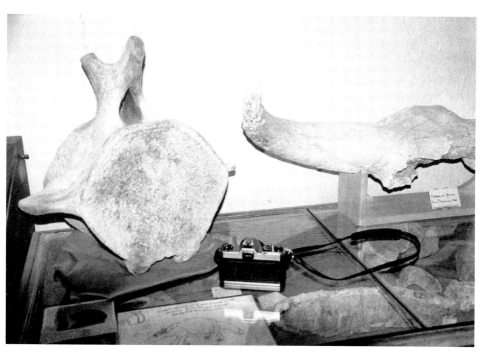

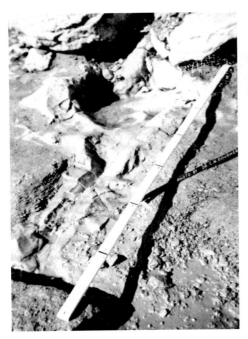

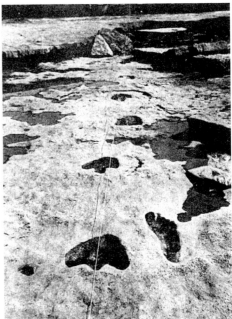

3 *The fossilized tail trail of a dinosaur footprints.*
4 *A trail of three-toed footprints of a dinosaur and large human footprints in the same layer of limestone.*

5 *Fossilized prints of human hands in Glen Rose.*
6 *The fossilized print of a dog's paw close to the print of a dinosaur.*

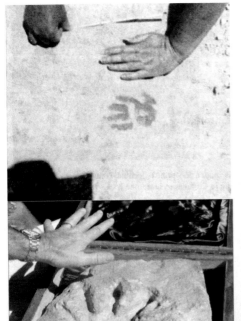

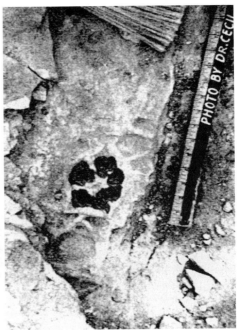

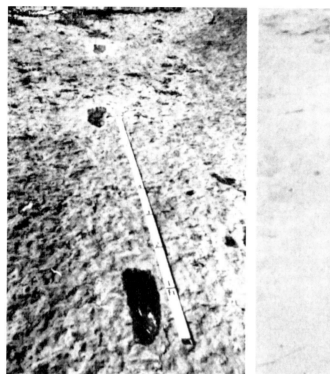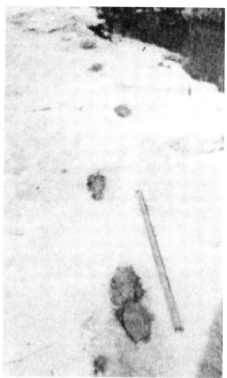

7 Three successive human footprints, right-left-right, in the correct stepping distance under the bridge of the Highway 144, Glen Rose.

8 In the vicinity of Glen Rose: five successive fossilized human footprints, uncovered 3 feet deep under a rock layer, containing fossilized dinosaur prints.

9, 10 Human footprints in layers of limestone. They were discovered about 7 miles west of Temple, Texas.

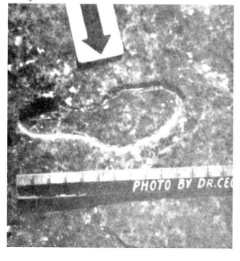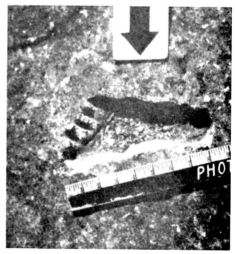

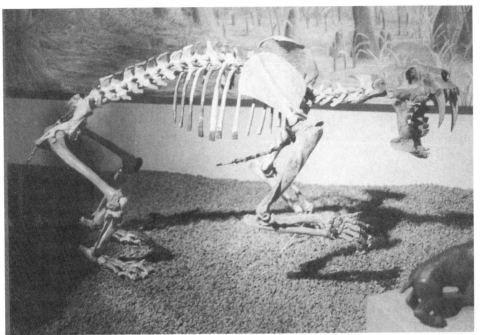

11 *The fossil skeleton of a Sabertooth tiger was found in Florida. The animal suddenly became extinct during the Great Flood, as were many other species. "Florida State Museum", Gainesville.*

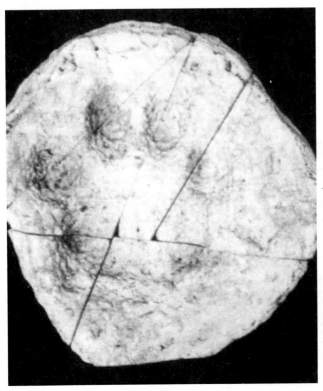

12 *The fossilized print of a cat, more than 7 feet high, probably a Sabertooth tiger. It was found in the area of Glen Rose, in very old limestone, right next to the prints of a dinosaur. The rock was taken apart by sectional cuts. The structure of the limestone proves the authenticity of the print. Sabertooth tigers and dinosaurs lived at the same time.*

13 From the banks of the river, it is possible to take a look at the footprints of dinosaurs located in the riverbed of the Paluxy River.

14 Footprints of dinosaurs, directly under the water surface in the riverbed of the Paluxy River.

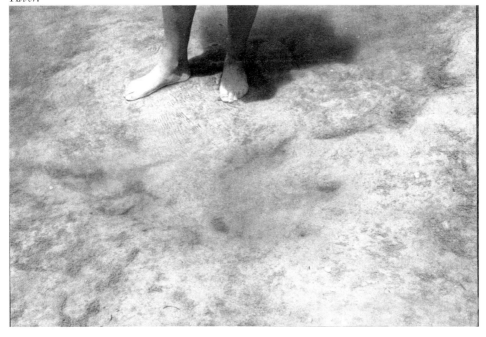

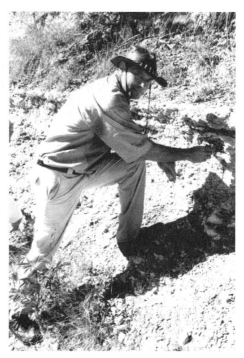

15 Carl E. Baugh during the author's first visit to the "Creation Evidence Museum".
16 The author collecting fossils at the banks of the Paluxy River.

17 Two of the beautiful fossil mussels, found on the banks of the Paluxy River. It is clear to see that these animals died suddenly and with strained muscles. Otherwise the shells would be open.
18 A fossilized mussel bank with closed mussels.

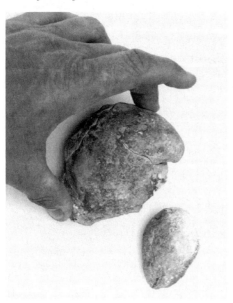
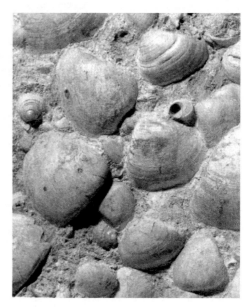

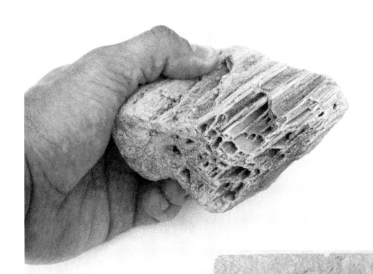

19 Petrified wood. Found by the author in the bed of the Paluxy River.

20 An entire fish with fins, fossilized in massive rock. Cause: sudden inclusion.

21 A very beautiful fossilized trilobite. This primeval crab looks like an ordinary rock and reminds us of the fossilized hammer in London, Texas that was surrounded by rock in a similar way.

22 The trilobite, allegedly to have become extent more than 400 million years ago, unfolds.

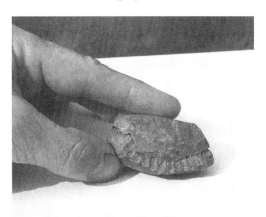

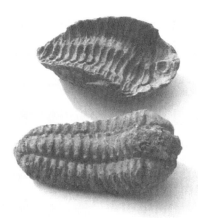

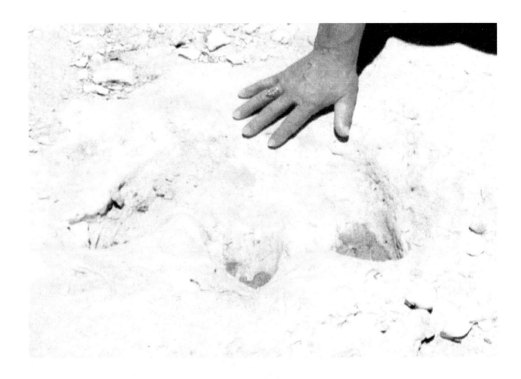

23, 24 *Fossilized prints of a three-toed dinosaur on the banks of the Paluxy River at "Dinosaur Valley State Park". The present limestone must have been soft at the time the prints were made.*

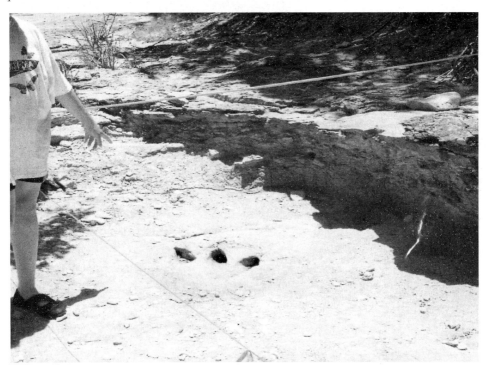

three-dimensional skeletons! If our view of primeval times is right, the ground in Africa would have to be full of fossilized bones or such in the first stages petrification who died in the past years. As this is not the case, further argumentation is unnecessary. There is only one explanation: the carcasses were rapidly covered by a fast hardening, alluvial material, sand, loess, or flue ash and preserved.

Apart from these finds from the dinosaur age – only serving to document their physical presence to an epoch – we can not really give a date. I must – in this context – point to the man-made fossilized hammer again, described in detail in the previous chapter, found resting in a similarly old rock layer. This find, however, is not an isolated case. Other objects, too, were found embedded in hard stone. The sites of such discoveries are scattered all over the world.

In 1844, David Brewster gave an account, titled "Queries and Statements Concerning a Nail Found Imbedded in a block of Sandstone Obtained from Kongoodie (Mylnfield) Quarry, North Britain" at the British Association for the Advancement of Science. The subject was about nails recovered from a massive block of sandstone in a quarry in North England.

A similar discovery – a clay figurine – was described in 1887 by Frederick Wright under the title "Man and the Glacial Period".[15]

On January 22, 1844, a mechanically manufactured gold thread was found in Rutherford-Mills, England. It was embedded in naked rock, at a depth of about 8 feet (2.50 meters).[16]

Another mysteries include metal spheres found in Africa. In a prophyllite mine near Ottosdal, spheres were discovered, encircled by engraved grooves. These metallic artifacts must be older than the prophyllite that surrounded them. The latter is estimated to be 2.8 billion years old! Do we now have to accordingly date back the age of mankind in the history of the Earth? Consequently, mankind would have lived in this world long before dinosaurs, trilobites, and others appeared – animals believed to have preceded us in the history of evolution. From this point of view, mankind must have come into existence when life itself began, when there were only protozoa and other primitive life forms to be found. If assessed according to the laws and dating methods of geology, this would be solid proof, assuming of course these finds are no forgeries and the scientifically estimated ages of the rocks are correct.

Again and again, we are faced with the same problem: something must be wrong about applied dating methods, geological eras, and evolution.

Luc Bürgin describes the problematic nature of the engraved spheres in his book "Mondblitze" (Moon Flashes). He got in touch with Dr. Roelf Marx

of the "Klerkdorp-Museum", in whose possession there are some of these spheres. A strange story came to light. An egg-shaped sphere was on display at the museum. After a while, it was noticed that the round object had turned. Assuming the cleaning lady or a visitor to the museum had changed the position of the sphere, the glass case was sealed and glued to the rack. Again, the egg-shaped object rotated. It was observed that the metal egg rotated on its axis once every 128 days. Similar phenomena were observed in the other spheres. Bürgin, however, also mentions the discovery of synthetically produced spheres in a coalmine in the vicinity of the city of Most (where — country?). The shapes showed similar grooves, but – apart from steel – also consisted of volcanic rock. Extraordinarily, these spheres share the peculiarity to consequently align themselves to the direction of the North Pole.[17, 18]

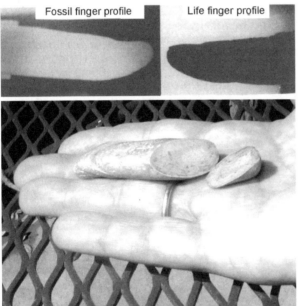

In February 1961, a geode (round mineral body) was found near Olancha, California, its surface covered with fossil mussels, which were estimated to be at least half a million years old. X-rays revealed an until now unidentified technical instrument made of a shiny metal in both halves

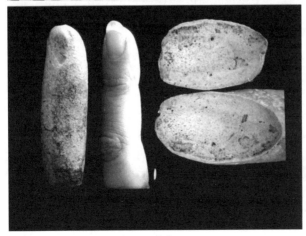

Fig. 3: Fossil Finger. Physical comparison of the finger profile compared to a live finger profile is shown in the upper and lower figure. The author is holding the original fossil finger in his hand (middle figure). To further verify this conclusion, the finger was sawed diagonally, as shown in the lower figure, to reveal any internal structure.

of the sawcd up geode. A metal pin or axis had originally linked both halves.[19]

There were other objects, such as a screw or some strange coin, found embedded in rocks or in deeper lying strata where actually no-one would have expected them. The reason is obvious: All of these objects must be older than the material surrounding them – material geology, without exception, estimated to be at least several million years old.

Another interesting find: a hair, sticking out of a boulder of the Cheops (Khufu) pyramid of Giza. Prof. Dr. Joseph Davidovits of the French Geopolymer Institute discovered it, examining rock samples under a microscope.[20] Either the hair is older than the rock surrounding it, meaning the rock formed later, or the boulder is synthetic. Examination and measurements of the boulders used in building the pyramid show high moisture content unusual for natural stone. They show moisture content one would expect to find in concrete. This suggests, at least some of the boulders of the Cheops pyramid are synthetically made, while, as beyond doubt, there are others consisting of real natural stone. If this sensational assumption is not correct, than we have to allow for an incredible age for the hair that was found, because it must be older than the rock it was embedded in. Both explanations flagrantly contradict our conventional worldview.

Another exceptional discovery was made in a stratum holding different fossils, located a couple of miles away from Glen Rose, in the area of Chalk Mountain. A fossilized human finger, completely fossilized and consisting of the same limestone material found in the rock strata in the area of Glen Rose. Comparing it to the finger of a living human, there is no optical difference perceptible.

Comparative examinations point to a female human being, whereas the size of the fossilized finger suggests a height 20 percent taller than the average height common today. Even the fingernail has survived. A cut made and other examinations (x-rays) of the inner structure of the fossilized finger showed that not only the original bone had survived, but the bone marrow as well. It was substituted by natural minerals while embedded in the soft ground material.[21]

This find, in any case, is unusual and almost unique, for not only were the bones preserved, but also the flesh was entirely fossilized. This is only possible, if the process of embedding with soft ground material took place extremely fast, hermetically sealing it from oxygen. Otherwise, the tissue would have decayed.

On June 16, 1987, an excavation, organized by the "Creation Evidence

Museum" and Dr. Baugh, revealed a tooth with black discoloration. It was found less than 4 inches (10 centimeters) above the second limestone layer in undisturbed ground. Size and form of the tooth suggested it was the tooth of a child. A dentist, who came in from Dallas, confirmed this assumption on first inspection and determined corresponding characteristics in shape and measures of the find with a human's upper incisor.

The excavation also revealed the bones of a tortoise, the roots of a fossilized fern, and – on August 18, 1992 and August 11, 1993, in the immediate vicinity – two more teeth.[22]

In summary, no final judgement about the origin of these finds is yet possible. While on one hand, the first inspection of the teeth by dentists revealed similarities with contemporary human teeth, on the other hand the various examinations of structure and surface quality by a number of institutes do not form a clear picture. The preliminary conclusion is that the tooth is of unknown origin. There seem to be human characteristics in its look, combined with properties of fish teeth in respect to the enamel structure of the surface.

Similar finds have not been documented anywhere yet.

It is not possible to draw a final conclusion. The examinations so far allow two possible explanations. We are either dealing with an until now unknown species of fish with teeth similar by appearance to those of humans, or with the teeth of humans as they might have existed before the Flood, showing an enameled structure comparable to that of certain species of fish. Whatever scenario, both lines of argumentation do not fit into the phenotypes we know.

George Adams, a citizen of Glen Rose, found two fossilized human skulls and a female skeleton, 7 feet tall (2.10 meters) in very old, not to say too old strata. The bones' site of discovery is located a few of miles away from Glen Rose, though it still lies in the area of the Paluxy River. The exact age of the fossil skeleton could not yet be determined.

Another remarkable find includes the print of a human hand. In 1978, Dr. Cecil Dougherty discovered a print of a child's left hand right next to the footprints of a dinosaur at the "Dinosaur Valley State Park".[23] Carl Baugh made a similar discovery in connection with footprints of humans and dinosaurs in similar strata.[24] In this case, it was a print of a right hand. Right next to this print, there are human footprints that included all five toes. This overall ensemble gives the impression of a human in an almost kneeling position, supporting his body with his right hand. The impression of the footprints of dinosaurs and humans, together with the clear print of a human hand allows only one conclusion: *dinosaurs and humans lived together and at the same time.*

As indicated earlier, Dr. Dougherty found the print of a dog paw next to the print of a dinosaur's foot with three toes in 1980. Apart from that, a sequence of seven fossilized prints of the paws of a large cat – probably a Sabertooth Tiger – was documented. Its shoulder height, based upon the size of the size of the print, is estimated to have been about 6 feet 7 inches (2 meters).[25]

Apart from that, a piece of a Sabertooth Tiger's skull was discovered. This animal too must have lived at the same time dinosaurs and humans lived. On top of that, the same stratum revealed the hoof of a horse with a segment of the bone. If one believes conventional schools of thought, *in the era of the dinosaurs, they were the sole inhabitants of the planet, except for some small, primitive and at most rat-sized mammals*. Discoveries of other kinds of animals in these strata are out of place and forgeries *without a single exception*. If the authenticity of one single find were **to** be proven – what I've done in several cases in the course of this book – the history of the origins of all living beings as well as the foundation of geology would have to be reconsidered.

Trilobites

Until now only discoveries of humans or animals have been presented, believed to have lived millions of years later than dinosaurs, whose remains, however, were discovered in the same stratum. But there are also fossils, assumed to stem from the time preceding the era of dinosaurs, whose remains were found together in identical strata, along with those of dinosaurs, humans and mammals.

Trilobites, coming in several kinds and sizes, are a good example of this. They are believed to have become suddenly extinct 400 million years ago – 150 million years before the reign of the dinosaurs began. These animals are primeval crabs (paleozoic arthropods) with a lot of tiny feet and a hard, three-lobed chitinous exo-skeleton, mainly living in coastal shallow seas, river valleys or swamps.

The conventional scientific school of thought uses these trilobites as index fossils. They play an important role in an indirect dating method in geology because beginning and end of the whole species' life span is considered to be known and proven. In agreement with Darwinian Theory, it is assumed that older forms comprise only simpler organisms. So if one finds a stratum with primitive life forms, then – according to Darwinian Theory – the respective stratum must be old. Complex organisms, such as human bones, can therefore

only appear in younger and thereby higher rock formations. A simple and strictly structured system, ruling out exceptions so it seems. But in fact it is easy to tackle for exceptions seem to be the rule.

Be that as it may, geology itself fixes the data in the history of the Earth based on the occurrence of index fossils in strata. Official doubting is *ruled out on principle*. This on the other hand proves evolution right, because Darwinism can refer to the datings given for strata by geology, by determining that the organisms found must have a certain age because they were found in an accordingly old stratum. Thereby a self-contained chain of evidence was invented *mutually inductive* (if-then-evidence) by a stroke of genius. The Theory of Evolution is no longer a theory, but an *irrefutable law*. It is considered a dogma – a dogma used to prove itself and thereby evolution. The mutual induction obtains conclusiveness and becomes impossible to doubt. In other words: it has become evidence serving to prove itself or a rational "perpetual motion machine".

I do not know whether there is one single place on Earth where examinations and excavations of strata along with the fossils they hold, could even roughly document the course of evolution in an unbroken chain of evidence. In discussions on the matter, geologists admit that one would probably have to dig in fifty different places on Earth, in order to be able to follow all stages of the alleged evolution. But how would anyone assess the correct sequence of these excavation sites? Here Darwinian Law comes to the rescue: the more primitive the organisms,the older the stratum is supposed to be. According to Darwinian Theory these simpler organisms should not appear in younger and therefore higher layers which include higher developed life forms. It is as easy as that.

According to Darwinian Law, trilobites should not be found in identical layers with dinosaurs, mammals, or humans. Such a thing would amount to finding a live dinosaur today. The Theory of Evolution – one should say Law– states that such findings have to be ruled out on principle.

But in fact Trilobites were found in great quantities along with the prints of dinosaurs, mammals and humans in the limestone layers at the Paluxy River. "Somervell County Museum" at Glen Rose possesses an impressive number of these and other fossils representing primitive organisms, as well as the fossils of higher developed animals, found in the area of the Paluxy River during the last decades. The "Creation Evidence Museum" has similar exceptional exhibits.

In 1968 William Meister made a significant discovery when pursuing his hobby with his family 43 miles northwest of Delta, Utah. He liked collecting

fossils. Hammering away on a piece of rock, a layer peeled off. To his amazement, it revealed two fossilized prints of human feet in the rock plate. He was looking at the prints of a right and a left foot, without perceptible details as caused by toes or heels. It was easily discernible that this human had worn shoes, as the edge of the sole had left clear contours in the originally soft ground. Because of the body's weight, the heels had left a slightly deeper print than the toes, just as would be expected. When looked at as a singular find, these fossilized shoeprints are almost unthinkable, as humans are supposed to have been wearing shoes only for a couple of thousand years.[26, 27, 28]

The greatest surprise and scientific sensation, however, is located on the inner side of the left heel. It had stepped on and crushed a trilobite, easily identified by an expert like Meister. This indisputable find – not even commented upon by established science – proves that Darwinian Theory is fictitious. According to the common school of thought, this human must have lived several hundred million years ago, as trilobites are believed to have become extinct a long, long time ago, before the arrival of dinosaurs.

Geologists fixed the age of the rock, containing the prints, to the trilobite era. Thus the logical conclusion would be that this human preceded the dinosaurs, as these animals – considering the stage of evolution at the era of the trilobites – had not yet begun to exist. Did Man appear in the beginning of evolution? This conclusion seems obvious, if we are not dealing with a forgery and if we are not considering the possibility of aliens from outer space visiting and leaving footprints. I have to mention that other fossilized footprints were also found in the area of the site of discovery. They, however, did not show any unusual features, as did this case.

Is the History of the Earth Shorter?

The trilobite must have lived together with all other animals and humans, during one and the same epoch. This is substantiated beyond doubt by the discoveries in the strata of Paluxy River. The development of these strata took less time than geologists and followers of Darwinian Theory want to believe. On account of the simultaneous finds of different animals – including trilobites as index fossils – dinosaurs, humans and mammals cannot possibly have lived 400 million years apart, when trilobites became extinct. They existed at the same time until the Earth was almost completely destroyed within a very short period of time by a worldwide cataclysmic flood.

In the previous chapters - some evidence has already been documented to substantiate the assumption that the layers of rock at the Earth's surface developed much faster than geology states. Otherwise there would be no hammer and no fossilized footprints.

Finds of primeval ferns and trees serve as further evidence for this assertion. In primeval or antediluvian times, they grew substantially larger than today. We know these giant plants well from the fossils that are found all over the world. These big ferns, maybe 65 to 100 feet (20 to 30 m.) high, had proportionately thick roots. There are not only footprints to be found in the strata of the Paluxy River, but also petrified roots ; some piercing vertically through several hard layers of rock. These plants were covered and preserved in a very short period of time. Otherwise these transitory parts of plant would have decayed. The vertical growth through several layers of rock testifies to a fast development of the strata. For these reasons, there is no way that these strata could have developed gradually.

Fig. 4: Findings in Geological Layers. *Qualitative presentation of the different strata of the geological eras that according to the Theory of Evolution can be ascribed unambiguously and that include certain index fossils. Only the life forms shown in the right column of the chart are allowed to appear in the specific layers. A trilobite find is not to coincide with traces of humans or bones of dinosaurs. The left side presents findings roughly fitting into this scientific model with its alleged strata ages. Almost all findings, however, can be made in almost all layers at the same time. That is why a precise allocation is impossible. Roots of primeval trees penetrating several strata are particularly interesting.*

There is only one final conclusion for the overall picture these discoveries convey: The Earth is younger, probably even *much younger,* than geology and Darwinian Theory wish to convey. A minimum of 400 or 500 million years have to be cut from the history of the Earth, as everything existed at the same time and a development from trilobites to humans can not have taken place.

In the special "Dinosaurs" of the magazine "P. M." we read: "....there are many corners of the world where no rock from the Trias, Jurassic or Cretaceous exist-. Either they never existed or erosion over millions of years ground— them to sand and washed them into the sea. That is why there are so many blind spots on the map of the dinosaur era."[29] Do I understand this correctly? Strata, supposed to have developed in a geological period of 200 million years, disappeared completely from large parts of the Earth, simply — washed away? All the deserts in the world and all the sedimentary deposits in the seas would hardly be enough for that. This was proven by drillings at the bottom of the sea.

The first line of thought seems more right: the geological eras Trias, Jurassic, and Cretaceous never existed. The areas in which we find layers from those alleged eras were struck by a cataclysm.

The rock melted, rapidly hardened again and formed a new Earth crust. Various organic or animal remains were locked-in like in a flash. Areas less affected by flood and volcanic activity caused by comet impacts show less or no such rock formations. In other words, cosmic impacts followed by ruptures of the Earth's crust lead to different temperatures of up to 100,000 degrees Celsius, decreasing according to the distance from the center of impact. These varying temperatures melted the rock to different extents. Animals and plants too close to the disaster areas simply burned out without any trace. The soft soil substances swirled up and were transported inland by the masses of water, and suddenly encapsulated animals either dead or still alive. This way the fossils we know today were locked in and fossilized.

This also serves to explain why the animals we find in rocks are embedded "from head to toe" or with their entire skeleton: the height of the prevailing temperature is decisive for the type of find. The further away from the center of impact, the more complete artifacts and life forms are preserved. This shows why the map of the dinosaur era shows large blind spots. Only if the conditions described above, including the right temperatures and pressure conditions, prevailed, was it possible for these animals and plants to become locked in and preserved. Areas less affected by devastation and regions in the

Area A **Area B** **Area C** **Area D**

Fig. 5 Different Fossil Findings. Why do the qualities of fossil findings differ? In area A, close to the center of cosmic impacts or ruptures of the Earth's crust, everything alive burns out: no findings. A little further away (area B) the heat was so great that all body tissue burned, but the bones remained – sometimes black as if burnt – and were covered and preserved by the mud of the water masses, which rapidly hardened. This is why we find skeletons embedded in massive rock. At a larger distance from the epicenter (area C), animals were preserved, including their body tissue, skin and fur by the processes described for area B. This is why we find entirely preserved bodies in massive rock. In area D there were no high temperatures or high waves. The mud layers were not strong enough, so the bodies of the animals were washed away by the flood and some of them were buried in mass graves of scattered and smashed chaos. Evidence: the many mass graves of various species found all over the world.

direct vicinity of the impact zone accordingly show little or no fossils. I will present more evidence for this later on in this book.

But maybe a lot more than 400 million years have to be deleted from the geological time scheme? If the rock layers on the surface of the Earth developed and hardened quickly, we have more questions to ask: why should the Earth not have developed equally fast before the Flood took place? Was there a second major event – maybe even the birth of our Earth? When we take a closer look at a number of geological layers, one above the other, we can usually differentiate two basic different types. The lower and therefore older layers are often strongly slanted, consisting of layers of effusive? rock with an eroded top surface. Above them, we often find horizontal layers of differing appearance, all, however, consisting of deposits. Horizontal and therefore parallel layers, with no signs of erosion on their top, are characteristic of sedimentary phases in fast succession during a flood. The bedrock with its often slanted and eroded layers developed during a catastrophe, while the layers covering them were produced by a major flood. In isolated instances, the succession of layers may have become disturbed by larger or smaller local disasters.

As there could not have been an evolution, there is no reason to assume there were long periods for the development of amino acids and a *chance* development of a protozoon to mark the beginning of evolution. Then maybe we could straight away delete a couple of hundred million years more. Maybe the early Earth cooled down much faster than assumed? Is our mother planet or rather the Earth's crust in truth relatively young? Until a couple of years ago, after intensively studying various literature, I too was firmly convinced that mankind, based on the findings described, was at least 60 million years old and that the Earth too was of a certain age.

One objection kept me thinking though: if mankind was that old, then why have ore deposits not long been exploited?

If we take into account how many irreplaceable raw materials we mined and used up in the past 100 years, after a minimum of 60 million years of history of man there should be nothing left! If we follow the idea of the co-existence of all life forms until the flood not more than 10,000 years ago, this objection logically fits into the line of our argument, proclaiming a younger Earth.

Discoveries Worldwide

Until now, we mainly spoke of discoveries made in the area of Glen Rose. Because of the horizontal strata the excavations in the area foster good results. Let us look however at other findings made all over the world.

Archeologist Dr. Rex Gilroy, Director of "Mount York Museum", Australia, found fossilized traces of giant humans and a skull close to the footprints of a brontosaurus in Australia.[30]

In Hughenden, about 125 miles (200 kilometers) Northeast of Winton, Queensland, even today marine fossils are discovered in large quantities. In primeval times, an inland sea is believed to have been located here. The town's main tourist attraction is a skeleton of a dinosaur 46 feet (14 meters) high, found in a canyon called Porcupine Gorge.[31]

SouthWest of Winton in Eastern Australia, footprints were found that are permanently on display. Everyone can go and see for himself and observe that the animals that allegedly lived in different eras, actually co-existed. The prints not only include those of dinosaurs, but all different kinds of animals, including emus. If we trust the Theory of Evolution, then these simultaneous finds in one stratum are not possible. Nevertheless, the rock solid evidence can be looked at. Geology estimates the age of the respective strata to be

100 million years.[32]

Bones as well as entire skeletons are found in Australia and they are much of the same type as those discovered all over the world. Consequently, a land bridge must have existed during the lifetime of the dinosaurs. Probably, at this time there was only one more or less connected large landmass. On a visit to the "Queensland Museum" in Brisbane in 1996, I had the chance to admire a completely assembled skeleton of a large dinosaur and a piece of original rock plateau with the tracks of this and other animals.

Apart from large quantities of dinosaur footprints and skeletal remains of primeval animals, Turkmenistan also offers fossilized human footprints. These findings are comparable to those discovered in the area of Glen Rose. This serves to prove that we were not dealing with some chance events in Texas. There are biological and geological parallels all over the world.

Fossilized dinosaur footprints were discovered in Africa, Georgia, Uzbekistan and Germany. In München̈hagen, Lower Saxony, in Germany, some fossilized dinosaur prints are on display, partly roofed-in for protection. At the foot of the Wiehern Mountains, in Barkhausen close to Bad Essen, the fossilized tracks of a sauropod and a theropod are to be seen on a now strongly slanted rock face. As a whole, its appearance is similar to that in Glen Rose, except that here we do not have human footprints accompanying the dinosaur prints. Fossilized footprints are no local phenomenon, but represent a process that occurred all over the world, in the same manner, but that today can no longer be witnessed.

At Gadafaova Valley in Niger, Africa, a mass grave of dinosaurs exists. Over a length of 110 miles (175 kilometers), in a former river valley, hundreds of different specimens died. They are buried up to 33 feet (10 meters) deep, some of the vertebral joints sticking out of the desert sand, shaping chains of small hills. *The phenomenon of discoveries close to the surface after 64 millions of years can be observed worldwide.* It, however, is in no way in accordance with our present geological worldview.

As mentioned, in the Gobi Desert of Mongolia, there are rich saurian cemetaries, were skeletons mostly lie directly on the surface. The "Museum of Central Mongolia" in the capital of Central Mongolia, Hohhot, is not only in the possession of dinosaur skeletons discovered in the area, but also has a fossilized mammoth on display, found in a coal mine. A fossilized mammoth is a rarity. Its discovery close to coal is also very interesting. Unfortunately, I was not able to find out whether the mammoth was found in hard coal or the younger brown coal. The brown coal of the Rhine area and some regions in Asia (Siberia and Mongolia) developed approximately 60 million years ago.

But there are also sites that are assumed to be only 5 million years old. In the first case, we have a problem in terms of time, because the different mammoths, up to four meters high, developed 24 million years ago and therefore, unlike dinosaurs, can not be found in old coal seams. The pig-sized ancestors of the mammoth lived 55 million years ago, which means they lived *after* the dinosaurs became extinct.

The "Dinosaur National Monument" is located near Grand Junction (USA). The attraction of the park is a rock face, showing the skeletons of dinosaurs. In a large hall, roofing in the rock face, visitors from all corners of the world can watch excavators as they uncover fossil bones. It is remarkable that these skeletons are in an upright position, as if they had been fossilized standing up. This once again indicates that these dinosaurs were preserved in an extremely short time, because otherwise the process of rot and decay would have brought the bones in a horizontal – two-dimensional – position. This means that these dinosaurs were buried and preserved in an extremely short time. Several feet of rock, enclosing the skeletons, must have formed fast and not over long periods of time.

Geologists have another explanation for the upright position of the dinosaurs. The mountains are believed to have formed *after* these primeval animals became extinct – which is true in this order ?– through which the massive rock was shifted from a horizontal to a vertical position. Consequently, geologists believe in a gradual folding of mountains, virtually *in a cold state of the original strata*. If this assumption were correct, then most mountains and rocks would have to show much more cracks, as cooled down rock has a hard and no elastic or plastic structure.

If great pressure is applied to a solid rock layer in horizontal position, the rock will crack open in many spots because the rock can only bear minor tractive forces. Concrete is reinforced by steel in order to avoid such cracks. It absorbs the tractive tensions that come from bending, which the brittle concrete alone could not do. If these forces are not taken up, cracks appear in places of highest strain. The rapid covering of the fossil bones and the crack-free bent rock layers testify to the plastic-elastic state of the original rock material before it was shaped. How else should the bones have gotten *into solid rock*? The answer can only be that the rock was still soft at the time of the fast embedding. There is no other explanation.

This also is the manner in which the fossilized human prints, which are dated to between 150 and 600 million years old, were formed. Respective

fossil findings were discovered in Kentucky, documented in the "Science News Letter" of 1938.

Henry Schoolcraft and Thomas Benton mention similar finds in "The American Journal of Science and Arts" in 1822.[34] The size of the footprints suggests that they were made by very tall humans.

The "Science News Letter" reported on October 29, 1938 that more fossilized human footprints were discovered in Pennsylvania.[35]

In 1927, in the coal-containing seam-stratum of Fisher Canyon in Pershing County, Nevada, the print of a shoe was found. The sole was so clear that even traces of the yarn could be made out. The age of the sole was estimated to 160 to 195 million years. [36]

If this footprint survived, the coal-containing stratum must have been soft and malleable at the time the print was left. The parallel to the prints left in limestone is obvious. Coal therefore can not possibly develop by carbonization or the process of combustion of organic components alone.

This coal as a sedimentary deposit must have been soft at a certain time and must have hardened rapidly, otherwise the print would have eroded. The phenomenon of fast-hardening sedimentary rock is not limited to special isolated cases or certain types of rock.

Exceptional Findings in Coal Seams

According to our current state of knowledge, coal too must have formed millions of years ago. It is, however, a fact that at different times in different places extraordinary discoveries were made in pieces of coal or seams containing coal.

A thimble, embedded in coal, was found. J. Q. Adams gives a report on this discovery, titled "Eve's Thimble" in an 1883-issue of "American Antiquarian".[39]

In June 1976, in the periodical "Creation Research Society Quarterly", Harry Wiant speaks of a spoon embedded in coal.[40]

The same newsmagazine in 1971 published Wilbert Rush's article titled "Human Footprints in Rock". It described the surprising find of an iron kettle in a piece of coal.[41]

John Buchanan, in 1853, described a synthetically made iron instrument from the vicinity of Glasgow, Scotland, found embedded in a coal seam.[42]

In 1885, in a block of coal from the Tertiary period, an exact cube, weighing 785 grams, was found. It was exhibited at the Museum of Salzburg until 1910

and consisted of a hard alloy of coal-nickel-steel with a low sulphur content.[43]

Another unusual find in coal included a gold chain of 8 carat. This case was documented at Morrisonville, Illinois, in the issue of the city's newspaper of June 11, 1891. According to a report in the magazine "Scientific American" of June 5, 1852 a metallic ship or container with a silver inlay was also found in the respective layers.[45]

One could continue this list as various objects, for example a bronze bell or plants from the more recent past of the Earth, were found in places where it should be impossible to make such discoveries. Again this leads to the conclusion that all of the man-made items must be older than the coal they were embedded in.

It goes without saying that coal seams also revealed remains of dinosaurs and other primeval animals in different places. A coal mine in Bernissart, Belgium, was a primeval cemetary with remains of a dinosaur species (Iguanodon), tortoises, crocodiles, and many fish. As the coal and the dinosaurs are believed to be very old, there seemed to be no obvious contradiction.

These combined discoveries of coal, primeval animals such as dinosaurs and the man-made objects prove that these animals and humans lived *before* the coal formed, because the artifacts were found *in* the coal. We have to underline this fact. Assuming all relics date back to the same epoch, we have to ask: did mammals, dinosaurs and humans co-exist at least 64 million years ago or did they inhabit the Earth only a short time ago? The flood mentioned before would provide us with a logical explanation. It could be responsible for the forming of coal and crude oil, as a major flood would have suddenly buried trees and other plants. High pressure, for example from overlying masses or caused pressure waves as well as a concomitant of the flood in form of an effect of heat under exclusion of air could have started the carbonization of trees. Depending on the type of coal, temperature plays the decisive role. Once this process has begun, heat and pressure are produced automatically, so that no further supply of heat or pressure is necessary. Remember that coal comes in different forms, such as hard coal, brown coal, anthracite and peat. What makes the difference between these forms of coal is the content of carbon compounds, enriched during the process of carbonization: Peat has 40–60 percent, brown coal 60–70 percent, hard coal 70–90 percent, and anthracite 90–99 percent carbon compounds.

Did coal form as fast as the limestone strata mentioned before? Recent studies seem to confirm this. This would conclusively explain the described embedding of various items in coal deposits.

A stepped-up carbonization requires a catalyzer, accelerating the chemical

Dr. Hans J. Zillmer

reactions involved. It was observed that many coal deposits rest on old layers of clay or loam, coinciding with volcanic eruptive material. These requirements are met by the concomitants of the flood. Bearing in mind that the coal deposits of the world are estimated to a possible 5000 billion tons, it appears obvious to look for a global cause. Irrespectively, of course, locally restricted disasters may in isolated cases be responsible for the forming of coal deposits.

Mount St. Helens

On May 18, 1980 the volcano Mount St. Helens in Washington State, on the Western coast of United States, erupted. This lead to the foundation of the "Mount St. Helens Monument", by which the area directly affected by the disaster was placed under the protection of the national park authorities.

The event completely destroyed 150 square miles of forest. Enormous amounts of lava poured into the valleys. The volcanic cone was cut by about 1312 feet (400 meters), and a crater, cracked open to the North and a little less than 1 mile wide (1.5 kilometers), remained. Today, the park is among the most impressive natural wonders of America. Hundreds of thousands stumps and logs were washed into See Spirit Lake, together with a large quantity of biological material and volcanic ashes. Within a few years, a large deposit of organic and especially wooden material, enriched by volcanic ashes, was accumulated at the bottom of the lake. (The peat that formed there was often of a structure and had an appearance similar to coal.) The bark peeled

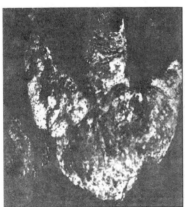 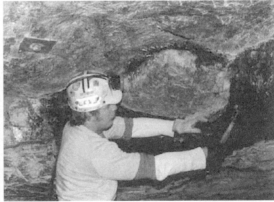

Fig. 6: Print in Coal. The mine "Castle Gate", Utah, revealed this prints of a three-toed dinosaur in 1924. It was found on the ceiling of a coal seam with rests of mud from the body of water that originally covered it. The right picture shows a dinosaur print at the ceiling of a coal seam.

48

off, sank to the bottom and formed thick layers of deposits. The stumps with rests of logs were partly deposited in the mud in a vertical position, because the heavier roots sank to the bottom first.

Should another volcanic eruption occur, these trees and the present peat layers would, under exclusion of air, be buried entirely by hot volcanic ashes and other sediments of the lake. All requirements would be fulfilled for the forming of bituminous coal. Dr. Steve Austin ran extensive studies in 1986 and the geological processes are still monitored today.[46] We can conclude from these facts that coal did not originate millions of years ago over a long period of time, but that the process under the right conditions took only very short periods of time.

As early as 1924, prints of three-toed dinosaurs were discovered in the coalmine "Castle Gate", Utah.[47] Since, hundreds of similar traces have been discovered in Utah and Colorado, sometimes consisting of complete trails. All prints have one thing in common: they were all found on the ceilings of the seams. Apart from that, they were often covered by dirt, such as sand or limestone. How do the footprints of dinosaurs get to the ceiling of a coal seam? These animals must have crossed slightly muddy terrain, sank into the underlying coal layer and left their prints in the top layer of the coal deposit. It is obvious that the coal must have been soft at the time, before it hardened. Otherwise erosive influences would have erased the tracks. This follows the same scenario we know from the formation of the fossilized prints in lime- or sandstone arises.

According to the accepted scientific school of thinking, coal forms by passing the brown coal stage in a process called carbonization, in which geochemical processes (pressure, temperature) prevail. Where do the required pressure and necessary temperature come from, letting coal harden just underneath the bottom of a lake? No, only a cataclysmic event makes the formation of coal plausible. Furthermore, the event must have had a global character because of the worldwide deposits of coal.[48]

Scientific opinion has it that dead vegetation – the basic material of coal – is thought to have formed an organic layer in the soil, covered in an airtight environment, keeping it from decomposing. The necessary warmth is supposed to have come from the interior of the Earth in the form of geothermal heat. With time, this layer is believed to have turned into a coal seam. And dinosaurs walked across this heated layer that was excluded from air? Is ordinary heat from the interior of the Earth sufficiently high enough to start carbonization just underneath the Earth's surface?

I will present an alternative explanation for the formation of coal and crude oil, than is offered by conventional school of thought, in detail in connection with the description of the Great Flood.

The Paradox of Time and the Evolution

One problem about the findings I described and similar ones discovered elsewhere poses itself over and over again: what geological era should we allocate them to, since they were found in the wrong places in allegedly much too old strata? That is why they are *categorically* referred to as *forgeries*. But who hides manmade items in deep, allegedly several hundred-million-year-old, strata all over the world? If one wants to believe the geological statements about the age of these strata, then findings of organic or synthetic origin in all these strata foster impossible results. Either all of these findings are forgeries – in order to maintain their working model the conventional school of thinking necessarily *has to claim this without even looking into isolated cases – or the acknowledgement of one single find* would let the Theory of the Great Geological Era and the accompanying evolution vanish into thin air.

If we assume that at least one of the *discoveries is authentic*, then we have to come up with a new and entirely different theory. As the objects embedded in rock or coal must be older than the material surrounding them, there is only one conclusion: the rock is substantially younger than believed up till now, and it must have been of soft consistency at the time the objects were embedded. Some cataclysmic event, the worldwide flood, embedded these items, as I have described, in soft or liquid material.

This process must have taken place not too long ago. This would resolve the time paradox. Under these circumstances, the authenticity of the described discoveries is no mystery but a natural, inevitable phenomenon.

The unpleasant consequence would include that rocks have to be dated to much younger periods. Logically, the Earth's crust too would be much younger than presently believed, if we assume a global character for the course of events. In this case, because of the problems involved in dating, there could not have been such a thing as evolution. This conclusion is inescapable.

If, however, there was no evolution, the question arises: Where did all higher developed life forms come from? There is only one answer: *They were created, by whomever.*

Until 200 years ago, the people of the Occident (where?) believed in the Holy Bible. And doesn't the bible say that God made – or rather "created" –

man according to his own image? As God – if he exists – is considered to be spiritual being that cannot be touched or seen, belief was substituted by the – on first inspection – logically explainable Theory of Evolution. Why? Because it offers the only alternative with respect to materialism and tangibility. Hence, there was no further need to believe in a rushed, divine creation. Darwin's Theory offered mankind a realistic explanation where previously there had been none. All facts presented in this book however unmask the idea of evolution as an intellectual dead end.

5 Time-Eating Monsters

Under the condition that the systems of uniformity of Lyell and Darwin lastingly apply to the long geological eras, direct assessments of age by geology leads to fairly acceptable results. If, however, there was a global catastrophe, then the boundary conditions and prerequisites simply must be wrong. The direct methods to determine age therefore must lead to ridiculously wild values. While direct methods for determining age suffer from errors, indirect (comparative) methods of assessing age were actually manipulated to support Darwinian Theory. It definitely is impossible to verify the specific age for rocks using these methods.

Mass Graves

The only argument in favor of an old world, which is considered to be a proven fact from the geological point of view, is the scientific determination of ages – allegedly indisputably proven by direct and indirect methods for the determination of age. The different eras of Earth's history are known, and have been given names such as Neozoic, Mesozoic, and Paleozoic or Cryptozoic; their duration has been precisely fixed. If there was, however, a worldwide Flood, then the scientific determination of ages must be wrong when it tries to assess the age of an object more than 5000 and up to 10,000 years old. In this chapter, I will take a discriminating look at the methods geologists apply to determine ages and I will prove that the foundations of these assessment methods are wrong. By doing so, the official story of Earth's history will be stripped of its basis and – disqualified as a completely wrong theory – and relabeled as a fabrication.

Approximately 95 percent of all known fossils are vertebrates of marine origin; 4,75 percent of all fossils are plants or algae. The greater portion of the remaining 0.25 percent consists of invertebrates such as insects. The smallest part of all fossils is made up of terrestrial animals, among them mammals, as well as humans. All over the world, about 1300 skeletons of dinosaurs – with upward trend – were discovered and the number of skulls found along with other fossilized skeleton remains of humans is substantially lower. In order for a fossil to form, it must be embedded in sedimentary deposits under, at best, flowing water and for the air-pores to fill with hard crystals of calcite or pyrite. This reduces the possibility of discovering respective fossils to isolated cases.

The nature of most discoveries points to a marine catastrophe. Interestingly enough, marine fossils are also discovered at heights of several thousand meters. Naturally, only very few remains of terrestrial animals and humans would survive such an enormous flood.

It is also to be expected that a flood of such dimensions would wash the remains of terrestrial animals together. It should be possible to find larger amounts of bones of animals who fled and sought protection in high-up caves and crevices. Actually, such virtual bone deposits are known all over the world. The asphalt-pits and caves of La Brea, near Los Angeles, California, were found to contain the tightly packed remains of several hundred animals of various families and species, such as horses, sloth, camels, mammoths, bison, peacocks and buffaloes. The bones of the animals formed an unidentifiable chaos, resembling a dump.

Charles Berlitz writes in his book "Die Suche nach der Arche Noah" (In Search of Noach's Arch) about such discoveries all over the world:

"In Wales and Devonshire, and in some parts of Southern England, entire ditches are found on hills, filled with the shattered bones of hyenas, hippopotami, elephants, polar bears and other known animals. We also know of such sites in the West of the European continent. The crevices of the hill Mont Genay in France contain bones of rhinoceros, elephants, lions, aurochs; the Swiss Alps those of crocodiles, giant ostriches and polar bears.

In Dakota, the great pressure formed the bones of camels and horses along with the bones of almost unidentifiable animals into giant blocks. In Nebraska, the remains of a rhinoceros and giant pigs were found."[50]

Bones of a whale were discovered North of Lake Ontario, 132 meters above sea level. In Vermont, they were found at 150 meters. An accumulation of the splintered bones of mammoths, "wool rhinoceroses" and other animals rested on hilltops and in crevices in central France. In Burgundy, France, a sedimentary layer at 400 meters contains the splintered remains of reindeer, horse, mammoth and other animals. Near Plymouth, in England, the remains of various animal species such as the lion, hippopotamus, bison, wolf, mammoth, rhinoceros, bear, and horse were found, broken into countless fragments. The crushed bones of the different animals formed a random chaos, mixed with sharp-edged stone-splinters.[50]

The rocks of Gibraltar are interspersed with crevices, filled with numerous broken and splintered bones of the remains of hares, cattle, rhinoceros, lynx, wolf, bear, hyena, panther and other species. The animals' remains, crushed into thousands of fragments, were neither worn nor gnawed at.[51]

In former times, the Liachnov Islands of Northern Siberia were called

Bone Islands, this because its mainland was covered with bones. Findings of this sort were also made in the sea.[51]

Another site, famous for the bone masses of numerous animal species to be found there, is Cumberland Cave in Maryland, USA. In 1912, digging a cleft revealed a cave with a strange accumulation of animals. The remains belonged to animals from different climatic zones: cold to moderate (lemming, hare, porcupine), as well as warmer (crocodile). Remains of species, now extinct, were found next to species that have survived (squirrels and mink). But they were also next to bones of animal native in dry zones (coyote, badger) or in areas with plenty of water (beaver, muskrat). These were discovered in the random mess, next to forest dwellers (squirrel), as well as animals of the open (horse). All of these different creatures died *together*. There is no way that these discoveries of accumulated remains of animals from very different climatic zones in one single place can be explained by the succession of longer glacial periods, as the conventional school of thinking defines them. The finds of Cumberland Cave in particular prove the opposite: a cataclysmic event at a certain point in time.

Another conclusion, however, is of even greater importance to our line of reasoning. The shattered bones show no signs of long— exposure to water. Therefore, the bones can not have floated in a river for a long— period of time. More likely, the carcasses were hurled against the rocks by enormous tidal waves, breaking the skeletons and bones and jumbling the remains of all different species together with gravel and rocks.[51]

Not at all welcome are discussions on the *extremely diverse strata* (Jurassic, Cretaceous, Tertiary) and the deep-resting coal seams discovered to contain mass graves with carcasses. Mass graves with very different kinds of animals from all over the world can only result from a sudden flood disaster. At the same time, processes of fossilization are characteristic of extraordinary circumstances. An animal's carcass is subject to mechanical (temperatures), chemical (acids) and biological (decay) destruction. That is why we do not find fossilization today, although uncounted creatures die every day. For a carcass to escape destruction and fossilize, its organic material has to be wrapped into a protective cover. As fossils are generally found in rock formations, this rock must have been liquid, or at least soft, at some point in the past. Only in isolated cases will fossilization take a long time. Fossils, however, are nothing exceptional; rather, they are easy to find all over the world.

A limestone bank in England revealed a host of trilobites in strange position: they were curled up. The species' rings of the lobes contain chitin, much like

that of today's woodlouse. These animals have the ability to curl up in case of danger. And this is exactly the state that these trilobites were found in. They were curled up and perished en masse, when sudden disaster struck.[51]

Ammonites are another example of an extinct species. Their sudden and complete disappearance poses an unsolved mystery to science. Equipped with a shell, this marine animal, once ubiquitous, was a good swimmer. Why did these animals, *filling almost all seas*, become extinct all over the world? This unlike the nautiloids, who were closely related to ammonites, of which some kinds have survived to this day.

This so-called contradiction has been considered conclusive evidence against a disaster of global impact in Earth's history. Otherwise nautiloids allegedly *would not have been able to survive* at all.

The answer to the problem: a completely *different shell structure of the two species*. The curvature of the partitions was bent to the opposite direction that allowed nautiloids to dive deeper than the ammonites, native to the shallow areas of the seas.[52] This difference is the reason why ammonites became extinct. As animals living close to the surface they were helpless when exposed to the elemental forces of a great flood and dropping temperatures while the nautiloids were able to survive in the more constant temperatures of the deep seas. The different kinds of Ammonites began to populate the seas about 400 million years ago and became extinct, along with the dinosaurs, approximately 64 million years ago. That is how the ammonite/nautiloid mystery does not provide an argument against a global extinction, but represents almost conclusive and *logical argu*ment— *for a global flood disaster.*

Fig. 7: Nautilus. *The cross section (illustration on the left hand side) shows the backward-bent partitions. Thanks to this curvature, they – unlike ammonites – survived in the depths of the sea.*

The mass graves of the most different kinds of species can not be brought into accordance with our worldview of a merely gradually changing Earth. This worldwide extinction presents one of the most fiercely discussed issues of the recent past. The discussion is as controversial as views on what may have caused the extinction of many different animal species. Recently, the long-scorned Theory of Catastrophism, however, has received once again more consideration in these discussions.

Safe Dating?

The assessment of age by using radio carbon dating[53] often results in varying values for the same object. Implausible results, on the other hand, are no rarity. The journal "Science" documented the dating of a mollusc's shell. Radio carbon dating fixed its age to 2300 years. The unpleasant part? It was a *live* specimen.[54]

In another case, the age for the shell of a live snail was listed as 27,000 years.[55]

The principle underlying the controversial radio carbon dating is based upon the decomposition of radioactive carbon. The technique was discovered by Willard Libby in 1947. The metabolic cycles of all living creatures take up small quantities of radioactive isotopes of carbon (chemical sign "C"). These isotopes C-14 form in higher zones of the atmosphere through strong cosmic radiation under simultaneous reaction with nitrogen isotopes in the air. Intake ends with the creatures' death. The radioactive atoms collected by the body until its death decompose at a certain rate, known as the half value period. C-14's half time amounts to 5730 years. After twice that time – in this case 11,460 years – the rate drops to a mere 25 percent of the original value. If we double this time again to 23,000 years, then the amount of isotopes, collected by the body, will be down to 6.25 percent. This is very small, considering that the concentration of C-14-atoms itself in the body is relatively low.

On account of this consideration, assessments of age exceeding a period of 20,000 or more years can not even be nearly precise enough, as the proportional share of the remaining isotopes drops by this percentage. With this method, even small deviations lead to substantial measuring errors. Radiocarbon dating provides us with usable results with an error rate of maybe ten percent for the past 5000 years only. Assessing longer periods, the amount of measurable isotopes has dropped so drastically, it tends towards zero.

These metric uncertainties are joined by more elements of uncertainty that question the measurements on principle. So far, considerations assumed

a relatively constant carbon content in the atmosphere throughout Earth's history. Is this actually correct? Various influences in the past may have had a more or less strong effect on the outer layers of the atmosphere, where C-14-isotopes originate:

· Debris from erupting volcanoes in the atmosphere.
· Exhaust fumes and any kind of emissions. A variation in the intensity of cosmic radiation (activity of sunspots).
· Nuclear tests or accidents in nuclear reactors.
· Meteors or other massive objects entering the atmosphere.

Climatic changes and upheavals caused by terrestrial cataclysms have had a significant influence. Should the atmosphere have had lower carbon contents before the flood, then test readings would confuse us with ages much too high. The dating of plants, growing next to highways, presents a famous example. The unnaturally high carbon content of the plants due to exhaust gases from cars, leads to faulty measured values.

So there are many events that more or less damage the ozone layer or merely influence cosmic radiation. These events further the rapid forming of radioactive carbon by increasing cosmic radiation. For these reasons,

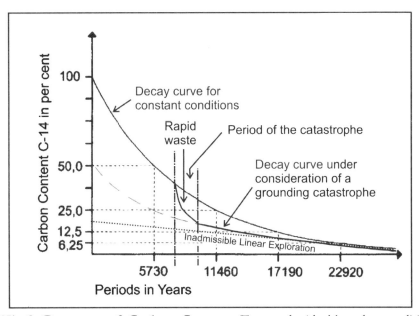

Fig.8: Decrease of Carbon Content. Even under ideal boundary conditions, the radio carbon method already becomes unreliable when ages to be determined exceed about 20,000 years.

measurements of longer time periods using radio carbon dating increasingly have been received with doubt.

The following comparison illustrates the whole problem in a simple way: finding a burnt-down candle in a closed room with a window, we are able to determine how long the candle burned, based on the contents of oxygen and carbon in the room, its size, and the amount of wax remaining when compared to the original size of the candle. We assume a constant general set-up: the room was closed all the time and the oxygen content in the room did not vary. This illustrates the conventional scientific dating methods. But who could tell whether the window – comparable to the sky – was not open at some point and closed again after a certain time? How long did the interruption last? Did special conditions prevail in the past – for example when the window was opened – that would increase the speed at which the candle burns down? Did the wind blow out the candle and did some other process re-light it afterwards? Simple questions, but no answers.[56] Only under certain assumptions and conditions are we able to determine the actual burning life of a candle. There are similarly indefinable key features when it comes to determining the age of organic or inorganic matter.

The age of fossil skull fragments of our human ancestors is generally determined with the help of indirect methods to avoid having to destroy some portion of the little valuable bone material that remains. Instead, the age of the stratum containing the find is determined. The controversial nature of this method, however, has already been discussed.

Though science knows of these uncertainties included in dating, they are ignored. Instead, new scientific methods of measuring are developed, aiming at proving the discussed dating procedures and giving them credibility.

Manipulated Chronologies

A well-known procedure is dendrochronology (chronology of annual tree rings). This method compares annual rings of trees that vary in thickness. A sequence of old trees is established to provide a calendar of annual rings, comprising a complete period of about 10,000 years.

This method, declared to be infallible by the followers of the Glacial Period Theory, is *one of the most unreliable dating methods*. Is it really an ascertained fact that in the past only one ring formed each year, as is fact today?

The width of an annual ring depends on local climatic conditions, i.e. prerequisites influence rate of growth. It makes sense, even to a layman, that

the climate is different in different places. It rains more on mountain slopes than in the adjacent plains. Direction is also a factor, because Northern slopes often offer less good conditions for growing than the intensely sunlit South slopes. This, of course, applies to the Northern Hemisphere only. On the Southern Hemisphere, it works the other way round. Trees growing only a few kilometers apart, may show in extreme cases annual rings, differing in width, and are hence not comparable anymore. Where an old log originated is usually unknown. The overlapping of annual rings, seen from this angle, appears arbitrary. Especially if we take the relatively short lifetime of a pine tree into account, making it necessary to determine a whole series of overlapping and increasing possible sources of error. The Pine Tree Chronology is said to be able to reach back 12,000 years without any gap. Professor Hans-Ulrich Niemitz and Christian Blöss voiced their severe doubts about these dating methods under the title: "Der Selbstbetrug der C-14-Methode und der Dendrochronologie" (Self-Deception of Radio Carbon Dating and Dendrochronology): "The expert knows that radiocarbon dating would have been lost long ago, if it had not been for dendrochronology. It is necessary to calibrate C-14-measurements. Only dendrochronology provides the extensive calibration source needed."[57] At the same time, they also state: "Little known, however, is the fact that dendrochronology would never have been able to establish a sequence of annual rings without a gap [...] if it had not been for radio carbon dating."[57] Two unreliable methods, supporting and proving each other. Again, the same procedure unfolds: evidence serving as proof for itself, analogous to the system that already helped Darwinism and geology determine the geological eras. When looking for a comparative procedure of measurement that is beyond any doubt, than this does not apply to these cases. Proof can not be based on two unreliable methods; at best assumptions can be.

An even more insecure procedure in dating the more recent Earth's past is the so-called "Warven Method". Ribbon structured clay lamination and seasonal coloration of lime are supposed to provide absolutely secure values for the past 10,000 years. They are based on the assumption that every year a layer of lacustrine clay is deposited. If there has been a global flood, as I argue in this book, in this period alone numerous layers would have been deposited with the successive tidal waves. This way, eras of several thousand years may be reduced to maybe just one day. This method opens a door to arbitrariness and randomness.[58]

Similar considerations apply to all other dating methods, such as "magnetostratigraphy, based on paleomagnetism of magnetic and sedimentary rock".[59]

This method allegedly allows dating of time periods up to 50,000 years back. In this case, the rate of formation per time unit and the prevailing intensity of magnetism on Earth at the time the rock solidified are also unknown.

Not one of the dating methods described is precise, because we simply do not know what the early and locally varying circumstances were in the past. Over and over again, attempts are made to project the constant conditions of today into the past with the support of the theories of uniformity of Lyell and Darwin.

Erroneous Dating of Inorganic Findings

Radiocarbon dating merely allows the assessment of the age of organic matter. The age of inorganic matter (rock) can not be determined. Other procedures were developed for this purpose, some of which I want to take a critical look at.

Most dating methods (thermoluminescence analysis, electron spin resonance procedure) use half-value period or quantity of radiation released for their scale. They are based on known mechanisms of decay series of natural radioactivity – uranium 238 in particular – which is most common in nature. I will try here to question the theoretical basis for this seemingly exact determination of age.

It is assumed that — the same radioactive isotopes existing in today's atmosphere also existed in the past. But maybe there are remnants in the rocks of a radiation that we do not know and that does not exist in the atmosphere anymore today. The divergent decay series of such an isotope would have to be included in the calculation of age and would result in an entirely different age. Apart from that, it is assumed that the intensity of radioactive radiation has remained more or less unchanged over the past 4,5 billion years of Earth's history. This theoretical basis of unchanging conditions in all assessments of age, and thereby the methods, has to be refuted. As soon as geology recognizes this discrepancy, dismisses Darwinism as a mistake and takes the consequences of catastrophes on Earth's history into account, it will be possible to give better and more reliable estimates for the geological eras.

Rapid Hardening of Sedimentary Rock

In recent years, some scientists have been giving the questions about age assessment some critical thought. Robert Gentry's studies, which I will explain in the next chapter, confirmed the doubts about the theoretical foundation for the dating of granite, i.e. primary rock, in contrast to the younger sedimentary rock, such as slate, lime- or sandstone, that was formed by deposition.[60]

Nobody has – aside from the cooling of red-hot lava – witnessed the forming of rock yet. All explanations of formation, or better solidification processes of the original mineral components, must therefore without exception *be assumptions*. Because solidification of loose rock material normally requires high temperatures and/or enormous pressures, geology thinks up a powerful circulation process to explain the presence of such metamorphic rock – i.e. rock formed from sedimentary rock or magma – on the surface of the Earth. Heat and pressure are assumed to have formed this rock tens of kilometers underneath the surface, but only after it was transported there by the regrouping of layers in the Earth's crust and circulated back to the surface afterwards. Under allegedly *uniform conditions* of Earth's history this is a wild and *highly improbable* journey – a working model only necessary to explain where the pressure, seemingly required for pressing and compressing sediments, may have come from. Given the common atmospheric prerequisites we know, there is *no way* loose material can turn into *solid rock on the Earth's surface*. It would also take heat and/or pressure, or hydraulic hardening (calcium carbonate).

According to the standard theory, Earth changes gradually. The process of circulation, therefore, can only be granted local significance. This is why science refers to it as *regional* metamorphosis – an event that is spatially restricted. Strangely enough, we find metamorphic rock all over the world: *the exception is the rule*. Do we have to conclude now that we are looking at a worldwide phenomenon, a *global* metamorphosis? This, however, would include Earth cataclysms, which are said not have existed. Even geologists are in disagreement whether metamorphosis affected the primary rock granite or that it is genuinely igneous rock. I will try to present a completely different theory to prove the rapid solidification of rock, as well as sediments on the Earth's surface.

The primary rock granite formed out of a once fluid substance of the early Earth and is supposed to have hardened slowly over a longer period of

time into different crystalline manifestations. This porous ground rock of the deep consists basically of quartz, glimmer and feldspar or a similar conglomerate. The Earth's crust consists of feldspars to about sixty percent, some of which are calcium sodium feldspars. The weathering of feldspar produces *kaolin*: raw material for porcelain production (china clay). Clay, however, mainly consists of kaolin. When sand and other substances are added, it is processed into ceramic tiles, by pressing at high pressure, followed by firing in a process that includes temperatures of 900 °C and more.

Could this process unfold under natural conditions during a cataclysm? Assuming – in opposition to our conventional worldview – an adequately high temperature during a disaster, we have to answer this question with a "yes". Under these conditions, however, the rocks set as fast as concrete or fired ceramics. As I will describe in greater detail, the flood-impact (= meteor impact) produced temperatures of far more than 1000 °C. In the direct vicinity of impacts, computer simulations calculated temperatures of more than 10,000 °C. All requirements are therefore met for a soil mixture to undergo rapid burning. Burning lime and clay (mar) at high temperatures produces cement, responsible for the fast setting of concrete. Portland concrete, an important type of concrete, contains up to 5 percent of gypsum or anhydrides. *Calcium* (calcium carbonate) is the responsible hydraulic hardener in hardening this soil mixture. Calcium is also the *main rock forming element* in limestone, marble, dolomite and gypsum rock. Salt water today also contains calcium ions in low concentration, that act as hardeners. The calcium content of primeval ocean probably was substantially higher:

· because the sea floor is made up of basalt and an exchange of corresponding ions took place;
· other salts and minerals too were washed out of sea floor;
· rivers carried erosion materials with dissolved substances to the seas;
· the emergence of hot magma in sea water triggered ionic exchange.

On the other hand, the accumulation of sediments in the Cambrian period (according to geology a period of 90 million years period starting 590 million years ago) indicates an increased formation of limestone. This is a mystery still to be tackled by science. The Earth's body actually only provides material for forming igneous rock (eruptive rock, granite and basalt), but very *little calcium*. From this viewpoint, this element must have come *from outer* space or must have been part of *our atmosphere*. Was it washed down out of the atmosphere onto Earth's surface by torrential downpours during the flood? This is a possibility I will delve into later.

By analogous reasoning, it must have been possible for the fluid Earth

substances emerging from enormous ruptures and heavy volcanic activity to set rapidly due to the calcium then present. In soil containing kaolin a rock similar to porcelain could have been formed, whereas predominantly calcareous soil mixtures would have formed into lime or a kind of concrete (sandstone). In fact, all kinds of mixtures would be possible.

This theory sounds utopian. It, nevertheless, is confirmed by facts and phenomena in nature. That is why I would like to dig deeper into the chemical and geological processes involved. Because, if my reasoning is correct, we will have to reconsider the interpretation of our Earth's past.

Clay formed through weathering from minerals contained in primary rock, particularly feldspar. The influence of mostly carbonated waters, a side effect of volcanic activity during the flood, led to the following reaction:

Feldspar + Carbonic Acid = Aluminum-Silicate-Hydrate (clay/kaolin) + K_2CO_3

Aluminum-Silicate-Hydrate is nothing else than solid ordinary clay, malleable when water is added. When clay is found in a *pure form* and is of whitish color, we are dealing with *kaolin (china clay)*. To make this clay water-resistant – argillaceous rock that is – a burning process is necessary. High temperatures of at least 1000 °C must have prevailed in large parts of the world during the course of the flood. It was then that ordinary clay under release of water turned into *water-resistant* calcined clay (aluminum-silicate). *The originally soft sludge hardened under cataclysmic conditions to solid rock.*

Aluminum-silicate and calcium hydroxide (slaked lime) form calcium-aluminum-silicate-hydrate and tricalcium disilicate hydrate. These chemical processes present nothing else than the *hardening scheme of anhydrous* (anhydride = gypsum free of water) *binders*, such as puzzolanas of volcanic origin: puzzolana, Santorini Earth, and *trass*. *Lime-trass*-mortar is used in special building techniques even today Romans preferred it because it *binds* (sets) very well *under water*. It therefore is in use especially in hydraulic engineering (walls of dams and bridge piers). I emphasize again that considering the increase in temperature in nature, fast-setting binders formed naturally and in all possible variations, responsible for the rapid setting of sediments to hard rock.

Reactions of calcined and fine-grained clay with a calcareous alkaline include busting the kaolin-molecule under the effect of heat above 650 °C while *water is released*. The chemical processes, requiring relatively low temperatures compared to the conditions during the flood, opened possibilities for new compounds to form. The aspect of forming free water will play an important role later.

The high temperatures required for these chemical processes were a side effect of the flood – something which until now has *not* been given

consideration by the scientific school of thinking. In a few thousand years and in little time, they produced:
- A kind of calcined clay down to "porcelain".
- Rock similar to concrete based on mixtures of sand and water with trass or other hydraulic additives.
- Limestone, under conditions with sufficiently high pressures, also marble of various kinds and degrees of hardness, based on the amount and the quality of what is added to the mixture.
- Mixtures of all above-mentioned substances.
- *Surplus water.*

The only thing left to explain is where the calcium hydroxide came from. When limestone (calcium carbonate) is baked at more than 1000 °C, it turns to quicklime (CaO) and carbon dioxide. Quicklime and water, which was present during the flood in ample amounts, builds calcium hydrate, i.e. slaked lime under release of heat. Slaked lime formed lasting compounds with the carbonic acid (carbon dioxide plus water) released during volcanic eruptions: *Limestone formed under the release of heat and two parts of water per molecule.*

Calcium hydrate + carbonic acid = *limestone* + hydrate water + heat

The consistency of the calcium hydroxide solved in water is important: it is a dispersion bordering a colloidal solution and basically responds like a *plastic gel.*

This *basically* explains the *rapid hardening of limestone* and the preservation of footprints by covering it with a fast-hardening gel-like substance. Dinosaurs and other animals crossed the sludge of areas that were recently flooded. Humans followed in their footprints, because this way walking was easier. The mud set fast, following the described chemical processes. Another flood covered the prints with the described gel-like substance (sludge) and preserved them. This layer too hardened rapidly, this time forming a kind of concrete mixture (limestone, sandstone). With each tidal wave new layers were deposited, forming layer after layer within a short period of time.

This also explains, why prints of humans and dinosaurs were found in several different, overlapping strata that – seen from a conventional geologic standpoint – formed millions of years apart.

The chemical processes forming layers of rock may be far more complex depending on local conditions: hydraulic rearrangement and enrichment with aluminium, silicon, sulfate, iron and silica, gel of argillaceous Earth, and oxygen in combination with quicklime, which – as described – forms with the free, available calcium or when limestone is baked. These processes allowed the

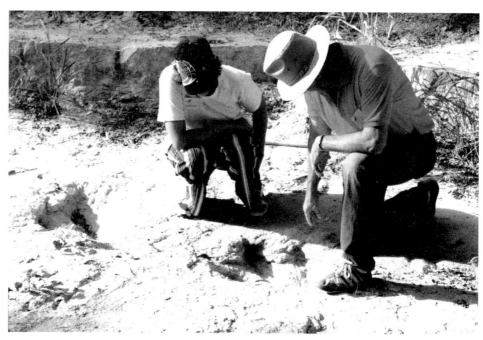

25 The author's daughter with a co-worker of Carl Baugh examine an especially well preserved footprint of the "Clark Trail".

26 Detail of the picture above. The footprint looks as if it had just been left behind in soft sludge, though it actually is solid limestone. Geology estimates the age of the rock to be 100 million years and more. The sludge must have hardened extremely quickly to solid limestone after the print was made. A gradual formation or development of the solid rock layer of approximately 16 inches has to be ruled out.

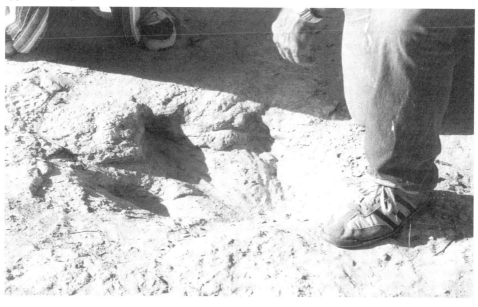

27 The "Creation Evidence Museum" in Glen Rose at the entrance of "Dinosaur Valley State Park" during the author's visit in 1996. The little picture shows the shell of the new museum.

28 Exhibits at the "Creation Evidence Museum": bones of the skull of primeval bull. Next to them, a picture of a former citizen of Glen Rose, who was more than 8 feet 2 inches tall.

29 At "Dinosaur Valley State Park" in Glen Rose: reproductions of dinosaurs, which inhabited the area in the past — Arcocanthosaurus and Pleurocoelus.

30 Roland T. Bird with his greatest discovery in 1938: the trackway of a sauropod and carnosaur dinosaurs in Glen Rose.

31 Bathing in a dinosaur print. Department of Library Services, American Museum of N. H., New York (#310437) 25.

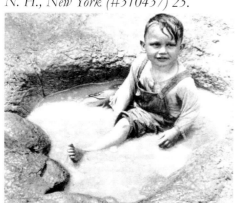

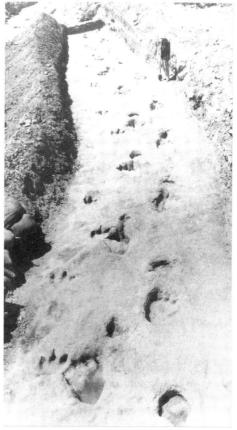

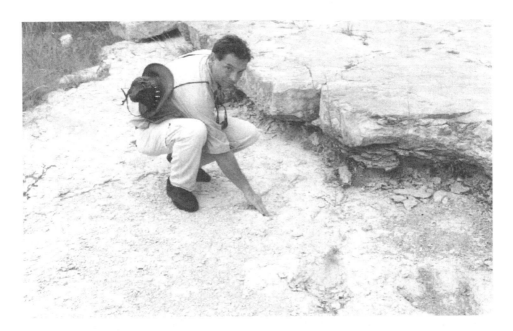

32 The author, looking at the strongly weathered print of a human foot of the "Clark Trail", already strongly eroded since it was uncovered in 1995. The tracks end in front of a massive limestone layer, 10 feet high, overlying a thin layer of slightly solidified debris.

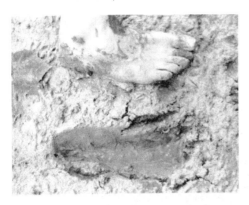

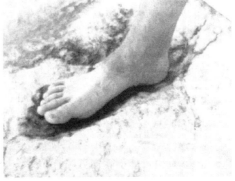

33 A freshly made footprint in mud.

34 The fossilized footprint "Ryals" in the vicinity of the "Taylor Trail". A distinctive print, compared to the print in picture 32.

35 This footprint belongs to the "Clark Trail". It was discovered in 1989 under a massive layer of limestone.

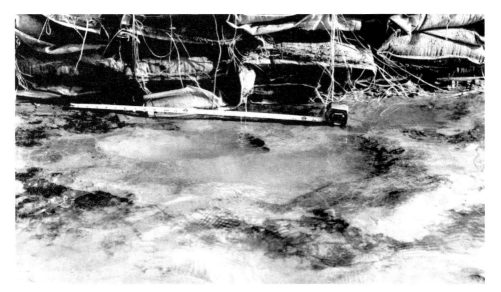

36, 37 (37 at bottom)
The last print, +6L, of the
"Taylor Trail".

38 Detail of the print +6L.

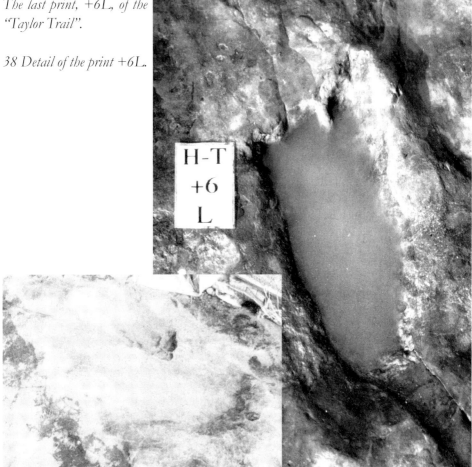

39 Paluxy River at the end of the "Taylor Trail", with an upstream view towards the "Clark Trail".

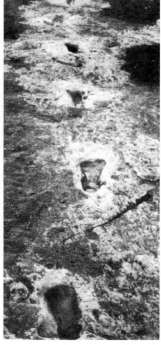

40 "Tailor Trail" in the mid-seventies. Prints 3 to +3.

41 Dr. Don Patton and the author during the clearance of the "Taylor Trail", in 1996.

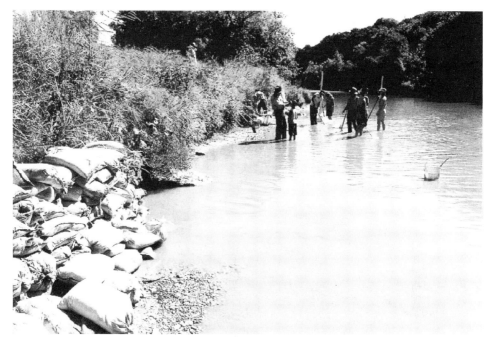

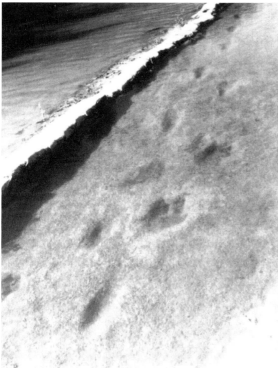

42 1996: the "Taylor Trail" in the Paluxy riverbed is being cleared from debris.

43 Bags with sand were piled up around the "Taylor Trail" in the riverbed. The footprints are already visible under the water surface. Later, the water will be pumped off.

44 A still muddy footprint of the "Taylor Trail". The three toes of the dinosaur's print are visible, along with a track in the shape of a human foot at the lower end.

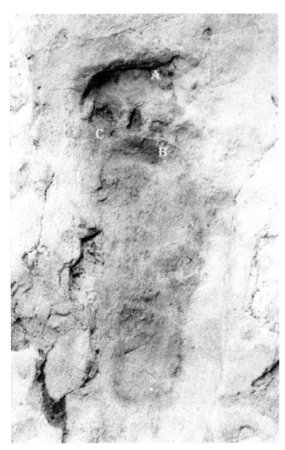

45 The print - 3BR of the "Taylor Trail" shows the print of a human right foot on the right edge of a three-toed dinosaur's print. The human foot stuck deep in the mud (A) and was pulled out: C= big toe, B= toes.

46 Cast of print - 3BR. This beautiful print is now destroyed. See homepage: "Refutes groundless insinuations that Glen J. Kuban destroyed a track": http://members.aol.com/paluxy2/rebutt.htm

47 Sketch of height-relief, showing the entire print - 3BR

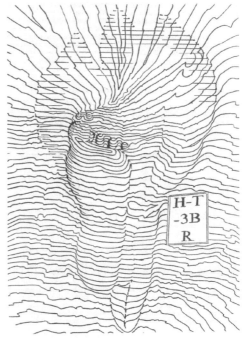

main elements of cement to form. Examples include tricalcium silicate, dicalcium silicate, tricalcium aluminate and calcium aluminate ferrite. The main agent in all these types of cement is quicklime (CaO), as indicated by its name.

Cement forms when a mixture of lime and clay is baked to sintering (compression under the influence of pressure and/or heat at temperatures below melting point) at about 1450 °C. In the process, lime is almost completely fixed to argillaceous acids. Cement lime (cement-water-mix) hardened through hydration (steeping and increase of volume by taking up water) sets just like ordinary lime does. It, however, forms a lasting compound on mineral basis. Chemically speaking, hydration is a process in which present water is bound. It is the chemical altering into hydrates, *releasing calcareous hydrates* among the calcium silicates. This is therefore the origin and the formation of calcareous hydrates.

Summing up, we can state that considering the high temperatures and pressure conditions during the flood event, new sediments (limestone, sandstone and slate) formed and solidified rapidly. Caused by locally prevailing high temperatures, the setting was very fast, in extreme cases within the short period it takes gypsum or other rapid binders on cement basis to harden.

Did it take millions of years for large parts of the Earth's crust to form or is it possible that rock formed as a kind of concrete mixture (products similar to calcined clay and/or porcelain in connection with diverse minerals) through sudden solidification? Footprints of dinosaurs preserved in rock all over the world show an extremely rapid solidification of the respective and the overlapping top layer, outcropped today in the form of rock in different degrees of solidity, according to the portion of calcium it contains.

How does geology explain the forming of rock layers? The book "Die Erde" (The Earth) explains: "All sedimentary types of rock have their own deposition rate... slate... takes about 3000 – 3500 years for three feet 4 inches (one meter) to form, limestone requires approximately 20,000 years. Limestone takes longer because it mostly consists of shells and skeletons of creatures accumulated at much lower rate than the sediments of rivers."[61] However, could a track survive 200 years until, finally, a layer of one centimeter has formed to cover it? Another question remains unanswered: where is the pressure supposed to come from, necessary to solidify loose rock in a cold state?

The fact that the described processes release water that originally was chemically bound in rock is important. Sea level rose by maybe 500 feet (150 meters) due to the flood. Until now this has been most convincingly explained

with the melting of glaciers at the end of the glacial period. True, when ice melts, water is released. But if there never was a real glacial period, then the surplus of unbound water must have another origin. Until now, no alternative, conclusive explanation has been found for the surplus of water.

On account of the chemical processes during the flood, I have presented the following inescapable conclusion which has, however, to be drawn: the formation of limestone and similar chemical processes involved in forming other rock includes the splitting of one molecule of water per molecule calcium hydroxide, originally chemically bound. This water corresponds with the known *construction moisture of new buildings*, splitting off even months after completion of a building – a phenomenon owners and tenants in newly built apartments have learned the hard way. From this analogous connection, a large part of the water results, suddenly to *increase the amount of water present on Earth*. Glaciers melting during a warmer period are no longer needed to serve as an explanation for the formation of additional water. This aspect takes away the until now most secure basis of the Glacial Period Theory. Other studies confirm that rock could not have formed gradually. (which?)

Little Monsters in Decay Series

There is much scientific evidence substantiating the theoretical considerations presented so far. Evidence that has not won the deserved recognition as of yet.

Natural uranium (U) 238 (99.3 percent) and U 235 (0.7 percent) are found in granite. This natural uranium successively disintegrates in nine different isotopes. These are types of atoms of an element, whose nuclei contain an equal number of protons, but differing numbers of neutrons. After each decay, radiation is released. It is possible to determine the stage of decay in the rock, because each isotope of the radioactive decay series leaves an individually sized print in the form of a small halo, corresponding with the respective intensity of radiation, within the range of centimeters. When granite is cut through an originally radioactive uranium atom contained in it, the different gradations of annihilation are perceptible, similar to the skins of an onion. Every grade of decay has its characteristic shell. As the half-time is known, it is possible to conclude at what point in time the granite formed. Putting the amount of end products (if not present then) in relation to the amount of the starting products allows one to calculate the moment of inclusion. If it is a granite from the time the Earth was formed, the result

reflects the age of the Earth.

Uranium's half-time is 4.5 billion years – believed to reflect the approximate age of the Earth. The last stages to release radiation in the radioactive decay series of U 238 are polonium 218, 214 and 210, after which stable lead isotopes are formed. Polonium isotopes show a half-time of only 3.1 minutes, 164 microseconds, and 138.4 days. Because of its low decay rates, polonium (chemical sign: Po) may – *as a by-product of the original uranium only* – be enclosed in the rock and identified. Polonium is nothing more than one link in a chain, with uranium serving as its starting link. It therefore can *not exist alone and independently*. During a gradual formation of the Earth and the hardening process of primary rock, polonium out in the open, as an element away from its radioactive decay series, rapidly would have evaporated, thus making it impossible to identify it. Polonium, existing independently beyond the decay series of uranium in nature, has not been identified by science yet. Or were such findings kept secret, because they do not fit into the concept of evolution?

In his studies, Gentry found granite in which these short-lived elements were contained without their mother elements. If polonium

Fig. 9. Uranium-238 decay series. The individual isotopes of this decay series are characterized by individual radiation levels. It is possible to optically detect their reach, lying within a range of centimeters, in rock. From the entire decay series (U1) only certain steps of radioactive annihilation (U2) are identifiable by their emitted radiation, what is called alpha decay. The displayed sections of decay series P1 (Po 218 to Po 210), P2 (Po 214 to 219), and P3 with the isotope Po 210 should, according to Lyell's theory, not be found alone and without their preceding mother elements (U 238 to Rn 222), because they only last in a stable state over a very short period. Nevertheless, they are detectable in granite.

210 existed as an independent element and simultaneously as a decay product of a primeval atmosphere, then the physical conditions of the world in the past must have been completely different from today's. Apart from that, it is not possible for rock with such motherless inclusions of polonium atoms to have set slowly, as geology dictates. Because of their short lifetime and their isolated location, polonium isotopes *would have annihilated rapidly and completely.* Gentry proved that polonium may be found either with all three isotopes simultaneously present, with a combination of Po 214 and Po 210, or Po 210 alone. The daughter element Po 210, being the penultimate decay stage before stable lead develops, alone without its mother elements Po 218 and Po 214? (verb missing) What were those different conditions that have prevailed in the past?[60]

The Earth's mantle is thought to have hardened over tens of millions of years. The half-time of polonium merely amounts to 140 days and the fact that it was enclosed in rock without its mother elements leads to the conclusion that the granite only could have hardened within this short spell of time.

I have discussed the chemical processes leading to a fast setting of liquid primary fluid to rock in the previous section. Isolated polonium isotopes in rock prove the rapid settings. This supports my seemingly fantastic statements and allow them to be seen from a different angle: scientifically substantiated. Over and over again, basic considerations of different discoveries and ideas lead to similar results. What does science say about it? "Nonsense." Of course! Everybody knows Earth's age...

Unfortunately for them, the proof of isolated polonium isotopes leads to a terrible realization for all the followers of evolution theory: that we live on a much younger Earth, if not a very young Earth.

Apart from the uranium decay series U 238 and U 235, there is a third natural radioactive decay series in nature: thorium (Th 232). It forms polonium 212 and 208. Approximately every 5500th atom of Po 212 annihilates with a twenty percent higher energy rate. The explanation offered by the traditional scientific school of thinking points at an originally different nuclear structure. Another conclusion suggests an originally long-lived radioactive element, no longer known to us, that existed in the primeval atmosphere.

An unknown radioactive element, no longer identifiable today, requires completely different physical conditions prevailing on this primeval Earth. This is a mere assumption, but of a high probability, if we look at the observations. It would be very speculative to assume the possibility of thermal neutrons causing an additional fission in nuclei of the rarely found uranium 235,

or fast neutrons, their kinetic energy exceeding a threshold value, forcing fission in the more commonly found uranium 238. A large body – Earth's sphere – generally does not reach these critical stages. In the course of the flood event, however, completely different physical circumstances must have prevailed. Considering the incredibly high temperatures, the kinetic energy released by cosmic impactors hitting the Earth's crust might have gone far beyond the critical threshold value and triggered nuclear fission on Earth.

This is why the annihilation of radioactive atoms did not take billions of years, but rather happened quickly, in a very short period of time, in the form of a chain reaction. The mathematical assessment of time must foster wrong results, because it is based on the assumption that the course of the annihilation of uranium or thorium takes place under ideal and steady circumstances throughout Earth's history.

Fig. 10. Halos. The individual isotopes of the decay series show varying radiation. Their reaches are optically detectable in rock. It therefore is possible to unmistakably identify the halos of the independent decay series P1, P2, and P3 (see figure 10) with the mother elements Po 218, Po 214 and Po 210.

In any case, the small independent polonium-isotopes point at a natural radioactivity, unknown to us. The very short annihilation rates of these atoms prove that the Earth's crust hardened fast. In other words: The period of time between the formation of isotopes and the crystallization of rock, holding these small atoms must have been very short and presents a kind of snapshot. The isolated polonium-isotopes, because of their own half-time before this moment, however, only existed for minutes or even fractions of seconds. As there are sometimes no mother elements at all, a nuclear fission might have taken place shortly before; or completely different physical conditions we can not fathom today prevailed. There is no other way to explain these phenomena.

When there is no other explanation for the presence of isolated polonium-isotopes in igneous rock, the methods for determining age in use today lead to substantially lower and directly proportional values, this because of the mathematically diverging initial figures. In any case, this discovery fundamentally contradicts the ideas we all cherished about evolution. The assumptions of those sciences dealing with Earth's history would be erroneous; hence their conclusions would be too.

Various questions come to mind. What was our atmosphere really like before the flood came? What physical conditions prevailed in the world of that time? What elements existed apart from the ones we know today? It also poses the question whether the age determined for our Earth and all inorganic matter is correct. The answer is? It is impossible to determine the age of the Earth.

Formulas in use are based on uranium 238 and its very long half-time. It takes up the largest part of all fissionable initial products in natural environments. If short-lived elements existed in the primary atmosphere, then there is no precise assessment possible.

If we use the very short half-times of polonium or averaged values for calculating the age of the world and fit them into the commonly used formulas of traditional dating calculations, we end up with a – in direct proportion – very *young world!* This also applies to the procedures based on thermo luminescence analysis and electron spin resonance, because the loss of energy or the lowering of electromagnetic radiation did not take as long as with uranium, but as little time as with polonium. A different energy level has to be taken into account.

Sediments – this also applies to marble, being metamorphic limestone – developed from a fast-setting, originally soft or liquid substance. This also solves one of the greatest mysteries. In 1931, the "American Journal of Science" wrote about a boulder of marble, reported to have been found 60 feet

(18 meters) deep in the ground. When it was split in slabs, one of the cuts revealed an indentation of 1.6 x 0.6 inches (4 x 1.5 centimeters). In it, two irregular shapes were visible, looking like the letters I and U.[62, 63]

This suggests that they were cut by humans. Marble, according to geology, is at least tens of millions of years old. At the time, no civilization knew how to write, if only because neither humans nor apes inhabited the world. The actual mystery is therefore how those letters got inside the boulder.

The original material of the marble must have been soft and must have covered the letters. There is no other possibility. The formation of the rock could not have taken place gradually. Logic leads to the observation, which I have described several times before, that man-made objects – in this case, letters – are older than the allegedly very old rock they are enclosed in.

Natural Nuclear Reactor

In a uranium mine in Oklo, in the African nation of Gabon, highly radioactive plutonium was discovered in a natural environment. This element, however, is an artificial product of neutron bombardment – e. g. in a nuclear power plant. There are no spontaneous chain reactions in the natural environment we know of, because the critical mass is never reached. Science, nevertheless, explains this amazing phenomenon as follows: a natural nuclear reactor developed in a natural environment by mere coincidence. For such a reaction to take place, enormous amounts of pressure are required – only to be found in a depth of 10,000 meters and below. We know from the technology in nuclear plants that the process also requires cooling agents. A mere coincidental nuclear reaction has to be ruled out, if we base our considerations on a conventional worldview of a uniform formation of the Earth.

If we look at the worldview I support and take a major cataclysm into account, then natural plutonium deposits do not seem as inexplicable. The flood's course included high pressures and temperatures, as well as the water of the flood to serve as cooling agent. Seen in this light, the isolated discoveries of different polonium-isotopes suddenly become intelligible.

Setting rock assumes magnetization and orientation, depending on the Earth's magnetic field. Above 580 °C (Curie point) liquified rock, on the other hand, is anti-magnetic. Paleomagnetic studies in various regions have often revealed repeatedly reversed, changed polarities. Therefore, the magnetic field of the Earth must have reversed accordingly: the North Pole became the South Pole and vice versa.

The magnetization of rocks with reversed polarity often is ten times stronger than the one produced by *ordinary geomagnetism*. This unsettling fact is not in harmony with the uniform development of Earth according to the theory of Lyell and the electromagnetic effects we know.

A magnetic field, influencing Earth from outer space – approaching planets, iron-containing clouds – induce electric phenomena in the Earth's surface layers. This thermal effect would lead to the liquification of rock, accompanied by volcanic activity. If there was an end of the world occuring in a number of stages that is accompanied by these effects, then shifting polarization is detectable in cooled down layers of rock.

Apart from that, these electromagnetic phenomena induce an *additional effect*. The rapid hydraulic hardening of liquified rock, as I have described, could even have been sped up by these electromagnetic phenomena, in a way that rock set from one second to the next.

6 The Earth Dances

There are studies and working models which I will present in detail in this book that prove that a great flood fundamentally and drastically changed all environmental conditions, the composition of the atmosphere as well as all climatic conditions. A cataclysm of worldwide impact contradicts the theories of Lyell (geology) and Darwin's Theory of Evolution (biology). During the flood, Earth's axis was shifted with disastrous consequences for our world, resulting in the mammoth's extinction.

Ancient Maps

By now it is a well-known fact that the Sahara desert once was an ocean and the South Pole was free of ice. Over the whole world, serious climatic changes occurred. This change, contrary to scientific opinion so far, did not happen gradually, but in a relatively short period of time as a consequence of the flood-impact event.

Fossil remains of palm trees in Canada, trees with fruits still on the branches, as well as entire frozen forests under the massive Antarctic ice cover are examples of the grave shifts in Earth's history. In any case, the radical change must have come about very fast, because otherwise the perishable leaves and fruits could not have survived. A number of animals too were frozen and fossilized in the process of eating, in motion or in their sleep. Very often, these animals have survived with their fur, flesh and intestines largely intact. This is a sign of death occurring within seconds, during an event that simultaneously initiated preservation. The most important point here is that everything must have happened very fast. Ordinary scenarios we are familiar with cannot be responsible for these phenomena.

A number of maps from the early 16ᵗʰ century show the Antarctic as an ice-free region. *Officially, the South Pole was discovered as late as 1818.* How could the old maps possibly include the Antarctic 300 years earlier? Until the Antarctic was officially discovered, the maps most commonly in use displayed water in its place – so, no ice sheets and especially no landmass in sight! Only since 1957 have we become familiar with the continents' topography with mountains, rivers and the coastlines hidden by the ice.

How come the South Pole was qualitatively correctly sketched on ancient

maps – ice-free on top of that? The standard work "Maps of the Ancient Sea Kings" by Charles Hapgood, published in 1966, presents the really amazing results of his studies of ancient maps.[64] The world map of Oranteus Finaeus from the year 1531 was based upon a variety of older maps, using differing projections. This map includes ice-free details of the Antarctic's actual coastlines.

The Mercator-maps, drawn by the Flemish geographer Gerhard Kremer (1512-1594), were gathered and published as an atlas in 1569. Several maps show the Antarctic. Finaeus' map, too, is included.

In the 18th century, the geographer Philippe Buache published a map of the Antarctic. It displays the Southern continent *entirely* ice-free. Apart from that, the topography of the mainland, hidden under the ice today, is shown and includes the waterway that divides the continent into two halves. I would like to state once more that the Antarctic had officially not been discovered when this map was published in the year 1737 and that at the time, nobody could have known anything about landmasses under the ice.

Contrary to the South Pole, the North Pole is no landmass, but consists of icebergs only, if we leave Greenland and some other islands out of the account. The originals these old maps were based upon seem to have been much older than the maps by Mercator or Finaeus themselves.[64, 65]

The most famous old maps are the world maps produced by the Turkish general and cartographer Piri Reis, dating from the year 1513 and discovered at the Topkapi Palace, in Istanbul, as late as 1929; the two fragments are stored there also today. At the time of their discovery, the details they included were judged to be vile products of his imagination, because we lacked the necessary knowledge. The fact that this map documents knowledge that was unavailable at the time of its discovery proves its authenticity – or did we have clairvoyants then? The authenticity of the map is unquestionable and beyond doubt.

This map not only included the coastlines of North and South America but also details about the continents, such as the location of the Andes and the source of the Amazon River. The Falklands were officially discovered in 1592, but are already displayed on the maps of Piri Reis, giving the correct latitude. It is interesting however that the map of Piri Reis also correctly outlines landmasses, mountains, bays, islands and coastlines of the Antarctic in incredible detail – features which today are covered by ice! *Only in 1957 did satellite imagery give us the opp*ortunity to make these discoveries.

From where did the knowledge about the existence of a continent at the South Pole and its coastlines – hidden in ice today – come from almost

500 years ago? Did aliens leave these maps behind? Or were our ancestors in the possession of some high technology, including precision instruments and maybe even planes, unknown to us? But according to our scientific worldview, there only was Stone Age man a couple of thousand years ago.

South of Fireland, where today there is ocean, the map shows a land bridge, connecting the Antarctic with South America. Sonar analysis of the area revealed that there must have been a land bridge between South America and the Antarctic, now covered by the sea. The following questions therefore arise:

· When were these maps really made – the maps we have now being only copies of much older maps?
· Was there actually any ice at the South Pole – and maybe even the North Pole – before the flood? Or was Antarctica completely free of ice?
· Did the ice, or at least vast parts of the ice shell, covering the Earth, appear suddenly as a result of the flood?
· Were these maps drawn based on aerial observations or did other precise measuring techniques exist?
· Did civilizations exist during or before the alleged Stone Age that were highly sophisticated and what were their technical means?

Even older maps, such as the so-called Dulcert Portollano, dated 1139, and the Zeno Map from the year 1380 include many places in Africa, Europe and up North to Greenland, with correct specification of longitude and latitude.[64, 65] The maps of Piri Reis show Africa and South America, again with the correct longitudes. Is it so simple to determine a location in such detail?

It is easy to determine the latitudinal circles, using primitive devices for angular measurements of the positions of the sun and the stars. *Determining longitude* is substantially more difficult and only became possible in the early 18th century, even then only with moderate accuracy. Since 1761 *more exact measurements were possible.*

The ellipsoid shape of the Earth turns out to be the difficult factor. Drawing a map with precise specifications has to take the curvature of the Earth into account. Larger distances require at least basic knowledge of spherical trigonometry or other methods of projection. Without knowledge of higher mathematics, engineering and handling of the necessary precision instruments, the making of an exact map is impossible.



An Ancient Navigation System

America was not discovered by Columbus. At least this we know from the ancient maps so far discovered, if we did not know it before. The Phoenicians sailed to America, rounded Africa a millennium before the Christian Era, 3500 years ago. It, however, is also possible that America was discovered even earlier. Heike Sudoff presents evidence for cultural exchange and contacts of ancient navigators with America in her book "Sorry, Kolumbus".[66] Relics of all kinds were found, indisputably proving the presence of Chinese, Phoenicians and other Levantine people in America. Evidence of African people includes the famous giant stone heads of the Olmecs.

Apart from that, a wide variety of inscriptions was discovered in various places in America. In Paraguay, there was an Iberian-Punian inscription; in Tennessee (USA) Hebrew letters were found; in Oklahoma a bilingual inscription of Celtic and Punian; in Vermont (USA) a Celtic inscription; in Rhode Island (USA) an Iberian stone inscription and in Davenport (Iowa), the inscriptions of the Davenport-Calendar-Stele included three languages. Apart from that, there are many inscriptions of an as yet unknown origin.

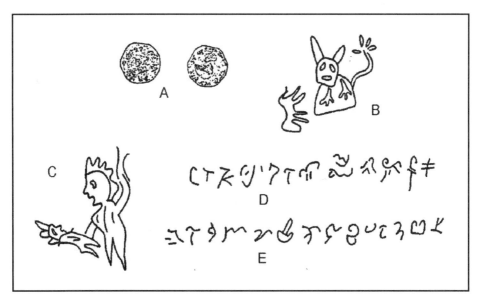

Fig. 11: Coin. *At a depth of 34 meters, a copper coin was discovered in Illinois, in rock more than 100,000 years old. The rim of the coin displayed characters. Front- and backside show hieroglyphic images. Which civilization, contemporary to cave men, manufactured modern coins? B = Detail of the Back, C = Details of the Front, D= Lettering on Back Rim, E = Lettering on Front Rim.*

Cecil Dougherty mentions characters similar to our shorthand, discovered 1891, in Cleveland, Tennessee. Another interesting find, made near Lawn Ridge, Illinois, in 1970, includes a copper coin, found at a depth of 111 feet (34 meters) in the ground. The stratum was estimated to be between 100,000 and 150,000 years old. The rim of the coin is covered with modern looking characters, more similar to our shorthand. The backside shows something like an animal, the front a human face with a child or doll.[67] The first Indians are believed to have immigrated to America a couple of thousand years ago; 100,000 years ago in Europe, man was living in caves and allegedly did not know the script.

If ancient peoples were not only capable of repeatedly sailing across the ocean but also of making maps with the projections described, then they needed precise navigation systems. In 1900, sponge divers near the coast of the Aegean island of Antikythera made an exceptional discovery. At the bottom of the sea, at a depth of about 200 feet, they found a ship, which sank in the first century AD. Apart from marble and bronze statues, it also transported amphorae with wine, olive oil and other food. The salvaged items were brought to Athens for examination, among them a lump of bronze and several fragments. After cleaning, the reconstruction of the object revealed a precision mechanism with a number of wheels, fixed into a ring-shaped mounting on different levels in a square box. A number of differentials connected the wheels in a way that allowed one to determine the cycles of the sun and the

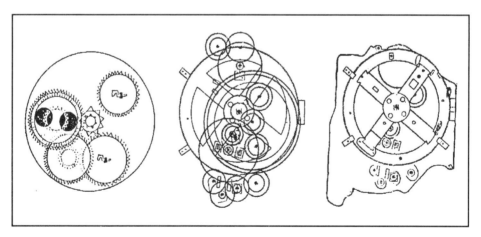

Fig. 12: Instrument of Antikythera. This 2000-year-old precision instrument was found in a ship's wreck in Greece.

This instrument was exhibited at the Archeological National Museum in Athens and declared to be a sun- and moon-calculator from 80 BC.[68, 69]

moon. Signs of the zodiac in Greek writing marked the round and angled parts. It turned out that this was a precision device and – judging from the type and number of the 40 wheels – must have had very little deviations and tolerances.

The first primitive devices built in the Middle Ages are not to be compared with the substantially older precision instrument made of bronze. They were made of brass and were much simpler and clumsier. Bronze casting is, however, suitable for *mass production*. The manufacturing of such an instrument, therefore, is much more difficult. This brings up the question whether there are equivalent discoveries and maybe even precursors. Usually, such an innovation is preceded by a longer phase of technical development. However, such discoveries have yet to be made. Or is it that such a device is stored in a museum, unidentified?

An Ice-free South Pole

Given our state of knowledge, the existence of the indisputably authentic maps of admiral Piri Reis, especially if they are copies and compositions of much older maps is incredible. This map proves that the South Pole was once ice-free. As the age of the original drawing must be limited, we may assume about 10,000 years as the limit for our estimate. This point in time coincides with the epoch of the flood. The ice cover of the Antarctic, today little less than a mile (about 1.5 kilometers) thick, apparently formed very suddenly and not at all slowly over a long period of time. Otherwise, how would it have been possible to make these ancient maps?

The Antarctic was not only ice-free, a warm or subtropical climate must have prevailed there. At Mount Weaver, 10,000 feet (3000 meters) above sea level, rich fossil deposit were discovered, containing prints of leaves and petrified wood. A petrified deciduous forest was discovered 250 miles (400 kilometers) from the South Pole. Drill specimens from the bottom of Ross Sea contained fine-grained sediments, pointing to rivers running to the sea before the Antarctic was covered with ice.[70]

On April 11, 1994, the "SüdWest Presse" announced the discovery of the fossil remains of a dinosaur only 400 miles (650 kilometers) away from the geographic South Pole at a height of 13,123 feet (4000 meters). All in all, four different kinds of dinosaurs were found in the Antarctic. In snow and ice?

Richard Lewis wrote about coal and fossil trees with diameters of about

two feet (sixty centimeters), found at the South Pole in 1961, in an article titled "A Continent for Science".[71]

Apart from that, thirty layers of anthracite (hard coal with a very high carbon content) were discovered, every layer between 3 and 3.3 feet (90 and 100 centimeters) thick. This shows that there also was a flood in the Antarctic, burying the trees under sediments, thereby providing the necessary crystallization.

It appears that the global flood destroyed and buried the forests. If this was the case, the Antarctic must have had a geographically different location, because the arctic climate prevailing today would not have allowed such phenomena. What event plunged the Antarctic in a Glacial Period or shifted the climate from moderate, bordering on the subtropical, to arctic? If there was a shift of the Earth's axis, it should be possible to detect similar past occurrences in the Northern hemisphere – and one can.

The Sudden Disappearance of the Mammoth

The extinction of the mammoth is one other of today's great mysteries which science is not too keen to discuss. The larger part of the ivory, used for carving in Eastern Asia, even today comes from the large ivory deposits in Siberia. These consist of tusks of long extinct mammoths. Ivory carving, an old traditional form of Far Eastern art, requires relatively fresh material. Fresh ivory from mammoths that became extinct several thousand years ago? The spontaneous answer would have to be a resounding "no".

Discoveries of frozen mammoths have been documented quite well since the 19th century. The first reports might even go back to the year 1693, 1723 the latest. Since then, more than fifty different discoveries in Siberia and at least six more in Alaska have been described at length in the literature. Discoveries of mammoths spread in a relatively narrow strip, measuring more than 5000 kilometers in length, along the coast of the Arctic Ocean.

Expeditions were organized and as such, in 1977, two mammoth babies were discovered 6 feet 6 inches (two meters) deep under the ice surface. The ice the animals were found in was clear and transparent, bordering light brownish yellow, with impurities of minerals, mud, loam and organic particles. More entirely preserved mammoths were also discovered, including some adult ones. These animals were preserved so well that for a long time, at least during a period of 1600 years, the Tunguse, living in Siberia, used them as food supplies. Well-preserved mammoths were found and fed to sled dogs.

The meat was deep-frozen and had not decayed. Its edibility for humans has, contrary to rumors, not been conclusively proven (you just said it WAS eated by Tunguse).

Even today well-preserved mammoth meat is found. The long, straggly, reddish fur has often survived. The stomachs of the animals were found to contain undigested grass, known to exist only in more moderate climates. This means that the climate must have been considerably warmer in the past. Particularly well-preserved mammoths even had buttercups, grass, wild beans, needles of larch and pine in their stomach, and as sometimes has been reported, in their mouths. The eyes, also, had been well-preserved, so that they virtually seemed to stare at their discoverers.

While surveying the New Siberian Islands, Arctic explorer Baron Eduard von Toll discovered the remains of a sabretooth— tiger and those of a fruit tree with an original height of about 88 feet (27 meters). The tree *had suddenly and completely been preserved* by the ice, including its ripe fruits, green leaves, roots and seeds, virtually instantly frozen. Nowadays, the only plants to be found there are creepers.

In other parts of the Arctic a moderate or even tropical climate must have prevailed also. In Spitsbergen, fossil palm fronds, corals and crustaceans, normally found much further South, have been discovered. What cataclysmic change took place here? The exceptional findings testify to a radical change in climate.

William Hornaday, in 1926, reported of a speech, translated from Russian, made at the "American Museum of Natural History".[73] In 1846, surveyor Benkendorf and his group set up camp at the Siberian Indigirka River. Heavy rainfalls, however, made the river rise and its banks erode. The group discovered a large object in the river. Their efforts to pull this large object ashore failed, because it was frozen to the river bottom. The next day, the river thawed again and the group of 50 pulled an entirely preserved mammoth ashore. The animal was about 15 feet (4.50 meters) long, 13 feet (4 meters) high, and in such an excellent condition that the sight of its opened eyes gave the impression of being confronted with a living animal. The stomach of the perfectly well-nurtured mammoth was opened and found to be filled with chewed leaves and other plant leftovers. A couple of hours later, the riverbank collapsed completely and washed the animal away to the sea. First of all, it was in remarkable condition and, secondly, the position of the animal was intriguing. It was found standing upright, frozen to the bottom of the river. This suggests a very sudden freeze. Otherwise, the animal would have fell to its side – animals do not die standing up or just freeze in such a position.

Another interesting specimen, too, was found in an upright position, at the Berezovka River, in 1900. Many bones, however, were broken by a sudden act of violence in a way that suggests that the animal had been virtually pressed into the hard ground. The animal's mouth is said to have revealed half-chewed food. Even the long straggly fur was still there. A great force must have affected the animal from above, so fast that it could neither swallow nor spit out the food in its mouth. Judging from the condition of the food and the upright position, this animal must have frozen instantly. The animal was brought to St. Petersburg for further research.

Based on the number of bones found and the use of old ivory continuing even today, the original number of the mammoths in Siberia and Alaska is estimated to be several hundred thousands, maybe even millions, of animals.

Art and science show mammoths almost always in a wintry environment with a long, straggly fur. Does this representation really correspond with reality and was the climate actually as cold and arctic as it is today?

A mammoth, its size ranging between that of an Indian and an African elephant, needed a lot of food. Vegetation available today and the small water supplies would not be enough to feed the multitude of mammoths that have been found. The leftover fresh plants in their stomachs suggest a *warmer* climate. Their long hair fell down to their toes. Moving over snow-covered plains would have made them freeze. Compared to sheep, mammoths had relatively short wool with single hairs a fair bit longer. In contrast to this, animals living in the polar region have thick fur, not long, greaseless hair. The mammoths found were all well-nurtured and had a lot of fatty tissue. Arctic animals, such as elks or caribou, show much thinner layers of fat. The presentation of mammoths in a *wintry setting*, because of their icy graves, is not correct at all.

Together with the mammoth, the rhino died remarkably well preserved in their instantly frozen state. These animals too are only found in warmer regions. Apart from them, discoveries of meat from horses, rabbits, squirrels, wolverines and one vole were found. Michael Zimmermann and Richard Tedford report about finding a lynx in "Science", in 1976.[74] 27 years earlier, Harold Anthony, had documented his discovery of a bison in "Natural History".

In this list of animals – and the list is by no means comprehensive – something catches the eye: all these animals lived or live in moderate parts of the world and thereby in warmer climates.

Mammoths were found with skin and fur, in upright position,

including easily perishable food left in their stomachs; other remains of

animals, usually living in warmer climates, were discovered with parts of their flesh still on their bones. Hence, there is only one explanation: they died extremely sudden deaths. *Slow* freezing due to worsening environmental conditions (Glacial Periods) has *to be ruled out completely*.

Judging from these discoveries, the disaster area, ranging from Siberia to Alaska, extends over a length of more than 3125 miles (5000 kilometers). A locally restricted cause is out of the question. It must have been an event of great impact, influencing large parts of the world. Parallels with the extinction of dinosaurs are obvious. The *two* cases of mass graves testify to the global scale of one or more disasters. The discovery of dinosaurs along with mammoths or other mammals, which to our understanding does not match with climate nor with era, sets one thinking.

According to today's orthodox views, the mammoth became extinct 13,000 years ago. Unfortunately though, geology does not document any drastic events that might sufficiently explain the sudden death of mammoths and other mammals, if we rule out the alleged end of the last Glacial Period.

All in all, however, things begin to shape into a distinct form. The Antarctic, at least in large parts, was originally ice-free and was suddenly covered by a shield of ice. On the opposite side of the Earth, Siberia's moderate climate was turned into an arctic refrigerator within hours. In two exactly opposing parts of the world, qualitatively similar events took place, even if they were of an intermittent character.

The oral traditions of the Wogules in Northwest Siberia mention the appearance of a snow cloud in the course of the World Flood. There are more myths about floods in North America.[76]

"Once, during winter, something peculiar happened: So much snow fell that the ground was buried under it and only the tops of the highest trees stuck out. It was unbearable... on the Earth, a mere lump of ice, there was dying of cold and starvation."[77]

The myth also mentions a long night, followed by heat, and, finally, the flooding of the mountains. These events also mark the impact of a large asteroid.

The myths of the Inuit that deal with the flood also speak of a great flood and *large glaciers forming afterwards*. In South America, sudden snow falls, heavy frosts and ice were reported. These myths underline our interpretation of a sudden hypothermia of the mammoths well.

There are, however, other aspects to the frozen discoveries in Siberia. Many hills, called Yedoma, measuring 50 to 200 feet (15 to 60 meters) high,

often contain large accumulations of animals, broken logs and extremely fine-grained soil (loess). Apart from that, they show high concentrations of salt and carbon, as well as layers of ice, as Adolph Erman reported as early as 1848.

Loess Deposits

Deposits of loess represent a mystery in themselves. They are well-known from the yellow rivers in China, which transport this material to the Yellow Sea. From the Atlantic coast in France, through Central Germany, Hungary, Southern Russia, Central and Eastern Asia up to China, extends a continuous belt of bench loess.

Rich in quartz, mica and lime, loess is a fine-grained loam deposit of a color ranging from ochre to light gray. We distinguish between bench loess (also called unstratified loess) and stratified loess. Layered loess is a typical alluvial product, often concentrated in glacial valleys, assuming the form of mountainous structures. Unstratified loess, on the other hand, is a weathering product consisting of quartz and calcium oxide (quicklime), the latter resulting from heat effects during the flood-impact. There are not enough weathering masses such as mountains to explain a local formation of these amounts of weathering products. Topographic elevations that should coincide with the belt of loess ranging from Europe to Asia are lacking. This rules out the possibility that the accumulation of loess resulted from natural downwinds.

This has given rise to a variety of speculations about where these enormous amounts originate from. In 1931, John Peniston discussed whether the loess came from outer space.[79] This assumption was based on the fact that the surface structure of particles of unstratified loess is squared, in contrast to that of grains rounded by wind and water. Apart from this, loess deposits are found at all elevations, in heights up to 6560 feet (2000 meters) and more.

How did unstratified loess arrive in Siberia? We have to look for the answer in the context of the flood. One or more parts of an asteroid penetrated the Earth's crust and hit the liquid magma shell and produced large amounts of ashes. This is the loess we find today. The volcanic ashes were whirled into the higher layers of the atmosphere and carried to Europe and Asia. There they settled down and were later washed to the banks of the flood basin. This was written up in the book "Alles über Atlantis" (Everything about Atlantis) by Otto Muck: "The loess, according to this view, is no phlegmatically formed weathering product of local lime or quartz mountains, but a stranger from far

away – a tiny drop of torn magma, then became volcanic ash and later high up in the stratosphere, whirled around by tornadoes and whirlwinds, joined the lime-rich marine sediments, snatched from the bottom of the Atlantic. This would be the geological recipe for loess production. It owes its lime content to the marine sediments, its richness in quartz to the siliceous magma of the surface. It is weathered magma, mixed with sea sludge. Weathering reached even microscopic level and so chemical constitution, but not structure, indicates its volcanic origin. This concept allows us, to visualize the formation of the stratified loess benches. The unimaginable downpours had come down."[80]

Fig. 13: Bench Loess Belt. *Reaching from the French Atlantic coast all the way to the Yellow Sea of China, the location of the loess belt has only qualitatively been sketched onto the map – not giving scales or concentrations. The loess zone includes large concentrations, particularly located at the Black Sea or in China. The raw material from which bench loess evolves from is volcanic ash. This was swirled up by the flood and washed to the shores by the flood's waves.*

If the flood had a global impact, then more loess deposits should exist in other parts of the world. Such findings were made in the Southern Hemisphere. The French naturalist, Alcide d'Orbigny (1802 – 1857) deduced that the large loess deposits in the pampas of South America must have been deposited by an enormous flood that also extinguished the animal world of the time. That cataclysm, according to Muck, uplifted the Andes. These observations impressively confirm the global character of the events that made the Earth tumble.

It needs to be emphasized over and over again that the flood had disastrous consequences of unbelievable dimensions. The flood was no local flooding as in Mesopotamia.

On reflection, this scenario also provides an explanation for phenomena that, if looked at as isolated cases, remain mysterious. For instance, the fact that many of the mammoths examined actually seem to have died of *suffocation*, is scientifically *unsettling*. Lungs and stomachs in some carcasses of these primeval animals were contaminated with tiny particles of a loamy or sandy origin. The amounts of flue ashes, released by an impact event, along with other pollutants that were produced, such as gases or nitric acid, can be an answer for the asphyxiation of the animals. This solves another mystery, not yet publicly discussed.

Ice, found in the vicinity of the mammoths, is also polluted accordingly and partly consists of water particles that passed through cold layers of air or even space. The structure of the ice discovered is easily loosened and reminds us of frozen hail or sleet. W.H. Hall published the results of his research in "American Journal of Science", in 1881. [81] Air bubbles locked into this ice contained more carbon dioxide and less parts of oxygen than ordinary boulders of ice. Mammoths were found under, above and next to such ice fields. The high percentage of sludge was also surprising. Mammoths were often found in frozen sludge, sometimes covering the ice deposits. Occasionally, these sheets were several meters thick. The frozen layers of sludge contain leaves and even entire trees, some of which still bear fruit. These plants have not fossilized, but were simply instantly frozen. This prevented fossilization.

The ice is often interspersed with thin layers of a loamy or sandy substance. This does not correspond with ordinary ice formation. Normally sludge, due to its higher intrinsic and ambient temperatures, would thaw ice and be washed away with the melted ice. The pollution in these ice deposits, be it inorganic or organic, must have frozen along with the ice. It was not part of any river or lake.

Research dedicated to deeper resting layers of ice has also been performed. O.F. Herz and E.W. Pfitzenmayer observed that with increasing depth, ice became whiter and more brittle.[82] As soon as it was exposed to ordinary air, it turned a yellowish brown. This suggests that the deeper ice layers froze quickly, locking in organic and inorganic pollutants. Even at greater depths, the ice did not grow slowly, winter after winter, but very quickly. This is the reason why dating, using drilled ice samples are erroneous: we base it on a rate at which ice forms today – one layer per year.

The processes accompanying the impact – presented in detail in the chapter on the flood: impact-winter, downpours, snow flood coinciding with a sudden change in climate, loess formation and findings of suddenly frozen and well-preserved carcasses – fit together well, like pieces of a jigsaw, revealing the total picture. Dinosaurs, humans, and animals in several parts of the world were struck by a sudden disaster and became partially extinct.

Flooding here, freezing there. Both, depending on climatic conditions and the elevation level involved, are part of the course of an impact. The flood was anything but an event of local significance. On the other hand, the impact of one or more asteroids – maybe coinciding with another cosmic event – caused worldwide disaster. This explains the phenomenon of the sudden demise of the mammoths.

Sudden Winter

The consequences of the impact included an impact winter. Dust particles in the atmosphere darkened the sky and drastically lowered temperatures.

During the age of the mammoths, a moderate climate prevailed in Siberia. The impact sequences shifted the mild climate to the icy weather conditions we know today. The shift must have taken place rapidly. Putrefactive agents had no time to do any damage. The mammoth carcasses were and still are salvaged from the ice, in well-preserved condition. After a slow climatic change, within a very little time-span, only skeletons would remain. Hence, the change in climate must have come about very suddenly, within hours. Could an impact winter, the result of an asteroid impact, have caused the rapid freezing of animals? This is hard to imagine. Otto Muck states that the climatic zone over Siberia was shifted by about 3500 kilometers South within a very small period of time.[83]

Were there similar phenomena in other parts of the world? Based on intensive studies of the ancient maps mentioned earlier, Hapgood states that

Antarctica once was ice-free. The South Pole revealed remains of vegetation that does not grow in arctic climates. The Antarctic landmass, originally, must have been located about 3200 kilometers further North, in more moderate climate zones.[84]

Even conservative geologists do not rule out an ice-free Antarctic. They, however, shift such a period further back into the past of Earth's history, many million years ago. Who drew the ancient maps, showing an ice-free Antarctic? The answer: a shift of the Earth's axis by at least 20 degrees leads to about the same results in two opposite regions of the world. Add to this the increased effect at colder elevation levels of mountains and, maybe, an impact winter – one of the events following the flood, to be described later.

On the other hand, British author Graham Hancock, in accordance with Hapgood's theory on a displacement of the Earth's crust, concluded that the entire Antarctic slid over the Earth's magma bed.[85] The enormous friction due to the weight of the slabs of the Earth's crust would not allow an entire continent, anchored to the magma bed, to drift away between 3000 and 3500 kilometers in a couple of hours or even days, for no special reason. On the contrary: the hindered friction would lead to cracks and gaps in the Earth's shell, allowing liquid magma to rise to the surface. This harder material survives through time, while the softer material around it erodes. Many well-known natural wonders, such as Ayers Rock, evolved this way. Only, in this case, a layer of sand and water was pushed to the surface through one of those cracks due to overpressure. Rapid hardening, aided by a supply of calcium, ensued. This is why the surface of the monolith is smooth like concrete – actually sandstone is almost exactly that. When I visited the rock in 1996, I had the chance to take a closer look at the seemingly polished surface, which

Fig.: 14 Ayers Rock. A giant, gradually grown sand (= concrete) block? During the flood high pressures were forced through Earth's cracking crust and hardened due to free calcium (calcium carbonate), then available.

is covered entirely with larger and smaller bubbles. These pores originally contained water (hydrate water), which evaporated after the concrete (sandstone) had set. Being a civil engineer, hardening concrete is no unusual sight for me to see.

But let us look at Earth's climatic changes. The Theory on the Continental Drift by Alfred Wegener does not apply to the shifting of climatic zones, because continental movement of a couple of millimeters or centimeters per year – if these measurements are correct, considering possible measuring tolerances – is too slow. Neither would climatic zones in Siberia and in Antarctica shift by about the *same* distance, although the higher amount of impacts in the Northern Hemisphere naturally have had greater effects. The crucial factors are climatic zones, shifted to a similar degree, and basically comparable events coinciding in Northern and Southern hemispheres. At this point, all other theories fail, unless coincidence stands in for missing evidence.

Otto Muck takes the view that a displacement of the poles and an accompanying shift of the Earth's axis of rotation by about 20 degrees resulted from a violent asteroid impact.[86] An explanation, in accordance with the described phenomena, is as logical —- as it is simple. There is much doubt whether such an impact alone could have had such an effect. Probably not; other cosmic influences must have played a decisive role.

Evaluating myths of a variety of people, Immanuel Velikovsky concluded that only a few thousand years ago different planets approached, e.g. Venus and Mars, the Earth's orbit. This event triggered the flood, displaced the Earth's axis or *substantially* increased an existing minor tilt. Cosmic influences set Earth reeling (precessing). The finds of preserved mammoth carcasses back this up. The displacement of the axis of rotation by at least 20 degrees – for a short period of time probably more, because of the pendulum motion – moved the climatic zones very quickly. Forced freezing, caused by this displacement, therefore did not take place in one step, but intermittently, like the tides. The apocalypse marked the end of the era of the mammoth, by sudden freezing in Siberia and Western parts of Alaska in the Northern Hemisphere, as well as in the Antarctic deep South.

Today, the angle of Earth's axis deviates by 23.5 degrees from the vertical of Earth's orbital plane around the sun. This tilt causes the phenomenon we call seasons. The Earth is slightly tilted and acts like a gyro, whose axis has been tilted from the vertical by an inflicted force during rotation. To illustrate this, we can tap a rotating gyro with a finger. The gyro, as our Earth in the past, starts to reel. This motion is called precession.

The extended Earth axis describes a circle in the sky, called the precession circle and runs through all twelve constellations. This precession circle today lasts about 25,780 years. Only after this cycle has been completed do we see the stars back in the same place in the firmament. Only, of course, if the Earth rotates evenly. However, the angle of Earth's axis of 23.5 degrees, also referred to as the skewness of the ecliptic, is not always the same, but varies in

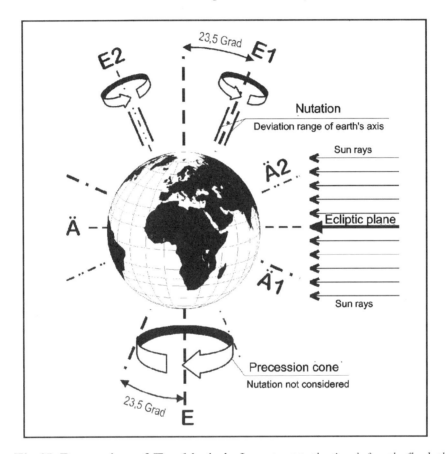

Fig.15: Precession of Earth's Axis. *In contrast to the time before the flood, the Earth's axis (E) today is tilted by 23.5 degrees (E1) and rotates (regardless of nutation) around the vertical axis (E) of the orbital plane (Ä = ecliptic plane), intersecting the center of the sun. In 12,890 years (180 degrees of the precession circle) the Earth's axis moves towards her own rotation sense from E1 to E2. This produces the impression that the stars seem to shift continuously. Only after completion of one precessional cycle of 360 degrees in about 25,780 years do they return to the same position in the firmament. The rolling of Earth's axis (nutation) also has to be considered. It superposes precession and approximately passes through a period of 42,000 years. Ä1 = equator to E1 at time X; Ä2 = equator to E2 at time (X + 12,890) years.*

small ranges between 22 and 24 degrees. This cycle (nutation) takes more than 40,000 years. Compared to a child's gyro, Earth bounces. Should the Earth's axis have been tilted only once at a certain time by colliding with an asteroid or some other event, then there would have been no seasons before the event took place. Did mankind, under these conditions, live more comfortably before the flood? This because winter did not exist or was exceptionally moderate. Under steady climatic conditions, fruits and other natural products would be available continuously. Was this world a kind of – or maybe even the – biblical Paradise?

The asteroid impact probably caused changes to the atmosphere and maybe also damaged the ozone layer, if it existed at all at the time. Therefore, completely different environmental conditions may have prevailed before the flood. The bible, the Babylonian epic of "Gilgamesh" and other ancient scriptures speak of humans, reaching ages of several hundred of years. As anyone can discover for himself, the ages of people ranged around 900 years, including 930 years (Adam: Genesis 5:5), 912 years (Seth: Genesis 5:8), and 950 years (Noach: Genesis 9:29). This, however, was before the flood. Afterwards, life expectancy dropped slowly though gradually. From Arpachschad (438 years: Genesis 11:13) over Abraham (175 years: Genesis 25:7) and Isaac with 180 years (Genesis 35:28), Jacob finally "only" living for 147 years (Genesis 47:28). The next generations had the same life expectancy we have today.

Are these precise data about ages, (when children were born) as well as the exact dating of the Flood within these genealogies only figments of the imagination or are they qualitatively correct data, even if a day may have only comprised twenty hours? Was the decrease in life expectancy caused by a weakened shielding of the damaged protective layers of the atmosphere? Did mankind degenerate due to increased cosmic radiation?

Is this the reason why there are so many terrible monsters portrayed in the myths and tales of all peoples? In detail, they describe giants with a single eye and other monsters. We experienced similar awful phenomena from the nuclear bombings in Japan at the end of World War II.

Has the rotation speed of the Earth altered? An impulse to the opposite direction of the rotation of the Earth could have lowered its rotation speed. In fact, the moving of the Earth's axis (precession), as already described, points into the *opposite direction* of the Earth's rotation. As with any gyro, the rotating Earth, due to its inner friction, tries to return into its upright position. As such, the angle of tilted Earth's axis is slowly decreased, while the time for

a reeling period to complete increases gradually.

The reeling of the Earth, and its crust, is now slowly settling. In the period following the asteroid impact, one reeling period must have been shorter. In other words, the completion of one precessional cycle did not take 26,000 years but – analogous to the gyro-theory – might have taken less than one thousand years. This leads us to the conclusion that there was damage to the protective layers of our atmosphere after the disaster. Radiation intensity must have been high, even for a long time after the flood. It caused degeneration and damage in the genetic makeup of the surviving animals and humans.

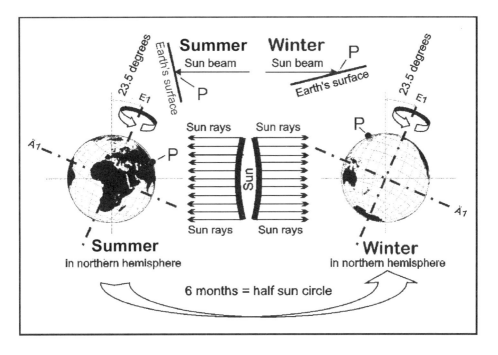

Fig.16: Origin of Seasons. *Seasons are not caused by varying distances from the sun, due to the elliptic orbit of the Earth. Earth's tilted axis, displaced by 23.5 degrees away from the vertical of the orbital plane, is responsible for seasons. During one half of the year, the sun shines more intensely in the Northern hemisphere, the other half, it warms the Southern hemisphere. The angle of sun's rays varies and thus warms the regions of the land surface to differing extents. Any given point (P) represents a location on Earth's surface in winter's and summer's half year. E1 = skewed plane and Ä1 = according equator line.*

Duration of Solar Years

Were there different physical conditions prevailing on Earth before the asteroid impact? Considering such different circumstances, did the giants, mentioned in the bible, actually exist before the flood? Did the length of a day differ from today? Did it correspond to the biological systems with about 25 hours per day? Why does the biorhythm deviate from an ordinary 24-hour-day, as Gernot Geise asks?[87] If there were no catastrophic and fundamental changes on Earth, but instead only gradual development, then, if Darwin is right after all, why has mankind not perfectly adapted to these conditions, after such an allegedly long history of evolution? Why does its inner rhythm deviate from the day on our planet?

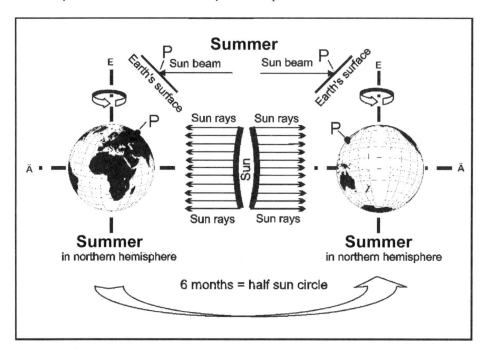

Fig.17: Upright Axis of the Earth. *Before the flood, Earth's axis was nearly upright, meaning vertical to our Earth's orbital plane. Therefore, no seasons existed – the incident angle and thereby the intensity of solar radiation for any given point on the Earth's surface remained the same throughout the year. As a consequence, a constant tropic to moderate climate prevailed throughout the world. Coal deposits at the South Pole and fossil coral reefs near the North Pole are evidence of this. The continuously low solar radiation at the poles produced polar caps similar to those on Mars, but no glacial periods. Any given point (P) on the Earth's surface is evenly warmed by the sun. Ä = equator, E = Earth's axis.*

Did one solar year, as measured before the flood, have a different length than 365.2422 days? The Mayan civilization produced outstanding mathematicians and calculated a year to 365.2420 days, as well as precisely determining the revolution cycles of planets, such as that of Venus. Mayan priests were capable of predicting the eclipses of moon and sun, using precise charts. The Mayan and other advanced ancient civilizations divided the solar year in 12 months, consisting of 30 days each. The missing five days were simply added. Why did the Maya, being the great mathematicians they were, not use months of varying lengths? Or did the original solar year only last 360 days and were the remaining five days added to the end of the year because of a certain event that called for such a re-adjustment of the calendar?

It is unknown, when the Egyptians began to use the calendar. At any rate, the calendar system they used consisted of twelve months, each divided into three weeks, 10 days each. Indeed, they used a 360 day-calendar, with five extra days, just like the Mayas did. These additional days were closely linked to the gods, suggesting that the calendar was extended for religious reasons.

General opinion identified the Egyptian gods with the stars. The 360 days also directly corresponded to the circle and therefore to the Earth as an idealized sphere of 360 degrees. In contrast to our ancestors of the Middle Ages, the Mayans and other cultures knew about the Earth's spherical shape. It is known, however, that they not only divided their calendar into 360 days, but also divided the sky as such, splitting it into 36 decans, each lasting 10 days. The remaining five days stem from the displacement of the Earth's axis and the extended orbit. Is this harmony of time and space characteristic of the antediluvian period?

If a calendar year without a tilted axis of the Earth lasted 360 days, the old calendar systems originally corresponded perfectly with the celestial mechanics. The displacement of Earth's axis, resulting in an extended orbit, changed everything. The additional five days per year, resulting from the disaster, were compensated by adding days to the calendar, rather than revising its design. The Egyptians "populated" these days with the births of the four children of Nut, the goddess of the sky: Osiris, Isis, Seth, Nephtys, plus the son of Osiris and Isis, Horus. The additional days were linked with births, signifying something new, or in other words, something *added*. Logically, there must have been a time preceding the "birth" that managed without those new additional days. This suggests that the calendar systems are older than the flood.

After the cataclysm, the old system was not re-created, but five days were

added to the year. This procedure made it easy to refer to old dates and calculations, without having to fundamentally change the system. An obvious and logical solution. A modification of the calendar system according to the new conditions – analogous to our contemporary calendar system – surely would have been more difficult.

The Babylonians divided the year in 120 days times three. The missing five days were considered a unit of its own. Probably, the Babylonians copied this system from the Assyrians, who inherited it from the Sumerians, believed to be the inventors of the circle divided into 360 degrees. In this context, I should mention that they already knew the planets as we know them today. We discovered the planets Uranus and Neptune in 1781 and 1846 – 6000 years after the Sumerians had. (source?) Considering these facts, how can we speak of a gradual evolution in accordance to the Theory of Evolution? There is no official explanation for the knowledge of the first advanced civilizations, unless if we accept explanations such as forgery or coincidence.

As Sudhoff proved convincingly in his book, there was a cultural exchange across the Atlantic in pre-Christian times.[88] Parallels between the calendars of Maya, Egyptians, Babylonians and Sumerians are obvious. Independent from one another, they also knew the zodiac. If the number of constellations was the same and identical or similar designations were in use, a coincidence in terms of a strange parallel has to be ruled out.

Earth's Staggering Axis

A sudden displacement of the Earth's axis, would give an observer standing on the surface of Earth the impression that the stars move with a jerk or even disappear behind the horizon. The sun also may disappear out of view or return to its zenith before it sets. In short, nights are longer in one part of the world, while on the other side they seem shorter.

An interesting case includes a displacement large enough to let the sun disappear out of the view of those on the sun-facing side and come into view of those on the sun-averted side of the globe, turning night into day. In this case, the sun, to the onlooker on the originally sun-averted side, seems to move into the opposite direction. I emphasize this statement: *opposite direction.*

We should illustrate this, using a simple model. To an observer on Earth, under these conditions, the sun would not rise in the East but in the *West*. This phenomenon may recur with the second or third reeling of Earth's axis, before friction forces, gravitation and inertia of the universe reduce the

displacement. In the period following the calendric calculations, this would no longer be possible, because the displacement of Earth's axis gradually decreases, letting stars and planets in the solar system move on unpredictable trajectories.

Before our calendar, calendar revisions were a normal procedure, not because the trajectories of stars and planets were not observed or calculated without care, but because of Earth's special, continuous intrinsic movement.

In 747 BC, the Babylonian king Nabonassar introduced a new calendar. The reason for this innovation was an astronomical event. Ancient sources, however, do not describe it in detail. There was no eclipse of the sun, assuming the Earth has rotated and revolved evenly since then.[89]

Chaldean astronomers were faced with the challenge of having to adapt the then existing calendars to the changes at hand. R.C. Thompson confirms this in "The Reports of the Magicians and Astrologers of Ninive and Babylon": "Various passages in the astronomic plates make it obvious that calculating the lengths of day and year were the main duties of astronomers in Mesopotamia. Scholars wonder: how could these people, especially hired for this, possibly make such mistakes?" [89, 90]

In the Bible, in the book Isaiah (24:18-20), it states: " ...the foundations of the Earth do shake. The Earth is utterly broken down, the Earth is clean dissolved, the Earth is moved exceedingly. The Earth shall reel to and fro like a drunkard, and shall be removed like a cottage..." Could there be a better description of the phenomena ensuing flood-disaster and the effects of a reeling Earth?

Changing Cardinal Points

The Roman writer Solinus wrote about the myths of the people living along the Southern border of Egypt. These ancient accounts mention a course of the sun, different from today's. During the lifetimes of their ancestors, the sun is said to have risen where it now sets. The Chinese spoke of a new order. Only since then have the stars been moving from East to West. Velikovsky observed that the Chinese signs of the zodiac follow each other in the reversed direction – opposite to the course of the sun today.[91] In Greece there are also accounts of reversed trajectories of the stars and the sun.

In "Electra", the Greek Euripides (ca. 485 – 406 BC) mentions stars in backward motion and a similar trajectory change for the sun. In addition to that, he writes in "Orestes": "... the sun chariots' winged rush ... changing its

Westward bound course through the vault of the sky, to where the dawning day rose flaming red."

Another Greek, the philosopher Plato (427 – 347 BC), in his dialogue "The Statesman" wrote about the change in the rising and setting of the sun, as well as other celestial bodies. Apart from that, the universe is said to have turned in reversed direction. Given a point on the Earth, an intrinsic motion of the universe can not be detected, but we believe to see a movement of the stars, and so, of the universe.

Central American cultures define four pre-worldly suns, with four motions. They gave four different names to these suns, indicating the different periods of the skies.

The Koran names two Easts and two Wests. The Talmud and other old sources mention a disturbance in the sun's movement at the time of the Jews' exodus from Egypt.[91]

In the second book of his "Histories", the Greek historian Herodotus (490 – 425 BC) wrote about conversations with Egyptian priests whom he had interviewed when he visited the country. He was told about 341 generations of kings and that the sun rose from the opposite direction four times during their reigns. Twice the sun described the course we know now and twice did she set where she rises today.

This statement has been discussed with great controversy in the past centuries. If we, however, assume a constant rotation and orbit of the Earth for the entire duration of Earth's history, we are unable to interpret such recordings. Egyptian texts, repeatedly and clearly, state that "the South became the North and the Earth bends forward", that the stars stopped living in the West and now appear from the East. The Egyptians knew different names for the Western and the Eastern sun. Are these descriptions merely circumstantial evidence of a strong gyration or do they actually describe a repeated turning of its orbit?

An old star chart, showing the zodiac and other constellations, was found on the ceiling of Senmut's grave. He was the architect of Queen Hatshepsut. The Southern view is reversed and the constellation of Orion seems to move towards the East into the opposite direction. All in all, the chart displays a switching of North and South, East and West. Obviously this image presents a chart of the skies, as they were before the poles switched.

The grave contains one more map. Its arrangement of celestial bodies looks as we know it today. However, all constellations have been shifted. The range of precession can not sufficiently explain this strong deviation. While the conventional school of thought has no explanation for the first chart, the

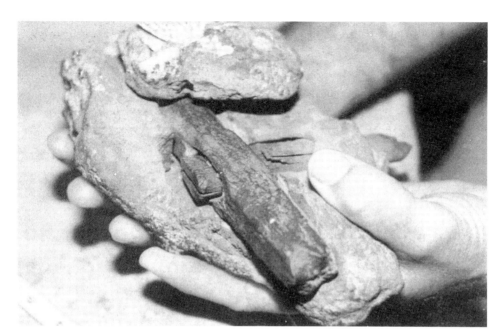

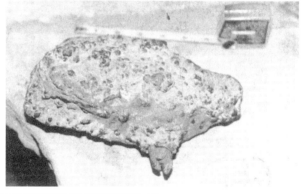

48 The hammer becomes visible after the rock was forced open. The tip of the hammerhead shows a small damaged spot in the form of a silvery spot, which to this day has not corroded.

49 The hammer of London (Texas) was completely surrounded by old sandstone. Only the petrified handle of the hammer stuck out of the rock. The age of the sandstone was estimated to 140 million years.

50 Carl E. Baugh and the author next to the fossil hammer exhibited at the international exhibition "Unsolved Mysteries" in Vienna in 2001 after they held their lectures at the opening.

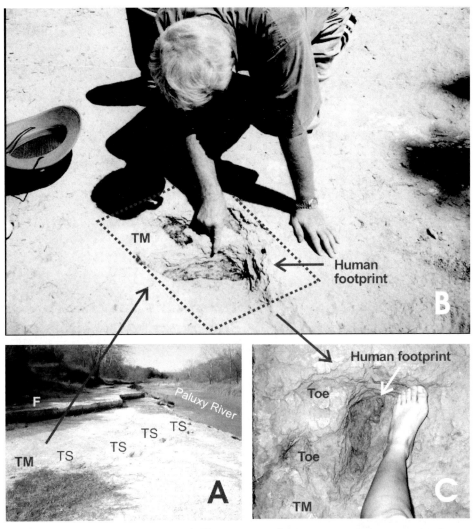

51 A new trail of dinosaur tracks (TS) was exposed (picture A) under a rock layer (F) in 1999. Inside one dinosaur print (TM) was one of three petrified human footprints (extension picture D). The foot of Larissa Zillmer, the daughter of the author, serves as size comparison (picture C). The original im-print can be inspected in the Museum.

52 The fossil bones of a woman, approx. 7 feet tall, were found at Panther Cave near Glen Rose.

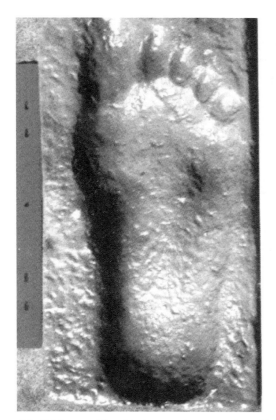

53 *Critics consider this human footprint, found by geologist Billy Caldwell, too perfect. This print was discovered in virgin limestone, interspersed with fossils.*

54 *The footprint, called Detweiler, is more narrow than the Caldwell. All five numbered toes are visible.*

55 *A fossilized nest of dinosaur eggs. It is discernable that the rock must have been soft, because it covered and conserved the eggs. How could such a nest fossilize slowly?*

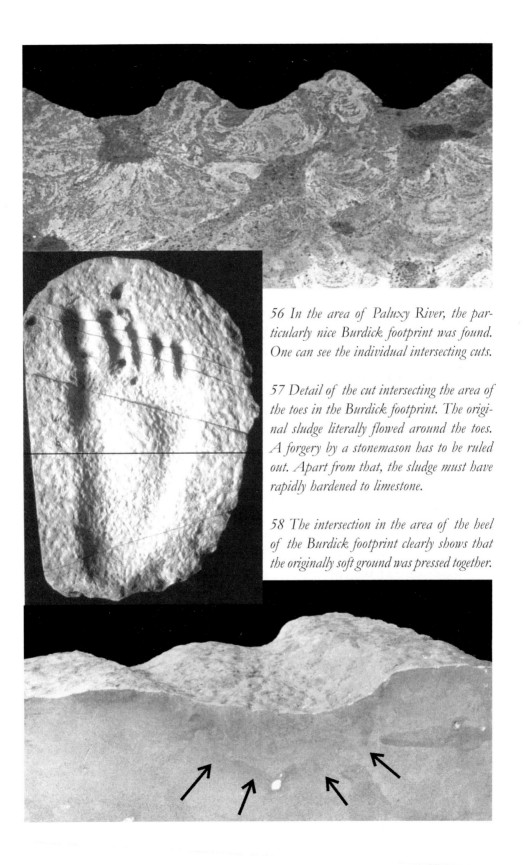

56 In the area of Paluxy River, the par-
ticularly nice Burdick footprint was found.
One can see the individual intersecting cuts.

57 Detail of the cut intersecting the area of
the toes in the Burdick footprint. The origi-
nal sludge literally flowed around the toes.
A forgery by a stonemason has to be ruled
out. Apart from that, the sludge must have
rapidly hardened to limestone.

58 The intersection in the area of the heel
of the Burdick footprint clearly shows that
the originally soft ground was pressed together.

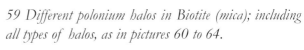

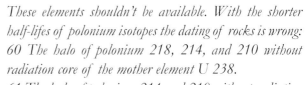

59 *Different polonium halos in Biotite (mica); including all types of halos, as in pictures 60 to 64.*

These elements shouldn't be available. With the shorter half-lifes of polonium isotopes the dating of rocks is wrong:
60 *The halo of polonium 218, 214, and 210 without radiation core of the mother element U 238.*
61 *The halo of polonium 214 and 210 without radiation core of either mother elements U 238 or polonium 218.*
62 *The halo of polonium 210 without radiation core of mother elements U 238 and polonium 218 or 214.*

Only these complete halos with all mother elements are necessary to get a correct dating:
63, 64 *The halo of radioactive decay of U 338 with the daughter products polonium 218, 214, and 210.*

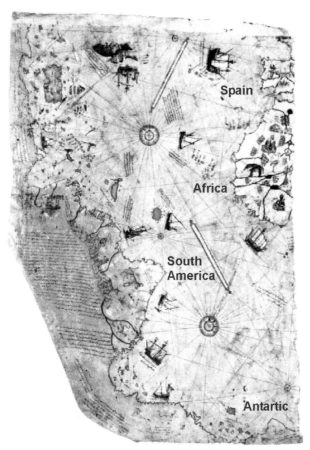

Spain

Africa

South America

Antartic

65 *The map of the Turkish admiral Piri Reis, from 1513. The Falklands were officially discovered in 1592, but are already included in this map, with the correct latitude. The fact that in contrast to the Arctic there is land under the ice of the Antarctic was officially only discovered in 1957. The landmass, consisting of two large islands, is however correctly depicted on this map.*

66 *The Buache Map of 1737. The landmasses of the Antarctic are displayed without any ice. It depicts the situation preceding the flood.*

DES TERRES AUSTRALES

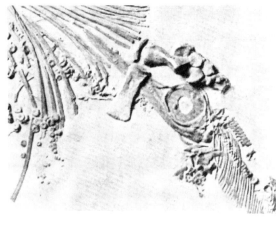

67 The fossilized birth of an ichthyosaurus in slate, in Holzmaden. Its head rests between the pelvic bones of the mother animal.

68 Sudden death and fossilization during meal.

69 (bottom left) A petrified root penetrates several massive layers of rock. From geology's point of view, they took millions of years to form.

70, 71 The rock geode found in California. The top picture shows its two halves cut open. The x-ray (below) reveals an unidentified metal object.

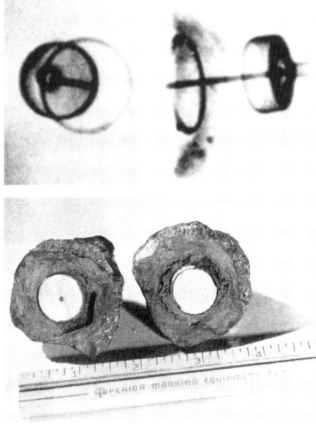

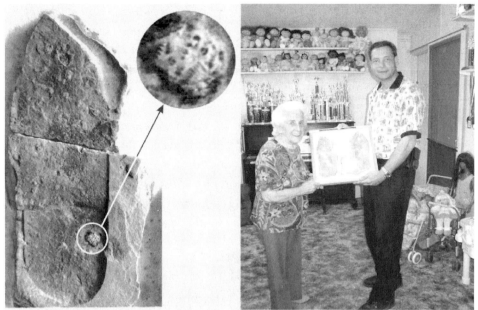

72 The fossilized shoe print, found by William J. Meister in 1968. A smashed trilobite, believed to have become extinct 400 million years ago, is located at the heel (trilobit see extension). Right picture: Mabel Meister, the widow of William Meister and the author with the original print in 1999, in Utah.

73 The author added the print of William Meister to the exhibition "Unsolved Mysteries" in Vienna, in 2001. At the opening, Dr. Michael M. Cremo and the author lectured to document artefacts and findings of human relics in geological layers with an age up to several hundred million years. Michael A. Cremo and Richard L. Thompson are the authors of the book "Forbidden Archaeology".

second deviation of the star positions is ignored. Instead, it is claimed that the map was passed down from distant generations, in which at some point in the 26,000 years of the precessional cycle the constellations actually coincided with the locations given in the chart. But when? Was it 10,000 or 20,000 years ago? Our present understanding does not allow for any advanced civilizations that were capable of keeping track of star movement at that time.

If we consider both pictures as snapshots of the sky taken before and after a cosmic disaster, including a change of the cardinal points, then both portrayals precisely reflect a point in the past, only a couple of thousand years away. The constellations' shifted arrangement testifies to a reeling of the axis of the Earth with a deviating angle of the axis. As I have outlined earlier, the deviation of a gyro is larger in the beginning and decreases slowly. By assuming that the axis had a steady tilt throughout the past, our traditional understanding of the past renders itself incapable of explaining past or future phenomena.

Based on the laws of Lyell and Darwin, we ground our ideas on the present state of the Earth and project its image into the past – unaltered, codifying current states of variations, falsely interpreted as constant conditions. This school of thought leaves no room for drastic changes in the development of the Earth, and even though large amounts of evidence of drastic geological upheavals has recently been given more consideration, they are reduced to locally restricted disasters of the Earth's past. Academically speaking, it, of course, is easier to put forward such a theory, when one is assuming steady and constant conditions. Natural laws are more easily determined if the theories of uniformity of Lyell and Darwin are considered valid at any time.

The ancient records and transmissions to describe the changes of the cardinal points are merely a few examples; many more could be added to this list. Old astronomical charts of Indian, Sumerian and Babylonian origin often include inexplicable deviations, as if they had been taken down at a distant place thousands of miles away. These calculations prove that a global disaster took place in a not too distant past, and that the position of the Earth relative to the firmament must have changed. Or is science right in saying our ancestors were just too stupid to run exact calculations?

Standstill of the Sun

The book Joshua (10:12–14) gives an account of cosmic events, giving rise to many speculations:

"... Sun, stand thou still upon Gibeon; and thou, Moon, in the valley of Ajalon. And the sun stood still, and the moon stayed, until the people had avenged themselves upon their enemies. ... So the sun stood still in the midst of heaven, and hasted not to go down about a whole day. And there was no day like that before it or after it..."

There are enough interpretations of this passage of the Bible. Discussing them is not worthwhile, because not one interpretation could, in the eyes of our scientific view of the world, possibly be credible. Should the Bible's account, however, be true, then Earth's rotation halted for almost one day, assuming the sun itself did not move in any exceptional way. There is no way of fitting such a statement into a steadily progressing course of Earth's history. Actually, there are only two, maybe three possibilities.

If we interpret the account of the sun's standstill in a way that while the sun was fixed in the sky for one day, *something* else, however, did move, then we detect parallels to the flood-scenario. If the Earth's axis was strongly tilted into the direction of the sun by some event and the sun was not up on the horizon, then one day simply lasted longer than 24 hours. To the eyes of the human onlooker, the sun would be shifted into the opposite direction, later taking up its old path again across the firmament. At the turning point, there is the familiar effect of a kind of standstill in movement, resulting from optical illusion.

If we take this passage of the Bible literally and assume *no movement* of the sun whatsoever, then the rotation of the Earth must have actually halted for one day. If the Earth would then, due to physical forces, pick up rotation in the opposite direction, it serves to easily explain the ancient transmissions about reversed courses of the sun.

The consequences of such a standstill in our Earth's rotation would probably be disastrous. Therefore, the first version is the more credible one, particularly because it would explain all other phenomena as well. This does not rule out that there was a change in the Earth's speed of rotation. The second version, on the other hand...

As I have mentioned before, the Earth rotates like a gyro. Earth's axis, theoretically, could arbitrarily be tilted towards the orbital plane, as is the case with *the planet Uranus today*. Under these circumstances, the visual impression of halting or even reversing of the sun's trajectory corresponds with the

passage, cited from the bible. One side of the globe would show a longer phase of darkness, while at the other side the day would have lasted just as long.

From a certain degree of displacement of the Earth's axis (more than 90 degrees) the sun disappears behind the horizon and rises for those on the opposite side of the globe. In this case, the sun moves opposite its usual course. East and West are swapped! To an observer on Venus, for example, our sun rises in the West, because it moves *retrograde*, meaning *opposite, to the rotation sense of our solar system* and our Earth.

If we want to believe very old accounts, this process must have occurred twice. Why should Earth not have experienced repeated strong displacement of its axis? Actually, this is even the way it must be, because a drastic displacement would result in a pendulum motion. Seen from the side, in a two-dimensional view, the axis of the Earth – and thereby the whole globe – would be swinging back and forth.

The second pendulum motion was not as strong as the original one, but was sufficient to produce the effect of the reversed course of the sun. The sun still rose in the West. The third subsequent swing did not make the sun disappear behind the horizon anymore, but *made it wander about the firmament on unknown paths.* Now, however, the sun rose in the East and set in the West again, as it originally had.

There was no severe disturbance of Earth's torque. Earth's orbit around the sun probably was *extended* and the duration of its orbit increased from 360 days to 365. Ancient calendars back this up. The speed of Earth's rotation was reduced. Even though this changed the basic physical conditions on our planet, it successfully survived the disaster.

If the Bible is right and the conclusions presented are correct, darkness must have prevailed on the other side of the world for almost one day. Author Zecharia Sitchin found out that Andean people documented such an event. They report that the sun stayed away for twenty hours, almost an entire day. This event is said to have happened under the reign of Titu Yupanqui Pachacuti II, the fifteenth ruler of the old time. Sitchin believes that both events coincided and date back to about 1400 BC.[92] Independently, *two seemingly incredible and opposing accounts of one and the same phenomenon have been proven right.*

A series of Catastrophes

In pre-Christian times, great changes seem to have taken place. One needs to doubt whether all these events could fit into a frame of a couple of hundred years. The flood came no more than 10,000 years ago. It might also have taken place 4000 years later. This would reduce the large gap in terms of time until the rise of the first advanced civilization we know of 3500 – 3000 years BC and would have lasted less than 1000 years. The mystery why almost all early advanced civilizations developed almost at the same time would thus be given a logical solution.

In this context, I would like to point out that after the global flood, Earth was hit by a number of disasters. The reeling axis of the Earth and a probably not completed or recurring cosmic event persisted even after the cataclysm. It is possible to deduce several such events, particularly for the 8th and the 15th century BC.

Velikovsky notes: "In the mid of the second millennium before the turn of the era, the globe experienced two displacements. In the eighth or seventh century there were three of four more. During the period in between, the trajectories of Venus, Mars and moon shifted."[93]

A study on the temporal course of the entire disaster would go beyond the scope of this book. It is important to emphasize that these events were preceded by a virtual end of the world. At the same time, an intermittent course of cataclysmic events becomes obvious. The scenarios I have described took place repeatedly in a more or less strong manner, on a larger scale. The ensuing layering of the Earth's crust, of the ice at the polar caps therefore happened, intermittently, within a couple of years and not over a period of millions of years. The conclusion that there was an "end of the world", in terms of a global flood not too long ago, fundamentally conflicts with the Theory of Uniformity, put forward by Lyell and Darwin.

The possibility of a worldwide catastrophe in historical times contradicts the Theory of Uniformity and thus also the Theory of Evolution. But Darwin's theory is a general postulate to which all theories, all hypotheses, all systems, must conform. Did a catastrophe happen a couple of thousand years ago? "Evolution science" is like religious thinking, as is evident from the fact that it is a pure belief system, often unsupported by truth.

The Hopi Myth

When looking at the oral traditions of the Hopi Indians, the memory of the displacement of Earth's axis that survived in them catches the eye. According to the myths of the Hopi Indians, we live in the fourth world. The first one was destroyed by fire. The second ended with the displacement of the Earth's axis, covering everything with ice. A flood destroyed the third world.

Are the Hopi right? Facts seem to confirm them. The accounts of a tilting of Earth's axis accompanied by an impact-winter and an ensuing formation of ice corresponds with the course of the events of the flood in the correct sequence. This scenario led to the extinction of the mammoths.

Myths, seemingly soaked with imagination, and more recent scientific discoveries, turn out to correspond. Is this a mere coincidence?

7 The Swapping of Roles

Geologist Dr. Horst Friedrich states in his book "Jahrhundertirrtum Eiszeit" (The Mistake of the Century – The Glacial Period): "The interested person may ask how science can believe to have determined that there was a 'Great Glacial Period' of one million year duration (allegedly to have come to an end 8000 years ago). The answer to this question is terribly simple. Lyell's doctrine of Uniformity in connection with Darwinism (itself being based on the Doctrine of Uniformity), demands it."[94]

Useless Theories

In school, our grandparents and sometimes even our fathers, were taught about the Flood, in a Christian context of "the Deluge". It had flooded the world and destroyed whatever came in its path.

After geology with the help of Lyell's theory and Darwin's law gained acceptance, the flood could no longer serve as the explanation for various phenomena used as evidence for a flood, as the Theory of Evolution left no room for a worldwide flood. It was either flood or evolution. They ruled each other out, like fire and water. But erratic blocks and debris were still there to see. How should these phenomena be explained? A steady development of Earth and the Theory of Evolution could not serve to explain fossil remains in several meters high, large, rounded boulders in plains, or the granite strewn limestone grounds of the Swiss Jura. *This is why Glacial Periods had to be invented!* There was no other way. It was considered to be responsible for all phenomena, formerly ascribed to the flood. Embarrassingly enough, though, the defenders of Glacial Period Theory were confronted with "the fact that in regions, definitely never covered by ice, also, completely identical erratic blocks are found, partly even in great numbers", for example in the region of San Diego, California. "According to the Glacial Period Teaching, the Peleponnessos never [...] experienced a glacial period. Its landscape in the appearance of its surface, however, is very similar to that of our – allegedly glacially shaped – Alpine Foreland."[94]

In 1787, Bernhard Friedrich Kuhn, a Swiss lawyer, published a theory, stating that glaciers transported the granite blocks of the Swiss Jura to their present location. Lois Agassiz, another Swiss, sketched the image of a global icing.[95] This was in 1837. Rejected at first, his worldview today is considered

an *indisputably* secured fact. Still, as yet, there is no general conclusive evidence, even though many treatises have been written on the subject.

In the last couple of hundred thousand years, there are supposed to have been at least three major glacial periods in periodic intervals with many minor intermediate glacial periods. Agassiz, already, was convinced of the existence of a vast sheet of ice, reaching from the North Pole down to the Mediterranean and the Caspian Sea.

The Glacial Period Theory failed because of the geographic range of the sheet of ice. Why did glaciers in Europe reach down to the 50th Parallel, in North America down to the 40th Parallel. This while *at the same time* Northeastern Siberia, at the 75th Parallel, now the coldest place on Earth, was *ice-free?* I presented evidence in favor of a moderate climate in Siberia along with the finds of preserved mammoths. The discovery of marine fossils, at a height of 300 meters above today's and 400 to 500 meters above the antediluvian sea level in Scandinavia, North America and Scotland is considered a paradox. The Glacial Periods could not have caused such a high variation of the sea level.

In 1865, Thomas Jamieson presented what was considered to be a brilliant explanation, decisively backing up the Glacial Period Theory. Pressure from the glaciers' weight, he stated, re-shaped the Earth's crust and indented the viscous layers underneath.[96] After they dissolved, weight reduction re-lifted the land and its marine fossils back to original height.

There are several arguments against his theory. The height at which fossils were found is similar in North America and in Europe. Earth's crust therefore would have had to rise *evenly* on both sides of the Atlantic, although the geological circumstances that are the prerequisites for settling conditions differ. On top of that, radar measurements revealed inhomogenities in the Earth's interior. On the other hand, it has to be doubted whether the large continental slabs, once sunken into Earth's viscous mantle, would rise again with the decreasing weight of thawing icebergs.

In theory, we can imagine such a process. However, the process of sinking into the viscous mass of a solid body is not entirely reversible. To some extent, it remains sunken in. Could these high-up shorelines not have been at these elevation levels since the flood? The answer is simple: They were formed by the flood.

In a later chapter, I will discuss the present tilt of the South American continent, which obviously not receded. Anyway, it is more important to determine why there could not be such a thing as a glacial period.

Nobody really knows why there must have been one or even more

successive glacial periods. Reasons for glacial periods to evolve and end *still remain unclear* today. There is, however, much speculation. Most of this is far-fetched and incredible. One of today's much favored explanations, found in the appropriate literature, concentrates on Earth's elliptic orbit: the sun, due to varying distances, warms Earth's surface sometimes more and sometimes less intensely. At certain times, the intensity of the radiation is increased or decreased by the tilted and reeling axis of the Earth. This may be sufficient to explain the formation of the smaller amount of ice at the poles. This theory can not plausibly explain the real glacial periods with massive sheets of ice in the Northern hemisphere. British astronomer Fred Hoyle pointed out that a temperature decrease? of four percent would not be sufficient to trigger a glacial period. The Southern hemisphere shows an increase in temperature of three percent, without any substantial effect on Antarctic glaciers. ?voetnoot.

In most cases, theories about glacial periods were put forward by astronomers and geophysicists instead of geologists. All working models assume a deteriorating climate. This, however, means that for some reason, it simply got colder all over Earth. The basic error lies in the beginning. In contrast to the Antarctic, there is *no land* under the Arctic. This means that massive icing freezes ocean water. This *cooling process, however, does not produce an iceberg,* but a plane sheet of ice comparable to that of a freezing lake. Regardless of temperature, no iceberg will form on such a frozen surface.

In order for enormous glaciers to pile up in the Arctic, without mountains underneath, an enormous precipitation in the form of snow and ice is required. This is the *only* way that icebergs could have formed.

Precipitation (snow, ice, rain), however, requires large amounts of vapor (clouds) in the atmosphere. Clouds evolve from intense evaporation of water. A process for which heat – for example in areas along the equator – is *absolutely necessary.* Warm climates in large parts of the world fundamentally contrast with a worldwide deterioration of the climate, i.e. the basic assumption of the Glacial Period Theory. Conclusion: *without heat, no precipitation and consequently no icebergs.*

Precisely these basic prerequisites existed when, a couple of thousand years ago, the flood occurred: eruptions caused vapor that, taking the form of snow, fell back to Earth in cooler regions and at the higher grounds of mountains. At this moment in time the icebergs that we encounter today formed, whereas mammoths, other mammals as well as plants or even entire trees bearing fruit, were instantly frozen in a permafrost.

Once more, I wish to emphasize the intrinsic contradiction in the Glacial Period Theory, because this point is of the utmost importance. The formation

of icebergs requires freezing and the piling-up of precipitation in the form of ice and snow, which itself can only be caused by the evaporation of water, this in moderate climate zones with higher temperatures. Under the prerequisite of a globally deteriorating climate, no glacial period with icebergs can evolve.

Obvious evidence for the alleged glacial periods are found in every appropriate publication in the form of impressive pictures: entirely smoothed strata all over the world, even in the present Sahara Desert. This region is believed to have once been located in the area of the South Pole. However, as ancient maps – such as the Piri Reis map – prove, there never were any glaciers in the Antarctic. Even resolute defenders of the Flood Theory, such as the Englishman William Buckland in the year 1824, failed when it came to interpreting the phenomenon of polished rock layers in a plain, to be found in Scotland.[97] Furthermore, the 19th century did not know enough about the real course of the flood, because the up-rolling tidal wave was preceded by a global blaze and a storm of fire. Later on, I will give more details about the course of the flood and the newest scientific discoveries. At any rate, volcanic eruptions and ruptures produce temperatures of several thousand degrees, melting rock and ore in mountains. The ancient Persian religion includes an account of an end of the world through fire, "liquifying all metals in the mountains".[98] This made it simple for the waves of the flood to polish the soft strata as smooth as plasticine. Afterwards, the soft fluid material rapidly hardened into solid rock, as I have described earlier. Because in the past the flood was associated with large amounts of water but not with high temperatures, certain phenomena could not be adequately explained. (The seemingly imagination-soaked transmissions give an account of realistic processes of our Earth's past.)

Of course, there are rock faces in mountains polished by glaciers. I do not question this. In this case, however, mountain slopes – due to their inclined surface – serve as *natural glide planes*! Sliding under these conditions is inevitable. Polished rock in plains and partly also in mountain areas were also formed by the consequences of the flood.

By the 1960s, the Glacial Period Theory should have been judged as untenable by everyone. Roman bricks and *post-glacial logs* were found in the gravel layers of the Alpine Foreland, believed to have formed prior to the last glacial period, 20,000 years ago. In another, until then, untouched gravel stratum, believed to have formed in the Glacial Period, *a rusty part of a bicycle* was found, as Windsor Chorlton reports.[99] This discovery should have put an end to the Glacial Period Theory, because at that time only Stone Age men existed. Or did our distant ancestors ride bikes? Strangely enough, however,

the Glacial Period Theory was *revived*. There was *no other alternative* within the boundaries of Evolutionary Thinking.

Ice Age or Flood?

If Earth's axis was vertical prior to the flood, then seasons did not exist. Instead, an atmosphere laden with water-molecules prevailed throughout the world, producing a greenhouse effect, while simultaneously providing protection against cosmic radiation.

All causes for a glacial period —- ever imagined, are superfluous if the assumption is right that the Earth's axis was not tilted before the flood came about. In this case, there definitely could not have been a glacial period prior to this moment in time. I would like to emphasize this: *with an upright axis of the Earth, there are no seasons and glacial periods are out of the question.* Against this background, the Glacial Periods, allegedly secured by geology, appear in a new light.

Under the ideal climate and physical conditions preceding the flood, polar ice may still have covered the poles, i.e. on the surface, similar to that on Mars or the Moon. It, nevertheless, is not to be mistaken for a glacial period. This point of view questions the very foundation of geology and paleontology. Logic speaks for itself.

In the course of the universal cataclysm, the angle of Earth's axis was tilted by at least 20 degrees, creating the precondition for the start of a glacial period. The suddenly frozen mammoths in Siberia testify to that.

The late Velikovsky, whose theory of recurrent cataclysms in Earth's history caused a sensation in the 1950s, stated in his book "Welten im Zusammenstoß" (Worlds in Collision):

"The poles were not always located where they are today and changes were not at all gradual processes. The glacial sheet of ice was nothing but polar ice. Glacial Periods ended with disastrous suddenness. Areas with a mild climate within a very few hours landed in the Arctic circle. The sheets of ice in America and Europe began to melt. Large amounts of vapor, emerging from the sea surface, increased precipitation and furthered the formation of a new sheet of ice. To a much stronger degree than the approaching ice, giant waves, moving over the continents, carried drifting debris and erratic blocks over great distances and deposited them on strange strata."

Looking at the boundaries of freezing on the globe's Northern half, we

see a circle: it centers on Greenland's East coast or in the sound between Greenland and Baffin Island, close to the magnetic pole of today. Its diameter of about 3600 kilometers comprises the sphere of the ice sheets during the last glacial period. Siberia's Northeast was not part of the circle. It included the valley of Missouri River down to the 39th Northern parallel. The East of Alaska was within the circle; its Western part, however, was not. It comprised Northwest Europe. A stretch behind the Ural Mountains bent the boundary Northward, cutting through the current Arctic circle.

This leads us to the question whether the North Pole might actually have been 20 degrees or more away from its present location, closer to America, while the old South Pole was the same 20 degrees further away from its current position, maybe in the area of Queen Mary Land on the Antarctic continent."[100]

I agree with Velikovsky about his scenario of the freezing of the polar regions, initiated by a global cataclysm. It is nevertheless necessary to emphasize that several thrusts of the ice boundary followed the Earth's swaying axis. As mentioned before, events recurred, varying in intensity. The ensuing ice layering did not take millions of years, but a relatively short period of time.

The Moraines

The phenomena coinciding with a drastic displacement of the Earth's axis solve many of our present mysteries. Until now, moraines were considered deposits in the form of boulder clay, rock, erratic blocks and debris of progressing and later retreating ice boundaries. As obvious evidence, these remainders of the last Glacial Period up to now has convinced almost every student.

These moraines, logically speaking, are much better explained if seen as areas that were repeatedly covered by water during the flood. Besides, it seems more logical to assume that the shape of erratic blocks was rounded by the movement of waves, rather than by being slowly pushed by ice boundaries or melted snow and ice. The basic question to be asked is this: could masses of ice or streams of melted snow and ice actually push larger erratic block over a plane or even rising terrain over longer distances? If the answer – contrary to my conviction – would be a positive one, the next question to ask is: could those rocks have been turned around and exposed to friction often enough to be left polished? Is an iceberg on a level surface capable of transporting anything over a greater distance? Only in mountains do we find the naturally slanted glide planes where we observe the effect of originally frozen rocks

moving. This does not apply to plains, where the weight of an iceberg would dent the ground – more in the middle and less around the edges. In soil mechanics, this effect is called "settlement trough" and occurs in every new building. The deeper denture of ground layers in the center would prevent horizontal movement.

Large amounts of water from thawing masses of ice could move stones, but under no circumstance will a process like this smooth and round erratic blocks of several meters, as if polished with sandpaper, like a marble. Streams of melted ice and snow will only to a smaller extent produce similar phenomena, but not across a stretch of hundreds of kilometers. Compared to that, an enormous flood, with tidal waves maybe kilometers high, would be capable of moving giant rock boulders over far distances. This is something we observe at the shores of our seas, when heavy stormtides strike. Along the shorelines, we almost exclusively find rounded stones. Erratic blocks, sand, and gravel are shaped by the force of the water, in the form of sea waves, rather than by massive sheets of ice. The type and form of deposits – unbroken lines at discovery sites as well as along coasts – give further evidence of this effect that is produced by the tidal waves of a major inundation due to the flood.

This is why Velikovsky remarked: "[I] tend to take the view [that] erratic blocks and boulder clay were not carried long by ice, but rather by the surge of giant tidal waves, caused by a change in Earth rotation. This is how we explained the moraines, wandering from the equator towards higher latitudes and levels (the Himalaya) or from the Equator across Africa towards the South Pole."[100]

The mysterious loess belt, extending from France to China, has to be put into this context also and identified as a deposit of the flood. The moraines and loess belt go back to the same event: they are remainders of the last flood. Looking at moraines and the loess belt as independent phenomena will inevitably foster the wrong conclusions.

So, the ice-free Antarctic on the maps of Piri Reis is a snapshot of the continent prior to the flood. No more than 10,000 years ago, the South Pole was free of ice.

The caps of polar ice, then small, began to melt with the flood. Displacement of the Earth's axis shifted this arctic region towards Siberia and Alaska. The Great Frost, one of the events related to the flood, created an arctic climate and a glacial period, which persists to this day. This implies that the glacial period is not a matter of the past, but rather of the present!

One common thread connects the flood, the displacement of Earth's axis and the sudden destruction of almost all life on Earth.

Ancient cities rest under the surface of the sea, and continental shelves under water testify that the sea levels were once lower. It is therefore considered a proven fact, accepted even by conservative scientists, that the sealevels prior to the glacial periods (flood) were at least 100, maybe even 200 meters lower than today. The melting of the polar caps during the last glacial period is supposed to have caused the sea level to rise to its present level. If, however, there was no glacial period and ice formed only in more recent time due to the tilting of Earth's axis, we have to ask where the additional water in the oceans comes from. In the final analysis, the early defenders of the Flood Theory failed to answer this question.

It is clear to orthodox scientists that the dissolving glaciers released a sufficient amount of water. On the other hand, if there was no glacial period, then water must have come from somewhere else.

The Bible, as already stated, mentions waters in the abyss. Meteor impacts released it. To a large extent, water is fixed in rock. Moreover, probably interconnected water layers existed under the Earth's crust, similar to modern ground water. We know that volcanic eruptions set free large amounts of water. Apart from this, meteors themselves may have carried water. Part of the water may also originate from a dissolving polar ice-cap. The Bible speaks of water above and under Earth's canopy. Water above the canopy may refer to an atmosphere of vapor or a hull of water, covering the entire Earth. The mutual occurrence of both phenomena cannot be ruled out.

The decisive reason for sea level rising has to be sought within the theory that water fixed in rock was released. Hydraulic action and chemical processes released this hydrate water which slowly gathered in the lower regions, adding to the oceans or creating new seas. This solves the mystery of the ocean's elevated sealevels, regardless of melting icebergs. Thus the alternative theory, presented in this book, allows for a logical explanation in the form of flood-related events. There is no need for major glacial periods in order to explain the facts.

Another Atmosphere

Waters are said to exist in the Bible, located underneath the canopy and separate from those above. Does the water above the canopy refer to liquids

of other planets as well as comets in space or did our atmosphere form a baldachin of water? Specifications about the flood, given in the Bible, support the Earthly origins of this water. The book Revelation (6:14) says, "And the heaven departed as a scroll when it is rolled together; and every mountain and island was moved out of their places."

Genesis (7: 11) adds, "[...] all the fountains of the great deep broke open, and the windows of heaven were opened. And the rain was upon the Earth forty days and forty nights..."

The Protestant Bible translation uses the expression "well of the deep". This choice of words emphasizes ground water emerging from the Earth or the release of water fixed in rock. The floodgates of heaven surely refer to a downpour or did the hull of water collapse? We know of other planets that have atmospheres that are rich in water molecules. Venus is believed to have once been covered by water. The liquid evaporated due to the high atmospheric temperatures on Venus, though it might today probably exist, fixed in rock.

Astrophysicist Carl Sagan believed that a greenhouse effect, based on carbon dioxide/vapor, accounted for the high temperatures of Venus. Above the thick vapor layer of Titan, Saturn's large moon – its diameter of 5000 kilometers makes it half the size of Earth – the space probe Voyager identified a blue haze, entirely covering the moon and blocking the view of its surface. The exact composition of the haze particles is still unknown. According to discoveries so far, it contains ingredients in combination with water.[101]

Geologists state: "... flood ... a chaos, during which water was no longer distinguishable from sky and Earth, because man saw, how surges of water merged into downpour. And from Babylon to China and beyond, people believed to know where the water came from. Obviously, it partly came from above the firmament, from where it tumbled, during the world quake that followed the "breaking of a column of the firmament". Just as obviously, it was also stored in a second bowl under the solid crust of the Earth, because during the world quake, "all wells of the deep broke open."[103]

In Genesis (1:6–8) we read: "And God said, Let there be a firmament in the midst of the waters, and let it divide the waters from the waters. And God made the firmament and divided the waters which [were] under the firmament from the waters which [were] above the firmament ... And God called the firmament Heaven."

The orthodox interpretation identifies this water above the firmament as hydrogen, ice or even liquid water on other planets or celestial bodies. However, a literal interpretation of the Bible corresponds exactly with the circumstances of a hollow water sphere surrounding the Earth prior to the flood.

It is necessary to realise that this event was linked to the appearance of additional water masses, appearing after the flood and forcing the sea level to rise, because the water above the canopy rained down on the surface of the Earth. Assuming a vapor-enriched atmosphere, other physical conditions must have prevailed. I have pointed out this relation earlier.

Almost more than a coincidence, on August 12, 1997, the German daily newspaper "Bild" published an article under the headline "Sensationalle Entdeckung" (Sensational Discovery): "The German research satellite Christa-Spas surprisingly has discovered traces of vapor in Earth's upper atmosphere. This may serve to back up the controversial theory on minor comets *bombarding* Earth with water. So far, it is not clear where the water originates from." Even if the water's origin is unclear, at least a thin hull of water still exists. It confirms my assumptions, to the effect that they, apart from the support by ancient writings, have a scientific basis after all.

More evidence of an atmosphere with an entirely different composition prior to the flood, is supplied by the steel composition of the fossil hammerhead, described in detail. The production of this steel required atmospheric conditions that are completely different from those we observe today. At the time, probably a minimum of two atmospheres pressure instead of one prevailed. Examination of old air bubbles locked into ice also indicate another composition of our previous atmosphere. Prior to the flood, the atmosphere's oxygen content must have been higher. Besides, the protective shield provided Earth with a steady and mild climate, securing constant growth of all plants throughout the year. With Earth's axis almost upright before the flood, there were no seasons. There was diffuse, but bright light on Earth. A baldachin of water acted as an ideal shield against various kinds of radiation from space. Did the hollow sphere of water collapse with the flood, "rolled up like a scroll", and is it that only since then this world is exposed to dangerous radiation?

These circumstances would explain gigantism prior to the flood. Not only dinosaurs grew tall, but humans as well, reaching heights between 2.5 and 4 meters. Fossilized footprints of up to 50 centimeters length, found all over the world, also provide evidence for this. Petrified samples found at different places all over the world prove the existence of giant ferns, horsetails and other plants. Everything seems to have been bigger than today. No scientific explanation of gigantism in an allegedly long-gone period of Earth's history has been offered so far. It is considered to be a scientifically non- explicable phenomenon.

I have proven the co-existence of humans and dinosaurs. Consequently, it is only natural that people were taller before the flood than they are now. Be it a baldachin of water or a vapor-enriched atmosphere, either would protect Earth and its creatures from damage by cosmic radiation and through a greenhouse effect that produced higher temperatures. It is comparable to a giant winter garden. Under such circumstance, there are no variations in climate. Conditions were ideal for increased growth at low rates of radiation damage.

What heat and moisture can achieve in nature, we observe in today's latitudes of subtropical climate around the Equator. The conditions of growth here

Creation according to Old Testament	*Progress according to scientific outlook Evolution*
1st day sky, earth, ocean	**4th day** light, stars, planets
2nd day firmament, **no rain** water above and underneath	**1st and 2nd day** land, vault **then heavy rain**
3rd day water gathers, land, plants	**1st and 3rd day** water gathers, primary ocean
4th day light, sun, moon stars visible	**5th day** life forms in water
5th day animals in skies and water	**6th day** terrestrial animals
6th day terrestrial animals, man **flood** for the first time: clouds, rain and seasons	**5th day** birds **6th day** man **No** flood

Fig. 18: Comparison between Creation and Evolution. The description on the development of the Earth, given in the Old Testament, contrasts sharply with the scientific Theory of Evolution. For better orientation, the days of Creation in "Genesis" were added to the alleged steps of evolution.

were better than in other parts of the world. In contrast to the present, an equivalent climate prevailed *throughout* the world.

So, the Bible is right after all, when it consistently attributes a high age of about 900 years to man prior to the flood (even if days might have lasted less than 20 hours[102]); and when it documents a continuous decrease in life expectancy after the flood down to the ages we have today? After the flood, mankind was defenseless, exposed to the intense radiation from space. Man degenerated. This conclusion stands in sharp contrast to the Theory of Evolution, which proclaims the continuous improvement of all creatures, throughout the epochs, past and present.

The Paradise, preceding the cataclysmic flood, brought with it the following conditions:

· There were no storms.
· There were no deserts and no ice, except for a minor icing of the polar caps.
· A moderate, warm climate prevailed from pole to pole without fluctuations.
· There was neither rain nor clouds.
· Plants and animals probably had a substantially higher life expectancy.
· Vapor, alone or in combination with carbon dioxide, protected our Earth from certain forms of cosmic radiation.
· A kind of diffuse light shone on the Earth's surface. So, there was no direct and damaging sunlight.

The Bible also includes hints to other conditions that existed before the flood. In Genesis (2:5), under the title "Paradise", it gives the following account: "... for the LORD God had not caused it to rain upon the Earth, and [there was] not a man to till the ground."

This statement refers to a period after God had created the Earth. Sky, oceans and dry land already existed, but it had not rained yet! This seems to pose a problem: where did the oceans come from, if it did not rain? Did the masses of water already exist when the Earth was born? On the second day of Creation – this means, sky, earth and primeval ocean were already there, but before the sun and the moon appeared in the sky. The water was divided: one part above and the other underneath the firmament. But still it did not rain. This only happened when the Deluge came. The Bible specifically confirms this circumstance. Impossible, you say? One exceptional interpretation, discussed later, corresponds with a Sumerian tradition and the details given in Genesis.

We should return to the new climatic and meteorological circumstances the flood brought about. Genesis (9:13-15) says: "I do set my bow in the cloud, and it shall be for a token of a covenant between me and the Earth. And it shall come to pass, when I bring a cloud over the Earth that the bow shall be seen in the cloud: And I will remember my covenant, which [is] between me and you ... and the waters shall no more become a flood to destroy all flesh."

It was only after the flood that the first rainbow (bow) appeared. The appearance of storm clouds is mentioned; *this did not exist prior to the flood.* The description in the Bible is very precise. And to make the matter clear and distinct, the Lord said to Noach, his servant (Genesis 8:22): "While the Earth remaineth, seedtime and harvest, and cold and heat, and summer and winter,

Fig. 19: Vapor Velum of the Earth. The biblical book Genesis mentions waters above the Earth and stars becoming visible only after the flood. Prior to this cataclysm, there was another atmosphere with at least two atmospheric pressures, instead of the one we have today. Apart from that, Earth probably was protected from harmful cosmic radiation by a thin, transparent baldachin of water or a vapor velum. This produced a mild, stable climate all over Earth. With the flood, the hollow sphere collapsed and the stars became visible.

and day and night shall not cease."

So everything started with the Deluge! Prior to this event, there was no need to sow because – without changing seasons – everything was provided in abundance, throughout the year. Neither frost nor heat existed. The diffuse light also lit up the night. There was no complete darkness and so neither was there a distinct alternation of day and night. This points to the vapor-atmosphere or the baldachin of water (hollow sphere of water) I described. The diffuse lighting conditions are also confirmed by, again, Genesis (1:14–16): "And God said, Let there be lights in the firmament of the heaven to divide the day from the night; and let them be for signs, and for seasons, ... And God made two great lights; ...[he made] the stars also."

The only surprising aspect of this statement is that it did not happen before the fourth day of Creation, meaning: after the plants and trees had been created. According to our understanding, the universe and the starry heavens, including our sun, are older than the Earth. Entire generations of biblical scholars have tried to interpret this apparently faulty order in the creation of the universe. If we, however, consider the completely different atmospheric conditions preceding the flood, the passage becomes intelligible: be it the hollow sphere of water above the atmosphere or just a vapor-enriched atmosphere, they produced diffused lighting.

The stars were therefore not clearly distinguishable. Not until the atmosphere of primeval times collapsed during the flood and the water tumbled down on Earth's surface, did the sun, moon and stars appear. So is the Bible right after all? Whatever the answer, when it comes to the course Earth's creation took, there is a world of difference between the chronology given in the Bible and our familiar scientific outlook, based on the theories of Lyell or Darwin.

Between the creation of the world and the flood, there was an epoch that was completely different from the post-diluvian world. With unimpeachable force, the wealth of fossilized finds proves that in Earth's olden times, a tropical climate prevailed from pole to pole. We only need to mention the coral structures and tropical coal forests discovered in Arctic regions, as Dr. Albert Vollmer has aptly stated.[104]

8 The Inevitable Birth of the Earth

Earth probably formed after an interplanetary disaster. The Asteroid Belt beyond Mars, as well as comets and meteorites are the shattered remains of this cosmic incident. Earth drifted through the solar system, approaching several planets (Earth–Mars, Venus– Earth) before stable conditions (orbits) were resumed. Then a number of smaller and some larger cosmic fragments – the aftermath of the cosmic collision – hit the Earth's crust.

Worldwide Cosmic Meteorite Impacts

The atmosphere hardly slows down large meteors. The impact of an asteroid of ten kilometers in diameter, such as the one that hit the Northern outskirts of the Yucatan Peninsula – an alleged 64 million years ago and believed to be responsible for the dinosaurs' extinction – released enormous energies, thought to equal the force of five billion Hiroshima-bombs and many million times more destructive than the violent explosion on Krakatau in Indonesia in 1883. At ground zero, it produced temperatures of over 100,000 °C, possibly even vaporizing the rock of the impact area. Sumerian-Babylonian myths report of an ocean impact, making the bottom of the sea visible.

Impacts coincide with vaporization, provided the impact velocity is high enough. Moreover, heat and shock waves may ensue, blinding and deafening even at a distance of several hundred kilometers away. They are accompanied by a red-hot nuclear fallout. Within hours, an enormous blast raged around the world and the shock of the blast could kill as far as a thousand kilometers away from ground zero.

According to computer simulations, at least a hundred times the mass that makes up the asteroid itself would shoot up from the ground. Gigantic amounts of dust and vapor would blow into the atmosphere and darken the sky. Computers calculated the impact effects of a comet, measuring only one kilometer in diameter, hitting the sea. It came up with a head of water 20 kilometers wide and 50 kilometers high. Tidal waves of one hundred meters high would struck the coasts. The simulation showed that violent hurricanes as fast as 800 kilometers per hour would rage around the globe. But what would happen if several, probably even much larger chunks, hit the Earth? Beyond any doubt, one could label it the apocalypse.[105]

The impact of a celestial body, fast and massive enough, releases large

amounts of iridium. Its concentrations are gathered in the Earth's layers of ejected material. Measurements and observations as such allow the *identification of an impact beyond doubt.*

The book of Enoch, one of the forefathers mentioned in the Old Testament, speaks of seven stars resembling burning mountains. Babylonian legends speak of the seven heads of a great snake of the doomsday monster. The comparison with a snake or a dragon is fitting, considering the burning torch of smoke and fumes tailing a comet or meteor.

Internationally acclaimed geologists Dr. Edith and Prof. Dr. Alexander Tollman – the latter is board member of the historic University Institute of Vienna – have done extensive research on the flood issue and its related cosmic impacts. In their book "Und die Sintflut gab es doch" (And there was a flood after all), they – apart from the asteroid impact on the Northern edge of the Yucatan Peninsula (Mexico) – present seven more major areas of impact, locations that are based on geological and mythological evidence. They lie in the Eastern Pacific Ocean, West of Mexico, in the Southern Pacific, West of Tierra del Fuego, South of Tasmania near Australia, South of India in the Indian Ocean, in the South Chinese Sea, in the Central Atlantic Ocean near the Azores and in the Northern Atlantic. A major terrestrial impact furthermore hit Köfels, in Austria.[103]

There are impact craters all over the world, although there actually are not enough of them if we judge it by the history of the origin of the Earth and the universe taught so far. If Earth really is five billion years old, the globe would be teeming with craters, even taking into account that the erosion on Earth is —- intense. Compared to other planets, Earth shows only a few craters. This factor, among others, indicates a younger age of Earth than estimated so far. However, craters on the moon and around the South Pole of Mars are concentrated in certain areas. They must have been produced by one particular event on a cosmic scale.

Apart from the larger fragments, additional smaller rocks impacted on Earth. Accompanying each major celestial projectile, medium sized chunks caused craters from 100 to several thousand meters in diameter. Along with these impacts, a shower of falling stars came.

Nordic myths speak of the fiery suns, following a comet, called Surtur. Not to forget, a rain of small comet stones produced impressive fireworks. In the Revelations of John (6:13) we read: "And the stars of heaven fell unto the Earth, even as a fig tree casteth her untimely figs, when she is shaken of a mighty wind."

Asteroids

A conspicuously large distance gapes between the red planet Mars and the giant Jupiter. The German astronomer Johannes Keppler (1571–1630) as well as other scientists filled the gap with a theoretical planet. The simple calculation of solar distances of our planets based on the rule of Johann Titius (1729–1796) and Johann Elert Bode (1747–1826) employs a fictitious in-between-planet, assumed to orbit the sun at a distance of 2.8 AU (= astronomical unit, equals the distance sun-Earth, i.e. 145,598 million kilometers).

Only in 1802 did Giuseppe Piazzi discover a minor planet beyond Mars. It became famous under the name "Ceres". All in all, there are about 50,000 minor planets of more than one kilometer in diameter. Ceres, a larger minor planet measures 930 kilometers in diameter. These planetoids, mostly irregularly shaped bodies, form a belt, the so-called Asteroid belt. German mathematician Carl Friedrich Gauß (1775–1855) calculated a circular trajectory for Ceres of 2.78 AU, coinciding with the averaged value of 2.8 AU, determined by the Titius-Bode Formula.

Between Mars and Jupiter, there apparently is a planet missing, represented by the Asteroid belt (Ceres) or – according to Greek mythology – Phaeton.

Planet	Distance (AU) from the sun	Distance according to Titius-Bode Relation (except Neptune)	Distance according to Titius-Bode Relation (including Neptune)
Mercury	0,39	0,40	0,40
Venus	0,72	0,70	0,70
(Earth)	(1,00)	(1,00)	(1,00)
Mars	1,54	1,60	1,60
Phaeton/ Tiamat	2,78	2,80	2,80
Jupiter	5,20	5,20	5,20
Saturn	9,54	10,00	10,00
Uranus	19,27	19,60	19,60
Neptune	30,21	-	38,80
Pluto	39,84	38,80	77,20

Fig. 20: Titius-Bode-Relation. Theoretically, we come up with a planet in the area of the Asteroid belt. (AU = average distance sun – Earth).

Does this merely fill the gap between Mars and Jupiter in terms of figures or did this ring of irregularly shaped chunks of rock actually once form an entire planet?

Astronomers may argue that the masses of all fragments in the Asteroid belt would not do to form a planet. Maybe, however, the search was not thorough enough? If a planet actually did exist where the Asteroid belt is today, it must have burst apart: there was a disaster. It is clear that Earth would have suffered too. We would have to reconsider the conditions of our solar system in respect to such an event. Are not only the Asteroid belt but the rings of Jupiter and Saturn, the countless craters on Mars and Moon, the many strange moons of the different planets in our solar system, the two

Planet	Distance from the sun	Proportion of growth excluding Earth, incl. Phaeton	Proportion of growth including Earth, excl. Phaeton	Proportion of growth including Earth, incl. Phaeton
Mercury	0,39	-	-	-
Venus	0,72	1,84	1,84	1,84
(Earth)	(1,00)	-	1,38	1,38
Mars	1,54	2,13	1,54	1,54
Phaeton/ Tiamat	2,78	1,80	-	1,80
Jupiter	5,20	1,87	3,42	1,87
Saturn	9,54	1,83	1,83	1,83
Uranus	19,27	2,01	2,01	2,01
(Neptune)	30,21	(1,56)	(1,56)	(1,56)
Pluto (with Neptune)	39,84	(1,31)	(1,31)	(1,31)
Pluto (without Neptune)	39,84	2,06	2,06	2,06

Fig.21: Proportions of distances between planets. Calculating the proportion between two planets' distances from the sun, based on 1.0 (= AU) representing the distance Earth – sun, yields a relatively constant factor. This on the condition that the Earth has to be excluded from the calculation and instead of it, an assumed planet in place of today's Asteroid belt has to be considered. Only if Earth is excluded – with or without Phaeton/ Tiamat – do we come up with a well-structured image of factors, similar in size, indicating increasing distances between planets.

extraordinary moons of Mars, Phobos and Deimos (fear and terror), comets, meteorites and maybe even our own Moon remnants of the lost planet Phaeton or its moon –mentioned in the Sumerian creation account, as early as 6000 years ago?

Did the planet burst? Did its fragments collide with Earth? Is the story about the birth of Earth, recorded on Sumerian-Babylonian clay tablets, true?

An Akkadian cylindrical seal, about 4500 years old, shows our *entire* planetary system. It also gives the planets' sizes in correct proportions. It is however bizarre that it shows eleven instead of ten planets. Between Mars and Jupiter, an additional large planet is located, where we today find the Asteroid belt. The planet Pluto is placed between Saturn and Uranus – in a wrong position. Odd is furthermore that the Titius-Bode Relation should determine the wrong values for the two outer planets, Neptune and Pluto.

From where did the Akkadians attain this knowledge? 4500 years ago, these people could not discern Uranus, Neptune and Pluto with their naked eyes. If, for inexplicable reasons they possessed this knowledge, then why should their presentation of the additional planet Phaeton rather than the present Asteroid Belt be wrong? If the information is correct, *this celestial body must have existed in the more recent past.* The Akkadian cylinder seal is exhibited at the "Vorderasiatisches Museum" (Middle East Museum) in Berlin, in Germany.

Violent Birth of our Earth?

Sumerian-Babylonian clay tablets stated that the original planet Phaeton, called Tiamat by the Sumerians, collided with another celestial body. The planet Phaeton/Tiamat broke apart. This suggests that Earth is what remained of this planet. Accompanied by its former companion Kingu, the largest fragment of Tiamat/Phaeton was hurled into the orbit Earth has today. Remarkably large and up to eleven kilometers deep, there is a hole in the Earth, today filled with the waters of the Pacific Ocean. Does this area represent the scar the collision left behind? The age determined for the seabed is substantially lower than that of the continental shelf: 200 million years in contrast to several billion years.

The seabed, from a scientific point of view, is much younger than continental rock. The latest satellite imagery, a digital map of the age of seafloor (picture 88), confirms this. The youngest regions of the Atlantic naturally are found on the edges of the tectonic plates, where hot magma emerges from

the Earth's interior. On the other hand, the entire Pacific seabed from Asia to the American coast, which is still lying eleven kilometers deep, seems to have formed at the same time, rather than developing along the edges like the Atlantic seabed. As the Pacific seabed is also young in geological terms, this could actually be the old sore from the planetary collision, described in the old Mesopotamian cuneiform texts.

Our image of Earth has a spherical shape with flattened poles. However, recent discoveries go against this interpretation. A planetary collision must have left scars behind. In April 1995, ESA (European Space Agency) launched a number of satellites and brought them into orbit at a height of 760 kilometers. The European Radar Satellite (ERS-1) is capable of seeing even at night and through most overcast skies. The analysis of images from March 1996 caused a sensation, even though it was hardly noticed: they show our Earth to be a rather kidney-shaped, potato-like object, not at all as spherical as expected. The region of the Pacific Ocean actually holds the giant hole, even though erosion and geological processes have partly changed its position. Once more, our worldview turns out to be wrong and old tales of legend appear to breath uncanny truthfulness. Are these mere coincidences?

Under these circumstances, it goes without saying that the material of the ocean floor geologically differs entirely from that of the continental shelf, both having a past of their own.

The fact that the ancient Sumerians wrote down their interpretation of Earth's genesis 6000 years ago, gives rise to the question where they attained there knowledge from.

We are not able to prove this unusual genesis wrong. The scenario described could serve to explain many of the mysteries our solar system holds. A view of the world several thousand years old appears to be more logical than our present one. The apparent contradictions of Genesis, which we could not explain, are one by one confirmed by new discoveries. We have to ask ourselves *when* progress actually did or does take place? Today? Or did it already happen the day before yesterday, at the alleged dawn of our civilization?

According to the statements in Genesis, water existed from the creation of Earth on, even before there was rain. If Earth is what is left of Phaeton/Tiamat, then there actually already was water. Sumerian cuneiform texts confirm that Tiamat/Phaeton originally was covered with water. If we, analogous to the information in Genesis, equate the creation of the world with the bursting of Phaeton/Tiamat, the apparently inconsistent specifications start to make sense: a cosmic disaster gave birth to Earth.

It already had the water that originally existed on the planet Phaeton/

Tiamat. It gathered in the deep wound where the Pacific Ocean is today. As such, the dry land became visible, for the Lord said: "And God said, Let the waters under the heaven be gathered together unto one place, and let the dry [land] appear: and it was so." (Genesis 1:9)

Part of the water evaporated and formed the Earth's water vapor layer that lasted until the flood. I have already pointed out the drastic differences between the Old Testament's version of how the world came into existence and that of the Theory of Evolution. These circumstances provide a logical reason for the correct reproduction of the geological events in the biblical Genesis. As I have stated earlier (Genesis 1:2–3), there was water before light illuminated our planet: "... And the Spirit of God moved upon the face of the waters. And God said, Let there be light!'"

As such, we have here a flagrant contradiction to scientific theories, because here the Earth's crust and primary water already existed, before the sun began to shine and the first clouds of rain formed. Prior to the flood, probably a hollow sphere of water existed. Alternatively, our atmosphere, due to the cataclysmic events when Phaeton/Tiamat split apart, was enriched with vapor and covered with dark clouds, so that light could not reach Earth's surface:

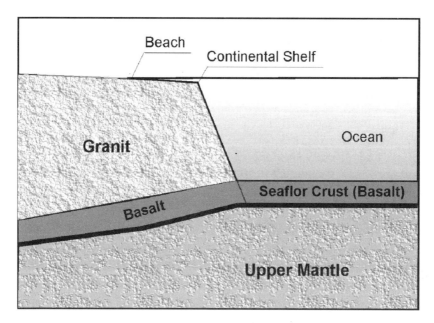

Fig. 22: Continental Shelf. *Continental Shelves drop to an ocean depth of 10 kilometers. The thin seabed crust consists of basalt, while the thicker crust ashore is made up of the lighter granite. These crusts differ in weight, thickness and age. Measurements of the seabed indicate that compared to it, crusts ashore are more than ten times older.*

sun, moon and stars only became visible after the dark clouds had dissolved. Water, however, already existed. Seen from this perspective, the Bible is right after all.

Various Bible editions of the past centuries misleadingly reproduced the original text, because a literal translation seemed to foster absurd results. The first word of the Bible, *bereshit* (Genesis 1:1) was one of these mistranslated words. The original text documents an incredibly sounding secret knowledge. "In the beginning" should be more precisely translated as "From that, which was in the beginning."[106] This illustrates the decisive difference. The biblical creator did not create everything new, but shaped what was already there: the body of the Earth and primary waters. Life was recreated later. Above all, it becomes clear that Earth's body existed already before the divine creation took place. This corresponds exactly with my depiction of the birth of Earth a couple of thousand years ago.

If our moon was Phaeton/Tiamat's former satellite where the Asteroid belt is today and Phaeton/Tiamat exploded, then the concentration of impact craters on only one side of Mars and our present moon – then our direct cosmic neighbors of the disaster – becomes understandable. Earth did not reach its present orbit right away after the disaster in our solar system took place. First, it had to cover the distance from Phaeton/Tiamat's trajectory (Asteroid belt), pass Mars, maybe also approaching Venus on its way. Velikovsky describes these approaches in detail, based on the evaluation of various myths from all over the world.[107]

This detailed consideration of cosmic events would go beyond the scope of this book. It is nevertheless important to state that the prerequisites for an apocalypse, in contrast to our Uniformitarian view of the world, exist and that they are substantiated by the ancient records.

There were two major and probably two or three minor consecutive disasters. With Phaeton's explosion and Earth's simultaneous birth, the first apocalypse took place. A couple of hundred or thousand years later the world once more was struck by fatal disaster: the flood.

Earth's globe probably repeatedly overturned on its odyssey through the solar system. Day and year had no fixed duration. The entire process of instability lasted until 2000 years ago, as the apparently chaotic calendar calculations of almost all ancient cultures indicate.

In the seventh century, archbishop James Ussher of Armagh calculated

the date of Earth's creation back to the year 4004 BC. He used the dates given in Genesis and later chapters of the Bible for this mental exercise. This calculation is considered as a classic example of our ancestors' ignorance.

The Bible documents the genealogies of all firstborn sons, starting with Adam, the first man, over a period of 2369 consecutive years. According to the biblical details, the flood took place 1656 years after Adam. Along with him, our world was created. The date usually given for the death of Joseph, the last member of the recorded line of ancestors, is 1600 and 1700 BC. This means that according to the specifications given in Genesis, the world was created around 4000 BC. Consequently, our world, or rather the crust of the Earth and not the globe, is 6000-7000 years old. The flood took place about 2000 years later. *The original body of Earth*, or rather Phaeton, is naturally much older. If we, however, do not include this in our considerations, we find some congruencies with Armagh's as yet ridiculed calculation and the biblical dates and times in reference to the *regeneration of Earth's crust*.

Is this presentation a mere utopian speculation? Maybe it is not, because practically all facts I have discussed point to a young age for our Earth – regardless of the possibility that the event could have taken place a thousand

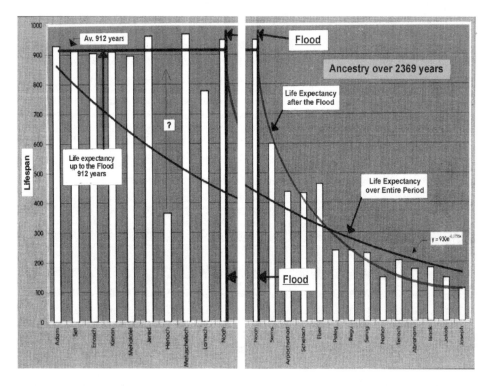

Fig. 23: Biblical *ancestral line of the first-born sons over a period of 2369 years.*

years earlier, as the day of Joseph's death is not exactly known. A global deluge around 5500 instead of 4500 years ago would much better fit into our history of culture – if it is at all correct to this point. I qualify this because there is evidence that during the Middle Ages, at the time of Charlemagne (747-814), a couple of centuries were simply invented. Considering it possible, even if the course of events presented by me should have to be pushed back into the past by about 10,000, 100,000 or even 1 million years, this does not touch my fundamental statement: merely the dates would need to be adjusted. Evolution, as seen by our worldview, still could not have taken place – time was simply too short.

Whatever. There was a period preceding the flood when everything was different. Atmospheric pressure was higher and under these conditions even much bigger animals, such as dinosaurs, existed. This epoch came to a sudden end when the flood occurred – caused, probably, by cosmic impacts. In the aftermath of Phaeton's split, planetoid splinters formed during the collision, which hit Earth with some delay. Large parts of the Earth were reshaped. With the apocalypse, everything began anew, creating entirely different conditions.

Is the Bible also right in claiming that animals and man were created? Before I dig deeper into this (disapproved of) question, there is another, in this context very interesting aspect, which I would like to consider.

Zecharia Sitchin interpreted the Sumerian creation myths in his book "The Twelfth Planet", stating that the body that collided with Phaeton/Tiamat was one more planet in our solar system, unknown to us.[108] Is this an impossible suggestion, because research has already discovered everything there is to discover? Maybe not, because the existence of a larger planet in our solar system has been also considered a possibility by various astronomers.

Star Chart of Thebes

In 1857, Heinrich Karl Brugsch discovered a star chart in a tomb in Thebes, Egypt. The coffin lid showed the goddess Nut surrounded by the twelve signs of the zodiac. Besides her, the twelve hours of the day and night were discernable. The planets are represented by heavenly gods, their barques symbolizing the known trajectories. The top portrays the planets Mercury and Venus side by side with the sun. Earth, Moon, Mars, and Jupiter sit in their barques on the left. The right side shows the planets Saturn, Uranus,

Neptune and Pluto in the correct sequence, but without barques, because their trajectories where not yet known. For a long time, we believed that our ancestors could only discern those planets that were visible to the naked eye. The Star Chart of Thebes with its depiction of the solar system, entirely different from that of science at the time, was long brushed aside as wrong or confusing. No wonder, considering that Pluto was *officially* only discovered in March 1930, but had already been found to be recorded on the lid of a coffin discovered 73 years earlier. Archeologists' interpretation of the exceptional star chart dates back a hundred years – to a time when *Pluto itself was not yet known to exist*. But who would voluntarily like to reconsider the statements of scientific authorities made in the past?

An important question comes to mind: how did the ancient Egyptians know about the existence of planets thousands of years ago, if they are impossible to discern without a telescope?

But it gets more interesting still: above Nut's head an additional unknown planet is depicted. The size of its barque suggests a long and wide orbit. Was the trajectory of this planet as familiar to early Egyptians as those of Mars or Venus?

Fig. 24: Star Chart. This star chart was discovered on a coffin lid in 1857. It shows the goddess Nut surrounded by the twelve signs of the zodiac. It also depicts the twelve hours of day and night. The top portrays the planets Mercury and Venus side by side with the sun. Earth, Moon, Mars and Jupiter sit in their barques on the left. The right side shows the planets Saturn, Uranus, Neptune and Pluto in the correct sequence but without barques, because their trajectories where not yet known. Pluto too is portrayed, even though we discovered the planet only in 1930. Moreover, above the head of the goddess we see a giant barque of one more planet of our solar system, not known to us. Is this the planet X/Nibiru?

This planet is often called the missing twelfth planet. This perspective requires the inclusion of the sun and the moon – being large visible celestial bodies – in the sum.

Sumerians already placed the sun in the *center* of the solar system. Galileo, who made similar statements, was called a heretic in the Middle Ages. Why did we know much more about our solar system 6000 years ago than our ancestors did in the Middle Ages – and maybe even more than we do today? Many of the statements made in the clay tablets of Nineveh are still ridiculed today, but piece by piece what may look like a well-made up science fiction story is confirmed by the latest research.

The Twelfth Planet

The quest for the twelfth planet in our solar system has occupied astronomers for a long time. The discovery of Pluto in 1930 was actually no coincidence. Before Pluto itself was identified, astronomers deduced the influence of an additional unknown planet from interference in the trajectories of Uranus and Neptune. Finding Pluto was only a matter of time and dedicated hard work.

Only in 1978 was determined that Pluto was much smaller than the calculations based on the laws of physics had led to expect. Moreover, this planet was accompanied by an as then unknown moon – Charon. These new findings indicated to the existence of another planet in our solar system, because Pluto is not of a sufficient mass and size to cause the measured disturbances in the trajectories of the other planets.

Many astronomers accept the necessity of one more as yet unknown planet in our solar system. They, however, consider searching for it a superfluous deed, assuming it is an icy piece of rock, revolving around the sun in distant space. If the influence of this planet is of relevance, then this celestial body must be of considerable size, depending on the distance of its orbit around the sun.

Actually, the discovery of a twelfth planet would not create a sensation. We merely have to find out where the Sumerians attained their knowledge from. According to the interpretation put forward by Zecharia Sitchin, they stated that this planet Nibiru was inhabited by a technologically highly sophisticated race. Every 3600 years, the comet-like trajectory of this planet is supposed to have crossed our inner solar system, where the Asteroid Belt is today.[108] In this case, two very bright objects periodically should become visible

in the sky: the sun and the twelfth planet.

If in the old days a planet because of its brightness was depicted as a radiant sun, there should be pictorial representations of it. And, indeed, there are. Many pictures in Mesopotamia show two suns. One of these pictures (picture 92) does not make sense, neither from a religious nor from a scientific point of view. It has to illustrate a real scene from our past, because along with the two suns, it also includes our moon.

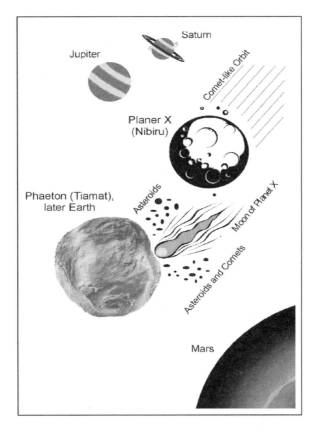

Fig. 25: Collision of Planets. *This nondescript twelfth planet (Planet X) came from the depths of space and approached what once was the planet Phaeton. It was split in two. One half disintegrated, one part forming today's Asteroid Belt and the comets of our solar system. The other half was hurled out of its original orbit and became Earth. The depicted outline of Earth represents a copy made by the author from an image based on data that was supplied by the satellite ERS-1. The image was generated by Thomas Anzenhofer for GeoForschungsZentrum Potsdam (GeoResearchCenter, Potsdam, Germany). It clearly shows the large hole (scale 1:4000) where today we find the Pacific Ocean (see picture 89). Earth is not a sphere, but an irregularly shaped potato. Is this the result of two planets colliding?*

74, 75 Ayers Rock in Australia is not a monolith that grew slowly. This boulder of rock is made up of sandstone. During the flood, a mixture of sand and water under pressure rose to the surface from an underlying stratum. The mixture hardened rapidly to a kind of "concrete" when calcium was added. Picture 78 shows holes, remnants of bubbles that contained the original water. When the "concrete" set, the water evaporated, leaving cavities behind. The surface of Ayers Rock is as smooth as concrete. This, however, cannot be the result of slow erosion through water.

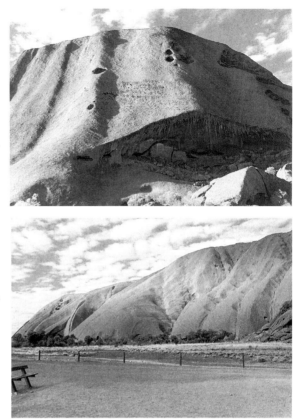

76 Arizona's Grand Canyon. Could the small Colorado River have accomplished such extensive erosion? A closer look reveals four segments with different forms of sedimentation. Why are the ripping zones steep and have they not collapsed over many millions of years, if Colorado River was indeed powerful enough to cut through the rock?

77 Folded mountain ranges like these in the area of Sullivan River, Canada, could only have formed in a soft stage. Had these sedimentary layers been formed in a cold state, they would show cracks.

78 A rock in Utah, shaped to a role, when it was still soft.

79 The wave at Paria River. Two different overlapping rock formations. Both layers were formed this way in a wet stage at different points in time and set quickly. Slow deposits of micro-organisms or slow deposition of sediments dissolved in the water of rivers cannot explain the formation of these rock formations.

80 Quick stratification of sediments during the volcanic eruption of Mount St. Helen. Setting occurred over a period of five years. The man, standing on the edge of the mountain, conveys an impression of the proportions.

81 During dry spells, the bottom of Spirit Lake (Mount St. Helen) reveals fallen tree stumps that originally did not grow where they are now. Water masses transported them here.

82 More than one million trees were destroyed and washed into Spirit Lake.

83 The splintered and petrified logs at Petrified Forest, after tens of millions of years, rest directly on the surface, where they were deposited during the flood. Cf. picture above.

84 This image of the earth was developed by Michael Anzenhofer, based on radar data acquired by the satellite ERS-1. Clearly visible: the hole, where the Pacific Ocean is located. Picture: Detail of the overall depiction of our earth as a "potato".

85 Satellite imagery served to develop this digital map of the ages of the seabeds. Very young areas appear in dark grey, followed by lighter grey areas as older ocean floor parts. The complete Eastern Pacific Ocean floor is young (no bandings), as are the areas along the Mid-Atlantic Ridge. The oldest parts of the ocean floor in the Atlantic Ocean are colored black and should be 180 million years old.

86 "This sandstone boulder, composed of stream-deposited sand grains, contains a layer of light-grey sandstone. In this layer the grains, which are quartz, are tightly bound together by an unusually hard, natural cement, called silica. Silica cement is more durable than the more common calcite cement of other sandstones. This silica was derived from volcanic ash carried here by winds from volcanoes in western Utah." This official description confirmed the quick setting of originally wet sand mixed with natural silicata cement. This event is no special case, but the general recipe of the formation of sediments and corresponds to the "Natural Concrete Theory".

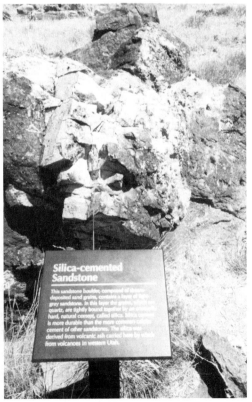

Silica-cemented Sandstone

This sandstone boulder, composed of stream-deposited sand grains, contains a layer of light-grey sandstone. In this layer the grains, which are quartz, are tightly bound together by an unusually hard, natural cement, called silica, which is more durable than the more common calcite cement of other sandstones. The silica was derived from volcanic ash carried here by winds from volcanoes in western Utah.

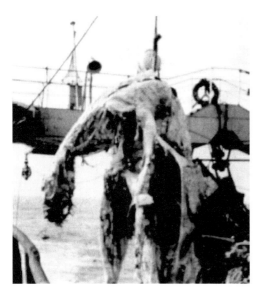

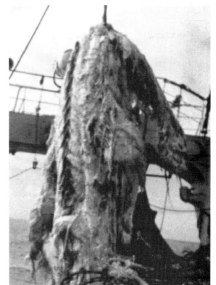

87 This creature, 10 meters long, was caught by a Japanese fishing boat, in 1977. It probably is a plesiosaurus, alleged to have become extinct 65 million years ago.

88 The carcass (picture 87), resembles descriptions of the monster of Loch Ness, seen from the back. Clearly visible, the dorsal vertebra that neither belong to fish nor shark.

89 The carcass lying on the deck of the ship, where it remained for one hour before it was thrown back into the sea. Some think that it is a shark.

90 An ancient wall painting in Pompeii (Italy).

91 Extension of the dinosaur (?) from picture #90.

92 The monster of Loch Ness ("Nessie") as a reproduction of a plesiosaurus.

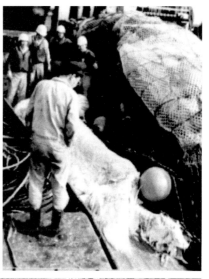

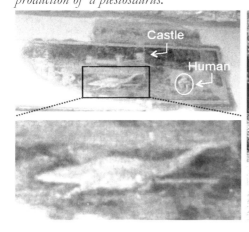

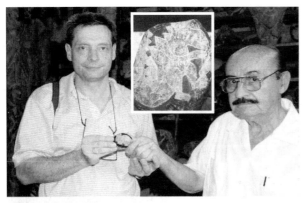

If any pictures of dinosaurs are older than 200 years, people must have seen dinosaurs with their own eyes.

93, 94 Realistic depictions of dinosaurs on Rocks of Ica, Peru. Dr. Javier Cabrera has more than 12,000 stones in his museum. In 1999 the author visited the Cabrera Museum and received one of the stones with an engraved dinosaur. How old are the artifacts really?

95 Innumerable figurines are collective in a locked room in the Cabrera Museum. Several figures show dinosaurs sometimes with humans. The photo shows a man who rides on a Triceratops. At this time there isn't any proof of its authenticity.

96, 97 Acambaro (Mexico) holds a collection of figurines. Some show dinosaurs, others people who feed dinosaurs, like domestic animals. The collection was probably a mixture of authentic ancient and modern artefacts.

98 A strange tablet is attributed to Narmer, the first Pharaoh of a united Egypt. Two mythical creatures are led by people.

99 *Were dinosaurs represented on a vase in the Gold Museum in Lima, Peru?*

100 *Is a dinosaur represented on this vase in Ica, Peru?*

101 *Gigantic ground drawings of mythical creatures into the Andes, Peru, called Nazca lines.*

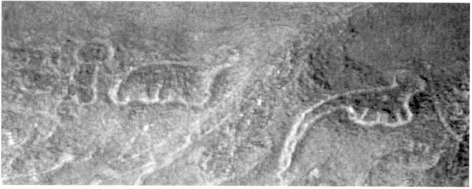

102 *In the El Morro National Park (New Mexico), this drawing has been protected since 1906. The artists were the American Anasazi tribe. The author noticed the detail of the thorn. Was a Desmatosuchus allegedly living 230 million years ago shown?*

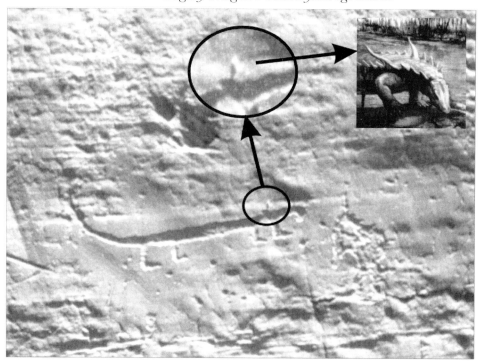

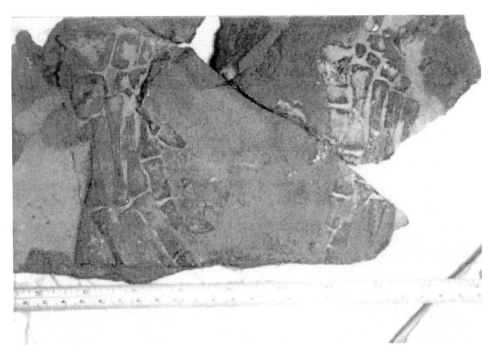

103 The author visited Professor Jaime Guitierrez Lega in Bogota (Columbia) who has fossilized human hands and feet. These were found by Bogota (Colombia) on heights of 2000 metres. In this rock are fossilized ammonites beside this human relics. But ammonites lived in the Mesozoic and died out 65 million years ago. This discovery was for the first time documented by the author. After this, the discovery was exhibited at the exhibition "Unsolved Mysteries" in Vienna. An anatomy specialist in Austria confirmed that these are human hands, because a special bone is visible that is not present in dinosaurs .

104 Jaime Guiterrez Lega and the author in Bogota in 1999.

We cannot rule out that it depicts a planetary approach of Earth and either Mars or Venus, when Earth went astray through our solar system, as Velikovsky – based on ancient traditions – states. This point of view, in harmony with the theories presented in this book, offers a plausible explanation for planetary approaches, that is lacking otherwise. Whatever scenario, it is the depiction of exceptional cosmic events. Different satellites, such as the Pioneer probes, explore the influence of an additional planet in our solar system. The infrared-satellite IRAS was launched in 1983, not least to find this additional planet.

Sitchin relates an interview given to the "Washington Post" – and other newspapers – by a scientist involved in the O'Toole Project, titled "Baffling Large Object on the Outskirts of our Solar System": "A telescope, called IRAS, has discovered a celestial body in the direction of the constellation Orion, possibly the size of the giant Jupiter and maybe so close to Earth that it belongs to our solar system.

The object is so mysterious that astronomers cannot say what it is: a planet,

Fig. 26: Orbit of Planet X. *Sumerian/Babylonian creation accounts speak of the existence of one more planet in our solar system, supposed to have an orbital period of 3600 years on a comet-like trajectory. When a celestial body, the size of a planet, invades our solar system, cosmic disasters and collisions of planets may be the consequence.*

a giant comet? A protostar that never became hot enough to turn into a star? A distant galaxy, so young that its first stars are just about to form? Or a galaxy, veiled by dust clouds, blocking the light of its stars?"[108] The object, sighted twice within six months, had hardly moved in the meantime. Consequently, it is no comet.

Are the Sumerians right after all? If this is the case, such a giant comet, regularly approaching the Asteroid Belt, would have disastrous effects on Earth as well as throughout the entire solar system. From this point of view, collisions of planets, like the destruction of Phaeton is conceivable.

Astronomical information on the clay tablets from the Royal Library of Nineveh include details about "three planetary systems". "The individual planets are fixed in their trajectories by three different systems. Each of these systems is described at great length, but only the last planetary and the last lunar system correspond with the current universal order."[109]

Then influence of a strong magnetic field during the approach of planets may have slowed down Earth's rotation or may even have halted it. There are extremely slow rotating planets, some that almost do not rotate at all, or others, like our moon, with induced rotation, which do not revolve around their own axis. Consequently, our Earth does not necessarily have to rotate in the way or at the speed we are used to. As Earth's rotation has reduced in recent years by an average of one second every 500 days (leap second), our Earth will – if deceleration rate remains constant in the future – show no self-rotation around its own axis within less than 120,000 years. In this case, the same half of the globe will constantly point to the sun, similar to what we on Earth observe in respect to the moon. Should Earth's rotation speed not be constant, this would serve to explain many of the irregularities in the calendar records of the ancient civilizations.

9 Geology and Myth

Ancient records include accounts of floods and other violent disasters. One well-known myth deals with the destruction of the antediluvian civilisation of Atlantis.

Geology from the perspective of Time

Twenty years ago, we only knew of a small number of meteor or asteroid impact craters on Earth. The followers of Darwinism and the Theory of Evolution vehemently denied the possibility of a giant cataclysm and rated such events as locally restricted catastrophes, without any significant global impact, this in order to prevent the fundamental consequences that such cataclysmic scenarios would otherwise have on their preconceptions.

The Nobel Prize winner (Physics, 1968) Luis Walter Alvarez (1911–1988) brought about a significant change in this awareness. In 1980, he opened a new sphere of activity in geology: the search for impacts of meteors, comets, asteroids and larger planetoids, as well as research on how such impacts affect Earth. Alvarez analyzed and documented an asteroid impact ten kilometers in diameter. This impact supposedly occurred 64 million years ago. Its disastrous consequences are assumed to have been responsible for the extinction of the dinosaurs.

In general, such research has to be welcomed, as it has led to a fundamental shift in thinking. There is, however, no telling where this shift will ultimately lead us. The only criticism of the research then, still valid today, is of how the impact date was fixed. This was based on the belief in Darwinism and Lyell's Uniformitarianism.

If dinosaurs and humans existed simultaneously, the event must have occurred more recently or, alternatively, the assumed age of mankind must be pushed much further back in time.

Theories and evidence presented in this book are supported by recent research. There have been thousands of publications in more than 70 languages dealing with the Flood myth and related problems. Almost all publications, however, appear to be based on the assumption that the Darwinian Theory of Evolution was valid. Geology today is inseparably linked with Darwinism. As such, the conclusions drawn regarding time periods in the distant past must be false. The starting points of geology are false because not only did

131

Earth's great sedimentary strata form in a relatively brief time, but the alleged difference of more than 60 million years between the age of the dinosaurs and the beginning of mankind has turned out to be nothing but a fabrication.

As soon as we attempt to re-evaluate the discoveries, rejecting the guidelines of Darwinism as unshakable laws, we will arrive at entirely new ideas and a revolutionary view of the world as defined by the principles discussed in this book. The conclusion remains unchanged: *dinosaurs and humans lived together* and their co-existence proves the invalidity of the Theory of Evolution.

Geology, along with astronomy, is one of the worlds' oldest sciences. But over the course of several thousands of years, ideas *and their various contemporaneous worldviews have constantly been subject to change*. For this reason, geology, in spite of its long tradition, is not categorized with the hard sciences.

Fossils were for a long period considered to be freaks of nature. Findings of fossilized mussels in the higher mountain regions of the world served the church as hard evidence for the biblical Flood. As late as the 18th century, the French writer Voltaire (1694–1778) interpreted these findings in the framework of a dawning Enlightenment. He postulated that these items were lost by early pilgrims. At the time, the opinion prevailed that the Flood had actually happened and that it was responsible for all fossils in Earth history. After Herodotus had identified shells of marine animals in fossils dating from 2000 years before, a literal interpretation of the Bible started in the third century AD. The Bible's interpretation permits only one conclusion: there was at least one cataclysm. Martin Luther (1483–1546) too was convinced of an all-engulfing Flood as proclaimed by church doctrine. William Buckland was one of the last advocates of this idea. In 1823, he presented the old school of thought in his book "Observations on Geological – Phenomena that Produce a Global Flood".

In 1812, Georges Cuviers (1769–1832) introduced the Doctrine of Catastrophism. What distinguished his theory from others was the acknowledgment of a series of floods over the entire history of the Earth, each of which caused abrupt changes in fauna and flora.

Leonardo da Vinci (1452–1519) was the first to define the basic principles of modern geology. He was convinced of an endlessly long history for the origin of fossils as the remains of marine animals. Such an approach allows no room for a flood as an explanation for the origins of fossil strata. Slowly but surely, the opinion that the Flood was a regional, not a global phenomenon, began to gain acceptance. Unfortunately, the church supported this change in opinion.

To this day, the doctrine by Lyell, dating from 1830, promotes the idea of

a world which has only slightly changed in the course of geological eons. His theory not only declares a shift in thinking away from the former theories of universal catastrophe that until then had been considered unassailable. In the end, it superseded these theories entirely. Lyell's principles advocate the influence of minute geological forces, reshaping the Earth surface. His principles leave no room for catastrophic events. A gradual, uniform and hardly noticeable development of the Earth and all inhabiting creatures was assumed to correspond with the ideas of Darwinism.

The principles of the latter are also reflected in the Theory of Continental Drift formulated by Alfred Wegener. Examples of his theory include: rivers, trenching valleys by slow erosion and mountain ranges created by terrain rising only a few millimeters per year over long periods of our Earth's history.

In more recent years, however, it has not longer been ruled out that the uniform development of the Earth, considered to be the normal case, may have been interrupted by a singular cataclysm. The influence of the Nobel Prize winner Alvarez has added to the acceptability of this idea and it thus has entered geology's academic circles. A worldwide significance of such a catastrophic event is now at least no longer sacrilege.

After more than two hundred years, Alvarez' in-depth research unexpectedly revived Cuvier's Theory of Catastrophism. Recent scientific work has at least partly modified Lyell's Uniformitarianism, whereas Darwinism still survives unquestioned. It is generally believed that disastrous events did not significantly interfere with the development of the species. Au contraire: species are supposed to have progressed by mutations. For now, it suffices to say that the occurrence of cataclysms of far-reaching global significance at least makes random selection and a steady progress of the species appear questionable. Uniform development, by its own definition, is one of evolution's fundamental conditions.

Myths about the Flood

Legends and myths have long been thought to be "just some old fairy-tale" – figments of the imagination. More recently, we have discovered that the accounts handed down have often misinterpreted the actual events they describe, be it because of ignorance or a lack of research.

Flagrant contradictions in the accounts often provoked misinterpretations of myths. Winter, heat and flood were phenomena that simply seemed unlikely to coincide. Many early events were therefore separated by adding — long

intervals. Many stand-alone stories were created. Research over the past few years, however, has followed new paths and has come up with new insights. Geologist Tollmann explains: "For us, geologists, the combination of global quakes, the Blaze, the Flood, the Darkness and the Frost that in most accounts of the great Flood are described as closely tied events, furnish a coherent foundation for their natural explanation. The geological research of the 1980s has done detailed research work on this odd linkage of natural phenomena that appear to contradict each other, using the model of the dinosaur-impact." 110

Myths necessarily have to vary according to the geographic location of the ancient tribe who treasure them. Where the Northern people – Inuit, Indian natives of North America or the Germans of Northern Europe – and the Southern people – in Fireland as well as in the highlands – settled, the torrential downpour soon must have turned into heavy snowfall. An impact winter occurring in early fall of the Northern hemisphere must be in line with an equally hard winter in the Southern hemisphere, in early spring. We verify the truthfulness of such ancient accounts by studying the sequences of these events and other mechanisms, described in the myths, and by examining them regarding their geological and ethnological aspects.

By doing so, on account of missing impact features or narrative elements, adapted or falsified by missionaries – frequently in respect to Noach's Ark, it also is possible to carve out descriptions of catastrophes of merely regional influence.

Aside from that, the evaluation of myths helped to determine the type and the course of the flood-impact event, as well as its consequences. The best known portrayal of a flood is found in The Revelation of St. John (6:12-15), probably recorded in 96 AD: "...there was a great Earthquake; and the sun became black as a sackcloth of hair, and the moon became as blood. And the stars of heaven fell unto the Earth ... the heaven departed as a scroll ... and every mountain and island ... were moved out of their places ... every bondman and every free man hid in the dens and in the rocks of the mountains."

This is a vivid description of some of the events that followed an impact: earthquakes; ashes catapulted into the atmosphere, blocking sun- and moonlight; red skies occurring early in the course of the event and recurring later, caused by dust particles enriched with tiny drops of water; and crystals as well as the fall of comet and planetoid splinters.

Revelations (8: 1-13) mentions seven angels (comets or asteroids) whose appearance caused havoc on Earth: "... there were voices, and thunderings,

Fig. 27: Atlantis. *In the Earth mantle, located at the geological position of the Azores plateau in the Mid-Atlantic, there is a hotspot, a place where red-hot magma emerges. Here, hardly any line of magnetic field strength is to be found. This suggests that its origin differs from that of the Mid-Atlantic Ridge area nearby. The magma emerging from the ridge, on solidification, leaves a magnetic field pattern. The Azores today are what remains of the Atlantis mountain range. Plato's description of the island – a mountain range in the North, plains in the island's South – qualitatively coincides with the topography of this submarine region.*

and lightnings, and an earthquake... and there followed hail and fire mingled with blood, and they were cast upon the Earth: and a third part of the trees was burnt up, and all green grass was burnt up ... and as it were a great mountain burning with fire was cast into the sea: and the third part of the sea became blood; and a third part of the creatures which were in the sea died; and a third part of the ships were destroyed. ... and there fell a great star from heaven, burning as if it were a lamp, and it fell upon a third part of the rivers, and upon the fountains of waters; and the name of the star is called Wormwood: and a third part of the waters became wormwood; and many men died of the waters, because they were made bitter. ... and a third part of the sun was smitten, and a third part of the moon, and a third part of the stars; so as a third part of them was darkened, and the day shone not for a third part of it, and the night likewise." And further (9:1-15): "... and I saw a star fall from heaven unto the Earth: and to him was given the key of the bottomless pit. And he opened the bottomless pit; and there arose a smoke out of the pit, as the smoke of a great furnace; and the sun and the air were darkened by reason of the smoke of the pit. And there came out of the smoke locusts upon the Earth: and unto them was given power, as the scorpions ... have power. And it was commanded then that they should hurt ... only those men ... they should be tormented five months: and their torment was as the torment of a scorpion, when he striketh a man. ... And the four angels were loosed, which were prepared for an hour, and a day, and a month, and a year, to slay a third part of men."

This account varies from the previous version and depicts an altogether different impact. It appears that several smaller simultaneous impacts or time-lagged events occurred. A strikingly strong emphasis is placed on the reddening of the sky and the sea. This reference is especially interesting because this passage has been misinterpreted over and over again in the past, when we knew little of the physical and chemical processes that coincided with an impact. Not blood is the explanation for red skies, but precipitation of nitric acid, an immediate consequence of the impact that in the form of corrosive rainfalls redden whatever they come in contact with. These rainfalls would poison water and make it taste like wormwood. Humans would suffer from cauterization just as they would from the sting of a scorpion.

Revelation (16:1–21) refers to the seven angels and the seven apocalyptic disasters coming from their hands, and then goes on to portray: "Go your ways, and pour out the vials of the wrath of God upon the Earth... and pour out his vial upon the Earth; and there fell a noisome and grievous sore upon

the men [...] poured out his vial upon the sea; and it became as the blood of a dead man; and every living soul died in the sea ... poured out his vial upon the rivers and fountains of waters; and they became blood ... poured out his vial upon the sun; and power was given unto him to scorch men with fire ... poured out his vial upon the throne of the beast; and his kingdom was full of darkness; and they gnawed their tongues for pain, ... poured out his vial upon the great river Euphrates; and the water thereof was dried up, . poured out his vial into the air; ... And there were voices, and thunders, and lightnings; and there was a great earthquake, such as was not since men were upon the Earth, so mighty an earthquake, and so great. And every island fled away, and the mountains were not found. And there fell upon men a great hail out of heaven, every stone about the weight of a talent..."

This depiction of the Apocalypse is more intelligible, offering much more detail. The shade of the sea, caused by rainfall carrying nitrogen oxide and nitric acid, is vividly described. *Reddish brown is the color of the blood of dead men, not the light red of fresh blood.* The color corresponds to that of nitrogen-oxide-saturated nitric acid.[110] The sores on human skin caused by acid rain are also realistically described. The enormous heat in the direct vicinity of the site of impact would cause even big rivers to evaporate. We know of similar accounts in the myths of many other cultures.

In the course of the giant deluge, islands sank and mountains were covered by water. We may conclude from this statement that this is a cataclysmic flood and not a number of smaller catastrophes of a localized nature. This does not contradict the possibility that there were several smaller successive disasters. A larger solar-system object may have fragmented or the impacts were caused by a *cluster of asteroids* (fragments of the planet *Phaeton*). Impacts may even occur with delays up to a couple of years because some fragments may swivel into trajectory before eventually falling to the surface of the Earth.

There are hundreds of flood-accounts in the world that vary in their depiction of the events and its circumstances, depending on the distance that lies between them and the site of impact. Only more recent research has correctly interpreted the material gathered by ethnologists. Myths narrate not only the successive stages of the deluge, but offer documentation about the sites of where the impact occurred also. *Geological research since 1980 has confirmed that the Earth was hit by a number of solar-system objects.*

The American continent must have been affected by the flood. Almost all oral traditions of Native Americans include vivid accounts of flood experiences. The Navajo tell of a flood as high as the mountains, covering everything except the lands lying to the West. The oral legends of the Choctaw

tribe speak of a long-lasting darkness followed by a gigantic tidal wave as high as the big mountains and approaching from the North.[111]

Old Tibetan sources mention the flooding of the Tibetan highlands. According to the old Chinese chronicle "Schu-King", the cardinal points were redefined, the motion and rising of sun, moon and the constellations recalculated and recorded, as well as the length of the seasons accordingly adapted. A new calendar was developed. Velikovsky aptly sums up the explanation for the measures narrated in the Chinese chronicles: "[they] give the impression that during the cataclysm the orbit of the Earth and thereby the year, the inclination angle of the Earth axis, the seasons, the trajectory of the moon and the month were changed. We are not told what caused this overthrow of the world but the old records mention that under the reign of Yahou a bright, shining star, appeared in the constellation Yin."

Plato's Narration

In more than 2500 years, many have been convinced that somewhere between Spain, Africa and America there once existed a vast island. Many of these speculations have been defended and dismissed since. What we know of the island is what Plato (427–347 BC) included in his dialogues, known as Critias and Timaeus. Critias, Plato's uncle from his mother's side, specifically emphasizes that even though the story sounds strange, it nevertheless is a true story, brought to Greece from Egypt by Solon, the sage.

The island referred to is the legendary island of Atlantis. Plato stresses the fact that it is not to be found within the Mediterranean, but somewhere beyond the Pillars of Hercules (Gibraltar and the Atlas mountain range). Plato continues: "The island was larger than Libya and Asia put together, and was the way to other islands, and from these you might pass to the whole of the opposite continent that surrounded the true ocean; for this sea which is within the Straits of Heracles is only a harbor, having a narrow entrance, but the other is a real sea, and the surrounding land may be most truly called a boundless continent." (Timaeus)

The preciseness is next to unbelievable, if we take into account that the story was written down by Plato but is said to be based on much older Egyptian sources. Not only is the Mediterranean described, including the Strait of Gibraltar, but another mainland – America – is believed to exist somewhere beyond the Atlantic ocean. In between, an island the size of a continent is supposed to have existed. We have to bear in mind that less regions of Asia

were known at the time. Asia was considered to be much smaller than it actually is. Almost two thousand years before Columbus discovered America, who may have known of the existence of a mainland – not an island – beyond the vast ocean? Strictly speaking, even Columbus never set foot on the American mainland. If this description turned up true centuries later, then why should the description of the island be less truthful?

In the past 2500 years, the reports of the large island in the Atlantic have been treated as a hoax and called mere fiction. The story sounds incredible because no trace of such an island has been found above sea level apart from maybe some smaller groups of islands such as the Canary Islands, Madeira, the Azores or even the Bahamas or Bermuda.

Aristotle, a disciple of Plato, criticized the story of Atlantis, calling it a fabrication. He confirmed however that the Phoenicians knew of a large island in the Atlantic, called Antilla. The similarity of the names Antilla and Atlantis is striking. The names given to many islands on this as well as the other side of the Atlantic Ocean therefore remind us of Atlantis.

Old records called the people of Northwest Africa who inhabited the regions along the Atlantic shore Atalantes or Atarantes. Among some Berber tribes, there are reports of a belligerent kingdom named Attala. The Vikings mused over the legendary land Atli, thought to lie to the West. Old Indian scriptures offer references to an island by the name of Attala, located half a world away in the Western ocean. The Aztecs believed that they originated from the island Aztlan in the Eastern seas. Seen from Central America, this refers to a location in the Atlantic.[113] Are all of these similarities pure coincidence?

Today, the names Atlantic Ocean and Atlas mountain range remind us of Atlantis. Greenland is bordered by the Greenland Current, Mexico lies in the Gulf of Mexico, India is in the Indian Ocean, Persia is in the Persian Gulf, then why should not Atlantis be found in the Atlantic?

Plato intimates comprehensively and in detail the topography, including rivers, channels and mountains. He tells of the type of government, gives population figures and speaks of the animal world.

He goes on to quote an Egyptian priest from Sais, a city located in the delta of the river Nile: "There have been ... many destructions of mankind ... There is a story, which even you have preserved that once upon a time Paethon, the son of Helios, having yoked the steeds in his father's chariot, because he was not able to drive them in the path of his father, burnt up all that was upon the Earth, and was himself destroyed by a thunderbolt. ... this actually signifies a declination of the bodies moving in the heavens around the Earth,

and a great conflagration of things upon the Earth, which recurs after long intervals..." This confirms the apocalyptic influence of a body in our solar system thrown out of trajectory, even if no impact is explicitly mentioned.

The priest continues his narration about the subsidence of the island of Atlantis: "But afterwards there occurred violent earthquakes and floods; and in a single day and night of misfortune all your warlike men in a body sank into the Earth, and the island of Atlantis in like manner disappeared in the depths of the sea. For which reason the sea in those parts is impassable and impenetrable, because there is a shoal of mud in the way; and this was caused by the subsidence of the island."

This passage in particular has been presented as implausible. How could an island, not to mention a small continent, possibly vanish in a single day? The theories of Lyell and Darwin with their understanding of a very gradual and uniform development of the Earth's surface and its fauna leave no room for cataclysms of this kind; they contradict them entirely. The doctrine of uniformity strongly rejects *the possibility of radical geological changes of such disastrous dimensions* and the disappearance of a large island of maybe 200,000 square kilometers without the slightest trace. This is why the story of Atlantis has been and continues to be rejected.

But geology's latest research shows that either a minimum of seven main fragments of a comet or a number of scattered solar-system bodies hit the various oceans of the Earth. Until now, not even a minor impact in the region, as outlined by Plato, or its environs could be identified. On the other hand, Plato placed Atlantis in one of the world's most unstable regions, close to the largest drift boundary of the Earth, the Mid-Atlantic trench rift zone.

"Here, the extremely thin crust of the Earth – nowhere on Earth do we find thinner crust – is not only subject to permanent tensile stress, it is also weakened by a dense net of gigantic longitudinal fractures and just as significant transverse fractures. This extraordinary type of crust rests on top of a lava chamber often some dozen kilometers wide, a cushion of thin-bodied basaltic lava, approximately 1200 °C hot. That cooler, and thereby denser and heavier, slabs of crust floating on an underground consisting of hot, specifically lighter lava, will collapse under the impact of a worldwide quake of unimaginable intensity is predetermined. ... we only know today that this crucial region of the Mid-Atlantic in the area of the Azores holds one of the few hot spots of the Earth, where hot streams of magma emerge from the depths of the Earth's mantle and add to the mobility of the lava."[114]

Computer simulations from 1996, carried out at the acclaimed Sandia National Laboratory in New Mexico, USA, prove that an asteroid with

ten kilometers in diameter striking our Earth would produce an impact crater 30 kilometers deep in no more than nine seconds. The shock waves triggered by the impact would be transmitted all over the globe, bundled in the Earth's interior – comparable to an optical lens bundling rays of light – and reflected to the opposite side of the planet. If a similar impact occurred there simultaneously, the combined tremors would make the Earth crust crack and cause disastrous eruptions. Naturally, the crust would tear at the very thin crustal spots along the existing perforation line first. This may have been the cause of the Atlantis disaster.

During a seaquake South of Tokyo, on September 1st, 1923, parts of the ocean floor were lowered more than 450 meters, other parts uplifted by an estimated 250 meters.[114] How much stronger must the consequences of the flood-impact have been?

As a consequence of these processes, the island of Atlantis too sank relatively fast by some thousand meters. The Atlantic forms a huge tub, split in half by a mountain ridge under sea and up to 2500 meters high, called the Mid Atlantic Ridge or Dolphin Ridge. The Western basin on average is about 6500 meters deep and as such an estimated 2000 meters deeper than the basin that lies East of the ridge that marks the rift between the continents, from which magma emerges to this day.

The accounts state that Atlantis sank within 24 hours. This timescale has been criticized over and over again. Otto Muck calculated that this figure, because of the geological peculiarity of this region, is precise when one assumes the sinking speed of the huge island to have been about 4 to 5 centimeters per second.[115]

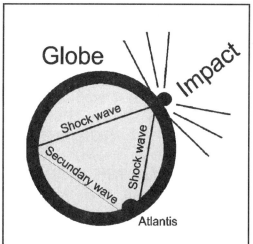

Fig. 28: Shock waves. When a body of our solar system strikes the Earth, the impact produces a shock wave. It penetrates the earth mantle, multiplies and reflects to all sides, causing cracks in the Earth's surface, eruptions and earthquakes in regions far away from the original impact site, even on the opposite side of the globe.

The course of the flood disaster corresponds with the description given by Plato: earthquakes, floods, cracks in the ground, collapsing land and lowering seafloor. One item remains to be examined: Plato states that the sea in those parts became impassable and impenetrable for ships, because there was a shoal of mud, caused by the subsidence of the island.

The eruptive material of volcanic eruptions in the past consisted of coarse materials, ashes and fine dusts. The coarse material of volcanic submarine eruptions is not as compact as flowing lava. Interacting with water vapor and liquid magma, it becomes very porous. The pumice stone that is produced by this process forms the larger part of the spills. Due to tiny air bubbles locked inside, pumice floats on the water surface for a long period of time. Greater volcanic eruptions may form extensive floating covers that would also impede even modern marine navigation across it. Wave motion of the sea slowly grinds the pumice stone to sand. Enormous amounts of ashes build an additional mud layer on the water.

The eruption of the rather small volcanic island Krakatoa in Indonesia in 1883 demonstrated how floating pumice stone not only endangered shipping, but made it altogether impossible. This layer was just 25 centimeters thick.

Based on these facts, Muck calculated the thickness of the coat of pumice stone, floating on the ocean surface, after the subsidence of Atlantis as 100 centimeters. Plato confirms this: "The sea in those parts is impassable and impenetrable, because there is a shoal of mud in the way."[115]

Plato seemed to describe something unusual. By his details, however, we perceive the truthfulness of his account. It is simply too good to be fictitious and in accordance with our latest research.

The seabed in the area of the Azores must have lowered relatively fast, and by 2000 or more meters. The submarine landscape is characterized by sharp edges, ridges and deep crevices. If this region was older, chemical and mechanical influences would have rounded the finely cut shapes.

Charles Berlitz and Otto Muck speak of characteristic discoveries from the bottom of the sea in the area of the Azores that we actually would expect to find on the Earth surface.[115,116] In his book entitled "Adam's Planet", Johannes von Buttlar described such discoveries: "In the course of a research project by the University of Halifax in 1973 and 1974, core samples from the Mid Atlantic Ridge were taken and analyzed. The results showed that the rock formation, lying under water at a depth of 800 meters, originally must have formed above sea level. The Swedish scientists R. Mailaise and P. Kolbe in 1956 already had made a particularly interesting discovery. They had succeeded in identifying the remains of diatoms in a depth of 3700 meters. Diatom is a

type of algae that must have lived in sweet water lakes 10,000 or 12,000 years ago."

"In 1898, repairs on the transatlantic cable, at a distance of 750 kilometers away from the Azores, became necessary. The search for the cable break revealed an ocean floor landscape of valleys, mountain tops and cliffs. Rock samples taken at a depth of 3100 meters turned out to be Tachylite (basalt glass). Tachylite exclusively forms under atmospheric pressure. It therefore must have formed above water. Apart from that, it takes 15,000 years for lava to decompose and so the Mid-Atlantic Ridge must have been a landmass at the time. Evidence, found by a – then Soviet – expedition in 1977 to an area North of the Azores, enforces this theory. It brought to light surface rock material from a depth of 2000 meters.[117]"

Different examinations of sedimentary columns have shown that the whole region around the Azores must have subsided by 2500 or 3000 meters. Globular limestone, for example, was discovered at a depth of 7500 meters, a discovery that is only possible at a depth between 2000 and 4500 meters. Therefore the examined region must have been lowered by 2800 or more meters. The Azores of today were the mountain tops of the once large island Atlantis.

Plato did not choose the first person narrative for his story of Atlantis. He also called everyone who attempted to interpret the story as a mythology a liar. Socrates, Plato's teacher, states in the Timaeus: "... and has the very great advantage of being a fact and not a fiction." Today's scientific research has confirmed the geographic and geologic specifications given in Plato's Atlantis narrative. It may well be that other parts of the story about the people of Atlantis are just as true. Was not only the island of Atlantis buried by the sea, but was a highly sophisticated civilization of pre-flood times buried along with it? If that should be true, and it should also be true that this civilization ruled the world, then Atlantis can be found all over the world in the form of its colonies that have survived. Maybe the cities of these colonies shared similar structures.

The Atlantic must have been much more narrow than it is today, not only because of the sea level then between 100 and 200 meters lower and the effects of the divergent continental drift, but also because the vast island of Atlantis with an estimated diameter of 1100 kilometers allowed for an easy —- crossing between Europe, Africa and America. The similarities of the different cultures on both sides of the Atlantic, artefacts and characters of the old world turning up in America from this perspective are no longer mysteries, but evidence of normal trade relations.

Is the Continental Drift Contradictory?

If the narration of the subsidence of a large island in the Atlantic encodes historic facts, does it not contradict the generally accepted theory formulated by Wegener? The Theory on the Continental Drift, introduced early in the 20th century, is based on the assumption of one single giant continent that existed a long, long time ago. This original continent disintegrated into smaller plates. Some time later and for some reason the continental plates started to diverge. The theory is true in so far that America must once have bordered directly on Africa. One look at a world map proves the point. On top of this, identical layers of rock were found on both continents. But contrary to Wegener's concept, the shelves of the North Atlantic do not fit together. *Instead, the boundaries of the Atlantic Ridge, deep under the Atlantic water do.* Between Africa and Europe on one side and Canada on the other side of the Atlantic a hole is formed that lies Northwest of the collapsed Mexican basin.

The development of the basin by the collapse of a landmass must have had devastating consequences for the Earth. The effect of one singular impact

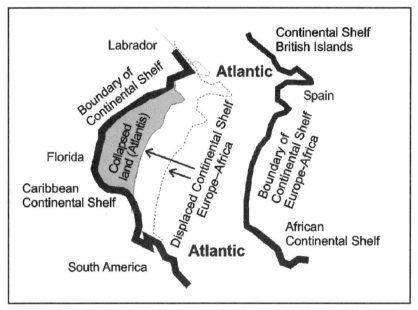

Fig. 29: Continental shelf. *The boundaries of the continental shelves of Africa and South America form an exact match. In the North Atlantic, the shelves of Africa, Europe and Northern America fit to the Mid-Atlantic Ridge. They indicate a missing landmass, a collapsed basin. It covers a space large enough to hold the lost island of Atlantis in the area of the Azores.*

and the multiplying shock wave it produced has been described as disastrous. Its consequences included the blocking of the sunlight and a climate shock. But what would happen if seven, eight or more larger and many smaller impactors struck in succession? Volcanic eruptions, earthquakes and other effects would almost entirely destroy the Earth's crust and reshape it. Mountain ranges would fold upward, valleys would be formed and huge sedimentary layers would be deposited. Plateaus would subside or be newly shaped by magma, emerging from the Earth's interior.

These circumstances not only allow us to see a deluge from another viewpoint, but they prompt us to reconsider our ideas concerning the continental drift. Violent cataclysmic events do not correspond with the theories of Darwin and Lyell. The continental drift within the scopes of the above-mentioned cataclysmic processes took place relatively quickly, even though there might have been some intermittence. It did not occur gradually.

The original continent, named Pangaea, with some probability disintegrated immediately after the explosion of Phaeton/Tiamat and in accordance with the events I outlined earlier. Only a few thousand years later did the deluge shift the continents even further apart. Before the deluge, cultural exchange between the people living on different continents was easily achievable. Maybe this could also serve to explain the similarity in words found in the most different languages on all continents of the world.

There is evidence that at one time in the past, there was one unified language in the world. My theory could solve this mystery: *One original people created by gods would also have shared one language.* After all living spaces were colonized, the languages went on to develop independently from each other. Aside from that, trade between the civilizations of neighboring continents encouraged mutual influences. The Bible's depiction of the building of the Tower of Babel, an illustration of experienced language confusion, fits into this concept. It testifies to the idea that in a past not too long gone, mankind shared one mutual language.

After the flood, landbridges no longer existed. Animals that had crossed those bridges became stowaways on rapidly diverging continental plates. This explains why we find *the same dinosaur species in both Australia and America.*

Lawrence Witmer of the Ohio University in Athens, USA, discovered a skull on the island of Madagascar. It belonged to a tyrannosaurus, a species that became extinct 65 or 70 million years ago. Findings of this particular type of dinosaur in various parts of the world show that a landbridge once must have connected Africa, Asia,and South America. "Madagascar was once part of a vast Southern continent called Gondswana, which at the height of

the dinosaur era, began to break into segments of different sizes." [118] The Antarctic was part of this proto-historic landmass and as such at least partly free of ice. The presence of a number of the same protozoa species – dinosaurs as well as other fossil mammals – on almost all continents further shows that landbridges must have *existed in a past not too long gone* and that dinosaurs then still inhabited the Earth. This serves as evidence that continents "... were connected, much longer than until now believed." (source?)

However, if the continents diverged later, then the drift speed must have been much higher than has been assumed until now. Are these different processes altogether compatible with the theory of uniformity that assumes only gradual changes of the Earth? Something must have increased the drift speed of the continents.

As geologists too not only assume the existence of one original continent, but also the existence of landbridges during the lifetimes of dinosaurs, only one logical conclusion remains: *the continental plates formed one landmass not more than a few thousand years ago.* The scientifically accepted continental drift theory by Wegener is correct within these circumstances. However, the speed of the continental drifts was much higher and did not last several million years.

10 A Global Flood

Only a couple of thousand years ago, a global flood submerged and burned the Earth. In the course of this event, mineral oil, coal and amber formed, whereas mountains and ranges were folded upwards.

The Course of the Flood

The dispersion of cosmic impacts over the entire globe is the result of the Earth's rotation. At the same time, this indicates a consecutive course of events.

Apart from the impact crater, Luis Alvarez discovered near the Yucatan that there were more large holes in the Atlantic's seabed, stemming from even larger planetary objects. In the area of Puerto Rico, there are two holes in the bottom of the sea, both 7000 meters deep, which are included in almost every map. Otto Muck assumed that they were caused by the impact of two fragments of giant planetoids coming in from the Northwest, each weighing one trillion metric tons. Such chunks would create tidal waves of ten kilometers in height, submerging even Mount Everest, which at the time may have been less high than it is today. The Bible and several myths expressly confirm a tidal wave and fossil finds at the higher elevation levels of high mountains provide the proof for these claims.

Some of these myths mention more than one impact. The flood legend of the Yámana recounts two separate impacts. After the first disaster had struck, a second one was reported to have flooded the mountains shortly afterwards.[119] In their myths about the years of the world, the Aztecs describe the course of the flood in detail. Four global cataclysms are distinguished, claimed to have extinguished mankind. The human race of the present is believed to be the fifth and perfect generation. The first human race was wiped out by the demon of darkness that ate man. The second epoch was torn away by the wind. At the end of the third epoch, fires from the skies burned mankind. The fourth epoch, of the watery sun, ended with the skies collapsing and falling to the ground – i.e. the storm-rain tide. The fifth epoch is the age of the Earthquake-sun. This characterization is fitting, because the impacts of the flood have strongly shaken, broken and pierced the Earth's crust. Earthquakes and eruptions persists today and may be considered the

delayed consequences of the enormous flood disaster.

The Tollmanns sum up the more recent findings about the course of the flood as follows:

· Impact of comet (asteroid, planetoid).
· Impact-induced earthquake.
· Raging volcanism.
· Blaze and global conflagration.
· Impact night.
· Impact winter.
· Downpours, snow flood and boiling ocean waters.
· Formation of pollutants.
· Ozone decomposition and radiation.
· Greenhouse effect.
· Widespread deaths following the impact.
· Extinction of life.[119]

Prior to Alvarez' research, all these events were considered to be isolated cases of locally restricted influence. They were not put into a global context. There was simply no logical explanation for individual scenarios, such as an impact winter with related instant freezing of the mammoths.

The Burning Earth

The computer simulations that were mentioned earlier and were carried out by the Sandia National Laboratory in Albuquerque, New Mexico, showed that enormous dust clouds caused by the asteroid impact in the Yucatan darkened the sun. The ensuing cooling of the Earth led to a climate shock; many creatures (dinosaurs, mammoths, etc.) did not survive. Apart from these phenomena, ground zero of the impact must have suffered an increase in temperature by several thousand degrees, so that from one moment to the next, 100 billion metric tons of rock evaporated. The sulphuric content transformed into a dense and very stable sulphur cloud in the upper atmosphere.

From the large hole in the Earth's crust enormous amounts of magma emerged, spreading over vast areas and burying everything within reach. Maybe this is how the 500,000 square kilometers Dekkan Plateau on the Indian subcontinent formed. The heat wave radiating from the center of the explosion may be what triggered the violent global conflagration. The induced hurricane

and a storm of scorching heat were able to rage forward at a speed of 1200 kilometers per hour, tearing down trees and entire forests as if they were matches. Splinters of comets and red-hot fallout (nuclear fallout) followed, producing disastrous and extensive fires that spread from different centers into all directions. The scorching heat burst rocks, drained rivers and made the seas and oceans boil. Comparisons with major urban fires and extensive blazes point to temperatures way above 1500 °C.

The myths therefore do not exaggerate when they report ore in the mountains that liquified. Consequently, reports in ancient Persian religion about metals that melted inside the mountains and flowed over the Earth in a red-hot stream are truthful. The melting point of copper is around 1083 °C, that of silver around 921 °C, gold 1063 °C and pure iron melts at 1535 °C. These temperatures were exceeded in our global disaster. In light of this knowledge, ancient myths no longer appear as imagination-soaked transmissions, as has been supposed for so long.

A soot layer in the atmosphere reflected the heat and increased the drying of the Earth's surface. Some materials may have been subject to sintering effects. At a distance of up to 1000 kilometers, cooled-down eruptive elements that had already fallen to the ground now melted again. The sky glowed and as a red-hot cloud virtually came down on Earth's surface. Soot, stemming mainly from burnt conifers and their resin, was found in the clay border layers. Ancient Indian writings speak of live charcoal raining down.

The Quiché of Guatemala had to deal with a resinous mass falling from the sky, and a "a great roar above their heads" was heard, as if from a blaze.[120] Velikovsky writes about the Buddhist book of the "Visuddih-Magga", which also contains a chapter on the world cycles. "There are three destructions: the destruction by water, the destruction by fire, and the destruction by wind... after a long time had elapsed after the rain had stopped, a second sun appeared ... there was no difference between day and night ... and incessant heat burned down on the world..."[120] The "Sibylline Books" explain: "The nine suns are nine ages ... Presently, it is the seventh sun." Velikovsky asks whether the reason for using the word *sun* instead of *age* may because "with every age the appearance of the star and its trajectory in the sky changes?"[120]

The Tidal Waves

In chronological order, after the quake of the Earth's crust, coinciding with gigantic volcanic activity, followed by the blaze and global transformation,

appeared what we actually understand by the word "flood": a huge tidal wave. A wall of water as high as mountains raged across the twilight, caused by ashes, with an increasing roar from horizon to horizon, towards the land's interior. Volcanic activity and the eruptive material emerging from ruptures in the Earth's crust heated the water of the sea. The boiling surges went beyond high mountains and mountain chains. Everything that had survived to this point was now scalded and scorched. At the same time, the blazing fires were extinguished. And so artificial objects and leaves survived in larger accumulations, burnt to coal. For these exceptional findings – which, even without closer examination, to our familiar worldview, *must be forgeries* because they were deposited in a geologically too early layer – the flood offers a convincing, logical explanation that is lacking from the traditional school of thinking.

At the higher elevation levels of the Alps, Himalayan and other mountains, the gigantic tidal waves left fossil and marine traces that almost every hiker is familiar with. Remains of large ships and stone anchors were found at an altitude of 4000 and 5000 meters in Eastern Anatolia, Turkey, on the Ararat Mountain, where Noach's Ark might have landed.

Genesis (7:19-21) reports on the hugeness of the tidal waves: "And the waters prevailed exceedingly upon the Earth; and all the high hills that [were] under the whole heaven, were covered. Fifteen cubits upward did the waters prevail; and the mountains were covered. And all flesh died that moved upon the Earth."

Quite clearly, the uncanny extent of the gigantic tidal wave is expressed: *all the high hills*. Geological findings, ancient writings and other evidence presented in this book confirm this statement, even if we have to assume that prior to the flood, mountains were not as high, as the creation of mountains was partly only completed during the flood.

Myths of many people all over the world confirm this incredible deluge. The Gilgamesh epos mentions mountains immersed in water. In the Egyptian Book of the Dead, the sun god Ra speaks of the great flood he created and the god Amun threatens to destroy the Earth: "This Earth shall turn to water, an ocean by flood, as she was from the beginning on."[121]

The Cheyenne and other Indian tribes possess knowledge of four floods in their original home, located further South. The last flood is said to have occurred *many hundred years after* the main disaster. It is reported to have comprised of an earthquake, volcanic eruptions, great floods and a long winter.

The Chinese "Book of Scriptures", dating from the 6th century BC, relates a huge flood, submerging the world and the highest mountains of the world.

The legends of the Southern Cantonese mountain people, the Jau-dze, speak of waters rising so that the highest mountains resembled the seas.[122] The Inuit gave a similar description of the flood: the water flowed over the mountain tops and ice drifted across them. When the flood subsided, the ice stranded and formed icecaps on the tops of the mountains everywhere.

Interesting is the statement in reference to glaciers having formed during the flood, instead being the result of climatic fluctuation. Whether in Northern Siberia, India, Mongolia, Vietnam, Sumatra, Australia or South America, traditions speak of huge surges of water that inundated even high mountains.

America is particularly rich in flood myths. The Navajo tell in their myths of water like a rock face without gap and of a flood like a mountain range taking up the entire horizon. Similar statements are included in the oral traditions of the Choctaw in the Oklahoma-Mississippi region, as well as in Peru and in Aztec writings.[122]

The course of the entire flood did not take the form of one single tidal wave. All in all, there were several impacts in different parts of the world. Earthquakes radiated from where the Earth's crust had been torn, all over the world, causing the dreaded tidal waves – tsunamis – in the sea. The different impacts and ruptures in the crust of the Earth gave rise to giant tidal waves, followed by more waves, intersecting and overlapping in various parts of the world.

We are able to identify four individual and – in terms of time – separate great flood waves in Indian oral traditions in North America. In the area of Paluxy River near Glen Rose, these distinct flood waves left overlying strata behind, varying in thickness between one foot (30 centimeters) and ten feet (3 meters). The individual strata vary in solidity of structure, allowing one to peel them like onion skins. Here, we see particularly well that the individual layers did not form gradually, as geologists claim, but that these are the fast setting deposits of distinct and consecutive floodings.

The Darkness

Almost all myths so far cited or mentioned also relate a darkening of the sun. They mostly describe it as the *duration of a long night* or *for a long time*; the Gilgamesh epos reports of extinguished stars, sun and moon, coinciding with the darkness.

When the small volcanic island of Krakatoa in Indonesia's Sunda Strait erupted in 1883, a relatively small amount of eruptive material was noticed,

less than 100 cubic kilometers. The dust particles were carried 30 kilometers high into the atmosphere, dispersed around the Earth and were identified there afloat for two years. This led to the effect of the red shining sky that also could be seen after other volcanic eruptions.

Judging from the much longer active rupture in the Atlantic Ocean, the volume of eruptive material must have been maybe forty thousand times greater than that of the Krakatoa explosion. Because huge masses of dust, smoke and ash were simultaneously blown into the atmosphere in several places, the hazy cloud, tens of kilometers big, spread rapidly throughout the continents.[123]

In many places, myths mention that the flood arrived when the darkness had spread and that its duration differed from region to region. Prevailing wind directions show that the density of impacts in the Northern hemisphere was stronger than in the South. Consequently, in Northern Europe the phase of darkness lasted longer, the formation of ice was more prolonged and snowfall was heavier than in the Antarctic.

In the Southern Mediterranean region and Mesopotamia the impact-induced night did not last as long. Longer lasting darkness and the ensuing twilight resulted in the Northern civilizations requiring more time to recover. Evidence for this is found in Nordic legends and myths. Freezing and heavy snowfall, caused by the displacement of Earth's axis and an impact winter, left only gradually and hindered the development of the Nordic races.

Archaeology refers to the time prior to the rise of advanced civilizations as the Stone Age. The world was almost entirely destroyed by the flood. After this apocalypse, mankind had to start again from the very beginning. They were however left with some technical remains and memories of the time before the flood. This is why there are so many remains of tools that appear to be too old to fit into the familiar picture of evolution and the gradual development of mankind. It surely is no Stone Age in terms of a stage of development of humanity, even if mankind had to live under very primitive conditions.

We are familiar with the lasting effect that lack of light has on plants. Leaves and stems bleach due to the reduced content of chlorophyle. Under the dark cloud, the living conditions of plants were meager. The conditions for animals and humans in the years of darkness following the flood were much the same. The number of red blood cells decreased and humans became more anemic and paler. Otto Muck consequently asks: is this how the light color of skin, poor in pigments, developed and with it the white race?[123] Granted, a very provocative question, but nevertheless a fascinating one.

The effect of the dark clouds on the animal world and us humans was incisive. Dinosaurs, mammoths and other animals became extinct. The giant plants, which we know from petrifaction, decayed and regenerated to no more than a mere mini-edition of their former selves. The known gigantism of earlier eras of Earth's history ended with the flood, rather than tens of millions of years ago.

A Sudden Drop in Temperature, Snowfall and Torrential Downpour

The Nordic myths describe how the seas rose up to the sky, violent storms, masses of snow came from all directions, harsh frost and three winters with no summer in between occurred. The Wogules of Northwest Siberia remember a snow cloud crashing down, coinciding with the global flood.[124] The Chukchi at the Bering Strait in Northeast Asia know a terrible snowstorm that killed most humans. The Indians of America's Northern regions report of a long night, heat, flooding by mountainsand and snowfall covering next to all fir trees.[120] By analogy, there are similar transmissions about snow storms and snowfalls, lasting several months at the Southern tip of America in Tierra del Fuego.[121]

Cooler temperatures were apparent throughout the world. Low temperatures in the atmosphere in the impact night made the masses of vapor, hurled up earlier by eruptions, fall down on the entire Earth in the form of dense snowfall at elevation levels of 1000 meters and more. As reported in detail, this is the decisive and only possible scenario for the formation of icebergs.

In other parts of the world, at lower elevation levels, there was no snowfall but instead torrential downpours washed everything away. Myths speak of boiling hot masses of water falling from the sky, scorching everything. At first glance, these statements seem contradictory. They, however, produce a conclusive overall picture and testify to the indescribable cataclysm that had struck the entire Earth.

As the Tollmanns note, the glaciers in America's far North were partly formed from snow masses that turned into ice and partly from pools of ice left behind after the return flow of icy sea waters thrown ashore by the tidal wave, coming from the Arctic Ocean, as is described by the Central Inuit.[121]

Ensuing Damage of the Flood

The eruptions released enormous quantities of pollutants, such as carbon acid, sulphur dioxide and other gases, into the atmosphere. Moreover, nitric and other acids were produced. The heat from the global blaze and the liquified ores in the mountains activated the heavy metals and released dangerous poisons and gases. As a consequence, hot acid rains fell on Earth and destroyed everything alive. Aside from nitrogenous gases – which for example killed more than 30 000 people, when released by the rather small eruption of Mont Pelée in 1902 - and the high concentrations of carbon acid, volcanic eruptions blow relatively large amounts of water into the atmosphere.

I have mentioned the phenomenon of reddening skies earlier. It results from a chemical reaction in which nitric acid is saturated with nitrogen dioxide. Over-fertilization from the nitric acid, neutralized in limestone ground with nitrogen, in combination with sludge produces the later fertile soil.

The ozone layer, if it already existed at all, broke down completely as large amounts of oxygen were consumed. After the dark clouds had dissolved and the protective sphere of vapor had collapsed, intense ultraviolet rays reached the Earth's surface almost unhindered. Radiation combined with released pollutants damaged cells and the genetic make-up. Deformed children and sterility were the consequences. Maybe this led to the depictions of various monsters encountered in mythology, such as the Greek one-eyed Cyclops.

Due to the environmental conditions preceding the flood, humans and animals then probably enjoyed substantially longer lives. Later, pollutants and radiation reduced man's life expectancy. Even biologists are convinced that man – in purely biological terms – under ideal conditions, is capable of exceeding its life expectancy many times over. This is something that has been successfully proven with genetically altered mice. Life spans are genetically pre-programmed. After a maximum of 100 cell divisions, the amount of a certain molecule (telomeres), determined at birth, is used up – the tank is empty. Regeneration and control of this molecule substantially increase life expectancy. For our present scientists, this is no longer an utopian vision. Nevertheless, only a few years ago, these ideas would have been ridiculed and described as mere figments of the imagination.

Genesis (6:3) once again confirms this observation: "And the LORD said, My spirit shall not always strive with man, for that he also [is] flesh: yet his days shall be an hundred and twenty years."

Loud and clearly does this express the willfully limited life expectancy of mankind. This statement also corresponds with the present state of knowledge.

The average age we reach today is *not decreed by nature*, but apparently was *artificially planted* into our genetic make-up. Of interest is the usage of the word "also" in respect to the worldly body. Does this mean that god – or the sons of god mentioned in the context – is similar to man? Does a real god need sons or servants in flesh and blood?

Emergence of Coal and Oil

Hard coal formed from plant elements, while mineral oil according to the scientific conviction derives from organic constituents – mostly animal carcasses and biological waste. There are deposits of mineral oil and coal all over the globe, even in arctic regions and Spitsbergen. This suggests that oil resources are mass graves of a variety of animals. The gigantic consumption, as well as the reserves of far more than 100 billion metric tons, point to a *global cause* for their formation and a gigantic mass of dead organisms. Because this process must have taken place all over the world, the flood is the most obvious event that could have triggered it. The mere fact of dying does not preserve an organism. Instead it decays and simply disintegrates due to mechanical (varying temperatures, heat, frost), biological (scavenging animals and decay) or chemical (acids) influences. This results in the scenario we have observed over and over again: everything must have happened rapidly for mineral oils and coal to form at all. Moreover, it could not have been a restricted area, but must have affected the entire world – as widespread deposits and sites of fossil findings prove. The existence of raw material deposits testifies to a cataclysmic event and contradicts a uniform and gradual development of Earth and of the plant and animal world in particular. Noteworthy is that the great resources of oil are found close to the major flood/impact areas, such as Texas, in the Persian Gulf and in the North Sea.

Global findings of oil and coal consequently represent evidence for a worldwide flood. On the other hand, I am in doubt whether there was enough biological material in the past to form such gigantic resources. (Short of the mighty seams of soft coal.)

Is there another possible working model to explain the formation of mineral oil, not relying on organic substances? "Yes, of course", the answer should be. When *hydrogen and carbon* – both existing in sufficient amounts in Earth strata - are brought together by great pressure and heat, *petroleum is produced*. The theory of an inorganic origin of mineral oil without any biological mass fits into the outlined model of a global flood. It provided the decisive

geochemical conditions, i.e. pressure and heat, while the disaster affected the Earth to different extents.[124] Mineral oil is the product of a chemical reaction, while certain kinds of coal evolved from organic substances. Conventional thinking is incapable of accepting this consideration for always the same reasons: According to Lyell and Darwin such extreme environmental conditions in terms of heat and pressure could not have existed on a global scale, because a uniform evolution of the species under such extreme and hostile circumstances would have made it hard for species to survive. When Mount St. Helens (USA) erupted in 1980, the situation in nearby Spirit Lake must have been similar to that which prevailed during the flood. In a previous chapter, I described in more detail how only after a few years coal started to form in a process that is still observed today. This process took the same

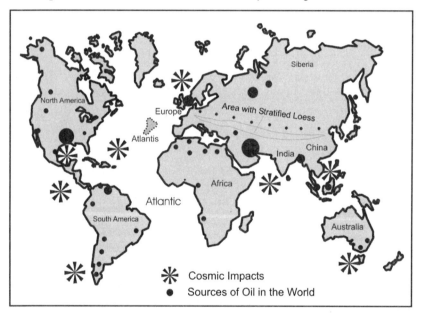

Fig. 31: Impacts and Mineral Oil. Seven major impacts of asteroids on Earth were located through the discoveries of tectite fields and the analysis of myths. The impact in the South Pacific, near Tierra del Fuego, South America, has not been totally proven. Geology does not categorize the *impact that killed the dinosaurs, occurring in the Yucatan (Mexico), an alleged 65 million years ago, along with the other impacts in terms of chronology. The overall appearance of finds in Texas (USA) and geology's incorrect dating, however, suggest that there is a connection between these events in terms of time. The oil resources of the world are located in the areas of impact, because the pressure and the heat there were extremely high, or along the edges of flood waves. Oil resources and a parallel zone with stratified loess extends from the North Sea, over Germany, all the way to the Yellow Sea of China.*

course under the circumstances created by the flood. Coal and oil formed only a few thousand years ago.

I have described the astounding finds of man-made objects in larger lumps of coal. An 8-carat gold chain, clay figurines and other man-made objects prove the existence of man before and during the epoch that coal formed. Just as we find leaves and organic natural substances in coal today. The coal must have formed rapidly. Single artificial and natural objects escaped combustion for some reasons. The hurricane coinciding with the global blaze gathered dried-up leaves, branches, trees and bushes, depositing them together in specific places. The heated ground metamorphically turned charred wood into coal – not entirely, however, because in the interior, uncharred objects survived while the subsequent tidal waves extinguished the fires.

A similar effect is observed, when one burns a phonebook. The pages are burnt around the edges, while on the inside readable fragments remain.

Emergence of Amber

The drying of trees produced amber. Resin, molten by the heat, was preserved by the flood and saved from burning entirely. This is why animals locked in amber resemble *present-day* specimens. This is something that more than once has evaded scientific attempts of explanation within the realms of evolution. Amber is said to be 60 million years old and supposedly stems from the dinosaur era. But the processes during the flood also turned fossil resin into amber and did indeed coincide with the extinction of dinosaurs. Still, there was a decisive difference: the process did not take place 60 million or more years ago, but during the flood, a relatively short time ago.

South America tilted?

In South America, the Cuvieronius, an animal with a trunk, allegedly became extinct about 12,000 years ago. The toxodon, an animal resembling a hippopotamus, died out in the eleventh millennium BC.[125] The moments of extinction for both species are close together and were probably caused by the same event. The chronological correspondence with the sudden death of the mammoths a few thousand years ago is obvious. In this period of time, other species became extinct in America as well: the saber tooth tiger, the giant sloth and horses. Even Darwin, to his surprise, concluded that the mussels

found in South American soil dated back to the time of the extinct species. At the same time in Europe, the great Irish elk and the aurochs, and in Southeast Asia many kinds of elephants and rhinoceri died out.

The amazing aspect about the remains of the cuvieronius and toxodons is their location: Tiahuanaco on the South shore of Lake Titicaca. The city's ruins lie 4000 meters high. What elephant or hippopotamus-like animals lived at heights 2000 – 3000 meters above their usual habitat? In any case, these are species unknown to us. Did these animals flee from the flood, seeking shelter higher up? Hardly, because the flood approached much too quickly. Were their carcasses washed up there? The location of the finds makes this unlikely. Equally strange were the marine fossils that were found at the same height. Was the South American West coast lifted up? In any case, a chalk-white line stretches along the coastal rocks of the Cordilleras. The explorer Alexander von Humboldt noticed and described this coastal strip at 2500 to 3000 meters height between 1799 and 1804.

But what caused this enormous lifting of South America's West coast? Did the Andes gradually rise due to the squeezing of the continental plates

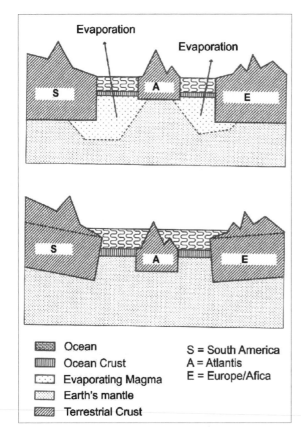

Ocean
Ocean Crust
Evaporating Magma
Earth's mantle
Terrestrial Crust

S = South America
A = Atlantis
E = Europe/Afica

Fig. 32: Atlantic Basin — Collapse. The collapse of the North Atlantic seabed and the ensuing evaporation of emerging magma caused a hollow space, lowering the island of Atlantis and the coasts on this side, while the opposite edges rose. This lifted the Southern part of South America. Prior to the flood disaster, the Atlantic was narrower. Magma emerging from the widening ruptures on the seabed made it wider and the continents shifted apart.

colliding in the Pacific Ocean? Or did the entire continent tilt along its axis? Muck assumed a tilt of South America along an axis extending from Panama to Bahia.[123] If such a tipping axis exists, the Northeast coast must have lowered. A look at a map of seadepths reveals a gently sloping shelf off shore. Far away in the Atlantic Ocean, it suddenly becomes steep, dropping almost vertically to several thousand meters deep. The mouths of the Amazon and Rio Paraná used to lie much further away from the present coastline, in areas today located below sea level.

Maybe South America tipped along an axis so that the Southwest rose up high, while the Northeast was lowered. What caused this? One or more asteroid impacts during the flood.

In this area of the North Atlantic Ocean, there are many ruptures in the ocean's floor, forced open during the flood-impact. The island of Atlantis, where the Azores are today, sank by several thousand meters. Liquid magma emerged from the ruptures in the seafloor and were hurled into the air by eruptions and evaporating ocean water. The remains of the hurled-up masses created a mighty loess belt, extending throughout Europe and Asia, but also discernable in South America. The magma level in the North Atlantic sank and pulled the island of Atlantis downward. At the same time, the edges of the neighboring continental shelf lowered because of isostatic reasons – they swim in a viscous bed of magma. The sinking of South America's Northeast coast, in terms of statics, forced the Southwestern side to rise along a tipping axis. This is why we suddenly find extinct terrestrial animals of the lowlands, ocean mussels and the city of Tiahuanaco, as well as the entire age-old coastline at a height of up to 4000 meters. If the continental shelf of South America tilted and if this was caused a lowering of the North Atlantic ocean floor, then related evidence should also be found on adjacent continental shelves.

Evidence is found in the long submarine channels of river mouths. Muck explains several examples: the fjord-like mouth of the Congo River in West Africa continues for more than 100 kilometers under the surface of the sea, till it reaches a depth of 800 meters. The West coast must have sunk accordingly. The North American coast too gives the impression of a lowered coastline. The Hudson River reveals a submarine trough 800 meters deep, ending at a depth of more than 2000 meters. "K. Bilau discovered an enormous submarine trough, which sweeps offshore at Cape Breton to the South-Southwest at a depth of 2500 meters collecting the waters from the rivers. These rivers all have a clear westward bend in their lower course directed towards this sink in the Atlantic Ocean."[123]

The present low location of the continental shelves in the North Atlantic prove the impact of at least one very large celestial body in this area and the disastrous consequences in connection with the flood. The described events suddenly forced the continental plates to move apart, Europe and Africa to one side and America to the other side .

This process did not take millions of years as the Theory of Continental drift, put forward by Alfred Wegener, suggests, but took place just before, during and after the flood. This scenario does not rule out that a gradual continuous movement of the continental plates exists.

The Folding of Mountains

Mountains probably already existed before the flood. They were however not as high as the mountains of today. Marine fossils, mussels and skeletons of marine animals are found on the highest mountains, even in the Himalayas. How did they get there? Why did mountains rise from the bottom of the sea while at the same time landmasses sank? What powers lifted them? Why is a human skull or a skeleton found inside mountains by miners for example or under a thick layer of original basalt or granite?

The Earth's rotation was slowed down by cosmic influences, impacts, approaches of other planets with strong magnetic fields or the passing of an interstellar, ferruginous cloud. The buildup of incredible forces between the Earth's crust and the Earth's mantle was the consequence. All layers of the Earth share the same angular velocity. Absolute velocity, however, grows with the increase in distance from the Earth's core. Different velocities between individual layers – between the Earth's crust and the underlying viscous magma bed – during braking cause friction and ensuing strains in the Earth's crust. Heat is produced thereby. The consequences would comprise rifts, cracks and ruptures in the Earth's surface, allowing ember rock to emerge from the Earth's interior and settle on top of sediments. This solves another mystery, as sedimentary rock should only be found in isolated cases and in the vicinity of volcanoes, underneath eruptive rock. In reality, this exception can be observed regularly all over the world. Allegedly older layers sit on top of younger strata. This explains why human remains were discovered under basalt strata.

These forces lowered entire regions, such as Atlantis, or rapidly uplifted them through pressure applied from the side, as is the case with the Himalayas. This process occurred fast. The resulting frictional heat and the global blaze

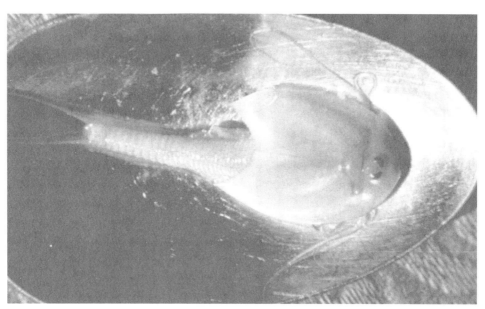

105 Triops are found in desert habitats. They are related to the trilobites and live in small pools that accumulate after flash floods in the summer. Triops is called "a living fossil" because it remained unchanged for millions of years. Triops cancriformis is probably the oldest living species on earth, older than dinosaurs. When we compare living animals to their fossils, we see that they have remained unchanged for millions of years, contrary to the Theory of Evolution. This fact is a clear evidence that falsifies the claims of evolutionists.

106 One of the most important finds is the footprints found in Laetoli, Tanzania. These footprints were found in a layer that was calculated to be 3.6 million years old. Russel Tuttle, who examined the footprints, wrote: "A small barefoot Homo sapiens could have made them ... In all discernible morphological features, the feet of the individuals that made the trails are indistinguishable from those of modern humans" See also picture´s 33–36. Why do the footprints looks like human feet and not like ape feet?

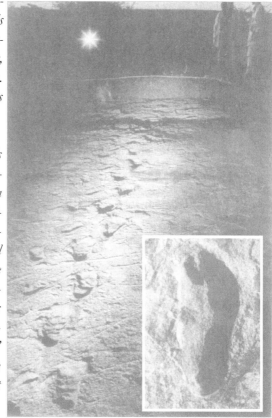

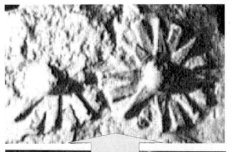

107, 108 This Akkadian stele of Naram-Sin (2300 BC) clearly depicts two suns.

109, 110 These Central-Babylonian Cuderra (1100 BC) include two suns and a moon.

111, 112 The Akkadian cylindrical seal (2500 BC) shows our solar system, giving eleven planets instead of the ten we know. Between Mars and Jupiter, where the Asteroid Belt is today, is a large planet. The position of Pluto is incorrect. Did our solar system look like this in the past?

Phaeton
(Planetoid belt)

Earth Moon

Mars

Mercury

Jupiter

Venus

Sun

Neptune

Uranus

Saturn Pluto

113 *The 2000-year-old machine of Antikythera.*
114 *The ancient battery of Baghdad, Iraq.*
115 *Depiction of light bulbs at the Temple of Denderah, Egypt.*
116 *At the Temple of Sethos in Abydos, Egypt, we find depictions of helicopter gun ship, tank, submarine, and machine gun.*

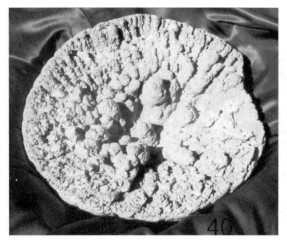

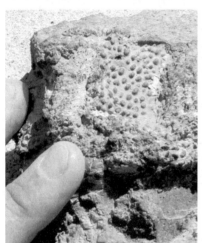

117 A jellyfish, this one petrified complete with her tentacles. This animal almost totally consists of water. How can a jellyfish petrify completely?

118 The author took part in the excavations of a dinosaur in Colorado. He points at a petrified piece of dinosaur skin.

119 A gigantic dinosaur skeleton lies in the sand desert (Niger, Africa) on the earth's surface. Skeletons of dinosaurs also lie in Mongolia, China, America or Australia on the earth's surface.

as part of the flood softened rocks; they were no longer brittle as they are in cool, normal conditions. Hence the folding of mountains and layers that under normal conditions would be impossible, because a cold formation would have caused the Earth's strata to tear. Brittle rock, much like concrete, takes up tensile stress only to a certain degree without cracking. The formation of mountains requires an at least malleable state of the raw material, comparable to chocolate softening, reshaping and setting once again. Under these circumstances, chocolate is malleable. Trying to shape chocolate in a cold state without warming it up creates cracks; it breaks part. In an elastic or malleable condition, chocolate can be given any shape imaginable. This also applies to rock, except that its melting point is much higher than that of chocolate and consequently these extreme temperatures must be present.

In the area of Sullivan River in the Canadian Rocky Mountains, there is a high mountain range with very nice wavy stratified sediments (see picture 88). The official caption of the picture says: "This dramatic example illustrates the constant action of awe-inspiring forces, shaping the conditions of our Earth."

Taking a closer look at the picture, we see several tightly and steeply arranged waves. Forces acting from the interior of the Earth could not have formed these very steep waves. Instead, they are the result of several different individual forces. The necessary pressure and attendant traction would have caused the strata to produce cracks. It, nevertheless, has survived homogenous. What we see resembles marble cake. As long as the dough is soft, we can imitate the layering of the mountain with it. As soon as the dough (stratum) has hardened, deformations can no longer be forced. Consequently, the mountain, when it was shaped, consisted of a soft material that hardened fast.

11 Witnesses of Time

Along with the flood, a new world came into being. All of the Earth's crust was crushed, re-layered, polluted and inundated. Nearly all of our present-day knowledge cannot be transferred onto the world that preceded the flood. Earth was literally re-created with an entirely new framework. Our world, or to be more precise, Earth's crust, in its present form has only existed for a very short period: our Earth is young.

Dating the Flood

Even if we assume there were no glacial periods, we still profit from the research that was done to determine the age of the last alleged glacial period, this in order to find out when the flood occurred.

The geologists state that North America's Great Lakes are remnants from the end of the last glacial period. Only fifty years ago, people believed that the last glacial period occurred 30,000 to 35,000 years ago. In the past twenty years, the famous Niagara Falls in North America, from Lake Ontario towards Lake Erie, reduced by 1.50 meters per year. Given a steady rate of erosion, we are able to calculate the age of the Niagara Falls to about 7000 years old. If we however assume greater water masses – equivalent to a higher rate of erosion – these waterfalls will be even younger: their age is estimated to be 5000 years. This moment in time probably marks the end of the flood. It was about then that the first ancient advanced civilizations appeared. A mere coincidence?

Similar considerations, measurements and calculations applied to sludge deposits at the bottom of the Alpine Lakes, foster comparable results to those of the Niagara Falls. As such, geology has continuously been forced to move the end of the so-called last glacial period closer to the present; today it is fixed to 10,000 to 13,000 years.

Plato, referring to Solon and the original statements made by an Egyptian priest, dated the disaster of Atlantis to 8560 BC. Many sources erroneously quote this date, placing it 1000 years too early, because the duration of 9000 years, given by the Egyptian priest, is either applied to the Greek or the Egyptian civilization. The ages of these two civilizations, however, differ.[123]

There are, nevertheless, scientific results that can chronologically pinpoint the flood. We can clearly distinguish the layers in Greenland's mighty ice shell.

The intense production of acid during the flood-impact very probably was detected by a core sample of ice taken in Camp Century, in Northwest Greenland. It is officially said to go back 10,000 years. Based on the scientific worldview of a hardly changing Earth, an age of 7640 BC was determined. This assessment of age must be wrong. Snowfall then did not occur each winter – as is the case today – but to a large part spread layer over layer within a very short period of time during the flood event. That is why the period of time, determined for the formation of these ice layers in harmony with the laws of Lyell and Darwin, is too long. Nevertheless, the scientifically determined age may serve as a threshold value: *older than that the flood cannot be.*.

With the present knowledge at hand, it is impossible to give an exact date for the flood: new discoveries would have to be congruent with scientific evidence. We can nevertheless give an estimate for when the flood occurred: a minimum of 4500 years and no more than 10,000 years ago. An age of up to 6000 years appears most likely. Earth was literally recreated and all in existence before was almost entirely destroyed. The memories of the few survivors have been preserved in peoples' oral traditions and writings.

Even if the age of the flood is approximately fixed by its major event – the impact itself – we still are dealing with a sequence of events, most likely to have structured the disaster. Their duration covers a period of several hundred years.

Consumption of Raw Materials

Consumption of raw materials in the past 6000 years and the last 100 years in particular, must be subjected to a critical review. Supplies of oil and other raw materials are, to a large extent, exhausted. We know of ancient mines, but exploitation then was insignificant, as these deposits of raw material have survived almost untouched. If humanity existed as long as limestone, all resources would be depleted by now.

I wish to restate an important observation: if we assume a short history of mankind, then the fossil footprints in the so-believed age-old rock will prove geology wrong: limestone, in this case, is just as young as mankind!

Specific Geological Characteristics

If geology was right and the strata were old, had gradually grown and was of solidified materials, then possible movements in the Earth's crust would

produce visible cracks in the brittle material, in those places where tensile stress is inflicted by forced bending. However, the contrary is the usual case. Looking at many rock layers, we have the impression that they were formed, or rather deposited, in a liquid or elastic consistence. Often strata are spaced in waves or even in semicircles without visible disturbances in their structure or cracks. We have to conclude that the Earth's strata formed fast instead of slowly. This conclusion is substantiated by other observations as well.

To followers of the Theory of Evolution, petrified logs or roots of trees, penetrating several solid strata, pose a mystery, because they already must have existed prior to formation of these strata. They not only prove the rapid formation of one individual stratum but of several in short succession. The affected area repeatedly must have been inundated by tidal waves. The waves subsided again and again, leaving quick setting layers of sludge behind, each varying in height. They preserved different finds, such as the footprints of dinosaurs and humans, as well as petrified roots of trees.

In Spirit Lake, Mount St. Helens, some tree stumps, washed away by the eruption of the volcano, floated upright, roots down. They were deposited in this upright position at the newly formed lake bed. Gradually, the sediments accumulated in the lake and renewed the bottom of the lake, layer by layer. If at some point in the future, this lake dries up, digging in its floor will reveal several different, overlain strata with upright tree stumps, their logs penetrating several sedimentary layers. Similar finds were made in Texas as well as in other parts of the world. Interpretation of such discoveries confront conservative geologists with some insurmountable obstacles when they try to stick to the principles of the determination of the ages of individual strata.

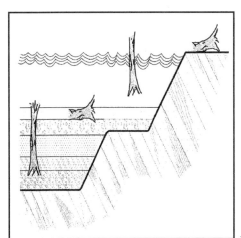

Fig. 33: Tree Stumps in Spirit Lake. During the eruption of the volcano Mount St. Helens, trees were broken into pieces and washed away to Spirit Lake. Some of the treestumps drifted in the water in upright position, roots down. In this position, they sank to the bottom and were buried by successive layers. Should these deposits (sediments) harden, the future will show logs penetrating various individual strata. This corresponds with the geological concept of a flood event.

At "Dinosaur National Monument", on the border between Utah and Colorado (USA), fossilized skeletons of dinosaurs were discovered in an nearly upright position, enclosed by solid sandstone. The geological processes responsible for its preservation are identical with those forming Ayers Rock and the strata near Glen Rose. The mixture of sand and water set quickly due the addition of a setting agent.

In contrast, what does science say? The special "Dinosaurier" of the magazine "P. M." states: "The primeval stream that once flowed here carried thousands of animal carcasses that were deposited at a river bend. There they fossilized over millions of years. This assumption is backed up by the fact that a number of these discovery sites revealed heaps of dozens of tightly packed fossils."[126] So fossilization takes millions of years? And the bones survive by the exclusion of air by mere coincidence? How does something fossilize? Does it merely have to lie around long enough? Which process is decisive for a gradual fossilization to take place and sandstone to set grain by grain? Only the setting of the solid rock, containing the fossilized bones, through a setting agent (calcium carbonate) can be the correct answer. All facts I have listed earlier argue for this conclusion.

Other inexplicable geological findings comprise of fossilized raindrops, wavy seabeds close to the shore and tracks of humans and animals. All of these phenomena across the entire world must have been preserved quickly, otherwise they would have eroded. Overlain strata must have had a soft consistence or else the tracks of the underlying strata would not have survived. These phenomena are not results of a process that took millions of years. Even a few days would be too long. Considering the force and vehemence of tidal waves during a flood, then all mountains and hills in areas, directly affected by the flood, must have formed from sedimentary deposits during this time. Whoever looks for original old rock must dig down deep into the crust of the Earth.

Did the Grand Canyon form during the flood? The canyons are composed of four different groups of layers, essentially distinguished in color (red, yellow, gray/black), in terms of granularity and material (limestone, slate, sandstone). One huge, red sandstone layer is interesting. This third layer sits *between* two darker, parallel slate layers. Its peculiarity lies in the sandstone's deposition angle, which is wider than the inner angle of friction, while the layers above and underneath are horizontal. If – from a geological view – a slanted layer inevitably must result from slow movements in the crust of the Earth, then the strata below and above have to show faults also. It is not possible to

substantially reshape a sandwich layer after setting without affecting the adjacent layers. The sole explanation is provided by the thesis I have propagated over and over again: these layers must have been soft during the deposition, were shaped by wind and water and rapidly set, thus preserving their unusual shape or steep angle. Here lies the fundamental difference between the geologists and our perspective. The consequences of such a discovery are more far-reaching than one at first would assume.[127]

The Colorado River does not nearly carry enough water to produce erosion as extensive as that of the Grand Canyon. There must have been greater masses of water draining off; the flood would have provided them in overabundance. The water that subsided after the individual tidal waves must have formed enormous channels of erosion in the only just deposited and not yet completely hardened alluvia. Impossible? Not in my book, where it is theoretically absolutely possible. On account of sober, logical considerations, this explanation almost suggests itself. This probably is what created Zion Canyon, Grand Canyon and other well-known natural wonders. The red-hot magma, emerging from ruptures in the torn crust of the Earth, cooled, retaining the shape of towers and battlements, after the fresh sedimentary layers had been washed away. Bryce Canyon and Monument Valley were formed this way.

Does the South side of Grand Canyon not show a regular ripping edge with a relatively flat hinterland? A helicopter ride revealed to me that this edge as well as the ones below, cannot be very old. As the Colorado River must have begun its erosion very early and since then is supposed to have cut 1600 meters deep into the rock formation, these edges would have to be very old, because it is assumed that it takes the river 1000 years to cut approximately 15 centimeters deeper. In this case, however, the adjacent highlands would have to show stronger molding by wind and water.

According to general opinion, the old Kaibab Plateau began to uplift 65 million years ago, while the Colorado River simultaneously cut into its rock. Erosion is supposed to have widened the Canyon ever since. This official statement contradicts itself: over such a long period of time, erosion of the edges would have advanced significantly. The more *steep slopes slip when escarpments collapse.* They become ever more flat, until they reflect the cast angle of the ground. After tens of millions of years, no extensively connected ripping edges should have survived – especially if the plateau simultaneously was uplifted and is relatively even and flat today. According to my observations and the evidence and theories presented in this book, there is only one solution: the Grand Canyon, along with other natural wonders, formed only a relatively

short while ago.

We assume that there was a slope covered by a thick layer of topsoil or loam. Heavy rain would produce deep trenches in the unhardened material. Under these circumstances, one or more mini-sized canyons would form in no time. Similar observations can be made in the surf zones of the sea. During a rest phase, after a storm has thrown new sand on the beach, deep draining channels form in the alluvium.

These processes have to be projected on a gigantic scale, adding the influence of a hardening agent that – in our example – hardens the sand of the shoreline to a kind of concrete with varying degrees of hardness. The results are Grand Canyons on a small scale. Was this natural wonder created over a period of 70 million years or did it form in batches no more than 10,000 years ago?

There is another question we have to ask: *why is nature so beautiful now?* After tens of millions of years under constantly changing environmental conditions – glacial periods – mountains and rock formations must long have eroded. Actually, today there should be nothing else to look at than debris and eroded mountains. Only in isolated cases, but not in general, would natural beauties have survived. "Balancing rocks" or rock arches in terms of geology are no isolated cases or strokes of luck, but are instead quite frequently observed natural phenomena. Are there not frequent reports in publications of all sorts about imminent gigantic landslides in the Alps, based on the damage in the tree population by acid rain and changing environmental circumstances?

Why are the Alps in danger only now? Did past geological eras generally provide an ideal climate as a basic condition for the growth of trees?

A Weaker Protective Screen

Another proof of a young Earth is the strength of the Earth's magnetic field. Why Earth and other planets have a magnetic field and others do not – or only have a very weak one like the moon – is not clear. Magnetism is said to result from electric currents in the outer section of the Earth's core, literally an earthly dynamo.[128] It is interesting that the strength of our magnetic field continuously drops at a rate of 0.07 percent per year. *As such, in 4000 years' time, it will have disappeared completely.* As it is magnetism that protects us from fatal cosmic radiation, even a substantial reduction of its strength would have disastrous consequences for life on our planet. Scientists believe that our magnetic field changes polarity every 250,000 years and that this process is

due. But will we really have a new magnetic field with changed polarity soon and would that field also recharge automatically? An odd idea.

Let us assume that the magnetic field changes polarity but is not able to recharge. This assumption results in a young Earth, as a decrease of the strength of magnetic field at a rate of 0.07 percent per year, projected into the past, would reach an absolute limit value very quickly. Calculations based on scientific observations and measurements since 1829 have yielded a period of time of approximately 22,000 years as the maximum limit.[129] Earth could therefore not be older than this limit value, assuming there was no decisive influence in the past. But it is geologists and followers of the Theory of Evolution who propagate a uniform evolution of our planet as the foundation for their worldview. And this Theory of Uniformity has also been applied to the formation of universe, galaxies, their stars and clouds.

The Salt of the Seas

Ocean water contains plain table salt (chlorine sodium). Rain could have washed this sodium out of rocks. As the chlorine content of rocks is however fifty times too low, the question is: where did this element originate? The steel of the fossil hammer described earlier contains apart from iron strangely enough also chlorine. Oceans have an average salt content of 3.5 percent. The salt and mineral content in rocks is washed out by rivers and transported to the sea. The natural salt content of the seabed, atmospheric influences (volcanic activity), evaporation, groundwater and the erosion of coastlines are also influencing factors.

All these influences gradually increase the salt content of the oceans. Supposing a constant general set-up and a limit value derived from the present, we come up with a maximum age of the oceans of 62 million years. At this moment in time, it must have been fresh water without any salt. Consequently, salt water could not have existed at the time of the dinosaurs.

The average increase of the salt content amounts to only 0.06 percent in one million years. Should Earth really be more than 4 billion years old, then the calculated rate would be fifty times too high and would tend towards zero. Considering the decisive influence of the flood or other events that include higher erosion rates, reduces the assumed age of the oceans drastically. Besides, the growth rate of the salt content would rather decrease with time, because over the years, rivers would transport less and less sediments to the sea. Earth

therefore must be substantially younger than this calculated maximum value. The calculated age of 62 million years therefore represents an absolute limit value. The first ocean, as geology has it, is supposed to be fifty times older than that! If that is so, where did all the salt go?

Mountains were elevated only a few thousand years ago. That is why the processes measured today could not have had an effect over a long period of time and rivers had much less time to wash salt and eroded material away, towards the oceans.

The Erosion of the Continents

Considerations on the oceans' salt content may also apply to the quantity of sediments at the bottom of the sea. Rivers carry eroded material in the

Fig. 35: Mantle of Erosion. Rivers carry eroded material in the form of debris, sand, gravel and loam to the seas and oceans. As such, Earth can not be older than 15 million years. Assuming a steady rate of erosion, within this period of time all hills and mountains would have eroded, turning oceans into seas of mud. This period is a maximum value which in fact has to be lower, because erosion must have been stronger in the beginning. However, mountains and ranges existing today are said to be hundreds of millions of years old. If that were so, the sedimentary layer resting in seas and oceans would have to be much thicker than they actually are.

form of sludge, gravel and debris to the sea. The material of a landscape is slowly taken away to the bottom of the oceans, where it accumulates. This way continents lose mass, while the seabed gradually rises.

A period of 70 million to three billion years, i.e. the estimated age of mountains, would provide enough time for the rivers to remove this eroded material. Comparing today's amount of materials washed to the sea with the volume of all landmasses above sea level, we realize that in less than 15 million years, there will not be any mountains left in the world – all available rock and ground material will have been washed into the seas and oceans. This, of course, if one again presupposes a steady rate over the entire period. If this process was accelerated in the past, the calculated age of mountains would drop in proportion.

It is possible, on the other hand, to measure eroded material already washed to the sea by taking core samples. Taking the present rate of erosion as an example, it takes 15 million years to wash the measurable present sediments to the seabed. According to these considerations, Earth could not be older than 15 million years. This figure is at least fifty times less than the age continents are supposed to have. If the continents were three million years old, mountains would no longer exist and oceans would be *filled up* with alluvium. As both these critical considerations – the salt content and the quantity of sediments – independently foster a comparable maximum limit for the Earth's age, then these considerations must be conclusive. The question remains: how young are the mountains and the hills really?

Looking at the mouths of great rivers, we notice their deltas, reaching far into the sea. They consist of eroded material, carried to the sea by rivers. Should the geologists be right, fixing the age of the youngest mountains to – the still very high age of – 70 million years, then related rivers would have to be just as old. The sizes of all deltas in the world are too small for that. Does this mean that rivers are much younger than mountains? Did rivers not exist prior to the flood, or are mountains accordingly younger? This consideration also applies to old inland seas and lakes, which would now have to have been filled up by sedimentation.

During the flood, the oceans' sea level rose by more than 100, maybe even 200 meters. Consequently, old deltas now rest under today's water surface. Still, they do not show a sufficient size that would document an age of many million years. A relatively young surface of the Earth, formed only a short while ago, would solve this mystery without any contradiction whatsoever.

Dripstone Caverns

A popular example for the age of Earth are the dripstone caves. Stalactites and stalagmites are said to be extremely old, this because the drops of water that fall in long intervals take a long time to form these towers and drips. Carbonated water extracts lime from limestone. Drops of water containing this lime form dripstone. The age of a dripstone is projected, based on its size and present growth rate. The result would be correct, provided there were no changes in the past.

Concrete and simple mortar contain hydraulic binders. When the sealings of bridges or balcony platforms leak, water flows along the structural components via hairline cracks in the concrete. On the underside of such concrete parts, water, containing calcium bicarbonate, emerges from the cracks and forms cones – modern dripstone. Underground car parks and other parts of underground buildings show these amorphous sinter cones of lime. The speed at which contemporary dripstone grows is remarkable if the water supply is continuous. If no new cracks occur, the lime resources in this area diminish and further growth slows down.

Fig. 36: Ocean Temperatures. Thanks to the oceans' heat storage capacity, temperatures in the oceans dropped only to a minimal degree when a cosmic impact – such as the dinosaur impact – occurred. In contrast, after four to five months, the atmosphere near Earth's surface had cooled down to – 20 °C.

This is exactly what happens in nature. Cracks in limestone slowly elutriated with time and the rock's calcium content dropped. As such, more water passed through the cracks in the past, extracting larger quantities of lime. Cave floors are often covered with slippery, extensive and thick lime layers. These layers prove that originally more flowing water existed. For these reasons, the growth of dripstone automatically decreases over time. Dripstones can not serve as evidence for an advanced age of the Earth.

Tropical Corals

More evidence of an old Earth is supposed to be provided by corals, inhabiting the oceans at tropical latitudes. They die when the water temperature drops below 20 °C. Hans Queiser therefore concludes: "A global 'nuclear' winter, caused by the impact of an asteroid, would not have killed ammonites alone, but corals too would have become extinct."[130]

This statement relegates the global flood to the sphere of legend. Followers of the Theory of Evolution were happy about the scientifically absolutely justified objection. The latest research, however, was not duly considered at the time. I have solved the mystery of how the ammonites became extinct. But how could corals survive?

A study by O. B. Toon in 1984 revealed that oceans, thanks to their enormous heat storage capacity, cooled only to a minimal extent when the atmospheric temperatures close to the ground dropped to –20 °C in the four or five months following the impact. Greenhouse gases in the atmosphere (carbon monoxide, carbon dioxide, nitrogen and methane) that were released by the impact produced a greenhouse effect. Core samples from the Southern Atlantic Ocean have detected a rapid increase in temperature in the seabed by 5 °C.[132]

This increase in temperature provides different conditions. Tropical corals probably felt even more comfortable in the warmer water and produced more lime. As their rate of formation was therefore higher than it is today, the ages calculated for the coral reefs are not correct if they use today's condition as their starting point.

Live Swimming Dinosaurs

Some biologists and oceanographers, such as Prof. Dr. Jabolow, are convinced that the great depths of the Indian Ocean, as well as the Southwest of the Pacific Ocean between the 25th and 35th parallel South, are inhabited by water saurians, plesiosauri and mosasauri. Modern reports of saurian-like marine life forms are plenty.[133]

In 1977, a Japanese fishing boat with a crew of eighteen people off the coast of New Zealand hauled its fishing-nets from a depth of 250 meters. In it, they found a bad smelling object, ten meters long. It was already rotting and had been dead for about a month. The body weighed almost two metric tons and had four fins of about equal size, two in the front part of the body and two at the rear part. Moreover, the monster had a vertebra, a fin-less tail, while the head sat on a long neck.

A crewmember took five pictures. Apart from that, a piece of a fin was kept, before the carcass was thrown back into the sea. If kept, the find would have ruined their fishing.

The animal in the pictures could not be categorized as any known animal species. A chemical examination of the fin showed similarities with fish and reptiles. Any similarity with mammals such as the whale was not detected. The overall size, the long neck and the vertebra contradict the assumption that we are dealing with a large unknown fish or an exceptional type of shark. Besides, it had four fins of about equal size, different in size and position from any marine animal we know. The dead animal bore a resemblance to a plesiosaurus. Unfortunately, this animal is believed to have become extinct 64 million years ago. As a result of this discovery, Japan issued a stamp depicting a plesiosaurus.

Bernhard Heuvelmans reports of an incredible sighting made during the Second World War in the North Atlantic Ocean, when the German submarine "U28" sank the British steamer Iberian.[134] After the ship had been torpedoed and sunk, an explosion occurred under water. A little later, the captain and some of his officers noticed a giant monster shooting up high into the air, convulsing. Within seconds it disappeared into the waters of the Atlantic again. The creature was reported to have been about 20 meters long and looked like an oversize crocodile with webbing between its toes.[135]

In the seventies, several marine monsters, called Morgawr, were sighted near Falmouth in Cornwall, England. In 1976, two pictures were made (alledged to be forgeries) of an animal with a series of humps on its back, with a long neck ending in a small head.[135]

There have been many credible sightings of various kinds of sea monsters in the more recent past. The existence of giant squids was relegated to the sphere of legend. Depictions of these giant animals on old sea maps appeared to stem from the fear of the unknown. However, these animals do belong to the realm of our existence.

A giant squid of about eight meters in size was discovered on November 30, 1861, near the coast of Tenerife. In the past years there have been similar sightings and finds. These animals inhabit greater depths, so they are hardly ever seen. Whale stomachs, however, have revealed the remains of these animals, proving the existence of giant squids of twenty or even thirty meters in length.

In 1976, near Hawai, an until then unknown type of shark was fished out of the Pacific Ocean. This animal, called megamouth, was 4.5 meters long. Its jaws were very wide, to be able to take in as much plankton as possible. A second specimen of a megamouth was retrieved off the Californian coast in 1984.[135]

So there are larger unknown inhabitants of the sea after all. Lakes in North America and Scotland teem with monsters, if one wants to believe the observers. There is hardly an American or Canadian state (left) in whose waters there is not at least one monster to be found. Particularly many monsters exist in the states of New York and Wisconsin.

Old Indian legends speak of a frightening monster in Champlain Lake, New York. Samuel Champlain, after whom the lake was named, saw the animal in 1609. The monster has been affectionately named "Champ" and to this day, people claim to have seen the monster.[135]

A giant sea serpent was observed more than 200 times in Okanagan Lake, British Columbia (Canada). It might be a dinosaur of the basilosaurus-type. The Indians living along the lake know the creature under the name "Naiaka". Today, it is officially called "Ogopogo".[136]

Places where monsters were repeatedly seen and described include Lake Pohengamook near Quebec, Chesapeake Bay, Vancouver, Flathead Lake in Montana and several more lakes in Scotland.

The Russian newspaper "Kosomolskaia Pravda" reported in 1964 of a dreadful monster, which the biologist Professor Gladkikh claimed to have encountered at Labynkyr Lake in Yakutia. The monster was said to have resembled a fish-like creeping ichthyosaurus. It surfaced, swam ashore and headed inland.[136]

The most famous representative of its kind is "Nessie". As early as 565 AD, the chronicles of St. Columba, a monk and founder of a monastery, mention

that he accidentally attended the funeral of a victim of the monster of Loch Ness. Afterwards, the saint banished the monster by virtue of his prayer. This event converted the Scottish people to Christianity.

The Scottish poet, Sir Walter Scott (1771-1832) notes in his diary the attempt to capture the legendary seacow. A diver saw a big monster in 1880 and in 1933. Mr. and Mrs. Spicer witnessed Nessie crossing the A82 road, which runs along Loch Ness. It had a small head, a long neck, a fat body, four fins and was about eight to nine meters long. It carried another animal in its mouth. After a short while, it waddled on its large fins back into the water. Actually, this is a precise description of a plesiosaurus, resembling the carcass that was caught by the Japanese fishing boat. Pure coincidence? Yet, in 1933, nobody knew that a similar animal would be caught in 1977.

All in all, Nessie is claimed to have been observed several hundred times. A sonar placed in the Southeast corner of the at least 325 meters deep lake, detected an exceptionally fast and large object on August 28, 1968. In October 1987, an entire fleet of twenty sonar-equipped boats lined up to comb the lake back and forth. Three mysterious objects were located but could not be traced in a second attempt. These locations were at a greater depth than the usual habitat of the fish living in the lake. There are, however, some mostly blurry snapshots of Nessie, which have been labelled forgeries.

The idea that a species could survive over 64 million years in a self-contained habitat appears unlikely, even if Nessie seems to be able to move ashore. As monsters were also sighted in neighboring Scottish lakes, it seems these creatures are able to move ashore. The survival of a species requires more than just one animal. Sonar recordings and sightings do not rule out that this is the case. Should dinosaurs have lived until only a few thousand years ago, when the flood struck, then the existence of monsters, of plesiosaurs in seas and lakes all over the world, looks a lot more credible. This relatively short period of time could have been bridged by a small number of maybe long-lived animals.

The Middle Ages told stories of dragons, slain by courageous knights. Dragon slaying was almost a dictum. Do these stories contain some truth? Did large saurians still exist in the Middle Ages? Maybe they were smaller dinosaurs, the size of a komodo dragon, that had survived the flood?

The Vikings decorated their ships with dragon heads. Saint George is said to have freed Beirut from a dragon. Depictions of dragons exist across the whole world – particularly in the Far East. We know of prehistoric rock drawings of dinosaurs (see pictures 102 and 103), often and for obvious reasons labelled forgeries.

Did dinosaurs live recently, if not presently, or is Michael Buhl right when he writes in the magazine "P. M.": "Early findings of bones could explain that myths about frightening monsters were already present in the Stone Age."[137] Should our ancestors have bothered about large bone findings? Where did such skeletons come from? Did they dig for them? Dinosaur remains could not have lain around on the surface for tens of millions of years without disintegrating.

Live Fossils

The most famous example of a live fossil is the coelacanth. We know this fish well from fossils finds. For a long time, this species was considered to have become extinct 64 million years ago. I remember the school lessons in which this animal with its fins and stumps was presented to us as the first fish to move ashore and as the link between terrestrial and marine life forms.

This opinion, however, turns out to be untenable. The fins, resting on stumps, are much too weak. They would not support a relatively large animal weighing tens of kilograms, neither ashore nor in the sea.

The missing link in evolution's endless chain, meaning the first animal to move ashore and evolve into a mammal or reptile, has not been found yet. It will never be found, because such an evolution never existed.

Off the Comoro Islands near Madagascar, a live coelacanth was caught in 1938. Hans Fricke, the German marine biologist, filmed the animal in its natural environment at a depth of 200 meters.

Is it an error of nature that a species should survive over tens of millions of years in its original form? Or are their fossils evidence of a flood? In every scenario, a surviving animal from primeval times is not compatible with the Theory of Evolution, even if its followers with a twinkle in their eye argue that nature just accomplishes virtual wonders through incredible coincidences.

And less than a wonder – from a scientific point of view – would not do to prove a not yet verified thesis. But who cares about the endless number of coincidences appearing in just the right sequence? Only one thing is clear: living "fossils" fundamentally contradict the Theory of Evolution and the continuous adjustment and evolution it stands for.

Assuming that the fossilized animals gradually evolved into other animals in harmony with the theoretical guidelines of Theory of Evolution, we have to ask a crucial question: how is **it** that living specimens of animals, unchanged since primeval times, exist at all? Why do we not find a coelacanth that is

Fig. 38: Evolutionary Tree. *This simplified presentation of macro-evolution shows the evolution of life forms. Altogether unclear is the question from where a biological cell could draw the genetic code. Was there an influence from outside? Are we on the verge of starting a similar biogenetic experiment on Mars? The coelacanth, the alleged missing link between terrestrial and marine life forms, has lived for tens of millions of years without the least change. Does this live fossil not contradict the basic idea of the Theory of Evolution that proclaims that less well-adjusted species are unable to survive? Why have the various transient stages of coelacanths' or other animals' evolution not survived? In case evolution did take place, evolving creatures lived in chronological succession; should there, however, have been a creation, then all kind of creatures lived simultaneously.*

slightly more evolved? If this species has existed for the past 64 million years, then it should come in a variety of evolutionary stages and not only in that one original version we know. Or is it yet another coincidence playing *the* crucial role, contrary to all logic and statistical probability? The evolution of a new animal takes places in very small steps through changes in the genetic make-up – a basic prerequisite of evolution.

If the coelacanth evolved gradually – and the original animal after 64 million years still exists today – then there should be *a great number of half-finished evolutionary species* that we currently don't know of. But as only perfectly evolved animals appear to exist, there could not have been such a thing as evolution. The precursors of the present species would have had to survive in biological niches, at least in isolated cases.

Science desperately searches for the "missing link". *But the root of the problem has not even been discussed:* every transient form between two animal species could not consist of one individual species, but instead would be a series of of missing links, slightly deviating whilst they progress! Every missing link must represent an entire evolutionary sequence of individual stages, because the Theory of Evolution assumes a gradual change over long periods of Earth's history.

Basically, the question is whether a half or partly developed animal would be capable of surviving. The transformation of a fin into a foot and all other transformations could only have taken place in very small steps. But a foot, not yet developed in its final stage, would not be of any advantage for the animal but would rather be a *regular handicap*. Were these animals capable of surviving and were they *better adjusted than their precursors*? Definitely not!

In order to avoid the visible lack of evidence, followers of the Theory of Evolution should simply claim that the transition of one animal species to another occurred quickly, executed in a kind of *hyper-macro-evolution*. All these contradictions would be explained in one go, sparing them a lot of reasoning. I am convinced that we, the general public, would blindly believe any scientific thesis, as long as the manner in which it is presented is serious enough. The question, however, remains: how does such an animal pass its capabilities on?

Another example of a living fossil is the Komodo dragon. Reports by natives were long considered as figments of the imagination. Only in 1912 was the reptile, more than three meters long, discovered on the Indonesian Komodo Island, from where it received its name. This lizard is considered a survivor of the dinosaur era – but it does not seem to have evolved further. A hexagonal-shaped animal, about three centimeters in diameter, with lines of

black spots, was discovered near hot springs in the Atlantic Ocean. Until the day of its discovery, this animal was considered to have become extinct 70 million years ago.[135]

Mokele-mbembe

As I mentioned earlier, I did not meet Dr. Baugh when I last visited Glen Rose. He was participating in an expedition in New Guinea. Natives there reported large monsters raiding graves. There is cause to believe that this could be a surviving species of dinosaurs. Evidence of surviving dinosaurs has so far not yet been produced, though large animals have been observed with infrared binoculars.

There is a monster, supposed to inhabit the Congo swamps in Africa, which the natives call Mokele-mbembe. There have been reports about this animal for 200 years and unidentifiable footprints have been spotted. As early as 1913, Captain Baron von Stein zu Lausnitz returned from an expedition with reports of an animal that was the size of an elephant or at least of a hippopotamus, with a very flexible neck.[135]

The Swede J.C. Johanson claims to have encountered a saurian on a safari in 1932. The animal was said to have had a length of 16 meters. A picture of the encounter exists, but, unfortunately, it is very blurred.

In 1959, a Mokele-mbembe is supposed to have been killed by a native. Everybody who ate from its meat died. The Congolese zoologist Marcellin Agnagna was head of an expedition into the Likouala Region. He claims to have seen a Mokele-mbembe with his own eyes. The animal is normally described as five to ten meters long, including its tail, having four short legs and claws. It is a plant eater and has footprints of approximately 30 centimeters.

Maybe there are dinosaurs that survived. If they lived not too long ago, as I have convincingly set out, then it would be possible and even probable that certain isolated species of dinosaurs survived to this day. The dragons in myths all over the world would no longer be figments of our imagination, but realistic depictions of surviving dinosaurs or other monsters. At least, they would be surviving memories of the days before or shortly after the flood.

12 Evolution or Creation?

A worldwide flood, primeval animals, dinosaurs, human beings and mammals, living at the same time; on the other hand, the Theory of Evolution. They are mutually exclusive. There can not be any in-between solution, no "if or but". Without evolution there can only be one result: All beings where created.

Theorem of Entropy

Evolution is incompatible with the laws of nature. The Principle of Entropy, the second principle of the thermodynamics, says that without external effort heat cannot by itself turn into a body of high temperature from of a body of low temperature. From another perspective, this means that everything gets older and falls apart: **S**tars burn, living creatures age, new things fall apart and energy always turns into less usable energy.

Evolution necessarily contradicts this law of nature, since it aims at creating better and more complex beings. From where and in which form does the supplementary energy emerge to reach a higher level of development and, moreover, increase it? This additional energy must furthermore have constantly been available throughout the planet's history. One argument on behalf of the formation of this extra energy and therefore the motor of life, is supposed to be chlorophyle. This substance, which first had to be developed via an incredible series of coincidences, enables a cell to transform sunlight into chemical energy. Is this the additional energy required to defy the Theorem of Entropy?

Overlooking further wonders and coincidences required for a cell to evolve, the path evolution takes, should lead to a dead end. As a side effect, the process of converting sunlight into energy produced and released oxygen on our planet for the first time. The primary atmosphere did not contain oxygen. Contradicting all statistical probabilities, we also assume that the first cells could thrive in an environment of methane, ammonia and nitrogen. Cells living in this environment must have experienced the first oxygen, resulting from this transformation process, as a deadly poison. Evolution would have killed itself – but there still is the alternative of "luck".

Established science assumes that nature fiddled around until a lucky line-up of an endless number of coincidences produced complicated organisms.

This lottery can be compared with a work of several books flawlessly written be a chimpanzee who was handed a typewriter but no pattern.[139] Nobody would expect an ape to be able to do this, but the evenly improbable development from a protozoon into a human being *has definitely taken place?*

Microevolution

Microevolution erroneously is used to prove the macroevolution, the transition from one order of animals to another.

Surely there were and are changes in plants and animals: microevolution, not to be mistaken for the evolution proclaimed by Darwin. The development or better selection of existing qualities is performed on a daily basis in nature and is not an issue.

Existing genes of an organism offer uncountable possibilities of combination. Color of hair, skin, eyes and all other characteristics of humans or animals can be combined and passed on in any chosen way. Even man serves as a creator, acting out microevolution every day by breeding new kinds of plants or animals. Microevolution does take place and therefore creation can be and is controlled by humans. Inconspicuously, wild growing flowers can be transformed into a splendor of blossom, as was done with the red begonia e.g., which was cultivated in this century. Likewise, dogs, poultry and birds are altered or even newly created, making use of the genetics defined by the Austrian botanist Gregor Mendel (1822—1884).

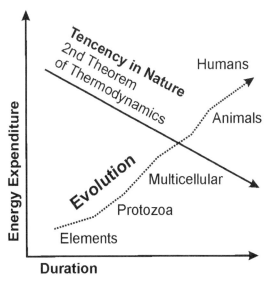

Fig. 39: Nature's Tendency. The idea of evolution is not compatible with natural law. The Principle of Entropy, the second principle of thermodynamics, denies the possibility of evolution. Without an external effort, a body of low temperature cannot turn into a body of high temperature. Without an additional energy supply all things age and fall apart. Therefore, development from a simple to a complex system is not possible. Over time, existing states of energy evolve into less employable states.

Due to the variation of genes and adjustment to the particular living conditions, different races can evolve from a group of humans – even without erratic mutation. These examples definitely do not serve as evidence in favor of the Theory of Evolution as a whole, since all characteristics are already stored within the genes and are only different combinations, including slight mutations.

Another good example for micro-evolution is the development of the dog. What do a dachshund, an Afghan hound or a German shepherd have in common? There are various races and types of dogs. Nevertheless, recent studies confirm that all dogs can be traced back to one primeval mother. This is verified by studies of the DNA. This "mother" is quite a recent species. Regardless of the actual period during which the diversification occurred, it is known that new sorts of dogs are easily created, through natural cross-breeding. The resulting animals are able to reproduce. After the flood, different dog races emerged from only a few specimens or maybe even only one surviving pair. Since all dogs descended from one primeval mother, one is automatically reminded of Noah's Ark and the animals that survived the flood. A memorable parallel.

The genetic make-up of all dogs is practically the same and only shows variations of a given set of genes, mixed by chance, adapting to nature, or as a result of breed selection. In no case did an evolution in the sense of macroevolution occur. Nevertheless, dog races differ widely and may likely be considered proof of Darwinism, which of course is absolutely absurd.

From one primeval horse, various species such as zebras, dwarf horses, ponies and other phenotypes may develop. Adaptation is possible through the selection of individual, already available genes; this is microevolution. But a horse can not turn into a different animal, and an ape can not turn into a human being, like Darwin's Law wants us to believe. This development cannot occur through the transmission of acquired characteristics; this type of reproduction is impossible, since the number of chromosomes differ.

A real evolution, i.e. macroevolution, could only occur through mutation or defective genes. I remember my biology lessons well. Our teacher convincingly explained that during their embryonic development, all beings would go through the history of their ancestors, in rapid succession. Young embryos of a fish, a salamander or a pig supposedly do not differ from those of humans. This knowledge goes back to the German zoologist Ernst Haeckel (1834–1919) – one of the leading evolutionists along with Charles Darwin – and represents an important Biogenetical Law of the Theory of Evolution. I

want to underline the word "law" as it has the same validity as Darwin's Law of Evolution, which it supports significantly. Who would doubt the words of these renowned scientists, especially since both theories – "laws" – correspond perfectly. There seems no room for doubt. The discoveries of Haeckel are considered to be the cornerstones of our worldview. They prove the descent of species, claiming that in the womb, every foetus develops through all steps of evolution, from fish to mammal. There is apparently no better evidence in favor of evolution, and if this proof did not exist, it is so good that it should be invented. With other words: this evidence is nearly too good to be true. The German newsmagazine "Focus" published the newest scientific realizations from 1997 with the title "Faked Drawings": "The drawings, with Haeckel presented in support of his theory, were derived from the human embryo without evidence, claims Michael Richardson of the St. George's Hospital, who along with colleagues did worldwide research on embryos. The fraud was uncovered only now, because embryologists have not done comparative studies for decades."[140]

Fig. 40: Haeckel's Sketch. *This faked document by Ernst Haeckel served as evidence to prove the biogenetical law of embryonic development, significantly supporting the Theory of Evolution. Decades later, Michael Richardson of St. George's Hospital and his colleagues ran worldwide studies on embryos, revealing the fraud in the process.*
[From left to right: Fish, salamander, tortoise, chicken. pig, cow, rabbit, human]

In other words: *A Biogenetical Law was simply invented in order to support the Theory of Evolution.* The dogma of Haeckel was pulverized. When will that of Darwin disintegrate?

Another comment actually seems uncalled for, as the slanted view of the world of the biologists of the last century, *which we still trust without reservations,* exposes itself. Does the Theory of Evolution remain firm, even though its legs have been cut away? We still hold on to the old and by now overcome statements of this group of scientists of the last century in an unreserved manner.

The example of the alleged metamorphosis of an ape into a human shows that either a double wonder occurred or that humanity can not descend from the ape.

The Theory of Evolution claims that monkeys left their trees once in a while, walking on two legs for short periods of time. In order to look out over the steppe grass, apes had to stand erect. Monkeys managed this the best, due to a genetically based deformity of the joints, a sickness they passed on to the next generations. According to the Theory of Evolution, human beings emerged from this group of sick monkeys.

The most recent studies defeat this popular picture of the Theory of Evolution. In 1996, the newsmagazine "Focus" reported on a computer simulation of a Liverpool group of scientists. The outcome of this costly three-dimensional animation *refutes* the common school of thinking.

Lucy's way of walking was simulated. Lucy was a monkey-like being that walked erect. This alleged primary mother of mankind is supposed to have lived in Eastern Africa about 3.6 million years ago. The computer-skeleton dropped when ordered to walk like a chimpanzee. A bent back and crooked knees were proven incapable of surviving. That is why the British anthropologist Richard Crompton is convinced that our ancestors either walked fully erect or died out and transmuted from four to two legs in a "very short time", even before they left the trees. [141]

There are two solutions to this problem. According to the Theory of Evolution, Lucy clearly was the very model for the development of human beings, resembling an ape as her brain could not have been bigger than that of a present-day ape. But her skeleton was supposed to be similar to that of a human being of today. Nevertheless, Lucy was not humanlike and did not belong to the human species. Therefore, Lucy's ancestor must have walked erect.

The other solution states that Lucy already was a more developed model and the history of development of the supposed ancestor of mankind must

be dated back further into the past. This solution, however, corresponding with the Theory of Evolution, refutes the computer simulation: *when it comes to the* creeping gait of apes and erect walking human beings there is *nothing in between* and therefore no development as the Theory of Evolution states, occurred; neither in Lucy's times nor some time before.

For anatomical, statistical and evolutionary reasons, the ability to survive was not given to species walking in a bent manner. The conclusion is: the ape came down from the trees, walking erect. Now, however, the question arises: what does an erect standing ape do in a tree?

Why should an ape without a center of speech turn into a talking human? Did this happen quickly? With whom did the talking specimen converse? Or did it happen slowly and did it teach others how to speak? However, if it was a mutated animal, where did the counterpart come from, since you need a female and male specimen for reproduction. Mutated chromosomes are usually

A B C

*Fig. 41: **Pace of Ape**. The British anthropologist Richard Crompton from Liverpool University reconstructed the development of walking erect and becoming human. Walking like an ape (A) is not suitable for the first human. Walking in a bent manner (B) does not offer chances of survival. Walking erect (C) shows the only successful mode of movement. The result refutes the common school of thinking, which dictates that our ancestors came down from their trees, walking on two legs. A development from creeping to walking erect did not occur.*

useless for reproduction, because of the abnormal number that will be rejected by the intact ovum. A human being can not crossbreed with a chimpanzee and there are several other animals of one species that are not able to do so, e.g. spiders. The reason is the different number of chromosomes. Their forms and types are different in every animal. Since you need a pair for reproduction, two animals, mutated in the same way, have to mate to secure the existence of their species. All those steps of development do not occur erraticly. Therefore, evolution needs an almost endless number of very improbable coincidences and a long period of time.

Ruth Moore confirms my opinion in her book "Evolution": "The work of many laboratories showed that most mutations are harmful and more extreme ones usually cause death. They wrap up the wrong way since each change in a harmonic and good adjusted organism is disadvantageous. Most carriers of extreme mutation do not live long enough to pass on their transmutes to their descendants."[142]

This opinion, which is absolutely congruent to my own, is reversed in the same book by stating the following: "So some mutations – normally the minor ones – are beneficial for the species."[142] After laboratories discovered the contrary, a second statement without any evidence is made. Who decides what to consider a smaller or bigger change? Afterwards the consequent question is pointed out: "How can a single, small and beneficial difference – for instance a minor change of the bones, through which a fin possibly could turn into leg – be successful within the species?"[142] The plausible questions show the nonsense of alleged macroevolution.

How is a fish supposed to know that an inferior change of its fin will, in a few million years time, turn into a leg? And if it does not know this, *the transmuted fin will be an obstacle* since it obviously got along well with the original one. Were fish with deformed fins sentenced to die out due to selective breeding and a deficient ability to survive? Does the example of the living fossil not show that fish can still live very well after 64 million years, not having been displaced by allegedly higher advanced species? Why, as followers of the Theory of Evolution claim, did this special fin turn into a leg?

Not only the link for the transmutation of the ape into a man is missing. Dinosaurs are thought to be the ancestors of the birds, but where is their link? There are no steps of development or unfinished animals, even though feathered flying saurians were found. All creatures seem to have developed ideally. There are no prototypes or has evolution come to an end? The answer must be *no*, evolution can not have reached its end, since the ape, as ancestor of man, has not reached its highest level of development yet, otherwise homo

sapiens could not have emerged from it. The Neanderthal man, named after a find of fossil bones near Düsseldorf, Germany, was long considered "modern" man's ancestor.

Visiting the new "Neandertaler Museum", I saw that this supposed primeval human was impressively presented for the followers of the Theory of Evolution. The geneticist Suante Päabo of the University of Munich sawed a

Fig. 42: Microevolution. Microevolution is characterized by a combination of all available inheritable features, which develop to different extents, depending on the environmental factors. However, the macroevolution in the Darwinian sense includes greater evolutionary leaps. The figure depicts transmutation of a saurian into the first glider and afterwards into a primeval bird (archaeopteryx), able to fly. Our present-day birds are said to stem from these flying dinosaurs. Even if primeval birds had feathers, the biogenetic distance between a gliding reptile and a wing hitting archaeopteryx is too big in almost any respect.

piece from the upper arm of the bones of Neanderthal man. He was the first to examine the intact DNA of the Neanderthal man in 1997. Comparing these genes with those of modern man (Homo sapiens sapiens) revealed significant differences. In today's races, a maximum of eight genetic differences can be found. Nevertheless, humanity and Neanderthal man are believed to have had the same ancestor about 600,000 years ago. Strange that some monkeys, supposed to have split from our development much earlier, therefore having a much older family tree, are more closely related to us than Neanderthal man. There are also big differences in anatomy, since with a height of approximately 1.60 meters and a weight of about 85 kilograms, the primeval human was essentially smaller and heavier. Conclusion: Neanderthal man died out and was no ancestor or distant relative of modern man.[143]

If humans evolved from monkeylike beings, it seems strange that they are the only species *without natural enemies*. It is also not natural that humans kill their own kind, since this is an unknown phenomenon in the animal kingdom.

Why are there monkeys today anyway? Should monkey not have been displaced by early human by now? In any case, this is one of the Theory of Evolution's fundamental statements.

Ready-made Beings?

The duckbilled platypus of Australia is an example for a ready-made creature. It is an egg-laying mammal with a toothless duckbill, claws with webbing and a seal-like fur; in short: a unique creature. It lives in the rivers and lakes of Eastern Australia and Tasmania. This animal does not correspond with our general expectations of species because it combines the most different characteristics of various animals, not belonging to the same family. The female broods her eggs and then nurses the breed. From the Theory of Evolution's point of view, this animal could be considered a link between different species. If this, however, is the case, other species must have emerged from the duckbilled platypus or there must have been ancestors of the duckbilled platypus. However, such other creatures were not found and they will not be found either. The duckbilled platypus is what it is, a creature in its completion lacking a history of development. There is no reason for this unique life form to turn into a duck because of its bill, even though this mammal lays eggs. Why should it?

If the duckbilled platypus originally was not as it is now, it must be possible to find duckbilled platypus' which are developed to a degree of about 90

percent since the continent of Australia was separated from the mainland when the flood occurred. There could also be duckbilled platypuses that do not nurse their cubs, but bring them up like ducks, geese or even animals without bills. All types would have the same natural enemies. Moreover, the animals' development must have been a coincidence in a locally restricted area. Did these slightly developed animals displace the original species? They definitely did not. In a widespread area, different sorts of duckbilled platypuses would have been able to survive. The animals live on the Australian continent and on the offshore island of Tasmania. Today, the continent is about 240 km away. Did better developed animal swim the distance to Tasmania and replace the prototype that lived there? The duckbilled platypus generally lives in rivers and lakes, rather than in the sea. How did it reach the island?

13,000 years ago, Tasmania was supposed to be connected to Australia. It is interesting that this moment in time, coming from the world of science, coincides with the time of the Flood. Was the duckbilled platypus cut off and did it stop to develop? If this is the case, which I do not believe, there still must be examples of different stages of development, even if they vary only slightly. But there is just one sort of duckbilled platypus with the characteristics of different species.

The duckbilled platypus simply exists and did not develop. If this statement is true, must not somebody have genetically developed the animal out of different characteristics of other animals? Such a task would fall within the possibilities of modern science.

A less controversially discussed issue is the development of the protozoan into a multicellular lifeform. This, again, forms the backbone of macro-evolution. As far as I know, beings with only one cell do exist. There are, however, none with two, three, four or five cells. Did the monad not have to transmute into a multicellular lifeform first? Or do beings with one cell directly unite to form complex beings of numerous cells? There are creatures with six to twenty cells, but only in the form of parasites. If there was macroevolution, there must have been levels of development in a two-celled form, which would be the logical step between a monad and multicellular bodies. Is this not a flaw in Darwin's Theory on how life developed?

Cells are thought to have united directly, in order to form complex structures and not "beings with a small number of cells". In this case, several cells are required, magically emerging at the same time, finding each other in the vastness of a sea. Wonder over wonder...

Feathers and Flight

With a whole chain of evidence, attempts were made to prove that birds emerged from theropods. There were dinosaurs with feathers. This, however, is no reason for an animal to become a bird. The lack of evidence still leaves many scientists skeptical.

Embryonic studies apparently suggest that the first step in this development from a hand into a wing are the outer fingers, i.e. the fourth and fifth finger of the hand. This corresponds with the appearance of a bird's hand. It is nevertheless a fact that their alleged ancestors, the theropod, did not have outer fingers. It seems that this rule has a decisive exception. Biologists now try to prove that the carpal bone and the finger of the non-bird-theropod are equivalent to those of later birds in terms of form and joint. But both cases refer to *absolutely different fingers*! All interpretations of parallel development therefore must seem arbitrary. But biologists are desperate searching for the missing link.

Theropods, the assumed ancestors of our birds, are estimated to have lived 150 million years ago. The next of bird kin – maniraptora – are 35 million years younger. The time remaining to the present is too short for a gradual development in terms of the Theory of Evolution. In other words: there is no evidence of an unbroken line of ancestors.

Almost needless to point out is that the complex lung characteristic of the bird species could not have developed from that of a theropod. The German magazine "Spektrum der Wissenschaft" (Spectrum of Science) stated: "Actually, the objection can presently neither be proven nor disproved since this organ does not fossilize. Yet, there is no other animal from whose lungs this very complicated organ of birds (since it differs from the lungs of all other animal groups) could have evolved."[144]

What applies to bird lungs, also applies to other specific organs in the animal kingdom, in much the same way. There is no history of development, otherwise several in-between stages would have to be proven. Vague and incomplete circumstantial evidence by the disciples of the Theory of Evolution is what it is: unproven suggestions, in essence self-contradictory.

Ready-made Plants?

Did cultivated plants develop independently or where they created? "The Mexican huichóls, for instance, insist that they received corn from their culture-

giving god Mayaguagy."[145] Many civilizations speak of gods that brought culture to man from the skies. In spite of intensive research, it has not been possible to explain the origin of corn or wheat.

Geise points out another mystery of a cultivated plant that suddenly emerged: the banana.[145] It contains a maximum of vitamins and trace elements that are essential to mankind's nutrition. It is said to be possible to survive on bananas alone. How does this perfect hybrid multiply? Not by seeds, but by shoots. How interesting… How could a plant without seeds spread so far? Bananas are found on many continents and even on the smallest islands. How does the plant reach all those places if its seeds are not spread by the wind? Was the banana created?

"According to an Indian tale, it was brought to Earth as Kandali (banana bush) by the Manu, 'spirits' helping man. But that is just a legend…"[145]

Gigantism

Genesis (6:4) explains the origin of giants: "There were giants on the Earth in those days; and also after that, when the sons of God came unto the daughters of men, and they bare [children] to them."

The revised Lutheran Bible translates this passage more clearly: "… they gave birth to their children, who grew into giants on Earth."[146]

At a certain time preceding, or to be precise, until the flood came, gigantism existed. Various fossil finds prove this. The knowledge about the dinosaurs, based on the discovery of their bones, is modern knowledge, only available in the 20th Century. Discoveries in the previous century were therefore dismissed as mere fabrications, as the tendency of ongoing evolution is thought to be a one-way street. Seen from the stance of uniform development, there simply was no room for both higher developed, giant animals and humans in the primeval past, at least not on a global scale. Local disasters do not hinder worldwide development. According to Darwin's and Lyell's theories, worldwide catastrophes did not occur. Since there is evidence for gigantism all over the world, it indicates a certain step on the ladder of evolution. In this case, there could not have been a steady development of the species, otherwise evolution would show a reverse tendency. If the phenomenon of gigantism is a global one, the sudden end of this area implies a worldwide disaster. Both possibilities defeat the Theory of Evolution and in particular Lyell's theory.

Dinosaurs and humans weren't the only giants. Nearly all animals of that epoch existed in megasize: ants with a wingspan of 16 centimeters, dayflies

that were 20 centimeters long, centipedes several meters long and giant scorpions...

In Patagonia, South America, the remains of a giant armadillo were found. It reached a length of more than four meters. Interestingly, the bones and skins of this animal were also found. These had been processed by humans. This meant that this huge armadillo was hunted by humans or might even have been domesticated. Consequently, this serves as evidence of the co-existence of humans and giant animals. This means these giant animals did not live in primeval times, millions of years ago, but were still around recently, when the flood occurred.

Remains of a giant ape, gigantopithecus, were found on Java, Indonesia. Pieces of its jawbones that were twice as big as those of the present man were found. This means that an animal of more than four meters high could have existed. While ransacking Chinese pharmacies in 1939 in Hong Kong, a German immigrant, Prof. Franz Weidenreich, found fossil teeth of the same type. The size of these masticatory organs is astonishing, being three times as big as those of present-day humans. Similar finds were made in Eastern Africa and South China.

Weidenreich, working at the University of Chicago, was called to the Beijing Institute to support the excavations of the so-called Beijing Man. Concluding from the teeth, he was convinced that the jaw and teeth did not belong to a giant ape but to a giant human.

Giant apes and giant humans do not fit into Darwin's Theory of Evolution, since only the evolution of a smaller and simpler into a bigger and higher developed being is considered to be possible. But these discoveries prove the opposite and once again defeat the Theory of Evolution.

In SouthWestern Africa, unusually large hatchets and scrapers were found, fit for use by giant humans. Single hand-axes had a size of 32 centimeters, were 22 centimeters high and weighed 4.2 kilograms. In Syria, similar pieces were found, weighing 3.8 kilograms. Consequently, beings of a height of four meters may have existed. Could it be that the myths of giants or titans are true and are not exaggerations after all?

Is there a genetic limit to growth? According to a report of August 27, 1996, New Zealand scientists discovered a gene in cattle that enabled muscles to grow twice their usual size.[148] The limit of growth as well as age seem to be genetically controlled. The question is why.

Did someone put up artificial hurdles or is nature itself intelligent enough to judge where limits of development need to be enforced? Natural steering seems not to apply here as giant growth was normal in earlier times, as proven

by several discoveries. The only explanation left therefore suggests an artificial hurdle. But who implemented it?

The Biblical Creator

If there was only microevolution and no development of species, the question is: where did humans and animals come from?

Should a faithful Christian not listen to the Pope, who recently accepted the Theory of Evolution because of its popularity? Or should he believe in the words of the Bible? If so, the answer is a definitive one: creation by God.

In Genesis (1:20–27) it is worded very clearly: "And God said, Let the waters bring forth abundantly the moving creature that hath life, ... and every living creature ... and every winged fowl after his kind... And God made the beast of the Earth after his kind, and cattle after their kind, and every thing that creepeth upon the Earth after his kind: and God saw that it was good.... And God said, Let us make man in our image, after our likeness; ... male and female created he them".

Genesis 2:7 and 22 adds: "And the LORD God formed man of the dust of the ground, and breathed into his nostrils the breath of life; and man became a living soul. ... And from the rib, which the LORD God had taken from man, he made a woman, and brought her unto the man."[146]

It is striking that God should use a plural when referring to himself. In these times, pluralis majestatis was not used when rulers spoke of themselves – unlike it's being used by several kings and emperors of our epoch.

Beyond any doubt, Genesis describes the creation of animals and humans. The statements of the Bible are absolutely contrary to those of the Theory of Evolution. Gods shaped man after an image that resembled themselves. His companion was created from his rib. With this statement, the Bible lost much of its trustworthiness. A human made from a rib? Incredible.

Walter-Jörg Langbein gives a plausible explanation in his book "Das Sphinx-Syndrom".[149] The Sumerian cuneiform "ti" for rib has a second meaning: vitality. Is this a mistake in translation and transmission? Considering today's possibilities in genetics, this passage may be interpreted in a new way: "The Gods took Adam's vital power."[149] Fifty years ago this interpretation of this passage would have been judged a mere fabrication. Today, one has to wonder: why not, it sounds possible?

Giving it more thought, we might even come up with a "probably". For where else should the second specimen for reproduction have come from?

Each cell contains DNA. It is required to create a second human, because both have to be equal, to allow these beings to multiply. Memories of the film "Jurassic Park" come to mind.

Approximately 300 years ago Western civilization believed that the world was created in accordance to Christian doctrine. But over these and preceding centuries, the Bible was revised and rewritten several times. Interpretations and beliefs of the Bible were influenced by the prevailing spirit of the times and the level of its technical development. If the reforming Luther had had to translate the word *machine* in the Middle Ages, he might have chosen the word *power* to translate it since at that time machines where hardly known.

The ancient Hebrew wording of the Bible does not use the word "God" but speaks of the "Elohim". The difference lies in the use of the plural: there were several creators or even a larger group of them. Thus, Genesis (6:1–4) says: "When men began to multiply on the face of the Earth and daughters were born unto them that the sons of God saw the daughters of men that they [were] fair; and they took them wives of all which they chose... and they bare [children] to them... the same [became] mighty men which [were] of old..."

Either there is a misunderstanding in this text or these Gods were made of flesh and blood. Verse 3 confirms: "...for that he also [is] flesh..."[146] The word *also* means that Gods' sons and most likely the creators themselves were of flesh and blood, as were their offspring.

These descendents (of humans and Gods' sons) were half-gods with divine (extraterrestrial?) and human blood running through their veins. Since these half-gods were said to be physical, the references to half-gods in mythology must be given serious consideration. They are not fabrications or fairy-tale-like depictions.

In nearly all traditions, gods and demi-gods appear. The Babylonian Gilgamesh-epos describes its hero Gilgamesh as a being which is one third human and two thirds divine. A very precise, maybe even too precise description. Why the effort to state the *proportion of mixture?*

Examples of half-gods can be found in nearly all mythologies. Manetho, an Egyptian high priest who lived around 300 BC, wrote a three-volume work about the Egyptian history. He describes a period of 13,900 years during which the gods ruled Egypt, followed by a period of 11,000 years under the rule half-gods.[150,151]

It seems bizarre that giants are mentioned in the Bible. They are mentioned not only in the book Moses, but also in Hezekiah and the apocryphical text of Enoch. In the apocryphical texts, the prophet Baruch explicitly states the

number of giants to have died in the flood: 4,090,000. This reference to giants is important, because footprints of a length up to fifty centimeters were found at the excavation site near Glen Rose, as well as other places. The unusual size of fossil footprints was often the cause for them being interpreted as a forgery. But if you want to fake something, why should you create something that is so incredible? Many old scriptures confirm the existence of taller humans. And skeletons of such "giants" were found. Are the great numbers of giants, titans and cyclops of legends mere fantasies and exaggerations? Did these creatures exist? The fossil traces seem to be rock solid evidence.

The belief in God as creator was replaced by Darwin's theory. Why? Because it was easier for people to understand evolution as a doctrine of a miraculous development of chemicals which turned into a human? The other view was that of a miraculous creation by a spiritual being. Today, genetics enable us to alter the genes of animals and plants and even create mixed creatures. We are slowly maneuvering ourselves towards a frame of mind where the biblical descriptions can be understood once again.

After having shown that all kinds of life forms – from trilobites to dinosaurs and humans – lived at the same time, there is no longer the necessary space for a development over a long period of time. The logical conclusion is evident: Man was created or was brought to this Earth, virtually ready-made. Humans might may have been created on this Earth, maybe genetically developed out of a primate, which itself had to be created before.

Several scientific studies have shown that humanity had *one primeval mother* in Africa about 100,000 years ago. Supposedly, mankind descended from only one couple, located in Southeast Africa. We are descendants of a very particular creation with only one primeval mother. The Bible's story of Adam and Eve comes to mind. But who knew about today's scientific discoveries a few thousand years ago?

The Sumerian Creator

The Sumerian creation myths are usually considered to be the basis of the "Old Testament", since different representations of the Bible were already written down on the older Sumerian/Babylonian clay tablets. The Jews were held prisoner by the Babylonians and thus had access to the old Sumerian chronicles. These old Sumerian and Akkadian scriptures relate a story that is simply too good to be conceived. I have already referred to its observations

on the origin of our planetary system.

Zecharia Sitchin translated these old scriptures word for word. His interpretation resulted in an interesting, quite realistic and detailed alternative about man's creation. The Anunnaki, inhabitants of the as yet unknown tenth or, depending on one's viewpoint, twelfth planet, Nibiru, came to our solar system. They required gold to protect their atmosphere. After landing on Earth, they built their first station in Mesopotamia, the area that later became the habitat of the Sumerians. They extracted gold from the waters of the Persian Gulf. But the material was not rich enough, so they started mining in South Africa. The gold was refined and transported to their home planet Nibiru.

But work in the mines was strenuous and the Anunnaki refused to continue working. They decided to create a simple worker to take over the heavy work. This creature was named Adamu – Adam. The literal translation means "Earthling". The Sumerians called man, in the sense of worker and servant, "Lu". The newly created being was called "lulu" which actually means "the mixed".[152, 153]

It is odd that these Sumerian statements correspond with those of our scientists: humanity originated in Africa. Moreover you find ancient mines in Southern Africa and we do not know who constructed them.

The Bible as well as Sumerian creation myths testify to man's creation in the image of his creators. Therefore, it is only natural that *both groups* looked alike. The controversy raised over and over again, why passengers of actually sighted UFOs are described as humanlike beings – aside from a small and a very big type – could thus be reasonably answered. Man's unique nature, compelled through the countless wonders of evolution – naturally? – forbids a similar development on other planets. These humanlike creatures, even if only developed by way of coincidence, could not reach us because of the great distances between us. If the human race was created after the image of aliens as the old chronicles state, then the similarity was no matter of coincidence. Quite to the contrary: *we have to look like our creators*. If the Sumerian creation myths are true, then these aliens did not have to cover great distances to reach us. Space bases on the Moon, Mars or other planets or moons would seem normal. Some mysteries – geometric patterns on Mars, an old mine on the moon, etc. – could be solved. The ultimate consequence of these thoughts are mind-expanding. Aliens, resembling us, have to live among us, and UFOs are real?

The Sumerian creation myths contain more astounding details about our solar system, only confirmed by the more recent research of the Voyager

probes. The creation of man as well as the location and the reason for this creation were clearly described. The information about the origin of the Anunnaki is unusual. Their home planet Nibiru originally came from the depths of space and today wanders in an elliptical, comet-like orbit around the sun with an orbital period of 3600 years. This means that this planet reaches far into the ice-cold universe. The low temperature would have to freeze the planet of the Anunnaki. Hard to imagine that the Anunnaki could survive on such a planet. But if these beings are able to create living beings and construct high technology flying machines, maybe they managed to solve this problem. Genesis offers a clue on this issue. The atmosphere of Nibiru had to be protected with gold, which they mined in South Africa, in order to secure the survival of the Anunnaki. Our space satellites are protected by foils made from gold as well. A chance parallel? How did the Sumerians know this? Merely coincidence or imagination? Details on these old claytablets, at least, must set a neutral and unprejudiced reader thinking, or is all this not more than a perfectly imagined coincidence, a 6000 year old science-fiction story?

13 The House of Cards Collapses

Many works that have been published in the last few years describe strange ancient finds, not corresponding with the views of archeology or other sciences. They, however, do completely correspond with the worldview presented in this book. Let us delve deeper in some of these extra-ordinary cases.

Thousands of Year-Old High-Tech

The Sumerian creation myths report of aliens called gods, as well as on spacecraft, spacebases and rockets in every sort known by us.

Flying dragons, chariots in the sky or chariots of fire appear in all myths from China, India, Egypt, Israel, Central and South America, as well as in ancient Greek. Clear descriptions of flying machines, spacebases and the war among the gods are depicted in the very old Indian Vedas, where they are described in incredible detail. An excerpt of the old Indian epic "Ramayana" shows the accuracy of the text:

"... Rama sat down in the sky-carriage ... and prepared himself for the flight. The carriage was two stories high and had many rooms and windows. When the carriage took off, it made a howling sound. The sky-carriage shone like fire in a summer night, was like a comet in the sky, glowing like a pink fire."[154]

The Bible also offers several descriptions about flying objects and of particular prophets flying to different places on Earth and specific spots on the firmament.

The gods taught our ancestors how to develop high-technology objects. Most likely, they used aircraft. This might have been a "divine concession" to the ancient kings, in order to show their superiority over their subjects. Surely, the common people would not have listened to a king who was not able to offer something comparable to the means of the gods?

One specific Egyptian achievement I do not want to leave unmentioned: battery-stored power. "Das Licht der Pharaonen" (The Light of the Pharaohs) by Peter Krassa and Reinhard Habeck deals with the high-technology and usage of electric power in ancient Egypt. The authors are convinced that air-vehicles (sun barques), destructive weaponry (beam weapons), radio- and TV-satellites (audio- and video-birds), as well as TV-sets (magic mirrors) existed several thousand years ago, in Egypt.[155]

Images of helicopter, tank, submarine and machine gun triggered passionate discussions under tourists who visited the Temple of Sethos in Abydos. During a visit to this temple, I saw these hieroglyphs myself. Everyone who sees these pictures, comes away with the idea that these depict flying machines and other military apparatusses. Doubts are almost out of the question.

Pictures of transparent bulbs, in the shape of bubbles, are found in the crypts of the Temple of Hathor at Dendera. They are depicted in a slanted position, leaning on a support. Inside the bulbs, there is a wavy snake emerging from a flower at the lower end of the bulb. Egyptologists call this bulb a "snakestone" and the support is called a "djed-pillar". The question is: do the aggressive snakes represent the efficiency of electricity? Are the supports voltage isolators? Does the lotus flower from which the snake wriggles

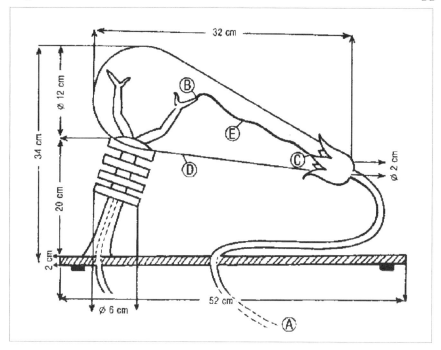

Fig. 43: Antique Light Bulb. *Authors Krassa and Habeck describe the function of an ancient Egyptian bulb: "Today we know that relatively high vacuums are able to produce so-called ejectors (jet pumps) (A), especially if these pumps are available in cascades – meaning a series of connecting parts of the same kind. If the bulb, with two metal parts reaching into its inside (B) (C), is evacuated, a discharge occurs at a lower voltage, depending on the size of the bulb (D). At a pressure of 40 torr, a filament winds itself from one metal part to the other (E). If evacuated further, the snakelike line widens until it finally fills the whole bulb. This corresponds exactly to the illustration in the subterranean chambers of the Temple of Hathor."*[155]

represent a (bulb) socket with cables? The cable leads to a square box – a battery or a generator?

When the ancient characters were deciphered, a model of the bulb was rebuilt and it actually worked. The book by Krasa and Habeck gives precise technical details and there can be no doubt whatsoever in respect to the correctness of their statement and the interpretation of the picture at the Denderah temple.[155]

In 1936, a 15 centimeter high and 2000-year-old vase was excavated in Iraq. Its inside revealed a pitch-plated cylinder made of copper. The cylinder contained an iron stick, isolated by an asphalt plug. Since then, several similar and bigger vases were discovered, which are on display at museums in Iraq and Berlin.

Originally believed to be religious instruments, these objects turned out to be dry cell batteries. After a new electrolyte was added, they worked. These objects and the power of about 1.5 Volt which they produced, was and still is used to gold-plate or silver-plate (galvanize) objects for the bazaars.[156] Could this electrical power also have been put to use for other purposes, such as the illumination of temples, a library or public houses? Proof lies in the picture of the bulb of temple of Denderah.

The secret of how underground corridors of many known temples and graves were illuminated, some of which are closed to the public today, might now be solved. Traces of oil lamps or torches were never found neither on ceilings nor walls. Nevertheless, countless pictures and inscriptions are found in the deep dark corridors. The common and – as far as I know – only explanation is the one given to tourists: a number of mirrors were used to illuminate these dark quarters. There is just one major problem with this possibility: the mirrors would have to have been constantly readjusted, following the position of the sun. On cloudy days, there would be virtually no light whatsoever. On top of that, the loss of light between the mirrors in the nooks and crannies of the corridors several stories deep would have been significant. If any at all, inferior lighting would have been achieved. Furthermore, such mirrors would have required a precise cut. The necessary technical ability to produce these mirrors, however, is something the ancient Egyptians are not considered to have been capable of.

The myths and ancient writings of different peoples mention *eternal* lamps, used for illumination. Electric lighting would explain this mystery.

Maybe our ancient ancestors had even other means of using electrical power. It is a pity that this knowledge was lost during the Dark or Middle Ages, the era of least general and technical knowledge.

A New Worldview

There are many other curiosities, fit to fill several volumes, if we need to mention all of them. The Sumerian knowledge of the solar system, our planet's creation, of mankind, the description of flying machines in ancient times must be accepted as fact. These discoveries and knowledge have one thing in common: they do not fit into our worldview.

The example of the dinosaurs showed that conventional science is only ready to change its point of view very slowly. This is based on the narrow rules we arbitrarily apply to world history. It is said that the dinosaurs definitely lived 64 millions of yeas ago and that merely a few less-developed mammals lived at that time. This is taken for granted and passed on as the present state of knowledge. My on-site research showed that dinosaurs, larger mammals and humans co-existed. Surely, the day will come when it is written that dinosaurs and bigger mammals lived at the same time? The evidence for this conclusion was given years ago.

Why were the respective locations not examined on a broader scientific basis? The answer is an obvious one. The proof of the co-existence of different types and species defeats the theory of the development of the species and Darwin's law. Co-existence and evolution definitely exclude each other, since a development in small steps simply would have taken too long. Until the end of the 18th century, people were convinced of the creation of the world and the existence of a Flood. I believe our ancestors were right.

Do you believe creation is impossible? Coming to this conclusion was a very long process for me. Even if it was unthinkable only a few years ago, precise working models to create an atmosphere that enables the creatures of our planet to live on planet Mars have been produced – it is called "terraforming". Under these circumstances, a settlement of plants and animals on the red planet no longer seems utopian. Our genetic engineers could create new animals, perfectly adapted to Mars' environment. Did our planet undergo a similar process, a few thousand year ago, made possible by an alien intelligence who looked like us?

Everyone is free to continue to believe in God, the almighty Creator, for if aliens created us, the question remains: who created the aliens?

Epilogue

When participating in excavations in 1996, I still believed that the Earth was old and, according to the fossil tracks found together, humans and dinosaurs lived together 64 millions of years ago. It was then that I started writing this book. But simple problems *could not be solved* within the boundaries of our scientific view of the world. Again and again, countless numbers of coincidences and wonders were needed to explain certain phenomena.

The system of evolution seems convincing. It, however, also appears that asking specific questions is not allowed. *It is not at all allowed to ask critical questions.* Our worldview is so brittle that it will not survive the smallest shake. Since our real knowledge does not balance against the official description of our world, it should be open and flexible enough to integrate new discoveries without problems. But the opposite occurs; we try to press the newest scientific findings into the small box of the consciousness of these "antique" intellectual capacities of biology and geology.

Working on this book changed my perception. In one of his books, Gernot Geise wrote that you never know how the project of writing a book will end and this is precisely what happened to me. A new view of the world emerged in my thoughts. Existing contradictions cancelled each other out. One only had to vary the factor of time, even if the consequences seemed uncomfortable.

The principles of Uniformitarianism by Charles Lyell and Charles Darwin serve as the basis of our conventional scientific worldview. It can definitely not be correct. If we take the proof, the theories and the considerations I have given into account, Darwin must be wrong. If only one of these discoveries would receive scientific consideration, a slow and purposeful development analogous to the theories of uniformity would have to be ruled out.

Chaos and disaster mark the general condition of the universe and our planet's history. A uniform development is literally not of this world. Taking these conditions into account, macroevolution is impossible. Only microevolution may have occurred.

The Earth, more specifically the Earth's crust, cannot be very old. During the disaster that occurred, it formed again, in batches, in a plastic and elastic manner. The devouring flood with its ensuing disasters was real.

The core of the Earth, lying beneath the Earth's crust, is older and was probably part of a larger planet, destroyed only a few thousand years ago by

colliding with another planet. There are geological and mythical hints, which allow us to believe in this scenario. A lot of cosmic secrets may, in accordance with this theory, receive logical solutions. Conclusive evidence, however, has yet to be presented.

The proof of one or more cataclysms on this planet poses a blatant opposition to our worldview that is based on the laws of Lyell and Darwin. The Apocalypse and evolution exclude each other. There is no in-between solution. *A young Earth presupposes creation*, since there is no time for a slow and steady development.

In the end, it is not important whether the events took place exactly the way I described them. Much the same applies to the exact moment in time. If the end of the world did not occur 10,000 years ago, but rather 100,000 years or 10 million years ago, one statement remains correct: *Darwin was wrong*. There just was too little time for a slow development of the species and of man.

A change of perspective is required as major disasters definitely played a role in shaping our solar system and the history of our Earth.

The Biogenetical Law of Ernst Haeckel has already been unmasked as a fraud. Since this fundament of the Theory of Evolution was uncovered as pure invention, it is time to summarize all doubts in respect to Darwin's Theory of Evolution and to prove and realize one of the greatest mistakes of human history.

"Unwanted Darwin" was the title of an article published in the newsmagazine "Spiegel" (edition 17/1998, page 17). It stated that the leading organization of scientists in the United States, the National Academy of Sciences, had published a "Guideline for Biology Lessons in Schools". According to the desire of conservative legislators from various American states the Theory of Evolution, referred to as "the most important concept of modern biology" by the academics, should completely vanish from the school curriculum. The biology books of the state of Alabama already claims that the Theory of Evolution is merely a "controversial theory". In addition, the "Washington Post" reported that several schoolboards assigned their teachers to provide "equal space" for teaching the biblical 6-day Creation and teaching the Theory of Evolution in biology lessons.

Evidence for the co-existence of all beings, which I personally witnessed during the excavation in Texas, prove the incorrectness of the Theory of Evolution. When I started to write this book, in 1996, I had to state and represent seemingly utopian theories. After a work of nearly two years, a change in biology and paleontology seemed to come about. This change of

view supports my thinking. The finds in Glen Rose appear in the light they deserve: facts, not fantasies or fake. *It is certain: Darwin was wrong.*

The co-existence of dinosaurs and large mammals is proven by the fossil finds at and in Paluxy River. On April 30, 1998, the British scientific magazine "Nature" (392/1998) announced that the American biologists Sudhir Kumar and Blair Hedges of Pennsylvania State University studied fossil genes. They came to the conclusion that most mammals lived more than 100 million years ago and existed simultaneously with dinosaurs. Under these conditions, you seriously have to ask when evolution took place. To repeat myself once again: *evolution and co-existence rule each other out!* Hence, the co-existence of all beings proves creation. This official announcement created great controversy among palaeontologists. One wonders why...

Scientists seem, however, to be slowly shifting towards my point of view. The planetary collision is getting more likely. The scientific magazine "P. M." (6/1998) states: "A huge heavenly body is going to fall upon the Earth and will smash a big part of our planet." This message is based on a simulation made by the astronomer Glen Stewarts of the University in Boulder, Colorado. The debris of a cloud of rocks orbiting Earth along the equator is believed to have compressed, forming our moon within the space of just one year. According to the Theory of Evolution, this collision took place four billion years ago.

Parallels between this declaration and my own statements are obvious. The enormous periods of time have to be reduced to cancel out the remaining contradictions. It all happened only a few thousand years ago. The Earth may be old, but the Earth's crust is young...

Appendix: Superfloods

The "uniformitarianism" principle of Charles Lyell holds that scientifically reliable inferences about the past must be confined to invoking only the slow-acting, low-magnitude processes currently in evidence to human observers. This theory on the exclusive effectiveness of miniscule contemporary forces on changes on the earth's surface laid the foundations for our present view of the world. This means that the appearance of the earth has merely changed slightly and insignificantly in the course of the earth's history.

The above-mentioned theories of uniformity reject any global catastrophe as a matter of principle because it would prove that a uniform development of the species is unfounded. All observations made today are still projected into earth's past. This is a comfortable system with fixed, unchanging key features, allowing calculation and interpretation of any phenomenon.

In this book Zillmer give new perperctives in Earth Science and discussed historic accounts of superfloods and also several smaller floods of the last several thousand years. In this case Charles Lyell's geological theory is wrong. This view way revolutionizing the geology is supported by a new article in Science. Victor R. Baker is in the Department of Hydrology and Water Resources, University of Arizona in Tucson. In the journal "Science" (1) he published an article at 29 March 2002 to give evidence for superfloods exactly at the time as this book is on the way to go to thePrintery.

The original article of Baker (Science, Issue of 29 March 2002, Vol. 295, pp. 2379-2380):

"Large, high-energy floods are both rare and dangerous. Evidence of their impacts in the geologic record is often subtle, but the greatest obstacles to advancing the knowledge of superfloods have come from misapplied scientific logic. Particularly troublesome are flawed notions of hypothesis testing, verification, and the principle of simplicity. Contrary to conventional views of scientific methodology, there has never been a general theory of superfloods that could be tested, confirmed, or falsified by observation and experiment. Instead, as in much of geology, observation has preceded theory, and understanding has emerged as previously unrecognized phenomena were discovered.

Methodological problems with the study of superfloods began early, at the inception of geology as a science. The influential 19th-century geologist Sir Charles Lyell passionately advocated a regulative principle for validating the inferences that geologists make about the past. Presuming that geologists

reason by induction, Lyell thought that such a principle was necessary if geo-logical inferences about past causative processes were to achieve the same kind of certainty as those made in experimental sciences like chemistry and physics. It was Lyell's most capable critic, the Cambridge polymath William Whewell, who in 1832 named this principle "uniformitarianism." Epistemo-logical uniformitarianism holds that scientifically reliable inferences about the past must be confined to invoking only the slow-acting, low-magnitude proc-esses currently in evidence to human observers.

This principle was applied blindly by Lyell's intellectual descendents well into the 20th century. In the 1920s, Bretz's documentation (2) of the spec-tacular effects of late-glacial flooding in the Channeled Scabland region in Washington state met with immense criticism from the scientific community. Not until the 1960s was it generally accepted that this flooding was caused by catastrophic failure of the immense ice-dammed Glacial Lake Missoula along the southern margin of the Cordilleran Ice Sheet, which covered the north-western mountains of North America about 20,000 years ago.

Over the past 40 years, evidence has accumulated for catastrophic failures of ice-dammed lakes, overflows of lakes that had formed along ice margins, and subglacial outburst flooding in the many river systems associated with the immense continental ice sheets of the last ice age. The southern margin of the Laurentide Ice Sheet that covered northeastern and north-central North America was episodically drained by outburst floods (3). These freshwater

Deposits of the cataclysmic Missoula floods. The largest boulder has a long axis of 18 m. It was eroded from scabland basalt outcrops and was transported about 10 km to the proximal portion of the immense Ephrata Fan, which covers about 1000 km² of the Quincy Basin in east-central Washington state.

discharges greatly influenced ocean circulation and climate at the end of the last ice age (4).

Even more extensive evidence of superflooding has been documented in Asia, recorded best in the Altai Mountains of the upper Ob river basin (6). Spectacular superflood features are also found in the upper Yenesei river basin in Tuva. A system of huge spillways connected the late glacial lakes that inundated large parts of the Ob and Yenesei basins. The huge meltwater influxes greatly extended the areas and volumes of paleolakes in basins now occupied by the much smaller Caspian and Aral Seas and drained into the Black and Mediterranean Seas (5). The mountains forming the border regions of modern Russia, China, Mongolia, and the central Asian republics also contain extensive evidence of ice-dammed lakes, many of which spilled catastrophically.

Long geologic records from river basins bear witness of repeated superflooding. The Columbia basin was affected by superfloods numerous times over the past 1.5 to 2.5 million years (7). Its flood sediments were introduced into the Pacific Ocean, where they were transported as turbidity currents along a 1000-km path across the sea floor (8). Hydraulic reconstructions of the flood discharges show that their magnitude can be substantial: The Missoula and Altai superfloods achieved peak discharges of about 20 million m^3/s (6), comparable to the volume of water moved by many ocean currents.

Ocean currents rarely move faster than a few m/s, whereas superflood flows may move several tens of meters per second. High-discharge floods in narrow, deep bedrock channels also generate immense magnitudes of power per unit area and of bed shear stress (9). Paleohydraulic calculations have shown that high-energy floods may lead to large-scale turbulence, cavitation, boulder transport (see the figure), suspension of very coarse particles, and abrupt changes in flow dynamics (9). The bedrock is scoured to form longitudinal grooves, giant potholes, inner channels, and cataracts. Deposited material forms giant current ripples composed of gravel and boulders and immense bars of gravel and boulders. Slackwater sedimentation occurs at the margins of the flood discharge channels.

These well-documented features associated with superflooding have been used to infer even more spectacular flooding scenarios during the last ice age. In a recent interpretation of the central Asian evidence, Grosswald (10) infers that immense volumes of water were conveyed from the margins of the great ice sheets that occupied what are now the shallow continental shelves of northern Asia. The floodwater moved southwestward, not only cutting

spillways between the major north-flowing river systems but also inundating hundreds of kilometers of intervening upland to produce an east-west flow pattern in the topography that is apparent on satellite images of central Asia. Another much-disputed theory ascribes subglacial landforms associated with the late-glacial ice sheets to meltwater flooding beneath the ice, leading to outburst flooding at the ice margins (11).

These highly controversial studies of superfloods show that flood science has not achieved the universally accepted valid scientific methodology envisioned by Lyell. Instead, it is my view that superflood studies are motivated by a notion introduced by Whewell, who proposed in 1840 that productive scientific hypotheses work toward achieving "consilience," a kind of confirmation through the unexpected connections and explanatory surprises they engender.

The most unexpected superflood connection has been the discovery of immense flood channels on Mars, which have morphologies that are best explained by direct comparison to flood-eroded landscapes on Earth (12). Less spectacular, but highly relevant to human adaptation to flood hazards, is paleoflood hydrology (13) in which the generally smaller floods of the last several thousand years are reconstructed with techniques previously applied to the study of the superfloods of the last ice age."

References

1. Victor R. Baker, Science, Volume 295, Number 5564, Issue of 29 Mar 2002, pp. 2379-2380
2. J H. Bretz, *J. Geol.* 32, 139 (1923).
3. A. E. Kehew, J. T. Teller, *Quat. Sci. Rev.* 13, 859 (1994).
4. J. T. Teller, *Paleoceanography* 5, 897 (1990).
5. S. A. Arkhipov *et al.,* *Boreas* 24, 196 (1995).
6. V. R. Baker, G. Benito, A. Rudoy, *Science* 259, 348 (1993).
7. B. N. Bjornstad, K. R. Fecht, C. J. Pluhar, *J. Geol.* 109, 695 (2001).
8. G. G. Zuffa *et al., J. Geol.* 108, 253 (2000).
9. J. E. O'Connor, *Hydrology, Hydraulics, and Sediment Transport of Pleistocene Lake Bonneville Flooding on the Snake River, Idaho* (Geol. Soc. America Spec. Pap. 104, Boulder, CO, 1993).
10. M. Grosswald, *Cataclysmic Megafloods in Eurasia and the Polar Ice Sheets* (Scientific World, Moscow, 1999).
11. J. Shaw, in *Geomorphology sans Frontiere*, S. B. McCann, D. C. Ford, Eds. (Wiley, Chichester, UK, 1996), pp. 182-226.
12. V. R. Baker, *Nature* 412, 228 (2001).
13. P. K. House *et al.*, Eds., *Ancient Floods, Modern Hazards: Principles and Applications of Paleoflood Hydrology* (American Geophysical Union, Washington, DC, 2002).

Notes

1 Buttlar, 1987
2 "APA Guides". 1991
3 John Mackay , in "Creation Ex Nihilo", Volume 5 No. 4, Australia
4 Zillmer, H.-J.: "Gemeinsame Spuren von Dinosauriern und Menschen", in "EFODON Synesis", 27/1998, 15-20
5 Dougherty, 1984
6 Baugh, 1991
7 "P. M.", Special "Dinosaurier", Munich 1997, 34
8 "Nature" 320/1986, 308
9 "Nature", 321/1986, 722
10 Baugh, 1991
11 "Focus", No.14/1998, 216
12 Baugh, 1991
13 "Illustrierte Wissenschaft", Volume 7, April 1998, 24
14 "Bild", 10.12.1996
15 Wright, 1887, 379-381
16 Buttlar, 1996
17 Bürgin, 1994
18 Däniken, E. v.: "Golfbälle der Götter", in "Ancient Skies", I/1988
19 Steiger, 1989
20 Langbein, 1996
21 Baugh, 1991
22 Helfinstine, 1994
23 Dougherty, 1984
24 Baugh, 1991
25 Dougherty, 1984
26 Däniken, 1974
27 Steiger, 1989
28 Brown, 1980
29 "P. M.", Special "Dinosaurier", Munich, 1997, 10
30 Baugh, 1991
31 "Reise Know-How", 1993, 294
32 "Reise Handbuch", 1993, 244
33 "Science News Letter", December 10, 1938, 372
34 Schoolcraft, H.R. und Benton, T.H.: Remarks on the Prints of Human Feet, Observed in the Secondary Limestone of the Mississippi Valley", in "The American Journal of Science and Art", Volume 5, 1822, 223-231
35 "Human-like Tracks are Riddle to Scientists", in "Science News Letter", October 29 1938, 278-279
36 Däniken, 1974
37 Tomas, w/o year
38 Geise, 1997

39 J.Q. Adams: "Eva's Thimble" in "American Antiquarian", Volume 5, 1883, 331-332

40 Harry V. Wiant: "A Curiosity from Coal", in "Creation Research Society Quarterly", Issue No. 1, Volume 13, 1976, 74

41 Wilbert H. Rusch sen.: "Human Footprints in Rocks", in "Creation Research Society Quarterly", Volume 7, 1971

42 Buchanan, J.: "Discovery of an Iron Instrument Lately Found Imbedded in a Natural Seam of Coal in the Neighborhood of Glasgow", in "Proceedings of the Society of Antiquarians of Scotland", Volume 1, 1853

43 Buttlar, 1996

44 "Morrison Times", June 11, 1891, 1

45 "A Relic of a By-Gone Age" in "Scientific American", June 5, 1952, 298

46 Austin, S.: Video "Mount St. Helens: Explosive Evidence for Creation", Institute for Creation Research, 1992

47 "Natural History", 3/1924

48 Zillmer, H.-J.: "Dinosaurierspuren in weicher Kohle", in EFODON Synesis", 28/1998, 13-18

49 Berlitz, 1987

50 Hancock, 1995

51 Velikovsky, "Erde...", 1994

52 Vollmer, 1989

53 For detailed description, see Glossary

54 "Science", 141/1963, 634-637

55 "Science", 224/1984, 58-61

56 Petersen, 1986

57 "Zeitensprünge", No. 3/1996

58 Blöss und Niemitz, 1997

59 Friedrich, 1997

60 Gentry, 1992

61 Brown, 1980

62 "Rätselhafte Vergangenheit", 1993, 118

63 Dougherty, 1984

64 Hapgood, 1979

65 Hancock, 1995

66 Sudhoff, 1990

67 Dougherty, 1984

68 Sitchin, 1994

69 Däniken, 1973

70 Hancock, 1995

71 Lewis, R. S.: "A Continent for Science", in "The Antarctic Adventure", New York 1961

72 Brown, 1980

73 Anthony, H. E.: "Nature's Deep Freeze", in Natural History", September 1949

74 Zimmermann, M. R. and Tedford, R. H.: "Histologic Structures Preserved for 21300 years", in "Science", October 8, 1976

75 Anthony, H. E.: "Nature's Deep Freeze", in "Natural History", September 1949

76 Anderson, 1923

77 Tollmann, 1993
78 Erman, 1848
79 Penniston, J.B.: "Note of the Origin of Loess", in "Popular Astronomy", Volume 39, 1931, 429-430 and "Additional Notes on the Origin of Loess", "Popular Astronomy", 51/1943, 170-172
80 Muck, 1976
81 Dall, W.H., in "American Journal of Science", 1881, 107
82 Brown, 1980
83 Muck, 1976
84 Hapgood, 1970
85 Hancock, 1995
86 Muck, 1976
87 Geise, 1997
88 Sudhoff, 1990
89 Velikovsky, "Welten...", 1994
90 Thompson
91 Velikovsky, "Welten...", 1994
92 Sitchin, 1992
93 Velikovsky, "Welten...", 1994
94 Friedrich, 1997
95 Agassiz, 1840
96 Chorlton, 1983
97 Buckland, 1824
98 Ziegler, K. and Oppenheim, S.: "Weltuntergang in Sage und Wissenschaft" in "Natur und Geisteswelt", Leipzig 1921
99 Chorlton, 1983
100 Velikovsky, "Welten...", 1994
101 Sagan, 1996
102 Today, Earth's rotational speed decreases by one second every 500 days (leap second). Assuming a steady rate of speed loss, in 10 000 years' time, days will be 1,5 hours shorter.
103 Tollmann, 1993
104 Vollmer, 1989
105 "P. M.", 2/1998, 48
106 Langbein, 1995
107 Velikovsky, "Welten...", 1994
108 Sitchin, 1995
109 Velikovsky, "Welten...", 1994
110 Tollmann, 1993
111 Riem, 1925
112 Velikovsky, "Welten...", 1994
113 Berlitz, 1986
114 Tollmann, 1993
115 Muck, 1976
116 Berlitz, 1986
117 Buttlar, 1991
118 "Bild der Wissenschaft", News-Ticker May 18, 1998

119 Tollmann, 1993
120 Velikovsky, "Welten…", 1994
121 Tollmann, 1993
122 Riem, 1925 (cf. Tollmann)
123 Muck, 1976
124 Velikovsky, "Welten…", 1994
125 Hancock, 1995
126 "P. M.", Special "Dinosaurier", Müchen 1987, 20
127 Brown, 1980
128 "P. M.", 11/1996, 12
129 Morris, 1994
130 Queiser, Hamburg, 1988
131 Toon, O. B.: Sudden Changes in Atmospheric Composition and Climate" in Holland H.D. and Trendall, A.F.: "Patterns in Change of Earth Evolution", Berlin 1984, 14-61 (cf. Tollmann)
132 Tollmann, 1993
133 Langbein, 1996
134 Heuvelmans, 1068
135 Bord, 1989
136 Fiebag, 1993
137 "P. M.", Special "Dinosaurier", Munich 1987, 37
138 Petratu and Roidinger, 1994
139 Geise, 1997
140 "Focus", No.34/1997, 128
141 "Focus", No.39/1996, 178
142 Moore, 1970, 91
143 "Focus", No.29/1997, 108
144 "Spektrum der Wissenschaft", 4/1998, 43
145 Geise, 1997
146 "The Holy Bible", King James Version, Cambridge University Press
147 Bürgin, 1995
148 "Bild", August 27, 1996
149 Langbein, 1995
150 Däniken, 1989
151 Waddel, no year
152 Sitchin, 1995
153 Sitchin, 1996
154 Popowitsch, 1991
155 Krassa and Habeck, 1996
156 Berlitz, 1986
157 Meyers Lexikon

Bibliography

If not specified otherwise, biblical quotations follow the standard translation "King James Bible".

"King James Bible" = "The Holy Bible", Authorized King James Version, Cambridge University Press, Cambridge, no date

Agassiz, L.: "Etudes sur les Glaciers", Neuchatel 1840

Alvarez, G.: "Mass extinctions caused by large bolide impacts" in "Physics Today", New York/Washington 1987

Alvarez, L. and Alvarez, W.: "Extraterrestrial Cause for the Cretaceous-Tertiary Extinction" in "Science" 208, 1095–1108, Washington, June 6th, 1980

Andersen, J. A.: "Polsprung", Weilersbach 1998

Anderson, D. L., und Dziewonski, A. M.: Seismische Tomographie: 3-D-Bilder des Erdmantels, in: "Die Dynamik der Erde", Heidelberg 1988

Anderson, W.: "Die nordasiatischen Flutsagen", Dorpat 1923

Anthony, H. E.: Nature‹s Deep Freeze, in: "Natural History", September 1949

Arguelles, J.: "Der Maya-Faktor", Munich 1987

Asimov, I and J.: "Frontiers II", New York 1993

Asimov, I.: "Die Wiederkehr des Halleyschen Kometen", Cologne 1985

Austin, S. A.: "Grand Canyon", Santee 1994

Azzaroli, A.: Cainozoic Mammals and the Biogeography of the Island of Sardinia, Western Mediterranean, in: "Paleogeography, Paleoclimatology, Paleoecology", 36, 1981

Baars, D.: "The Colorado Plateau", Albuquerque 1983, 6. Aufl. 1994

Balázs, D.: "Galápagos", Leipzig 1975

Barker, G.: "Prehistoric Farming in Europe" in "New Studies in Archaeology", Cambridge 1985, 139-147

Barnes, F. A.: "Canyon County Geology", Salt Lake City 1978, 6th Edition 1996

Baugh, C. E.: "Dinosaur, Scientific Evidence that Dinosaur and Men walked Together", Orange 1987, Reprint 1991

–:: "Dinosaur, Scientific Evidence that Dinosaur and Men walked together", Orange 1987, Reprint 1991

Beiser, A.: "Die Erde" in der Reihe "Life- Wunder der Natur", 1970

Bellamy: "Moons, Myths and Man", 1938

Berckhemer, H.: "Grundlagen der Geophysik", Darmstadt 1990, 2nd Edition 1997

Berlitz, C.: "Mysteries From Forgotten Worlds", New York 1972

–: "Der 8. Kontinent", Munich 1986

Binford, S. R. und L. R.: "A preliminary analysis of functional variability in the Mousterian of Levallois faces" in "American Anthropologist", Bd. 68

Blackstone, D. L.: "Traveller's Guide to the Geology of Wyoming", Laramie 1988

Blöss, C., and Niemitz, H.-U.: "C14-Crash", Gräfelfing 1997

Bolsche, W.: "Das Leben der Urwelt", Leipzig 1932

Bonatti, E.: Der Erdmantel unter den Ozeanen, in: "Spektrum der Wissenschaft", Mai 1994

Bonechi, C. E. (Ed.): "Yellowstone and Grand Teton Nationalparks", Florenz 1996

–: "Grand Canyon Nationalpark", Florenz 1997

Bord J. and C.: "Unheimliche Phänomene des 20. Jahrhunderts", Munich 1989

Boschke, F. L.: "Die Schöpfung ist noch nicht zu Ende", Rastatt 1985

Brown, T.: How I control Gravitation, in: "Science and Invention", 1929

Brown, W.: "In the Beginning", Phoenix 1980, 6th Edition 1995

Browne, M. W.: Skepticism Over Dinosaur DNA, in: "International Herold Tribune", 22.6.1995

Brugger, K.: "Die Chronik von Akakor", Düsseldorf/Wien 1976

Bryan, A. L.: An Overview of Paleo-American Prehistory from a Circum-Pacific Perspective, in: "Early Man in America", 1978

Buckland, W.: Reliquiae Diluvianae; or the observations on the Organic remains Contained in Caves, Fissures and Diluvial Gravel and Other Geological Phenomena Attesting the Action of an Universal Deluge", London 1824

Büdel, J.: "Die Klimazonen des Eiszeitalters", EuG 1, 1951; "Die Gliederung der Würmkaltzeit", Würzb. Geogr. Arb. 8, 1960

Bührke, T.: King Kong unter Druck, in: "Bild der Wissenschaft", 10/1999

Bürgel, B. H.: "Die Weltanschauung des modernen Menschen", Berlin 1932

–: "Weltall und Weltgefühl", Berlin 1925

Burroughs, W. G.: Human-like Footprints, 250 million years old, in: "The Berea Alumnus", Kentucky 1938

Busse, F. H.: Magnetohydrodynamics of the Earth's Dynamo, in: "Annual Review of Fluid Mechanics", Band 10, 1978

Buttlar J. v.: "Adams Planet", Munich, 1991

–: "Leben auf dem Mars", Munich 1987

–: "Schneller als das Licht", Düsseldorf 1996

Carey, S. W.: "The Expanding Earth", Amsterdam 1976

Carlson, M. P.: "Geology, Geologic Time and Nebraska", Nr. 10, Lincoln 1993

Carpenter, K., Hirsch, K. F., and Horner, J. R.: "Dinosaur Eggs ans Babies", Cambridge 1994

Carrigan, C. R., and Gubbins D.: Wie entsteht das Magnetfeld der Erde, in: "Spektrum der Wissenschaft", 4/1979

Ceram, C. W.: "The first American", 1971

Chain, V. E., and Michajlov, A. E.: "Allgemeine Geotektonik", Leipzig 1989

Charig, A.: "A new look at the Dinosaurs", London

Charlton, W.: "Eiszeiten", in der Reihe "Time-Life", Gütersloh 1983

Charroux, R.: "Le livre des secrets trahis", Paris 1965

Chorlton, W.: "Eiszeiten", in series "Time-Life", Gütersloh 1983

Chronik, H.: "Pages of Stone, Grand Canyon and the Plateau County", Seattle 1988, 4th Edition 1977

Cleophas, C.: "The White River Badlands", Rapid City 1920

Closs, H., Giese, P., und Jacobshagen, V.: Alfred Wegeners Kontinentalverschiebung aus heutiger Sicht, in: "Ozeane und Kontinente", Heidelberg 1987

Colbert, E. H.: "The Great Dinosaur Hunters and Their Discoveries", Toronto 1968, Reprint 1984

Coleman, R. G.: "Ophiolites: Ancient Oceanic Lithosphere?", Berlin 1977

Courtillot, V. E.: Die Kreide-Tertiär-Wende: verheerender Vulkanismus?, in: "Spektrum der Wissenschaft", Digest 5, 1997

Credner, H.: "Elemente der Geologie", Leipzig 1912

Cremo, M. A., and Thompson, R. ,L.: "Forbidden Archaeology", Badger 1993

Cuvier, G.: "Discours sur les Revolutions du globe", Paris 1812

–: "Discours sur les révolutions de la surface du globe, et sur les changements qu«elles ont produits dans le règne animal", Paris 1821

Daber, R.: "Geologie erforscht und erlebt", Leipzig/Jena/Berlin 1965

Dacqué, E.: "Die Erdzeitalter", Munich und Berlin, 1930

–: "Die Urgestalt", Stuttgart 1951

–: "Urwelt, Sage und Menschheit", Munich und Berlin, 1931

Dall, W. H.: Extract from a report to C. P. Patterson, Supt. Coast and Geodetic Survey, in: "American Journal of Science", 21, 1881

Dallmann, G.: "Vorzeitliche Meeresspuren – Die Kalkmergelsand-Flora", Leopoldshöhe 1995

Damon, P. E., et. al.: Correlation and Chronology of the Ore Deposits and Volcanic Rocks, in: "U. S. Atomic Energy Commission Annual Report", No. C00-689-76, 1967

Däniken, E. v.: "Beweise", Munich 1974

–: "Die Augen der Sphinx", Munich 1989

–: "Meine Welt in Bildern", Düsseldorf/Vienna 1973

–: "Golfbälle der Götter", in "Ancient Skies", I/1988

Darwin, Ch.: "Reise eines Naturforschers um die Welt", 30, März 1835

–: "The Descent of Man", London 1871

–: "The Origin of Species", London 1859

Darwin, Ch.: "On the Origin of Species by Means of Natural Selection", London 1859

Davidson, J.: "The Secret Of The Creative Vacuum", Essex 1989

Dawkins, R.: "Der blinde Uhrmacher – Ein Playdoyer für den Darwinismus", Munich 1987

Dell, R. F.: "Geology of Colorado Illustrated", Grand Junction 1994

Deloria, V.: "Red Earth, White Lies", New York 1995

Dewey, J. F.: Plattentektonik, in: "Ozeane und Kontinente", Heidelberg 1987, see also: "Scientific American", 5/1972

Dixon, D.: "The Practical Geologist", New York 1992

Donald, G. J. F.: The Deep Structure of Continents, in: "Reviews of Geophysics", Band 1, Heft 4, 1963

Dorozynky, A.: Le premier Américain était-il européen?, in: "Science & Vie", 1997

Dougherty, C. N.: "Valley of the Giants", Cleburn 1971, Reprint 1984

Drujanow, W. A.: "Rätselhafte Biographie der Erde", Leipzig 1984

Du Torr, A.: "Our Wandering Continents", Edinburgh 1957

Dunbar, C. O: "Historical Geology", 1949

Eisbacher, G. H.: "Nordamerika" in der Reihe "Geologie der Erde", Stuttgart 1988

Ercivan, E.: "Das Sternentor der Pyramiden", Munich 1997

Erdoes, R., and Ortiz, A.: "American Indian Myths and Legends", New York 1985

Ericson, M., and Heezen, B. und C.: Deepsea Sands and Submarine Canyons, in: "Geological Society of America Bulletin 62", 1951

Erman, A.: "Travels in Siberia", London 1848

Ewing, M.: New Discoveries of the Mid-Atlantic Ridge, in: "National Geographic Magazine", Vol. XCVI, No. 5, November 1949

Feduccia, A.: "The Origin and Evolution of Birds", New Haven 1996

Fiebag, J.: "Die Anderen", Munich 1993

Fischer, H.: "Rätsel der Tiefe", Leipzig 1923

Fitzhugh, E. F.: "Treasures in the Earth", Caldwell 1936

Flandern, T. v.: "Dark Matter, Missing Planets & New Comets", Berkeley 1993

Flint, R. F.: "Glacial Geology and the Pleistocene Epoch", 1947

Francheteau, J.: Die ozeanische Kruste, in: "Die Dynamik der Erde", Heidelberg 1988

Freyberg, B. v.: "Thüringen – Geologische Geschichte und Landschaftsbild", Öhringen 1937

Friedell, E.: "Kulturgeschichte Ägyptens und des Alten Orients", Munich 1936

Friedrich, H.,: "Erdkatastrophen und Menschheitsentwicklung", Hohenpeißenberg 1998

–: "Jahrhundertirrtum Eiszeit?", Hohenpeißenberg 1997

Fritz, W. J.: "Roadside Geology of the Yellowstone County", Missoula 1985

Geinitz, F.: "Die Eiszeit", Braunschweig 1906

Geise, G.: "Woher stammt der Mensch wirklich?", Hohenpeißenberg 1997

–: "Keltenschanzen und ihre verborgenen Funktionen", Hohenpeißenberg 1998

Gentry, R. V.: "Creation's Tiny Mystery", Knoxville 1992

Gish, W.:"Wie war das wohl mit den Dinosauriern?", Gräfeling 1982

–: "Logos und Chaos", Neuhausen/Stuttgart, 1985

–: "Wenn Tiere reden könnten", Bielefeld 1997

Goodwin, B.: "How the Leopard Changed Ist Spots", New York 1994

Gould, S. J.: "Zufall Mensch", Munich 1994

Gregory, J. W.: Contributions to the Geography of British East Africa, in: "Geographical Journal", IV, 1894

–: The African Rift Valleys, in: "Geographical Journal", LVI, 1920

Greulich, W. (Ed.): "Lexikon der Physik in sechs Bänden", Heidelberg 1998

Gripenberg, W. S.: "Über eine theoretisch mögliche Art der Paläothermie", Ark. Keemi 1933

Haeckel, E.: "Prinzipien der generellen Morphologie der Organismen", Berlin 1906

Hager, M. W.: "Fossils of Wyoming", Laramie 1970

Hallam, A.: "A Revolution in the Earth Sciences", Oxford 1973

–: "Revolution in the Earth Sciences. From Continental Drift to Plate Tectonics", Oxford 1973

Hancock, G.: "Die Spur der Götter", Bergisch Gladbach 1995

Hansen, R. W.: "The Black Canyon of the Gunnison in depth", Tucson 1987

Hapgood, C. H.: "Maps of the Ancient Sea Kings", New York 1966 and London 1979

–: "The Path of the Pole", New York 1970

Hartmann, F.: "Das Geheimnis des Leviathan", Berneck 1994

Haubold, H.: "Die fossilen Saurierfährten", Wittenberg 1974

Hausel, W. D.: "Minerals and Rocks of Wyoming", Laramie 1986

Hayes, D.: "Im Eis verschollen", Berlin 1994

Heer, O.: "Flora fossiles arctica: Die fossile Flora der Polarländer", Zürich 1868

Heinsohn, G.: "Wie alt ist das Menschengeschlecht?", Munich 1991

–: Für wie viele Jahre reicht das Grönlandeis?, in: "Vorzeit-Frühzeit-Gegenwart", Ausgabe 4/1994

–: Wann starben die Dinosaurier aus?, in: "Zeitensprünge", Ausgabe 4/1995

Heinzerling, J.: "Energie aus dem Nichts", Munich/Essen 1996

Helfinstine R. F., and Roth, J. D.: "Texas Tracks and Artifacts", Published by the author, USA 1994

Henke, W., and Rothe, H.: "Der Ursprung des Menschen", Stuttgart 1983

Hentze, L. F.: "Geologic History of Utah", Provo 1988, Reprint 1993

Herz, O. F.: Frozen Mammoth in Siberia, in: "Annual Report of the Board of Regents of the Smithsonian Institution", Washington D. C. 1904

Heuvelmann, B.: "In the Wake of the Sea-Serpents", London 1968

Hickmann, C. S., and Lipps, J. H.: Geologic Youth of Galápagos Islands Confirmed by Marine Stratigraphy and Palaeontology, in "Science", 227

Hirsch, W.: Urzeitliche Riesen besiedelten den eurasischen Kontinent, in: "Informationsdienst Wissenschaft", Online on September 26, 1999

Holroyd, E.. W.: Missing Talus, in: "Creation Research Society Quarterly", 24/1987

Hones, E. W.: Der Schweif der Erdatmosphäre, in: "Spektrum der Wissenschaft", 8/1980

Horgan, J.: "The End of Science", Reading 1996

Horn, A. D.: "Götter gaben uns die Gene", Güllesheim 1997

Howell, G. H.: Terrane, in: "Die Dynamik der Erde", Heidelberg 1988

Hsü, K. J.: Als das Schwarze Meer austrocknete, in: "Spektrum der Wissenschaft", Mai 1979

Hsü, K.: "The Mediterranen Was a Desert", New Jersey 1983

Hubbard, S.: "The Doheny Scientific Expedition to the Hava Supai Canyon, Northern Arizona", a copy of this personal correspondence on the Expedition of 1924 is available in the Peabody Museum of American Archaeology and Ethnologie of Harvard University

Humboldt, A.: "Voyage aux régions équinoxiales du nouveau continent", Paris, 1805–1834

Hutchinson, J. H.: Western North American Reptile and Amphibian Record across the Eocene/Oligocene Boundary and its Climatic Implications, in: D. R. Prothero, W. A. Berggren (Hrsg.): "Eocene-Oligocene Climatic and Biotic Evolution", Princeton 1992

Illies, J.: "Der Jahrhundertirrtum", Frankfurt/M. 1983

Illig, H.: "Chronologie und Katastrophismus", Gräfelfing 1992

–: "Die veraltete Vorzeit", Frankfurt/M. 1988

Isacks, B., Oliver, J., and Sykes, L. R.: Seismology and the New Global Tectonics, in: "Journal of Geophysical Research", Band 73, Heft 18, September 1968

Ivanov, A. A., Kouznetsov, D. A., und Miller, H. R.: Aus den Proceedings des 5. Internationalen Kreationisten-

Jacobs, J. A.: "The Earth Core", New York 1975

Jordan, T. H.: Composition and Development of the Continental Tectosphere, in: "Nature", Band 274, 10.8.1978

Junker R., und Scherer, S.: Entstehung und Geschichte der Lebewesen", Gießen 1986

Kahlke, H. D.: "Das Eiszeitalter", Berlin 1987

Kaiser, P.: "Die Rückkehr der Gletscher", Munich 1971

Kapfer, E.: "Lehrbuch der Geologie", 2 Parts in 4 Volumes, 6th and 7th edition, Stuttgart 1921–23

Keller, H.-U.: "Astrowissen", Stuttgart 1994

Kelly, A. O.: "Impact Geology", 1985

Kerr, R. A.: Continental Drilling Heading Deeper, in: "Science", Vol. 224, 29.6.1984

–: German Super-Deep Hole Hits Bottom, in: "Science" Vol. 266, 28.10.1994

–: Looking-Deeply-into the Earth‹s Crust in Europe, in: "Science", Vol. 261, 16.7.1993

Kozlovsky, Y. A.: Kola Super-Deep: Interim Results and Prospects, in: "Episodes", Vol. 1982

Krassa, P. and Habeck R.: "Das Licht der Pharaonen", Munich 1996

Kraus, E.: "Die Entstehung der Kontinente und Ozeane", Berlin 1951

–: "Die Entwicklungsgeschichte der Kontinente und Ozeane", Berlin 1971

Krenkel, E.: "Die Bruchzonen Ostafrikas", 1922

Kroh, H.: "Es werde Licht", Munich 1980

Kuban, G. J.: Do Human Tracks Occur in the Kayenta of Arizona?, in: "Origins Research", Vol. 14, No. 2, 1992

Kühn, A.: "Allgemeine Zoologie", Göttingen 1922, 10. Aufl. Tübingen 1953

Kuhn, T. S.: "Die Struktur wissenschaftlicher Revolutionen", Frankfurt/M. 1973

Laatsch, W.: "Dynamik der mitteleuropäischen Mineralböden", Dresden/Leipzig 1954

Lageson, D. R., and Spearing, D. R.: "Roadside Geology of Wyoming", Misspoula 1988

Lambert, D.: "The Field Guide To Geology", Cambridge 1932, Reprint 1988

Langbein, W.-J.: "Das Sphinx-Syndrom", Munich 1995

–: "Bevor die Sintflut kam", Munich 1996

Laubscher, H. P.: Alpen und Plattentektonik: Das Problem der Bewegungsdiffusion an kompressiven Plattengrenzen, in: "Zeitschrift der Deutschen Geologischen Gesellschaft", Volume 124, 1973

Lewis, R. S.: A Continent for Science, in: "The Antarctic Adventure", New York 1961

Ley, W.: "Drachen, Riesen", Stuttgart 1953

Lister, A.: "Mammoths", London 1994 (deutsch: "Mammuts", Sigmaringen 1997)

Lockley, M.: "Auf den Spuren der Dinosaurier", Basel 19893

Lyell, C.: "Das Alter des Menschengeschlechts", Leipzig 1864

–: "The Principles of Geology: Being an Attempt to explain the Former Changes of the Earth's Surface, by reference to Causes Now in Operation", London 1830

–:"Principles of Geology", London 1830, 3rd Edition 1834

Maack, R.: "Continentaldrift und Geologie des südatlantischen Ozeans", Berlin 1969

Macdonald, W. J., und Fox, P. J.: Overlapping Spreading Centers, in: "Nature", Vol. 135, 13.5.1983

Mania, D.: "Auf den Spuren des Urmenschen", Berlin 1990

Marchant, P.: "Die Frühgeschichte der Menschheit", Gütersloh/Munich 1992

Marien, K. H.: "Wie entstanden die Eiszeiten", Frankfurt 1997

Markham, C.: "The Incas of Peru", 1910

Markus, W.: "Schöpfung in neuem Licht", Bergisch-Gladbach 1990

Martin, H.: The Late Palaeozonic Gondwana Glaciation, in: "Geologische Rundschau", 70

McKee, E. D., Hamblin, W. K., and Damon, P. E.: K-Ar Age of Lava Dam in Grand Canyon, in: "Geological Society of America Bulletin", 79, 1968

Milanovsky, E. E.: "Riftogenez v istorii zemli" ("Riftogonese in der Erdgeschichte"), Moskau 1983

Monastersky, R.: Inner Space, in: "Science News", Vol. 224, 26.6.1984

Moon, P. H.: "The Geology and Physiography of the Altiplano of Peru and Bolivia", The Transactions of the Society of London, 3rd Series, Vol. I, Pt. I,

1939

Moorbath, S.: The Oldest Rocks and the Growth of Continents, in: "Scientific American", Band 236, Heft 3, März 1977

Moore, R.: Die Evolution, in: "Life – Wunder der Natur", 1970

Morgan, J. W.: Rises, Tenches, Great Faults, and Crustal B., in: "Journal of Geophysical Research", Vol. 73, No. 6, 15. März 1968

Morris, J. D.: "The Young Earth", Colorado Springs 1994

–: "What is Creation Science", Green Forest 1982, 16th edition 1997

Muck, O.: "Alles über Atlantis", Düsseldorf/Wien 1976

Müller, Roest, Royer, Gahagan and Schlater: Digital Age Map of the Ocean Floor, in: "Scripps Institution of Oceanography", Ref. Series No. 93-30

Naudiet, A.: "Paradies, Sintflut, Eiszeit", Hohenpeißenberg 1996, 2nd Edition.

Niaux, J. C.: "Die altsteinzeitlichen Bilderhöhlen in der Ariège", Sigmaringen 1997

Norman, D. B.: "Dinosaurier", Munich 1991

O´Niens, R. K., Hamilton, P. J., and Evensen, N. M.: Die chemische Entwicklung des Erdmantels, in: "Spektrum der Wissenschaft", 7/1980

Obuljen, A.: Essai déxplication héliogéophysique des changements paleoclimatiques, in: "Change of climates", Proc. Rome Sympos. Unesco, 1963

Parker, E. N.: Kosmische Magnetfelder, in: "Spektrum der Wissenschaft", 10/1983

Parrish, J. T., Spicer, R. A., Parrish, J. T., et. al.: Continental Climate near the Albian South Pole and Comparison with Climate near the North Pole, in: "Geological Society of America, Abstracts with Programs", Volume 23, Binder 5, 1991

Paturi, F. R.: "Die Chronik der Erde", Augsburg 1996

–: "Harenberg Schlüsseldaten Astronomie", Dortmund 1996

Petersen, D. R.: "The Mysteries of Creation", El Dorado 1986

Petratu, C. und Roidinger, B.: "Die Steine von Ica", Essen/Munich 1994

Pfeiffer, J. E.: "The Emergence of Man", New York 1978

Pitman, W., und Ryan, W.: "Noah‹s Flood", New York 1998

Popowitsch M.: "UFO Glasnost", Munich 1991

Posnansky, A.: "Tiahuanaco, the Cradle of the American Man", 1945

Potonié, H.: "Die Entstehung der Steinkohle", Berlin 1910

–: Autochtonie von Karbonkohlen-Flözen, in: "Jahrbuch der königlich preußischen Geologen", 1893

Quackenbush, L. S.: Notes on Alaskan Mammoth Expeditions of 1907 and 1908, in: "Bulletin American Museum of Natural History", Vol. 26

Queiser, H. R.: "Nachrichten aus der Eiszeit", Hamburg 1988

Raff, A. D.: The Magnetism of the Ocean Floor, in: "Scientific American", Edition of October 1961

Raup, R.: "The Nemesis Affair", New York 1986

Reinsch, D.: "Natursteinkunde", Stuttgart 1991

Repo, R.: "Untersuchungen über die Bewegungen des Inlandeises in Nordkarelien", Bulletin Comm. Géol. Finland. 179, 1957

Reuter, J. P.: "Die Wissenschaft vom Wetter", Berlin/Heidelberg 1978

Reynolds, S. J., u. a.: Compilation of Radiometric Age Determinations in Arizona, in: "Arizona Bureau of Geology and Mineral Technology Bulletin", 197, 1986

Ridley, F.: Transatlantic Contacts of Primitive Man. Eastern Canada and Northwestern Russia, in: "Pennsylvania Archaeologist", 1960

Riem, J.: "Die Sintflut in Sage und Wissenschaft", Hamburg 1925

Ringwood, A. E.: "Origin of Earth and Moon", Heidelberg 1979

Rona, P. A.: Erzbildung an heißen Quellen im Meer, in: "Die Dynamik der Erde", Heidelberg 1988

Rosnau, P O., Auldaney, J., Howe, G. F., and Waisberger, W.: Are human and mammal tracks found together with the tracks of Dinosaurs in the Kayenta of Arizona?, in: "Creation Research Society Quarterly", Vol. 26, 1990

Rubin, D. M., und McCulloch, D. S.: Single and Superimposed Bedforms: A Synthesis of San Francisco Bay and Flume Observations, in: "Sedimentary Geology", 26, 1980

Runcorn, S. K.: "Continental Drift", New York 1962

Rutte; E.: "Bayerns Neandertaler", Munich 1992

Sagan, C.: "Blauer Punkt im All", Munich 1996

Sager, W. W., and Koppers, A. A. P.: Late Cretaceous Polar Wander of the Pacific Plate: Evidence of a Rapid True Polar Wander Event, in: "Science", Vol. 287, 21.1.2000, 455-459

Sandberg, C.: "Ist die Annahme von Eiszeiten berechtigt?", Volume 1, Leiden 1937

Sarre, F. d.: "Als das Mittelmeer trocken war", Rüsselsheim 1999

Schaffranke, R.: "Ether Technology", private 1977

Scheven, J.: "Leben" ("Deutsches Schöpfungsmagazin"), Nr. 6, 1995

Schildmann, K.: "Als das Raumschiff ›Athena‹ die Erde kippte", Suhl 1999

Schmidt, R. R.: "Der Geist der Vorzeit", Berlin 1934

–: "Die diluviale Vorzeit", Stuttgart 1912

Schmitt, C.: Junger Vulkanismus in der Kordillerenzügen Südkolumbiens, in: "Zbl. Geol. Paläont. I", 3/4

Schoolcraft, H. R., and Benton, T. H.: Remarks on the Prints of Human Feet, Observed in the Secondary Limestone of the Mississippi Valley, in: "The American Journal of Science and Arts", Volume 5 1822

Schwarzbach, M.: "Das Klima der Vorzeit", Stuttgart 1993

Sclater, J. G., und Tapscott, C.: Die Geschichte des Atlantik, in: "Ozeane und Kontinente", Heidelberg 1987

Seibold, E.: "Der Meeresboden", Berlin/Heidelberg/New York 1974

Shackleton, E. H.: "The Heart of the Antarctic", vgl. Velikovsky 1980, 62

Shaw, H. R.: "Craters, Cosmos and Chronicles", Stanford 1994

Sheldrake, R.: "Das Gedächtnis der Natur", Munich 1993

–: "Das schöpferische Universum", Munich 1985

–: "Seven Experiments That Could Change The World", London 1994 Singh, M.: "Die Sonne", Berlin 1997

Sitchin, Z.: "Am Anfang war der Fortschritt", Munich 1991

–: "Der Zwölfte Planet", Munich 1995

–: "Stufen zum Kosmos", Frankfurt/Berlin 1996

Steiger, B: "Mysteries of Time and Space", West Chester Pennsylvania/USA 1989

Stokes, W. L.: "Dinosaur Tour Book", Salt Lake City, 1998, 2nd Edition 1992

–: "Geology of Utah", Salt Lake City 1987, 2nd Edition 1988

Strangway, D. W.: The Continental Crust and its Mineral Deposits, in: "Special Paper 20. Geological Society of Canada", 1980

Sudhoff, H.: "Sorry, Kolumbus", Bergisch Gladbach 1990

Suess, E.: "Das Antlitz der Erde" (4 Bände), Leipzig 1885/1909

Supan, A.: "Grundzüge der physischen Erdkunde", Leipzig 1916

Taylor, J.: "Fossil Facts & Fantasies", Crosbyton 1999

Thompson, R. C.: "The Reports of the Magicans ans Astrologers of Ninive and Babylon", II

Thorson, R. M., Clayton, W. S., and Seeber, L.: Geologic evidence for a large prehistoric Earthquake in Eastern Connecticut, in: "Geology", 14, Boulder 1986

Toksöz, M. N., Sleep, N. H., and Smith, A. T.: Evolution of the Downgoing Lithosphere and the Mechanisms of Deep Focus Earthquakes, in: "The Geophysical Journal of the Astronomical Society", Volume 35, Binder 1-3, December 1973

Tollmann, A. und E.: "Und die Sintflut gab es doch", Munich 1993

Tomas, A.: "Wir sind nicht die ersten", Bonn w/o year

Topfer, V.: "Die Tierwelt des Eiszeitalters", Leipzig 1963

Turekian, K. K.: "Die Ozeane", Stuttgart 1985

Velikovsky, I.: "Earth in Upheaval", Garden City 1955

–: "Worlds in Collision", New York 1950

Vollmer, A.: "Sintflut und Eiszeit", Obernburg 1989

Waddel, W. G.: "Manetho", Cambridge w/o year

Wagenbreth, O., und Steiner, W.: "Geologische Streifzüge", Leipzig 1990

Walker, J. C. G.: "Evolution of the Atmosphere", New York 1977

Walther, J. W.: "Geschichte der Erde und des Lebens", Leipzig 1908

Weber, H.: "Einführung in die Geologie Thüringens", Berlin 1955

Wegener, A.: "Die Entstehung der Kontinente" in "Geologische Rundschau", Leipzig 1912

–: "Die Entstehung der Kontinente und Ozeane", Braunschweig 1915

Weinschenk, E.: "Grundzüge der Gesteinskunde, Teil I", Freiburg 1906

–: "Grundzüge der Gesteinskunde, Teil II", Freiburg 1907

Weiß, E.: "Littrow, Wunder des Himmels", Berlin 1886

Wilder-Smith, A. E.: "Herkunft und Zukunft des Menschen", Hamburg 1994

–: "Wer denkt, muß glauben", Bielefeld 1997

Williams, G. E.: Geological evidence relating to the origin and secular rotation of the solar system, in: "Modern Geology 3", 1972

Willis, B.: "East African Plateaus and Rift Valleys", 1936

Wilson, J. T.: Kontinentaldrift, in: "Ozeane und Kontinente", Heidelberg 1987, siehe auch "Scientific American", 4/1963

Woldstedt, P., und Duphorn, K.: "Norddeutschland und angrenzende Gebiete im Eiszeitalter", Stuttgart 1974

Woldstedt, P.: "Das Eiszeitalter", Stuttgart 1954

–: "Quartär. Handbuch der stratigraphischen Geologie 2", Stuttgart 1969

Wolf, M.: "Kohlen permokarbonischen Alters im außerandinen Südamerika" in "Zbl. Geol. Paläont. I", 3/4

Woodward, S. R., Weyand, N. J., und Bunnel, M.: DNA Sequenz from Cretaceous Period Bone Fragments, in: "Science", Bd. 266, 18.11.1994

Wright, G. F.: "Man an the Glacial Period", New York 1987

Wuketits, F. M.: "Biologie und Kausalität", Berlin/Hamburg 1981

Wunderlich, H. G.: "Das neue Bild der Erde", Hamburg 1975

Zeil, W.: "Geologie von Chile", Berlin 1964

–: "Südamerika", Stuttgart 1986

Zillmer, H. J.: "Darwins Irrtum", Langen Müller Publishing, Munich 1998, 4th Edition 2001

–: "Der fossile Hammer aus der Zeit der Dinosaurier", EFODON Dokumentation" No. DO-38, Hohenpeißenberg 1998

–: "Dinosaurier Handbuch" (Dinosaur Manual), Langen Müler Publishing,

Munich 2002
–: "Irrtümer der Erdgeschichte" (Mistakes of the geological history), Langen
Müller Publishing, Munich 2001

Glossary

AU: Astronomical unit. Defines the average distance Earth–Sun as 149,600 million kilometers.

Binding agent: Substance used for binding or sealing on mineral, chemical, or organic basis – for example cement for binding of water and additives in concrete.

Calibration: Determination of relation between two different values or series of readings.

Conglomerate: Sedimentary rock, consisting of sealed gravels.

Consistence: Nature of substances in respect to cohesion of its parts and behaviour when reshaped.

Creation: Foundation of many religions. Shaping of the world out of nothingness by a divine being by an act of creation, particularly in Judaism, Christianity, and the "Popol Vuh", the sacred book of the Maya.

Darwin: Theory of Evolution by Charles Darwin. See Evolution.

Dendrochronology: Method for determining the age of archeological findings by determining the annual rings of attendant wood found.

Determination of Age (indirect): Dating of geological events and prehistoric finds. The purely geological methods (stratigraphy), in which spatially separated strata are chronologically allocated according to the index fossils they contain. They provide a relative age, but fail when it comes to very old strata without fossils. Other methods, such as counting the annual layers of stratified clay or dendrochronology provide absolute ages, assuming the validity of theories of uniformity.

Decay series: Radioactive matter (nuclides) or atomic nuclei, resulting from successive decay. Natural decay series include series of uranium and thorium.

Doctrine of Uniformity: See Theory of Uniformity.

Ecliptic: The largest circle, in which the plane of Earth's trajectory around the

sun intersects the sphere of the skies, depicted as infinitely large.

Embryonic development: Biogenetic law, put forward by Ernst Haeckel (1866), that claims that all living beings re-experience the entire phylogeny of its ancestors in its embryonic development. Therefore embryos of fish, chicken, pigs or humans are said to be indistinguishable. This doctrine, however, rests on faked drawings and has since been exposed as such.

Epicenter: Zone where an Earthquake originates (focus of quake).

Eruptive rock: These igneous rocks result from rock melting in the upper mantle of the Earth and the Earth's crust: basalt and granite.

Evolution: The phylogenic development of living beings from simpler to more sophisticated structures during long periods of time in which species change by mutation, re-combination, natural selection and isolation as the main evolutionary factors (theory by Darwin).

Genesis: Greek term for creation. Greek-Latin name of the 1st Moses, 1st Book of Pentateuch and the Bible in general. It is organized into two major parts: prehistory (e.g. Creation, Paradise and the Fall) and the stories of the forefathers, such as Abraham, Isaac, and Jacob, Joseph, and his brothers.[157]

Half-life period: Period in which original matter reduces to half of its initial value. In respect to radioactive decay, half-life periods describe the period of time in which half of the initial atoms half disintegrated. Under uniform conditions (Lyell-Principle), it is a characteristic value for every isotope, regardless of external circumstance.

Halo: Usually ring-shaped, occasionally spotty or striped, phenomenon of light.

Impact: Collision of a planetary body with a meteorite.

Isotope: Atoms of an element may show varying amount of neutrons. They are referred to as nuclide isotopes or, for short, isotopes.

Leap second: Uniform time scale TAI (abbreviated: "Temps atomique international"), defined by atomic clocks (cesium clocks) deviates from rotational time (rotation) of Earth – UTC (abbreviated: Coordinated Universal Time) = Coordinated Greenwich Mean Time – by no more than 0,9 seconds.[102]

As the rotational speed of the Earth (duration of day) has been decreasing in the last years, an additional second (leap second) has to be added in regular intervals of 500 days in order to maintain this relation. The first leap second was introduced on June 30, 1972.

Lyell Principle: Theory put forward by Charles Lyell (geology), advocating the exclusive influence of minute, current forces on the shaping of Earth's surface. It leaves no room for major cataclysmic disasters, such as a universal flood. Along with Haeckel's Biogenetic Law, this theory serves as the foundation for the Theory of Evolution.

Metamorphic rock: Because of their structure, some of them (metamorphites) are also called crystalline slates. They form from eruptive and sedimentary rock by way of metamorphosis, i.e. transformation through heat and pressure to varying extents. For example: granites turn into orthogneiss, clayey rock forms into paragneiss, limestones into marble. Metamorphosis may range from partial reflowing (anatexis), producing migmatites (mixed rocks) to total melting (palingenese) and the new formation of magma.[157]

Missing link: Missing transitional form (stage of evolution) within the sequence of a development in biology and anthropology.

Nuclide: Atoms, characterized by a determined mass number (protons, neutrons) and ordinal. See Isotope.

Nutation: Fluctuation of Earth's axis towards sky pole.

Perpetuum mobile: A machine, perpetually running without energy input.

Potassium-Argon Method: A method for direct assessment of age. It takes the isotope K 40, contained in natural potassium to 0,012 %, that with a half-life period of $1,28 \times 10^9$ years, among others, disintegrates into stabile Argon isotope Ar40 as a starting point. Ascertainable period of time: 10^5 to 10^{10} years.

Precession: The backward spin of Earth's axis lasted about 26,000 years. It caused the reverse motion of point of intersection of the sky equator and the ecliptic.

Radio Carbon Method: Carbon-14-Method (C14-method) is an established method for direct assessment of age, developed by W. F. Libby. It is based on the knowledge that nitrogen in the air transforms into radioactive carbon ^{14}C

and oxidizes to carbon dioxide ($^{14}CO_2$), when exposed to cosmic radiation. By way of exchange of CO_2 between atmospheric carbon dioxide and the bicarbonate dissolved in ocean water, 96 percent of ^{14}C feed the ocean in continual supply, another two percent are assimilated by plant and animal organisms, so that only two percent remain in the atmosphere. The overall reservoir of C is balanced. ^{14}C, lost through disintegration, is reproduced and replaced. When carbon-containing material is removed from the reservoir of ^{14}C (organism dying off or lime deposition in ocean), the proportion of isotopes at level of equilibrium $[^{14}C]:)[^{12}C]=1:10^{12}$ (recent value) drops with a half-life period of 5730 years. In order to assess age, the proportion of specific b-activity of sampled carbon is compared to that of recent carbon of, for example, fresh wood, calculating the time elapsed (up to 50,000 years) since sample was removed from the reservoir of ^{14}C.

Sediments: Sedimentary rock (stratified rocks) is deposited as a loose material (sand, sludge, and gravel) and solidified by diagenesis. They are categorized according to place of origin in marine sediments (shallow-sea and deep-sea deposits) and continental deposits (ashore and in inland waters) or descriptive in debris rock, such as loess, sandstone, greywacke, drift mar, some types of limestone, in chemical sediments, as products of chemical reactions, such as evaporite, plaster stone, some limes and dolomites, and in organogenic sediments, formed by organisms. Coal and lithothamnion, for example, are produced by plants, animals from coral limes and radiolarites.[157]

Setting of material: Process of hardening.

Stratified clay: Deposited as stratified clay in basins of melted snow and ice in front of glaciers. One light and one dark layer from the sedimentary are the result of one year. It allows to determine the age by counting, provided the theories of uniformity are valid.

Thermoluminescence Method: Procedure, mainly used to determine the age of ceramic products. Makes use of the fact that electrons are stimulated, i.e. lifted to a higher energy levels, by cosmic radiation or the radiation of natural radioactive isotopes in crystals of quartz and feldspar contained in clay particles. This process is reversed when ceramics are burned, especially, however, when samples are examined (heated to about 300 °C). Light is emitted (thermoluminescent radiation). Its intensity indicates the age of the sample (up to approx. 500,000 years).

The theories of uniformity: The foundation of our worldview is the dogma of Charles Lyell (geology) and Charles Darwin (biology). They assume a continuously uniform evolution the Earth and its lifeforms, without disasters (see Lyell Principle).

UTC: Coordinated Universal Time. Averaged solar time of prime meridian (averaged local time of Greenwich) serves as universal time, related to all time zones.

Index

inseparably linked to Geology.

Sedology inseparably linked with Darwinism 131

hammerstiel ~ see Fossil.

Picture Credits

Dr. Cecil & Lydia Dougherty (copyright reserved – permission granted for use by Heirs) 3–10; Felix R. Paturi 18; Carl Baugh/Don Patton 36-38, 44; Carl E. Baugh 12, 33-35, 43, 45, 48, 49, 51B, 53, 54, 61, 62, 64, 65, 75-77; Roland T. Bird (1938) 30; Don Patton/Collins 47; Robert Hefeinstine/Jerry Roth 41, 59, 60; Robert V. Gentry 59-64; Johannes von Buttlar 65; Graham Hancock 66; Dr. Albert Vollmer 67; John D. Morris 80-82; GeoForschungsZentrum Oberpfaffenhofen (Part extension and color change by author) 84; Steve Daniels (Walt Brown) 68; Creation Research Society 68; Ron Calais (in Brad Steiger) 70 ,71; Anselm Spring 79; Geological Survey of Canada (Foto Nr. GSC180345) 77; Internet 85; Louvre 108, extension from this 107 (Zillmer); Werner Folk 90,91; British Museum 109, extension from this 110 (Zillmer); Vorasiatisches Museum 111, extension from this 112 (Zillmer); Michihimo Yano 87-89; Luc Bürgin 97, Bernard Roidinger/Cornelia Petratu 94; Andreas Mehzoud 99; Javier Cabrera Darquea 100; Erich von Däinken 101; Evan Hansen 105; M. Leaky aus Yahya (2002); Zecharia Sitchin 113; Erich von Däniken 114; Peter Krassa/Reinhard Habeck 115; Naturmuseum Senckenberg 119; Archives Zillmer 1 ,2, 11, 13-17, 19-29, 32, 39, 40, 42, 45, 50, 51A, 51C, 55, 72, 73, 74-76, 78, 83, 86,92, 93, 95, 96, 98, 99, 102, 116–118.

Figure Credits

Carl Baugh 1; Robert Helfinstine/Jerry Roth 3; "Natural History" 6; Dr. Albert Volmer 7; Dr. Cecil & Lydia Dougherty 11; Zecharia Sitchin 12, 24; Dr. E. Tollmann/Prof. Dr. A. Tollmann (K. O. Emery) 27, C. Corvey (Tollmann) 30; O. B. Toon (Tollmann) 36; Glen J. Kuban 37; Britisch Museum 40; Robin Crompton (University of Liverpool)/Mercury Press) 41; Peter Krassa/ Reinhard Habeck 43. Hans J. Zillmer: (Base: Helfinstine/Roth) 2; (source: Robert V. Gentry) 10; (source: Otto Muck) 13, 22, 32; (source: Walt Brown) 14, 34; (source: Dennis R. Petersen) 19; (source: Zecharia Sitchin) 26; (Base: John Morris) 39; Zillmer 4, 5, 8-10, 15, 16-18, 20, 21, 23, 25, 28, 29, 31, 33, 35, 38, 42.

THE STONE PUZZLE OF ROSSLYN CHAPEL
Philip Coppens

Rosslyn Chapel has fueled controversy and debate, both recently in several worldbestselling books as well as in past centuries. Revered by Freemasons as a vital part of their history, believed by some to hold evidence of pre-Columbian voyages to America, assumed by others to hold important relics, from the Holy Grail to the Head of Christ, the Scottish chapel is a place full of mystery.

This book will guide you through the theories, showing and describing where and what is being discussed; what is impossible, what is likely... and what is fact.

At the same time, the book will virtually guide you around all enigmatic and important aspects of the chapel. The history of the chapel, its relationship to freemasonry and the family behind the scenes, the Sinclairs, is brought to life, incorporating new, forgotten and often unknown evidence.

Finally, the story is placed in the equally enigmatic landscape surrounding the chapel, from Templar commanderies to prehistoric markings, from an ancient kingly site to the South, to Arthur's Seat directly north from the Chapel – before its true significance and meaning is finally unveiled: that the Chapel was a medieval stone book of esoteric knowledge.

*120 Pages. Paperback. Euro 14,90 * GBP 7.99 * USD $ 12.00. Code: ROSC*

SAUNIERE'S MODEL
André Douzet

After years of research, André Douzet discovered a model from Sauniere.

Douzet reveals that Saunière spent large amounts of time and money in the city of Lyons... trips he performed in the utmost secrecy. Douzet finally unveils the location indicated on the model, the location of Sauniere's secret. Almost a century after Sauniere's death, the mystery of Rennes-le-Chateau is beginning to reveal itself.

*116 Pages. Paperback. Euro 14,90 * GBP 7.99 * USD $ 12.00. Code: SMOD*

CROP CIRCLES, GODS AND THEIR SECRETS
Robert J. Boerman

In the more than 20 years that mankind all over the world has been treated with thousands of crop circle formations, nobody was able to explain this phenomenon. You can read how beside a scientific and historical section the author links two separate crop circles. They contain an old Hebrew inscription and the so called Double Helix, yielding the name of the 'maker', his message, important facts and the summary of human history. This resulted in the commencement of cracking the crop circle code.

*159 Pages. Paperback. Euro 15,90 * GBP 9.99 * USD $ 14.00. Code: CCGS*

THE BIBLE FRAUD
The Untold Story Of Jesus And His Twin Brother, Judas Khrestus
Tony Bushby

This groundbreaking book reveals to the world for the first time original new information about the emergence of the New Testament and its story of Jesus Christ. It provides historical evidence showing not only vital ancient manuscripts been hidden from the public domain but also other sensitive and associated Biblical material has been purposely withheld or suppressed from the general populace.

*272 Pages. Paperback. Euro 24,90 * GBP 15.99 * USD $ 18,95. Code: TBF*

THE TRUE THIRD SECRET OF FATIMA REVEALED
Pastor Melo Nzeyitu Josias

What is it about the Third Secret of Fatima that it has been suppressed by so many Popes? Why did John XXIII collapse on reading its content, only to refuse to announce it in 1960? Why did Pope John-Paul II authorise the release in May 2000 of what's widely believed to be a fraudulent Third Secret? What could be so shocking to the Vatican, more shocking even than Armageddon? That Jesus Christ was back—and (again) was black?

*260 Pages. Paperback, Euro 27,90 * GBP 18,90 * USD $ 21,90. Code: TTSF*

VATICAN ASSASSINS
Wounded In The House Of My Friends
Eric Jon Phelps

An explosive, detailed, shocking, historical account of the long-suppressed history of the Jesuit Order and their involvement behind the scenes manipulating the world through the Pope, via the Jesuit's General, the "Black" Pope-the most powerful man in the world.

*700 Pages. Large Paperback, Euro 53,90 * GBP 35,90 * USD $ 41,95. Code: VATA*

Truth Behind the Christ Myth
The Redemption of the Peacock Angel
Mark Amaru Pinkham

Pinkham tells us the Truth Behind the Christ Myth and presents radically new information regarding Jesus Christ and his ancient legend, including:
* The legend of Jesus Christ is based on a much earlier Son of God myth from India, the legend of Murrugan, the Peacock Angel.
* Saint Paul came from Tarsus, the center of Mithras worship in Asia Minor.
* The Three Wise Men were Magi priests from Persia who believed that Jesus was an incarnation of Mithras.
* While in India, Saint Thomas became a peacock before he died and merged with Murrugan, the Peacock Angel
* The Emperor Constantine was a lifelong devotee of Mithras. He was baptized Christian on his deathbed.
* The Peacock Angel is a historical figure who has been worshipped by many persons worldwide as The King of the World
*174 Pages. Paperback, Euro 18,90 * GBP 11,90 * USD $ 14,95. Code: TBCM*

Colloidal Silver
The hidden truths
Keith F. Courtenay

This book explains the therapy that can change your life. It is the most amazing natural antibiotic medical science has ever discovered - and yet these incredible research findings have been kept hidden from the public! Read the research doctors themselves have witnessed for the last 80 years of this inexpensive, incredibly effective yet virtually unknown natural antibiotic that kills hundreds of viruses.
*246 Pages. Paperback, Euro 27,90 * GBP 16,99 * USD $ 23,90. Code: COS*

The Miracle Man
The Life Story of Joao de Deus
Robert Pellegrino-Estrich

The amazing story of the Brazilian healer who has been featured in Nexus Magazine and other publications. He treats 3,000 people per day; 15 million people treated in 30 years. He makes the blind see and the quadraplegic walk again. He does more operations per day than a large hospital in a month. Why is there no bleeding? How is it possible without anaesthetic? Why does he refuse payment?
*148 Pages. Paperback. Euro 19,90 * GBP 11,99 * USD $ 18,95. Code: MIRM*

The World's Sixteen Crucified Saviors
Christianity Before Christ
Kersey Graves, foreword by Acharya S
A reprint of Kersey Graves' classic and rare 1875 book on Christianity before Christ, and the 16 messiahs or saviors who are known to history before Christ!
*436 Pages. Paperback. Euro 25,90 * GBP 16,90 * USD $ 19,95. Code: WSCS*

The Orion Prophecy
Egyptian & Mayan Prophecies on the Cataclysm of 2012
Patrick Geryl and Gino Ratinckx
In the year 2012 the Earth awaits a super catastrophe: its magnetic field reverse in one go. These dire predictions stem from the Mayans and Egyptians—descendants of the legendary Atlantis. The Atlanteans had highly evolved astronomical knowledge and were able to exactly predict the previous world-wide flood in 9792 BC. In the year 2012 these stars will take the same 'code-positions'. For thousands of years historical sources have told of a forgotten time capsule of ancient wisdom located in a labyrinth filled with artifacts and documents.
*324 Pages. Paperback. Euro 21,90 * GBP 14,90 * USD $ 16,95. Code: ORP*

The Giza Death Star
The Paleophysics of the Great Pyramid & the Military Complex at Giza
Joseph P. Farrell
Physicist Joseph Farrell's amazing book on the secrets of Great Pyramid of Giza. The Giza Death Star starts where British engineer Christopher Dunn leaves off in his 1998 book, The Giza Power Plant. Was the Giza complex part of a military installation over 10,000 years ago? Chapters include: An Archaeology of Mass Destruction, Thoth and Theories; The Machine Hypothesis; Pythagoras, Plato, Planck, and the Pyramid; The Grand Gallery and its Crystals: Gravito-acoustic Resonators; The Other Two Large Pyramids; the "Causeways," and the "Temples"; more.
*290 Pages. Paperback. Euro 21,90 * GBP 14,90 * USD $ 16,95. Code: GDS*

Quest For Zero-Point Energy
Engineering Principles for "Free Energy"
Moray B. King

King expands, with diagrams, on how free energy and anti-gravity are possible. The theories of zero point energy maintain there are tremendous fluctuations of electrical field energy embedded within the fabric of space. King explains the tapping the Zero-Point Energy as an Energy Source; Fundamentals of a Zero-Point Energy Technology; Vacuum Energy Vortices; The Basis of Zero-Point Energy Inventions; Vortex Filaments, Torsion Fields and the Zero-Point Energy; Transforming the Planet with a Zero-Point Energy Experiment;

*224 Pages. Paperback. Euro 18,90 * GBP 12,90 * USD $ 14,95. Code: QZPE*

The A.T. Factor
Piece For A Jigsaw Part 3
Leonard Cramp

British aerospace engineer Cramp began much of the scientific anti-gravity and UFO propulsion analysis back in 1955 with his landmark book Space, Gravity & the Flying Saucer (out-of-print and rare). In this book, Cramp uncovers another aspect of those strange UFO propulsion systems.

*324 Pages. Paperback. Euro 21,90 * GBP 14,90 * USD $ 16,95. Code: ATF*

The Land of Osiris
An Introduction to Khemitology
Stephen S. Mehler

Was there an advanced prehistoric civilization in ancient Egypt? Were they the people who built the great pyramids and carved the Great Sphinx? Did the pyramids serve as energy devices and not as tombs for kings? Independent Egyptologist Stephen S. Mehler has spent over 30 years researching the answers to these questions and believes the answers are yes! Mehler has uncovered an indigenous oral tradition that still exists in Egypt, and has been fortunate to have studied with a living master of this tradition.

*272 Pages. Paperback. Euro 24,90 * GBP 16,90 * USD $ 18,95. Code: LOOS*

A Hitchhiker's Guide to Armageddon

David Hatcher Childress

Childress hits the road from Megiddo, the legendary fortress in northern Israel where Armageddon is prophesied to start. Hitchhiking around the world, Childress takes us from one adventure to another, to ancient cities in the deserts and the legends of worlds before our own.

Among the various topics in the book:

•The amazing sciences of ancient India and China

•David's involvement with the strange megaliths of New Zealand

•Intelligence operatives in New Zealand and the attempt on David's life

•David's travels to remote islands and the controversy that it has created

•The sunken ruins of the northern Pacific islands of Pohnpei and Yonaguni

*320 Pages. Paperback. Euro 21,90 * GBP 14,90 * USD $ 16,95. Code: HGA*

The Ultimate Reality

Joseph H. Cater

The deeper mysteries of the universe have always been considered beyond human understanding. There is one important and almost self-evident principle such believers, who make up all but a few of the world thinkers, see, to overlook. Everything in the process of creation proceeds from the simple to the more complex.

Every mechanical or electronic device, regardless of it's complexity, operates according to a very few simple and easily understood principles. It follows that the universe should also comply with the same patterns, regardless of its near infinite complexity. This book is Cater's follow up work to the Awesome Life Force. Within the pages of these two volumes Cater explains phenomena of all kinds. Evidence of UFO interference, the Hollow Condition of the Earth, The Nature of Magnetic Fields, Communications with Higher Realms, Energy and the Causes of Novas and Sunspots, Misconceptions of Time and Space, The Reality of Thought Forms, and much, much more.

*224 Pages. Hardcover. Euro 27,90 * GBP 18,90 * USD $ 24,95. Code: TUR*

Write for our free catalog of other fascinating books, videos & magazines.